ART AND
PHENOMENOLOGY

Philosophy of art is traditionally concerned with the definition, appreciation and value of art. Through a close examination of art from recent centuries, *Art and Phenomenology* is one of the first books to explore visual art as a mode of experiencing the world itself, showing how, in the words of Merleau-Ponty, "Painting does not imitate the world, but is a world of its own".

An outstanding series of chapters by an international group of contributors examine the following issues:

- Merleau-Ponty, Paul Klee, and art as perceptual engagement with the world
- how phenomenology helps us understand why art matters
- the work of art and its material objectivity
- Fichte, transcendence in immanence, and the painting of Mark Rothko
- realism in the history of art and the desire to experience the world through art
- the structure of self-consciousness and the art of Lucas Cranach the Elder
- Vermeer and the *presenting* of what it means to be in a world
- phenomenological history and freedom in Botticelli's art
- film and Husserlian phenomenology.

Including an extensive selection of full colour reproductions, *Art and Phenomenology* is essential reading for anyone interested in phenomenology, aesthetics, and visual culture.

Contributors: John B. Brough, Steven Crowell, Béatrice Han-Pile, Sean Dorrance Kelly, Jeff Malpas, Wayne Martin, Joseph D. Parry, Violetta L. Waibel, and Mark Wrathall.

Joseph D. Parry is Associate Professor in the Department of Humanities, Classics, and Comparative Literature, Brigham Young University, USA.

ART AND PHENOMENOLOGY

Edited by
Joseph D. Parry

LONDON AND NEW YORK

This edition published 2011
by Routledge
2 Park Square, Milton Park, Abingdon, Oxon OX14 4RN

Simultaneously published in the USA and Canada
by Routledge
711 Third Avenue, New York, NY 10017

Routledge is an imprint of the Taylor & Francis Group, an informa business

Typeset in Times New Roman by
Book Now Ltd, London

British Library Cataloguing in Publication Data
A catalogue record for this book is available from the British Library

Library of Congress Cataloging in Publication Data
Art and phenomenology/edited by Joseph D. Parry.—1st ed.
p. cm.
Includes bibliographical references and index.
1. Art—Philosophy. 2. Phenomenology and art. 3. Aesthetics.
N70.A775 2010
701—dc22 2010027347

ISBN13: 978–0–415–77449–9 (hbk)
ISBN13: 978–0–415–77450–5 (pbk)
ISBN13: 978–0–203–83394–0 (ebk)

CONTENTS

CONTENTS

PLATES

CONTRIBUTORS

John B. Brough is Professor Emeritus at Georgetown University. He has written essays on temporality, aesthetics, representation, and imaging. Recently he translated Husserliana Volume XXIII, which collects Husserlian texts on memory, image consciousness, and phantasy.

Steven Crowell is Joseph and Joanna Nazro Mullen Professor of Philosophy at Rice University. Crowell is the author of *Husserl, Heidegger, and the Space of Meaning: Paths Toward Transcendental Phenomenology* (Northwestern 2001) and editor, with Jeff Malpas, of *Transcendental Heidegger*. He has written numerous articles in phenomenology, continental philosophy, and the history of philosophy. He also edits the journal *Husserl Studies*. His most recent work explores the existential roots of theoretical and practical reason.

Béatrice Han-Pile is Professor of Philosophy at the University of Essex (UK). She is the author of *Michel Foucault's Critical Project: Between the Transcendental and the Historical* (Stanford University Press 2002) and of several articles on Nietzsche, Heidegger, and Foucault. She is currently working on two projects: a book on 'Transcendence without Religion' and a volume on Foucault for The Routledge Philosophers series.

Sean Dorrance Kelly is Professor and Chair of the Department of Philosophy at Harvard University. His most recent book, co-authored with Bert Dreyfus, is *All Things Shining: Reading the Western Canon to Find Meaning in a Secular Age* (Simon and Schuster) which will appear in early 2011.

Jeff Malpas is Professor of Philosophy and ARC Australian Professorial Fellow at the University of Tasmania, Australia, and Distinguished Visiting Professor at LaTrobe University, Victoria, Australia. He has written extensively on a range of topics, but especially on the work of Heidegger and Davidson, as well as on the philosophy of place. In addition to essays and book chapters, his most recent works are *Heidegger's Topology* (2006) and *Consequences of Pragmatism* (edited with Santiago Zabala, 2010).

Wayne Martin is Professor and Head of the Department of Philosophy at the University of Essex (UK). He is the author of books on Fichte (Stanford University Press, 1997) and Judgment (Cambridge University Press, 2006). He serves as General Editor of *Inquiry* and Series Editor of *Modern European Philosophy* (Cambridge University Press). He is Principal Investigator of *The Essex Autonomy Project*, a three year interdisciplinary research initiative funded by the Arts and Humanities Research Council of Great Britain.

Joseph D. Parry is an associate professor in the Department of Humanities, Classics, and Comparative Literature at Brigham Young University. He has published on a number of topics in the history of literature and culture from the twelfth to the sixteenth centuries, many of which grow out of his interest in questions of authority in literary, visual, and historical narratives.

Violetta L. Waibel is Professor of European Philosophy and Continental Philosophy at the University of Wien. She has published articles on theoretical philosophy (consciousness, subjectivity, intersubjectivity, space, and time), on the relation of cognition and emotion, and on aesthetics in Kant, German idealism, and romantic and modern art. She is the author of a book on Hölderlin and Fichte (Schöningh 2000) and has co-edited volumes on subjectivity (Suhrkamp 2005) and Fichte (Walter de Gruyter 2010). Her book on the *Fichte Studies* of Friedrich von Hardenberg (Novalis) will appear in 2011.

Mark Wrathall is Professor of Philosophy at the University of California, Riverside. His most recent book is *Heidegger and Unconcealment: Truth, Language, and History* (Cambridge University Press 2010).

ACKNOWLEDGEMENTS

The idea for this book was born in discussions I had with Mark Wrathall when he was still at Brigham Young University, and it is to Mark that I owe the greatest debt of gratitude for his advice and, yes, mentoring. Mark is an exemplary colleague and selfless collaborator. But in addition to the personal attention he gave me, and the contacts to the A-league contributors to this volume, Mark along with Jim Faulconer and David Laraway conducted what was for me a career-altering faculty seminar on phenomenology and embodiment in 2004 sponsored by BYU's College of Undergraduate Education. I am grateful to all three directors for their complementary ways of teaching me, and thanks are also due to Undergraduate Education and BYU's Philosophy Department for making the seminar possible and sweetening the funding so that people like Hubert Dreyfus and Sean Kelley could drop in and make a rich experience even richer. As a sidenote: to see both the profound influence that Bert Dreyfus has on his students long after they have left Berkeley, and also the love and admiration that those students have for him, is truly inspiring.

My thanks also go to John Rosenberg, Dean of the College of Humanities at BYU, whose friendship, as well as financial support, were crucial to this book's appearance. It very much took a communal effort for me to do the work for this book while I served as one of his associate deans, and so I thank him and my fellow "associates" Gregory Clark and Ray Clifford for taking some of my tasks at key times. Abbie Smith Rufener was my able assistant during the first part of my work on the book. Mel Thorne and his staff at the BYU Humanities Publication Center gave me some much needed editorial assistance at a crucial point in the project.

It's been a true pleasure working with Tony Bruce and his assistants Amanda Lucas and Adam Johnson at Routledge. I am particularly grateful that Tony allowed for the extra number of visual images in the book. Thanks, too, for their patience with this project — a few of our number were forced to deal with personal challenges and tragedies during this project, and we couldn't have asked for greater understanding and flexibility from them.

Finally, I thank my wonderful wife, Catherine Corman Parry, for her intelligence and wisdom, as well as her constant love and understanding, as she helps me talk through life as I live it.

PERMISSIONS

Plate 1 Paul Klee, *Abwägender Kunstler*, 1919, oil transfer drawing on paper on cardboard, 19.7 × 16.6 cm, Zentrum Paul Klee, Bern, Livia Klee Donation, © ARS, New York

Plate 2 Paul Klee, *Schema Ich-Du-Erde-Welt*, pen on paper on cardboard, 33 × 21 cm, Zentrum Paul Klee, Bern, PN26 M45/88, © ARS, New York

Plate 3 Paul Klee, *Segelschiffe, leicht bewegt*, 1927, pen on paper on cardboard, 30.5 × 46.3 cm Zentrum Paul Klee, Bern, private loan, © ARS, New York

Plate 4 Abraham van Beyeren, *Rough Sea*, oil on canvas, 69.8 × 112 cm, Museum of Fine Arts, Budapest

Plate 5 Donald Judd, *Untitled (Large Stack)*, 1991, anodized aluminum and plexiglass, Margo Leavin Gallery, Los Angeles, © Judd Foundation. Licensed by VAGA, New York

Plate 6 Vincent van Gogh, *A Pair of Shoes*, 1886, oil on canvas, 72 × 55 cm, Van Gogh Museum (Vincent van Gogh Foundation), Amsterdam

Plate 7 Giorgio Morandi, *Blue Vase and Other Objects*, 1920, oil on canvas, 49.5 × 52 cm, Private Collection, The Bridgeman Art Library, © ARS, New York

Plate 8 Giorgio Morandi, *Natura Morta*, 1943, oil on canvas, 30 × 45 cm, Museu Colecção Berardo © ARS, New York

Plate 9 Paul Cézanne, *Mont Saint-Victoire*, 1902–04, oil on canvas, 73 × 91.9 cm, Philadelphia Museum of Art, Philadelphia, photo by Graydon Wood

Plate 10 J.R. Cozens, *The Two Great Temples at Paestum, c.* 1783, watercolor, Victoria and Albert Museum, London

Plate 11 Robert Rauschenberg, *Bed*, 1955, combine painting: oil and pencil on pillow, quilt, and sheet on wood supports, 188 × 79 × 20 cm, Museum of Modern Art, New York, gift of Leo Castelli in honor of Alfred H. Barr,

Jr., © estate of Robert Rauschenberg, licensed by VAGA, New York. Digital image © The Museum of Modern Art, licensed by Scala/Art Resource, New York

Plate 12 Mark Rothko, *Untitled 1447, no. 16 [?]*, 1950–52, oil on canvas, 190 × 101.1 cm, Tate Modern Gallery, London, © ARS, New York

Plate 13 Jan van Eyck, *The Marriage of Giovanni Arnolfini*, 1434, oil on oak, 82.2 × 60 cm, National Gallery, London

Plate 14 Jean Baptiste Siméon Chardin, *Soap Bubbles*, 1733, oil on canvas, 61 × 63.2 cm, Metropolitan Museum of Art, New York, Wentworth Fund (49.24), © Photo SCALA, Florence/Metropolitan Museum of Art/Art Resource

Plate 15 Paul Cézanne, *La Table de Cuisine*, 1888–90, oil on canvas, 65 × 80 cm, Musée D'Orsay, Paris

Plate 16 Erle Loran, Diagram of Paul Cézanne's *La Table de Cuisine* from *Cézanne's Composition: Analysis of His Form with Diagrams and Photographs of His Motifs*, © 1943, 1971 by Erle Loran, University of California Press

Plate 17 Pablo Picasso, *The Women of Algiers*, 1955, oil on canvas, 116 × 89 cm, b/w photo by Picasso, Private Collection, Giraudon, The Bridgeman Art Library, © ARS, New York

Plate 18 Lucas Cranach, the Elder, *Adam and Eve*, 1526, oil on panel, 117 × 80 cm, The Samuel Courtauld Trust, The Courtauld Gallery, London

Plate 19 Lucas Cranach, the Elder, *The Fall of Man*, 1523, woodcut, British Museum, London

Plate 20 Lucas Cranach, the Elder, *Adam and Eve*, detail: signature, 1526, oil on panel, 117 × 80 cm, The Samuel Courtauld Trust, The Courtauld Gallery, London

Plate 21 Lucas Cranach, the Elder, *Adam and Eve*, 1533, detail: lion, oil on beech, 51.3 × 35.5 cm, Gemaldegalerie, Staatliche Museen zu Berlin, Photo: Jörg P. Anders, © Photo SCALA, Florence/BPK, Bildagentur für Kunst, Kultur und Geschichte, Berlin

Plate 22 Johannes Vermeer, *Woman in Blue Reading a Letter*, c. 1663–64, oil on canvas, 46.6 × 39.1 cm, Rijksmuseum, Amsterdam

Plate 23 Johannes Vermeer, *The Milkmaid*, c. 1658–60, oil on canvas, 45.5 × 41 cm, Rijksmuseum, Amsterdam

Plate 24 Gabriel Metsu, *Woman Reading a Letter with her Maidservant*, 1662–65, oil on panel, 53 × 40 cm, National Gallery of Ireland

Plate 25 Johannes Vermeer, *The Geographer*, 1669, oil on canvas, 53 × 46.6 cm, Stadelsches Kunstinstitut, Frankfurt, Germany, Bildarchiv Foto Marburg, The Bridgeman Art Library

Plate 26 Sandro Botticelli, *Cestello Annunciation*, c. 1489–90, tempera on panel, 150 × 156 cm, Galleria degli Uffizi, Florence, Italy, Allinari, The Bridgeman Art Library licensed by the Ministero per i Beni e le Attività Culturali

Plate 27 John Collier, *Annunciation*, c. 2001, oil on panel, 120 × 120 cm, Private Collection, image available at www.hillstream.com

INTRODUCTION

Joseph D. Parry and Mark Wrathall

The overarching aim of this book is to demonstrate not just what art can mean to philosophy, but also what it means *as* philosophy. Artists, of course, do not have to be philosophers to be good artists, or bad ones, for that matter, and it is not the general argument of this book that art is philosophy when or because artists deliberately use their work to make philosophical arguments. Indeed, that would seem a sure-fire recipe for making bad art. We do believe, however, that what art *does* is philosophically significant. Each chapter in this book is both an argument for and a demonstration of art's power to aid and inform philosophy. Our approach to art is to treat it as a kind of phenomenology—which is not to say that art can be reduced to a discursive content, but rather that art can function as a way of directing us to important phenomena and helping us to understand them in their own terms. In fact, we deliberately chose to approach this topic with a multiple-authored, "edited" volume. We felt that the best way to make the case for art as phenomenology was to show how diverse—in both the works of art that each author chose to examine, but also in the philosophical problems upon which they focus—and thus how versatile this approach can be.

Some of the chapters tackle philosophical problems by means of a phenomenological analysis of particular artworks. Others set out simply to understand a work of art or an artist better as a phenomenologically significant activity in its own right, thus suggesting a novel way of thinking about the very being of the artwork itself. But what all the chapters have in common is the sense that, as Steven Crowell expresses it, visual art matters. Crowell's chapter explores a question that will undoubtedly be on the minds of many of our readers—what is the relationship between phenomenology and aesthetics in the study of visual art. For Crowell, aesthetics and phenomenology are not rivals or opponents; aesthetics needs phenomenology because phenomenology can explicitly reintroduce into aesthetics why art matters, something that often seems to be missing from aesthetic studies. Crowell demonstrates how phenomenology situates "the search for a definition of art within a reflection on the horizons in which art shows

1

itself," and how, therefore, art can "disclose" why we care about it—for example, by showing us why we care about beauty. This is something we can learn from both with a beautiful piece of art and an ugly one, just as abstract art can be as profoundly about a represented object as a representational piece of art is. But to show how art becomes "an irreducible mode of truth," Crowell not only reads Heidegger, but also still lifes by Giorgio Morandi. Heidegger, Crowell argues, was ultimately unable in his work (including his "On the Origin of the Work of Art") to say what makes up the "thinghood of the thing." But Morandi's work is able to make "thinghood ... experienced and understood" in ways that an essay on art and thingliness is not.

We are by no means the first to make the claim about art's phenomenological significance. As Mark Wrathall argues in his chapter, there is a rich tradition in the existentialist-phenomenological school of philosophy of treating art as a mode of philosophical inquiry. In this volume we see ourselves as following the example set by such influential figures as Friedrich Nietzsche, Martin Heidegger, Maurice Merleau-Ponty, and Jean-Paul Sartre, in using works of art not simply to illustrate an already-formed philosophical question or problem, but also to reconceive and reconstruct the particular questions themselves that are important within the enterprise of philosophy. As is well known, Heidegger examines the Greek temple to think through the structure of unconcealing/concealing, a structure that, Heidegger argues, undergirds each historical world up to the present. Merleau-Ponty sits at the feet of Cezanne to learn from him concerning what it means, as an embodied being, to take up the world that opens itself to us in perception. Art is not a mere means to illustrate a philosophical point for either thinker here. Rather, philosophical insight is attained best through an experience of the work of art itself. For the existential phenomenologists, art is a neighbor to and co-worker with philosophy, and both art and philosophy proceed by directing our attention to our experience of the world. In a very real way, then, art can show us what philosophy, especially phenomenology, should look like. Wrathall reviews the case that Heidegger and Merleau-Ponty make for seeing art as a meaningful phenomenological activity. Indeed, as Wrathall notes, Merleau-Ponty claims that art has priority over written philosophy. But Wrathall also shows just how "phenomenological" the concerns of artists have been both in the past (the Renaissance) and more recently in the modern era with artists such as Paul Cezanne, Henri Matisse, and especially Paul Klee.

Each subsequent chapter likewise illustrates how visual art, especially painting, has a particular power to bring us into contact with the world that we study and in which we study because it can convey what the world itself gives us to perceive "in full innocence," as Merleau-Ponty famously declared. Saying it a different way, Merleau-Ponty claims that "only the painter is entitled to look at everything without being obliged to appraise what he sees" (2004: 293). How can he say this? Surely not all artists depict

the world without appraising what they see? Do not painters appraise—that is, sort out from among the many landscapes, human faces and forms, objects, colors, and textures, those that they wish to depict? Don't they evaluate and assess which are the best emotions to evoke from their viewers, like enjoyment and appreciation or horror, or outrage? What will provoke thought, produce a sensation? What Merleau-Ponty means is that painting cannot be the translation of what the painter sees into an incommensurable medium. It must communicate visually what the painter sees, even if it is a highly manipulated abstract view or form, and thus a painting cannot help but give us again what the world already gives us as we encounter it in our daily, "unthinking" actions and movements. Just as I do not create the pitcher of water that I see before me on the table, I do not bestow upon it its perceptual and practical meanings—the significance the pitcher holds for me when it comes to the very practical way I might deal with it as a pitcher. And our practical dealings with the world is where phenomenology grounds its analysis, in the space where I experience the world before I reflect upon it and begin to deliberate and make decisions on that experience. Before I think about the pitcher, I come upon it as an object I use without thinking about it, as an already meaningful thing that, as it were, gives itself to me to take it up as it is in its own being. True, these meanings depend in some sense on there being agents like me who are capable of recognizing the thing as the thing it is and, more importantly, using it as such. But there is a real sense in which the meaning resides in the things themselves, and my dealings with them are guided by the way the things solicit and give themselves to me. In Heidegger's terminology, a pitcher is a pitcher for me when I "let it be" what it is;[1] that is, the pitcher attains the full measure of its being when I use it as a vessel that contains, and from which I can pour, liquid. If I tried to use it as a hammer, I would quickly realize that the meaning I gave the object was not just wrong or misconstrued, but in this case, destructive to the object itself.

A painting records this instance of happening upon an object, a scene, a person, and letting them be. But in letting the phenomena of painted color, texture, and line all work together to present to us a pitcher or a human face, a painting doesn't merely represent reality. It duplicates, re-stages the meanings that make up and structure our most basic experience as human perceivers in the world in which we find ourselves, and a world, moreover, that we already know how to perceive as we perceive it. According to Merleau-Ponty, this is not the case when we meet up with the written word. From writers, including writers of philosophy, "we want opinions and advice" (2004: 293). That is, we expect our writers to say something *about* the world, to say something that helps us know how to think about our experience, whereas a painting opens up the possibility of having an experience with the world. A written description of how one uses a pitcher may very well let the pitcher be what it is, but it has not given me the opportunity

to do so in the way that I ordinarily experience and, in fact, make sense of my world. Heidegger would not disagree, despite the fact that he argued that linguistic works of art, "poetry in the narrower sense," have "a privileged position in the domain of the arts" (1977, 1993: 198). This is emphatically not because other forms of art have a linguistically expressible content, and thus are "varieties of the art of language" as language is ordinarily understood. Rather, the privileged position of poetry comes from the way poetry teaches us to rethink the way meaning works. Thus the poem for Heidegger, like the painting for Merleau-Ponty, teaches us to see significations that are operative on us in a way that resists propositional expression. It is beyond the scope of this collection to conduct a *querelle des genres* among art forms or even to explicate fully what both Merleau-Ponty and Heidegger meant by their respective claims about writing and language. We do not necessarily mean to privilege visual art or painting as the one true way of doing phenomenology. What is important to the writers in this book is that visual art *can* give us access to the world that we encounter in the primordial situation of our being: in our bodies in a particular time and place, and from within particular contexts and vantage points—in other words, in the pre-reflective space we occupy before we begin to think the world and its meaning by means of concepts we've learned to apply to our experience. These essays individually and collectively show that visual art can help us understand more fundamentally the nature and content of human perception that grounds philosophy as a study of the world in which we actually live. A book about poetry or dance may indeed be able to accomplish this very same task.

One of the vital impulses of the phenomenological approach is to come to a stop at the things themselves, rather than immediately taking them as instrumentalities for some further end. In returning to the things themselves and letting them guide our understanding, "phenomenology is," as Merleau-Ponty insists in *The Phenomenology of Perception*, "the study of essences" (2002: vii), and it is in this spirit that Jeff Malpas's chapter should be read. Malpas takes up the question of art's essence as a way of engaging what art can tell us about ontological concerns. Like Heidegger before him, Malpas argues that the artwork needs to be understood as a work, as something that we come to know as art because of *the way that* it is art, rather than its being a certain kind of object that formally fits a generic definition. Malpas locates art in its processes, not in its objective character, to understand what the relationship is between the artwork and its objective materiality. He turns to metaphor as just such a process that helps illuminate how art situates itself in a particular context in which it has meaning as art. Metaphor works by putting tension and conflict into an instance of language. If we take them in their normal sense, the words used in a particular context don't seem to fit that context, and so we have to make sense of the words by suspending the question of what is true in order to figure out

how the words are being used in this context. Art works by putting tension between its objectivity and the work it performs—the work of disclosing the context in which the artwork becomes a work. Like metaphors, works of art make us revise how we see the original context/setting and at the same time open up our sense of what is possible when words/images are resituated. It is this dynamism in art—its power to become, its power to transcend its own objectivity when resituated, its ability, in other words, to harness the power of freedom to open us to the openness of possibility—that makes art matter for Malpas.

In a way, Violetta Waibel's chapter on Johann Gottlieb Fichte's concept of the *schweben* (oscillation, hovering, floating, suspension) of the imagination in Mark Rothko's art is something of a *demonstratio* of Malpas's argument. Waibel turns to Fichte's "working theory" of the "oscillation," as "schweben" is usually translated, of the imagination between the finite and the infinite, the determined and the determinable. It is this notion of oscillation that allows her to understand how we experience the power of Mark Rothko's color-field paintings. We initially encounter the richly complex and finely nuanced fields of color as contrasts, but a longer view of the work allows these fields also to play off one another in such a way that the painting as a whole becomes a color landscape with the suggestion of depth and, of especial significance, an horizon. In fact, Fichte helps her interpret, as well as articulate, how Rothko in this interplay of color and "object" (i.e., the horizon) tries to stage an emotional drama for his onlookers, a tragedy, as the contours of human existence both emerge and dispel in our experience viewing the work.

In phenomenology we want to understand the thing, the work itself; we, for instance, want to "do phenomenology" by studying artworks very carefully as phenomena, as things of physical substance that we encounter not only because we have bodies, but also in our bodies. It is for that reason that we cannot speak of essences, Merleau-Ponty aptly observes, if we do not "put essences back into existence" (2002: vii). Here again, Merleau-Ponty translates Heidegger's insistence that philosophy attune itself to the basic "facticity" of our existence, but the French philosopher also (pardon the pun) fleshes out the German philosopher's thinking on what the "facticity" of our existence is. For Merleau-Ponty, our facticity cannot be understood apart from an understanding of our bodies. The body is the primordial situation of my being. The implications of his claim to philosophy are tremendous. It has the potential for overthrowing the priority of that dimension of being human that has so often been considered the very root of our existence since Descartes, our consciousness. For phenomenology insists that my consciousness—my awareness of myself, others, objects, all of the things that make up my world—is rooted in my experience in the world, and this experience is, in turn, rooted in my body. I am fundamentally an embodied being, and any attempt I make to understand or explain what, where, why,

how, or even that I am must build itself on this "fact" of my being. Phenomenology rejects the Cartesian grounding of consciousness in the thinking self, the famous *cogito ergo sum* ("I think, therefore, I am"), and the mind/body dualism that it establishes as the "given" feature of our being. Merleau-Ponty's pointed rejoinder to Descartes is: "The world is not what I think, but what I live through" (2002: xviii). The world that we "relearn to look at" is the world of my actual, embodied, lived experience. Wayne Martin's chapter takes up the problem of the structure of conscious experience, but he looks very carefully at Lucas Cranach the Elder's oft-executed paintings on the theme of Adam and Eve in the Garden of Eden in the context of Reformation thought to engage this problem in a pre-Cartesian framework. By doing so, Martin shows how effectively the study of art in its contexts can help us situate the study of philosophy in its own contexts as well.

Martin's essay demonstrates how necessary this work of "relearning" is, but also how very carefully it must be done, for in the modern era our ways of talking about and knowing ourselves, others, and the world (as exemplified most clearly in the sciences, but also present in history and philosophy itself) have become, as it were, disembodied ways of knowing, where both the self and world are objectified totalities that we can represent and rationally grasp as such in our study of them. Phenomenology's job is to help us do this careful, hard work of rethinking the most basic terms in which we explore what it is and means to be human as we are in our bodies. Consequently, Merleau-Ponty says, "all of [phenomenology's] efforts are concentrated upon re-achieving a direct and primitive contact with the world, and endowing that contact with a philosophical status" (2002: vii). Sean Kelly's study nicely demonstrates how painting can help us to "*re-achieve*" this "direct and primitive contact with the world," precisely because it facilitates the way in which we perceive it by re-enacting the basic situation of our being as embodied perceivers who bear themselves into the world by taking it up in its givenness. Kelly offers perhaps the most direct engagement in this collection of phenomenology with art as it has been constituted in art history. While not offered as a critique of the discipline, Kelly nevertheless shows that the story that art history tells about the progress of "realism" (the development of perspective, techniques of producing verisimilitude, etc.) in art since the Italian Renaissance can be taken as a somewhat different (and more valuable phenomenologically) story of "the perceptually driven desire to capture aspects of our everyday experience of objects rather than ... the metaphysically driven desire to present the features of the object as it is independent of us." Artists from Jan van Eyck to Cezanne to the video artist Bill Viola have increasingly developed the techniques and approaches that allow our stories of the history of art to fully facilitate our understanding of art as that which "include[s] the rich and complicated fact that we are active, embodied

perceivers in the world," which allows art, in turn, to teach us what it can about the very nature of experience itself.

Indeed, because the phenomenological questions and methods we employ attune us to how we experience particular works of art, we have felt obligated to pay especially close attention to the phenomena that these artworks themselves are. This is a different kind of inquiry than that engaged in by traditional aesthetic or art-historical modes of studying artwork, because we take the work of art as performing an important role in teaching us to engage with the world. Nevertheless, aesthetic and art-historical questions and concerns are very much part of the context in which several of the works are considered and, we hope, the phenomenological analysis is not without implications for aesthetics and art history. We regard this book as an invitation to the reader to, first of all, continue the project of phenomenologically engaging with works of art. In addition, we hope that the book might be treated by all students and scholars of visual art, not just other phenomenologists, as an invitation to extend a conversation begun here on the value of seeing art as a mode of inquiry into some of the most basic questions we can ask about how we experience the world. Joseph D. Parry's and Béatrice Han-Pile's chapters on Sandro Botticelli and Vermeer, respectively, are particularly well-suited to inaugurating such a conversation.

Han-Pile challenges the two-pronged trajectory of scholarship on Dutch seventeenth century painting—one of which understands the art through our sense of its cultural context (e.g., Protestant ethics, the tastes of the merchant class), and the other of which is "based upon a descriptive, realist approach to the world" that also reflects other cultural practices of contemporary Dutch society (interest in cartography and optics). She does this by performing a Heideggerian reading of Vermeer's work in order to understand what distinguishes this work as *artwork*. Vermeer's art is particularly effective at disclosing the world in his paintings by drawing us into that world through what the represented figures are doing; for instance, the work that the Milkmaid is performing. But it is also at this level of practical involvement, where we become aware of and relate to the "network of relations and possibilities associated with the practices themselves," that we, the viewers, encounter our inability to access fully a world that is past. Of course, our relationship to the past, as Joseph D. Parry's chapter on Sandro Botticelli's *Uffizi Annunciation* shows, is also about how we relate to the future and to the sense of possibility we discern in being. Parry is interested in how paintings of historical subjects take up that sense of possibility-that-has-been in order to accomplish two of history's most central tasks in a phenomenological understanding of being: enowning one's past and understanding freedom, or possibility, as the power to break with the past.

In the last chapter, John Brough looks at film as phenomenology. This provides an opening to take a step back from our primary focus on painting

in order to revisit and, hopefully, re-open the term "visual art" and its relation to phenomenology. We have not here included other forms of visual art—prominently sculpture and architecture—nor do we explicitly explore the visual dimensions of other performance art genres such as dance and theater. That work needs to be done, in addition to the ongoing work being pursued in film and phenomenology. But Brough's treatment of film as phenomenology in light of the very basic conception of phenomenology that Edmund Husserl set forth in his foundational thinking is a good model for posing the different kinds of question, from the most basic, to the more precise and nuanced, that we need to keep asking about the phenomenological significance of visual art in general, as well as of each form of visual art, in particular.

Note

1 See *On the Essence of Truth* in D.F. Krell (ed.) (1993) *Martin Heidegger: Basic Writings*, San Francisco: HarperCollins.

References

Heidegger, M. (1977, 1993) *The Origin of the Work of Art, Martin Heidegger: Basic Writings*, San Francisco, HarperCollins.
Merleau-Ponty, M. (2002) *Phenomenology of Perception*, London: Routledge Classics.
——(2004) "Eye and Mind," *Maurice Merleau-Ponty: Basic Writings*, London: Routledge.

1

THE PHENOMENOLOGICAL RELEVANCE OF ART

Mark Wrathall

Art and the existential-phenomenological tradition

One of the characteristic traits of the existential-phenomenological tradition in philosophy is a serious engagement with the fine arts – literature, poetry, theater, music, and the plastic arts. By the existential-phenomenological tradition, I mean the tradition of philosophers influenced by Heidegger, Merleau-Ponty, and Sartre, with its deep roots in the work of Nietzsche. This engagement with the arts doesn't typically take the form of a philosophy *of* art or an aesthetics. These philosophers are not primarily interested in offering a philosophical account of what art *is*. Nor are they interested merely in using art work as an occasion or excuse for philosophical reflection, nor as a mere illustration of philosophical doctrines. Rather, these philosophers believe that works of art at their best are capable of showing us the phenomena under consideration more directly, powerfully, and perspicuously than any philosophical prose could.

This reliance on works of art stems from the phenomenologists' understanding of the method and task of phenomenological inquiry. Heidegger sums it up this way:

> The word ["phenomenology"] only gives insight into *how* one is to exhibit and deal with that which is supposed to be dealt with in this science. A science "of" phenomena means: grasping its objects in such a way that everything which is up for discussion must be dealt with in a direct exhibition and a direct demonstration. The expression "descriptive phenomenology," which is at bottom tautological, has the same meaning. Here "description" does not mean a method of the sort of, say, botanical morphology. The title has rather a prohibitive sense: steering clear of all non-demonstrative determination. ... *Every exhibiting of an entity in such a way that it shows itself in itself may, with formal legitimacy, be called "phenomenology."*[1]
>
> (Heidegger 1962: G34–35)

For those working in this tradition, the highest aspiration of phenomenology is to resolve philosophical questions in and through an apprehension of the phenomenon in question. To the extent that a verbally articulated description of the phenomenon helps us to achieve such an apprehension, phenomenology will offer such an account. But there is no commitment to correct verbal description as such – indeed, there is a constant worry among these authors that certain otherwise correct descriptions of phenomena might actually make it more difficult to achieve an understanding of things. This worry is behind Heidegger's observation that "equipment can genuinely show itself only in dealings cut to its own measure (hammering with a hammer, for example)" (Heidegger 1962: 68). Some ways of talking about hammers – discussing them as substances with properties, for instance – obscure the way the hammer appears to us when we're hammering with it. That doesn't mean, of course, that phenomenology consists simply of hammering with hammers and cutting with knives, and so on. The trick is rather to figure out how to direct our attention to the constitutive structures of such activities, whether through an assertoric description or another mode of indication – for instance, the poetic or the pictorial. And just as it might take some verbal description to help point out what is decisive about the hammer that we are hammering with, it also might require considerable discussion to understand what it is that a pictorial depiction shows us.

It is in this sense that the existential phenomenologists rely on art as a kind of phenomenological demonstration. Their confidence in the phenomenological power of art is amply evident in their work. Nietzsche's first book was an analysis of tragedy, and in his later work he turned often to music, drama, and the pictorial arts for insight into our historical condition. In the *Gay Science*, for instance, he argued that:

> only artists ... have given men eyes and ears to see and hear with some pleasure what each himself is, himself experiences, himself wants; only they have taught us to value the hero that is hidden in each of these everyday characters and taught the art of regarding oneself as a hero, from a distance and as it were simplified and transfigured – the art of "putting oneself on stage" before oneself. Only thus can we get over certain lowly details in ourselves. Without this art we would be nothing but foreground, and would live entirely under the spell of that perspective which makes the nearest and most vulgar appear tremendously big and as reality itself.
>
> (1974: §78)

The power of art in this regard, and its superiority over philosophy, is a product of the way it works on us affectively, thus not just altering our beliefs about the world, but, more importantly, our dispositions through which we encounter and evaluate the world. "All art," Nietzsche writes,

"exercises the power of suggestion over the muscles and senses. ... All art works tonically, increases strength, inflames desire (i.e., the feeling of strength)" (1968: §809).

Like Nietzsche, Heidegger came to recognize that, by reorienting us and redisposing us for the world, art could show us things which we couldn't otherwise see. Indeed, Heidegger's 1935–36 essay on "The Origin of the Work of Art," marked a decisive change in Heidegger's approach to philosophy as a whole. Heidegger claimed that art, according to "the highest possibility of its essence" (*höchste Möglichkeit ihres Wesens*) is a "revealing that establishes and brings forth" (*ein her- und vor-bringendes Entbergen*) possibilities of existence that could not be understood and established in any other way (2002: 38–39). And yet Heidegger also was concerned that, in our historical age, we are losing our ability to experience art as world disclosive. "The question remains," Heidegger worried, "is art still an essential and necessary way in which that truth happens which is decisive for our historical existence, or is art no longer of this character?" (2002: 38). Much of his later work was concerned with reviving an experience of the work of art as a world-disclosive experience, a project he pursued through repeated reflections on Greek architecture, the paintings of Raphael, Van Gogh, Klee, and others, and the poetry of Hölderlin, Rilke, Trakl, and George.

These parallels between Heidegger and Nietzsche are instructive. But the philosopher I want to focus on here is Merleau-Ponty. His engagement with art is a little bit different than other existential phenomenologists, in just the same way that his focus on perception distinguishes him from the others. The "big questions" about history, the nature of human existence, the critique of our historical age – big questions directly implicated in the way the other phenomenologists engaged with art – hover only at the periphery of Merleau-Ponty's treatment in essays such as "Eye and Mind," "Cézanne's Doubt," and "Indirect Language and the Voices of Silence." There, Merleau-Ponty's central preoccupation is the lessons that art can teach us about the nature of our embodied perceptual engagement with the world. "Art and only art," Merleau-Ponty claimed, is able to show us "in full innocence" the "sensible and opened world such as it is in our life and for our body" (1964a: 57). In this context, the art that Merleau-Ponty refers to is primarily pictorial art. The reason that "art and only art" can exhibit for us the world as we perceive it, Merleau-Ponty proceeds to explain, has something to do with the kind of seeing that the artist practices, and the way that when the artist records what he sees on the canvas, it allows us to also take part in his way of seeing the world. Merleau-Ponty, in all likelihood thinking of Cézanne's paintings of Mont Sainte Victoire (see Plate 9), writes:

It is the mountain itself which from out there makes itself seen by the painter; it is the mountain that he interrogates with his gaze. What

11

exactly does he ask of it? To unveil the means, visible and not other-wise, by which it makes itself a mountain before our eyes. Light, lighting, shadows, reflections, colour, all the objects of his quest are not altogether real objects; like ghosts, they have only visual existence. In fact they exist only at the threshold of profane vision; they are not seen by everyone. The painter's gaze asks them what they do to suddenly cause something to be and to be this thing, what they do to compose this worldly talisman and to make us see the visible.

(1964a: 62)

There are two sides of this story that I want to focus on – on the one hand, the artist's side of the equation: the way that the artist "interrogates" the world "with his gaze." On the other hand there is us viewers of the work of art, who need to practice a receptivity to the work so that it can "make us see the visible" (this is, by the way, a paraphrase of Paul Klee. We'll discuss this later). Merleau-Ponty's most clearly worked out example of how these two sides work together comes in his discussions of Paul Cézanne. Rather than looking at Cézanne, however, I want to draw on the work of Paul Klee, an artist that Merleau-Ponty mentions from time to time, but whose work is not accorded the same kind of detailed treatment as is Cézanne's. I think that, precisely because of its abstractness, Klee's work in some respects illustrates Merleau-Ponty's view better than Cézanne's. But before getting to Klee, I want to say something more about how Merleau-Ponty's claim about the primacy of art in phenomenological investigation is, and is not, to be understood.

Pictorial technique and theories of perception

We can restate Merleau-Ponty's view in this way: art, and the pictorial arts in particular, is uniquely well qualified to help us understand our perceptual engagement with the world. This is because the artist somehow is able to become attuned to the means by which the world is composed for our visual perception, and then is able to orient us through the pictorial work to the process of composition. That means the work of art performs a kind of phenomenology insofar as it shows us something in such a way that we can understand it more perspicuously than we did before. But we have not yet said exactly what it is that art shows us, according to Merleau-Ponty.

In its insistence on the priority of the art of painting in understanding perceptual experience, Merleau-Ponty's view bears a certain superficial resemblance to a view espoused by, among others, Leonardo da Vinci. Understanding why da Vinci's position is not Merleau-Ponty's will help set us on the path to understanding Merleau-Ponty's account. But for that, I want to delve very briefly into art history and some of the developments in Renaissance painting that formed the background to da Vinci's view.

As is well known, one of the innovations in painting in the early Renaissance was a change in pictorial space brought about through the use of optical perspective. This innovation was achieved by a variety of techniques. For one, artists began to impose a consistent perspectival distortion on objects depicted throughout the painting – that is, the distortion that would prevail if all the objects in the painting were seen from a single, static point of view. Another development was the use of occlusion to create a sense of depth, closer objects occluding the view of more distant objects, as if the objects in the paintings were arrayed along a third dimension.

This was an important development, as one can see in the well-known differences between the Enthroned Madonna figures Cimabue painted and those done by his student Giotto. Both artists give their paintings a consistent viewpoint – the perspectival distortions of the thrones specify a viewer standing squarely in front of Madonna's throne, at about her shoulder or eye level. But in Cimabue's painting, even though the angels are occluding one another, they still somehow all stand in the same narrow plane, stacked up, as it were, along the sides of the throne. In Giotto's painting, by contrast, the angels to the side of the throne are standing three or four deep, on roughly the same level. Similarly, Cimabue's saints are at the bottom, positioned directly underneath the Madonna and child and thus still in the same narrow plane, while in Giotto's work, the angels at the bottom are not placed under the throne, but rather are kneeling in front of it and partially occluding it, creating yet another plane. In Cimabue's painting, in other words, depth is signaled almost exclusively by the perspectival distortions of the throne; all the figures in the painting occupy the same plane. In Giotto's painting, the distortion is accompanied by the existence of a number of planes at varying depths upon which figures are arrayed.

For a modern eye, however, there's something unsettling about the size of the figures in Giotto's painting. Of course, the disparity in size between the central figures and the angels is obvious – the Madonna and child are enormous in comparison to the angels. But even taking that into account, the angels kneeling in front of the throne simply seem too small. It might come as some surprise to discover that they are in fact the same size as the angels standing in the back row, and this is precisely the source of the problem. We "anticipate" that closer objects will occupy a proportionally larger portion of the visual array than more distant ones; when they do not, it creates a mild unease, a sense that the objects are unnaturally small or large, as the case may be.

It was this recognition that led to a third innovation in the Renaissance depiction of pictorial space – an innovation attributed to Filippo Brunelleschi (1377–1446), who is widely credited with introducing a more scientific understanding of the rules of optical perspective into his paintings. According to his contemporary and biographer Antonio Manetti (1423–97), Brunelleschi:

propounded and realized what painters today call perspective, since it forms part of that science which, in effect, consists of setting down properly and rationally the reductions and enlargements of near and distant objects *as perceived by the eye of man*: buildings, plains, mountains, places of every sort and location, with figures and objects in correct proportion to the distance in which they are shown.

(1970: 42)

Manetti testified that this development in Brunelleschi's paintings dramatically heightened the sense of realism. When the proper position was taken up vis-à-vis the painting, he claimed that "the spectator *felt he saw the actual scene* when he looked at the painting" (44, emphasis supplied).

Through such technical innovations, Renaissance painters achieved a kind of realism[2] in their works that was absent from paintings just a few decades before. The theoretical underpinning of these innovations was a view of the surface of the painting as a perpendicular plane intersecting the visual "pyramid" formed by rays extended from the visual array, converging on the eye – a view developed by Alberti (1996: 47–48). Alberti himself was cautious about using this theory to draw any direct conclusions about the actual functioning of perception. He noted:

> *Nor is this the place to discuss whether vision, as it is called, resides at the juncture of the inner nerve or whether images are formed on the surface of the eye as on a living mirror. The function of the eyes in vision need not be considered in this place.*

(47)

But working and writing a generation later, Leonardo da Vinci (1452–1519) seems to have been persuaded by what must have seemed to many the obvious parallel between the two-dimensional rendering of space in a painting and the two-dimensional reflection of space on the "living mirror" of the eye. On the basis of this parallel, da Vinci argued that painting is "the sole imitator of all visible works of nature." It "brings philosophy and subtle speculation to bear on the nature of all forms – sea and land, plants and animals, grasses and flowers. ... Truly painting," Leonardo concluded, "is a science, the true-born child of nature" (38). This view of the scientific relevance of painting was based on a particular understanding of the way visual perception works. According to da Vinci, "the eye ... receives [images] into itself, that is to say, on its surface, whence they are taken in by the common sense" (65). Or, as he put it elsewhere, "the sense takes in the images which are mirrored in the surface of the eye and then judges them" (149). The superiority of painting as a science is a result of the fact that "painting puts down the identical reflections that the eye receives, as if they were real" (52). Thus, da Vinci could conclude that "painting presents the works of

nature to our understanding with more truth and accuracy than do words or letters" (35).

Now, it turns out, da Vinci's justification for the claim that painting could assist in the advancement of scientific understanding, relying as it does on the strict parallel between the artistic picture and the image projected on the eye, is at least controversial (it doesn't follow, of course, that the conclusion is false – it could still be that painting can assist in the advancement of scientific understanding). The reasoning that leads him to this conclusion, for instance, seems as stated to fall prey to the objection that it will lead to an infinite regress of observers observing images within images. Descartes pointed out the error of inferring from a resemblance between pictures and things to the conclusion that the mind is directed toward picture-like images in the brain. "It is necessary to beware," Descartes warned:

> of assuming that in order to sense, the mind needs to perceive certain images transmitted by the objects to the brain, as our philosophers commonly suppose. . . . they have had no other reason for positing them except that, observing that a picture can easily stimulate our minds to conceive the object painted there, it seemed to them that in the same way, the mind should be stimulated by little pictures which form in our head to conceive of those objects that touch our senses.
>
> (Descartes 1965: 89)

This is a non-sequitur, Descartes argued, both because non-pictorial things can stimulate our minds to conceive an object, but also because we can see an object in a picture that only scarcely resembles the actual object itself.[3] And, in any event, Descartes pointed out that da Vinci's view – the view that in perception, we see a two-dimensional image projected on the surface of the eye – leads to a problematic regress:

> Now although this picture, in being so transmitted into our head, always retains some resemblance to the objects from which it proceeds, nevertheless, as I have already shown, we must not hold that it is by means of this resemblance that the picture causes us to perceive the objects, as if there were yet other eyes in our brain with which we could apprehend it; but rather, that it is the movements of which the picture is composed which, acting immediately on our mind inasmuch as it is united to our body, are so established by nature as to make it have such perceptions.
>
> (101)

But I want to set that sort of consideration aside since my reason for running through this brief history of the development of linear perspective in the Renaissance was simply to illustrate how Merleau-Ponty's position was not to be taken. If we can see why Merleau-Ponty would reject da Vinci's

superficially similar view about the role of painting in scientific inquiry, it will help to clarify Merleau-Ponty's position.

The reason is two-fold: first, da Vinci presupposes a certain ideal of what art should be like that Merleau-Ponty by no means shares. "Classical perspective," Merleau-Ponty argues, "is only one of the ways that man has invented for projecting the perceived world before him, and not the copy of that world" (1964b: 48). Its aim is "to be as convincing as things and does not think that it can reach us except as things do – by imposing an unimpeachable spectacle upon *our senses*" (ibid.). But, Merleau-Ponty insists, this is only an "optional interpretation of spontaneous vision." To understand why he says this, think back on Cimabue's *Madonna*. Was it *wrong* to represent the furthest row of saints the same size as the front-most angels? It's true that as they get further away, people fill up a smaller segment of our visual field than when they are nearby. But we don't see the people as smaller. Because we experience people as having a constant size even when the image they project on our retina varies significantly, another valid option for painting a scene such as this is to present the figures as having a constant size. Merleau-Ponty's claim is not that any particular style of painting gives us insight into perception. To the contrary, he sees art as continually driven by inadequacies in our understanding of the perceived world, and he believes that no art could finally and completely solve these inadequacies. "In painting," he says, there is "no cumulative progress" (1964a: 188).

The second reason that Merleau-Ponty's claim is of a very different sort than da Vinci's is that the viability of da Vinci's view ultimately rests on certain scientific and philosophical theories about how sense perception works. The argument for the priority of painting in da Vinci rests on the view that painting illustrates the sort of images the eye and the brain rely on in producing a perceptual experience of the world. Now, I think arguments over the role of a retinal image in perception are interesting, as are debates over the distinct but perhaps not unrelated question whether the content of vision is somehow similar to the representational content of a picture (Siewert 2005). And I also think that the phenomenology of perception will almost certainly have some implications for these issues. But Merleau-Ponty believes his phenomenology has a kind of priority over, and independence of, such theories. Whatever the final, best story about the biological and optical foundations of perception might be, a phenomenologically sensitive account of perception has a priority insofar as it helps us to identify the features of experience which are to be accounted for by this best story. To the extent that the pictorial arts can function like a description of perceptual experience, art gives us insight, not into how our experience of the world is produced, but into what it is actually like.

So having tried to indicate what Merleau-Ponty's view is *not*, I want to turn now to the questions: What is it that phenomenology can aspire to

teach about perception? And what role do pictorial arts play in this aspiration? In answering the second question, we'll want an answer that's more inclusive than da Vinci's – that is, one which will explain why it is that Merleau-Ponty is as interested in artists like Cézanne, Matisse, and Klee as he is in the artists of the Renaissance. The answer to that question, I believe, is offered by a slogan of Paul Klee's: "Art," Klee famously asserted, "does not reproduce the visible; rather, it makes visible" (1919: 28).

Phenomenology and perception

But before saying anything more about Klee, I want to return now to the specifics of Merleau-Ponty's claim for the phenomenological priority of art. According to Merleau-Ponty, what art can reach that the sciences cannot – the thing that non-phenomenological philosophy often overlooks – is the "sensible and opened world such as it is in our life and for our body" (1964a: 57).

But what does he mean by this? How is the world "in our life and for our body"? This specification is meant to direct us to our everyday, ordinary, unreflective, practical engagement with the things around us.

Heidegger is the first philosopher to have clearly articulated the principle shaping Merleau-Ponty's intuitions here – the principle we mentioned at the outset, according to which something can only show itself as it is in itself when we adopt the right kind of comportment toward it:

> Equipment can only genuinely show itself in dealings cut to its own measure, for example, hammering with a hammer. But in such dealings this entity is not grasped thematically as an occurring thing, nor is the structure of the equipment known as such even in the using. The hammering does not simply have knowledge about the hammer's character as equipment, but it has appropriated this equipment in a way which could not possibly be more suitable. ... the less we just stare at the hammer-thing, and the more we seize hold of it and use it, the more primordial does our relationship to it become, and the more unveiledly is it encountered as that which it is – as equipment. The hammering itself uncovers the specific "manipulability" of the hammer. ... No matter how sharply we just look at the "outward appearance" of things in whatever form this takes, we cannot discover anything available.
>
> (Heidegger 1962: 97)

The world as it is "in my life and for my body" is, in the first instance, a world of things which motivate or solicit me to engage with them practically. Heidegger and Merleau-Ponty hold, moreover, that these things are not articulated and individuated in the way we normally think they are.

When we encounter a pen or a door or a lamp or a chair, for example, Heidegger insists that:

> what is first of all "given" … is the "for writing," the "for going in and out," the "for illuminating," the "for sitting." That is, writing, going-in-and-out, sitting, and the like are something within which we move ourselves from the beginning. These "in order tos" are what we know when we "know our way around" and what we learn.
>
> (Heidegger 1976: 144)

Merleau-Ponty follows Heidegger along these lines, but emphasizes that entities so articulated are, as he puts it, polarized by our tasks. It is not that our world consists of a uniform and stable structure of "in order tos," but rather that it is a shifting and variable structure of solicitations to action. In addition, Merleau-Ponty develops in greater detail than Heidegger an account of the way the world acts on us, motivating or drawing us into particular forms of response. Here is a typical Merleau-Pontyan description of what this phenomenon is like:

> For the player in action the football field is … pervaded with lines of force (the "yard lines"; those which demarcate the "penalty area") and articulated in sectors (for example, the "openings" between the adversaries) which call for a certain mode of action and which initiate and guide the action as if the player were unaware of it. The field itself is not given to him, but present as the immanent term of his practical intentions; the player becomes one with it and feels the direction of the "goal," for example, just as immediately as the vertical and the horizontal planes of his own body. … At this moment consciousness is nothing other than the dialectic of milieu and action. Each maneuver undertaken by the player modifies the character of the field and establishes in it new lines of force in which the action in turn unfolds and is accomplished, again altering the phenomenal field.
>
> (1963: 168–69)

This sort of description is meant to capture what much of our everyday action in the world is like. For the football player caught up in the game, there need not be any awareness of a field, of objects like lines and goals, nor an experience of deliberate action. Instead the player feels drawn to respond in such and such a way as the situation dictates the player to act. As the player does act, the field of forces and tensions will alter and shift in response to the actions. As a result of the new configuration of tensions, new solicitations to further actions will arise.

Now, Heidegger and Merleau-Ponty have both, in a certain sense, described what the world is like "in my life and for my body." But these

descriptions are terribly inadequate in a couple of respects. First of all, they are vague about what exactly it is we are responding to when we decide to kick the ball just so or grab the glass like this. And in addition, there is something that these descriptions can't show us – namely, what it is actually like to be solicited or motivated by the world. But it is precisely here where things get a little sticky. It is not simply that the solicitations that we respond to in the world are not merely things upon which we normally do not reflect. In addition, they are things which do not function in the same way when we do reflect on them. Heidegger made this point in the following way:

> These primary phenomena of encounter ... are of course seen only if the original phenomenological direction of vision is assumed and above all seen to its conclusion, which means letting the world be encountered in concern. This phenomenon is really passed over when the world is from the start approached as given for observation or, as is by and large the case even in phenomenology, when the world is approached just as it shows itself in an isolated, so-called sense perception of a thing, and this isolated free-floating perception of a thing is now interrogated on the specific kind of givenness belonging to its object. There is here a basic deception for phenomenology which is peculiarly frequent and persistent. It consists in having the theme determined by the way it is phenomenologically investigated. For inasmuch as phenomenological investigation is itself theoretical, the investigator is easily motivated to make a specifically theoretical comportment to the world his theme. Thus a specifically theoretical apprehension of the thing is put forward as an exemplary mode of being-in-the-world, instead of phenomenologically placing oneself directly in the current and the continuity of access of the everyday preoccupation with things, which is inconspicuous enough, and phenomenally recording what is encountered in it.
>
> (Heidegger 1985: 187)

Heidegger's point is that when we look at things in such a way that we can make assertions and form judgments about them, we overlook the features of the world that are moving our pre-reflective, pre-conscious mode of being in the world.[4] So, Heidegger argues, there are actually two different kinds of looking at the world – one takes in the features relevant to our bodily engagement with the world (Heidegger calls this "*Umsicht*," "circumspection"); the other looks in order to identify determinate and easily observable and communicable features, and lifts them into salience (Heidegger calls this "*Betrachten*," "observation," "merely looking at without circumspection") (1962: G69).[5] This latter sort of looking is what we practice when we're trying to reason or deliberate about what to do.

The features of the world we disclose in circumspection are geared, not to our thought, but to our bodies as we are involved in particular practical

projects. These things will move me to act, to see things, to think thoughts, but without my necessarily having any thoughts about them. When the shape of the glass, for example, leads me to move my hand just so, I may not even know that I moved my hand, let alone be able to describe how I moved it, or how I should move it to best grasp the glass. And when I do think about it, I am no longer responding to the way the glass was motivating me to act. This is evidenced by the way that any effort to deliberately move my hand – to mediate the movement with thought – will be less smooth and skillful than simply allowing my hand to respond to the glass in its situation.

If this is right, it poses a real problem for the practice of phenomeno-logical description, since this practice seems to rely on our breaking out of our normal, fluid dealings with things in order to deliberately reflect on how they appear. When we do this, phenomenologists like Heidegger and Merleau-Ponty have acknowledged, we are at constant risk of focusing on features which are salient for deliberate action or disengaged observation, but not necessarily for our ordinary practical dealings. If the phenomeno-gists are right about this – that attending to a phenomenon with the purpose of describing it actually prevents us from seeing the phenomenon as it is present in our ordinary, everyday perception – then how can we proceed in clarifying the nature of ordinary perception?

The most readily available option is to try to descriptively reconstruct, after the fact, what it is that we were responding to. But there is plenty of room for skepticism that we can accurately do this, given the fact that circumspection works best by picking up features of the world that we are not focally attending to.

Another way to proceed would be to find some way of arresting our perceptual engagement in the world, of catching ourselves responding to the solicitations of the world. Pictorial works can do this because painting "gives visible existence to what profane vision believes to be invisible" (Merleau-Ponty 1964a: 62). The painter presents on the canvas what Merleau-Ponty calls the "secret ciphers" of vision, sensory qualities which are so organized and to which we are so attuned that they give rise to a certain experience and draw out of us a certain response. We'll look to Paul Klee in a moment to illustrate this idea, but let's review one more example to which Merleau-Ponty calls our attention.

Writing of Rembrandt's *The Nightwatch*, Merleau-Ponty notes:

> We see that the hand pointing to us ... is truly there only when we see that its shadow on the captain's body presents it simultaneously in profile. The spatiality of the captain lies at the meeting place of two lines of sight which are incompossible and yet together.
>
> (1964a: 62)

In the center of the painting, then, we see the hand as if from two different

angles. In its shadow, we see it as it would look from a vantage point above and to the left of the hand. Merleau-Ponty explains:

> Everyone with eyes has at some time or other witnessed this play of shadows, or something like it, and has been made by it to see a space and the things included therein. But it works in us without us; it hides itself in making the object visible. To see the object, it is necessary not to see the play of shadows and light around it. The visible in the profane sense forgets its premises; it rests upon a total visibility which is to be re-created and which liberates the phantoms captive within it.
>
> (1964a: 62)

The suggestion is this: as we marvel at the substantiality of Rembrandt's painting of hands, our attention is arrested by the play of shadows, and we are brought to recognize the role such things play in ordinary or "profane" vision. Or as Merleau-Ponty dramatically puts it, the normal vision "forgets its premises," while the painting "liberates the phantoms captive in it" (1964a: 62–63).

The artist fosters a special skill, then: that of learning to look at the world in such a way that she can discern the meanings of the world. In Merleau-Ponty's terms, the artist "interrogates the world with his gaze." This might seem to consist in the reflective moment that we worried about above, and indeed to some degree it does. But the artist's looking is more practical than reflective, as we will see. The artist looks to the world in such a way as to allow it to move her body rather than to describe it. Moreover, art has an advantage over phenomenological description: it immediately puts to the test of vision itself what the artist sets down on canvas. Each painting that succeeds in making us see something directly, that is, without functioning as a symbol that we associate with the object through a kind of mental act, will have partially unlocked the secret of vision by placing before us some of those things in virtue of which we are moved by the world to see.

In the remainder of the chapter, I want to turn from philosophers to an artist on the nature of art and perception. In the sections that follow, the matter of ultimate concern will be whether Klee's account of the production of the work of art, as well as the apprehension of the work of art, supports and advances on the phenomenological view I've tried to sketch out.

Klee and the artist's body as medium

Paul Klee affords us a rare opportunity in thinking about art as phenomenology. He was not just an artist, but also a theoretically sophisticated writer and lecturer. In addition to Klee's published writings and public lectures on his art and art in general, there are over 3,300 pages of notes from Klee's 10 years of lecture courses offered at the Bauhaus and at

the Düsseldorf Academy (see Franciscono 1991: 244). In the course of these writings, Klee developed an account of art and perception, and illustrated this account with numerous sketches and references to his pictorial works.

In an essay on the nature of art, Klee claimed that "the pictorial work came into being from motion, is itself motion that has been fixed in place, and is taken up in motion (eye muscles)" (1919: 35). Let us focus for now on the motion involved in the creation of the pictorial work. Klee believed, plausibly, that artists are more keenly attuned to what we pick up in perception than most. If this is right, then we stand to learn something by studying artists and their work – not because seeing the world is like seeing a picture, but because creating a depiction demands that you be able to see the world.

The work of art is born as the body moves into the appropriate position and disposes itself to apprehend the subject, and then moves to record this apprehension. Here is Klee's description of what it is like to create a painting or drawing: "A certain fire, yet to come, revives, works its way along the hand, streams onto the board and, from the board, leaps as a spark, closing the circle from which it came: back to the eye, and beyond" (1919: 34). At first glance, it might look like Klee treats the act of artistic creation as subjective expression – as a fire moving from inside the artist, along the arm, out into the world. But notice that there is no discussion of inner and outer. Notice also that the igniting of the creative fire originally has its source not in the spontaneous faculty of the mind, but in a "receptive" organ – the eye. Before the fire can revive, it has to be awaited. It is in holding himself ready for the fire "yet to come" that the artist is able to receive from the eye what is needed to awaken the fire. This holding oneself ready is not merely a mental state; it involves an actual physical readiness for the appearance of the object. So the artist's contribution to the art work is to put herself in position for the fire of inspiration. But she can't force it, she can only wait for the coming fire to awaken. When that happens, there is no longer an experience of expression – no longer an experience of the artist pressing something inner out into the world. Rather, the body is moved to respond, as it becomes the vehicle for creating a depictive work: "Swept up into such normal movement, we find it easy to develop a creative disposition. We are ourselves moved, hence find it easier to impart movement" (Klee 1956: 255).

The change that takes place in the world, in turn, reinforces the bodily attitude that the artist has adopted. The fire "closes" the circle, giving itself back to the eye which, in turn, can give rise to further bodily responses. Artistic creation as Klee experienced it, in other words, is a temporal process of finding a bodily attitude that will let the situation draw out a motor response.

That's how Klee describes it. One can also see how he depicts it in a self-portrait in *Abwägender Künstler* (Plate 1), a work roughly contem-

poraneous with the quotation above. In this sketch, Klee captures the way an artist's gaze poises his muscles for responsive motion. The artist is not yet ready to draw; he has neither pen nor brush nor paper nor canvas. And yet the hand is his most prominent feature; it is poised and ready to move in response to the information picked up by the eyes of the *Abwägender Künstler*, the "carefully considering artist."

On Klee's account, then, to be an artist, one needs to become sensitized to one's own body in a special way. Klee had certain metaphors for explaining the role of the artist's body in mediating the creation of the work. In his Bauhaus lectures, he referred to the artist's body as a bow which, like a violin bow drawn across strings, is drawn across a surface, sending out vibrations that arrange things into meaningful patterns. In a public lecture on art, Klee used the metaphor of the artist as a tree, deeply rooted in the world. The work of art is like the crown of a tree, which makes manifest the subterranean influences – Merleau-Ponty's "hidden ciphers." The artist's ability to depict depends on his first having learned to "find his way in the world," to "bring order into the passing stream of image and experience" (see Klee 1964: 76–77). The experience of the world moves his muscles and, in the process, shapes the content of what he sees. While thought and causal interactions certainly play a role in this, they don't exhaust it. In a famous diagram from his Bauhaus lecture notes, *Schema Ich-Du-Erde-Welt*, Klee depicts the experience of perception (Plate 2). He identified the three pathways from a "you," that is, something set before me as a visible appearance that "meet[s] in the eye and there, turned into form, lead[s] to a synthesis of outward sight and inward vision" ("Ways of Studying Nature" in Klee 1961). The three ways include 1) the optical-physical way, that is, the causal action of the object on my visual apparatus, 2) the cosmic togetherness that I and the object share – that is, I take it, our belonging to the same meaningfully ordered world, falling under the same concepts and abstractions,[6] but also 3) the way of the earth, a non-optical path through the shared earthly roots or "intimate physical contact" we have with things ("Ways of Studying Nature"). This, I take it, refers to the practices, bodily skills, and dispositions, derived from the object, that we bring to perception.

Together, then, our concepts, the physical properties of the object, and the motions and resonances that things produce in our body converge and give rise to the content of what we see. As Klee understood it, the things we experience in everyday life can't be specified solely in terms of the physical properties of the light they reflect. This is because they show up only as they draw on our earthly, bodily contact with things that goes far beyond the optical visual information received by our perceptual system:

> All ways meet in the eye and there, turned into form, lead to a synthesis of outward sight and inward vision. It is here that constructions are

formed which, although deviating totally from the optical image of an object yet, from an overall point of view, do not contradict it.

(1961: 67)

Klee's own testimony as an artist, then, supports the idea that the artist's gaze is not a theoretical observation. He is not restricting his view to some narrow subset of information – whether it is the optical, or the conceptual (i.e., it is not merely what we could sense, and it is certainly not just what we could say about a matter). Instead, the artist's looking is practical and circumspective: it aims at a translation of seeing into action, or rather, it develops a finely tuned ability to respond to the solicitations of the scene.

For Klee, the work of art works by showing us what kind of temporal movements are involved in structuring our perceptual experience:

> The function of a pictorial work is the way in which it communicates to the eye the temporally moved construction of the pictorial work, and how the characteristic movement character of the pictorial work in each case is forced upon the eye and upon the ability to pick up that lies behind it.

(1979: 105)

One of Klee's central aims, then, was to use his art to make salient to us the temporal structure of the way the world motivates our actions. For him, the work of art tries to elicit movements *of* the body and *in* the body of the viewer in such a way that the meaning of a thing or situation can emerge: "the pictorial work prepares ways, which are receptively to be followed, that are followed either only with the moved eye of the beholder or, like the interior of a house, are moved through with the whole body" (Klee forthcoming: 26 M45/42).[7]

We'll look at specific examples of this in a moment. But I should note first that this partially explains the "abstractness" of Klee's works. In his 1919 essay, Klee famously rejected a mimetic view of art in favor of an abstract view, where abstraction is understood as showing us the "formal elements" or "pure relationships" that structure our experience of things.[8] Because his aim was showing us *how* we see in natural perception, rather than *what* we see when we're attentively looking, Klee recognized that his art "must of necessity, as a result of entering into the specific dimensions of pictorial art, be accompanied by distortion of the natural form. For therein is nature reborn" (1964: 79).

By presenting these elements to which we respond when we see objects, "art does not reproduce the visible; rather, it makes visible" (Klee 1919: 28). Art makes visible in two ways – first, by showing us what we don't ordinarily see, indeed, what we may not be able to see at all, but which nevertheless gives content to our experience of the world. "Even if I cannot see it," Klee

says of things such as lines of movement, "I can sense it, and what I sense I can also perceive, make visible" (1956: 301). Art can also make visible in a second sense (I'll touch on this briefly in the conclusion): it can teach the eye to see, so that it then becomes sensitive to things of which it was oblivious before.

It is no objection, then, that Klee's paintings and sketches don't reflect the world as it looks when we are detached observers of it. Instead, he aimed to make visible the different ways that the world motivates the body to respond, as well as the ways our body attunes us to the world. There are "ways of looking into the object," Klee wrote, which "create, between the 'I' and the object a 'resonance surpassing all optical foundations'" (1961: 66).

Art can produce the same effects as objects do only because seeing a picture is itself a temporal activity, just as much as our perceptually mediated active engagement in the world: "The viewer's essential activity is also temporal. It brings [the picture] into sight one part after another, and in order to focus on a new piece, it must leave the old one" (Klee 1919: 34).

Klee understood intuitively that perception can't be understood as a processing of data taken up in discrete, static moments. Even a very small-scale picture is not something we can really see all at once. To see pictures in general, and a work of art in particular, requires the eye to "graze" across the canvas:

> This is due particularly to the local limitations of the eye. The eye can not be in the whole field of the pictorial work at the same time, but rather always only in a part. It stands itself before a relatively small picture board, before the task that has been posed, like a grazing animal. It must enter into movement because it can't see everything at once.
>
> (Klee forthcoming: 26 M45/42–43)[9]

The work of art thus leads the eye or the body through the canvas, and, in the process, it exploits a set of bodily anticipations and dispositions to produce a particular experience. We perceive, Klee believes, insofar as our bodies know how to follow up the temporal meanings that the world offers us. Seeing is becoming resonant to the meanings of the world.

In his Bauhaus lectures, Klee illustrated this through the example of a spiral. Klee's sketch of a spiral is deliberately done in such a way as to make salient the role that our eyes' exploratory movements play in giving content to what we see.

If we look at it at a glance, we see zig-zag lines, bisected with a vertical arrow. But if the eye follows the movements of the zig-zag, it can become a spiral moving around – in front of and behind – the vertical line, or back and forth across a projected plane, or, like a river, snaking its way forward

Figure 1 Author's copy of Klee's *Sketch at Klee* 1961: 87.

through space. The arrow then can be a vertical line, a pole, or the projection of a plane. Thus, the precise course the line takes depends on the way we move our eyes to encompass it, as Klee was well aware. As we experience this in looking at Klee's drawings, we are taught to recognize how the temporal structure of perception affects the content of experience. What we see in the line is not simply a product of its optical properties, but is opened up by the way our past experience of it disposes us to anticipate its future course, and these dispositions and anticipations then constitute it as the kind of line it is. This is true not just of an abstract zig-zag, but of any line in Klee's works – our experience of it is meant to change depending on how we set about exploring it.

In Klee's works in general, lines often serve double duty, specifying both an object's outline, but also guiding the viewing eye in a course of movement. By working overtime in this way, Klee's lines teach us to see the role that the occluding edge of an object plays in guiding our visual exploration of things in the world, but also, simultaneously, the way that our eye's movement across the thing lets us see it as the visual object that it is. Look for example, at *Segelschiffe, Leicht Bewegt* (*Sailing ships, lightly moved*) (Plate 3). Let's examine the sailboat in the center. Klee presents the ships in a fashion distantly related to cubism – that is, we see them from several different vantage points at once. The hull of the center boat, for example is seen (proceeding from the left), in port profile, then from aft. As the size of

the sail makes clear, the boat is also seen at varying distances. Unlike a typical cubist work, however, the different facets of the boat are not presented simultaneously, but sequentially – while the viewing eye traces the outline of the sails, so to speak, the ship moves and turns into a new position. By the time the eye returns to the boat itself, it is in a different place. This makes Klee's work markedly different than a cubist portrayal. Cubist works don't specify movement so much as lay out the three-dimensional spatial structure onto a flat surface.

In some ways, Klee's painting of these ships is closer to that of Abraham van Beyeren in *Rough Sea* (Plate 4). Van Beyeren tried to create an impression of motion by depicting nearly identical boats at various distances and angles of list. One can thus imagine the motion by thinking of the three boats as the same boat at different moments as it recedes into the distance. But of course, this is the snapshot model of motion perception, according to which we construct the motion by welding together various individual pictures of static objects. What Klee does is something that neither the cubists nor van Beyeren succeeded in doing – he specifies simultaneously the movement of the eye and the movement of the object over which the eye grazes. This is, of course, the way perception works – an object in motion is changing facets even as the eye moves over it. In our perception of the world, there is no need to cement different facets together, but rather only to track in our bodies the transition from one to the next.[10] Now, of course, the point is not that, by letting our eyes graze across the page, we will have an experience qualitatively indistinguishable from one in which we are watching sailing ships lightly moving. But as the experience of the sketch unfolds over time, we do experience something different than we do if we just glance or even stare fixedly at the painting. In particular (at least, so it seems to me), we can experience something of the rhythm and tempo that comes from watching a moving object. And if so, then we are made aware of a certain temporal rhythm that structures ordinary, motivated action.

Conclusion

By studying Klee's descriptions of the artist's experience of looking in order to draw, as well as his theories of art perception, we've discovered a view which anticipates, and might serve to confirm, the claims made by Merleau-Ponty about the role of the body in perception. If Klee's art work does allow us to catch ourselves in the act of perceiving, then it will apply independently of any particular scientific theory about what produces perceptual experience, because it gives us the phenomenological data, as it were, for which scientific theories of perception need to account. And Klee's view of art as "making visible," will apply very broadly to different styles of art, just so long as each style gives us access to the way things like color, line,

shadow, light, depth, movement, and physiognomy work together to give rise to our experience of the world.

But, as I've already mentioned, Klee believes that art makes visible not just in the sense that it shows us what we see. There's another role that art can play in making visible – Klee called art which plays this role "art in the highest circle" (1968: 186). Art in the highest circle trains us to perceive things that we haven't been picking up on before. His aim was to use his works "to penetrate deeply into this cosmic sphere, and to come out of that as changed observers of art, and then to wait for the things" we've learned to see (1961: 296).

We perceive, Klee believes, because our bodies are attuned to resonate to particular features of the world – attuned, in particular, to the way they signify beyond themselves, invite us to move beyond them and explore beyond them. The work of art's highest calling is in helping us to get so attuned. For Klee, then, there is both a "descriptive" and a "normative" function for art – art can both show us what we see, but also attune us to see things in a different kind of way. Those are not sharply distinguished tasks – art educates the eye, and thus can be understood, as Heidegger argued, as performing a world-disclosive function.

Notes

1

> Der Titel Phänomenologie ist demnach hinsichtlich seines Sinnes ein anderer als die Bezeichnungen Theologie u. dgl. Diese nennen die Gegenstände der betreffenden Wissenschaft in ihrer jeweiligen Sachhaltigkeit. "Phänomenologie" nennt weder den Gegenstand ihrer Forschungen, noch charakterisiert der Titel deren Sachhaltigkeit. Das Wort gibt nur Aufschluß über das Wie der Aufweisung und Behandlungsart dessen, was in dieser Wissenschaft abgehandelt werden soll. Wissenschaft "von" den Phänomenen besagt: eine solche Erfassung ihrer Gegenstände, daß alles, was über sie zur Erörterung steht, in direkter Aufweisung und direkter Ausweisung abgehandelt werden muß. Denselben Sinn hat der im Grunde tautologische Ausdruck "deskriptive Phänomenologie". Deskription bedeutet hier nicht ein Verfahren nach Art etwa der botanischen Morphologie – der Titel hat wieder einen prohibitiven Sinn: Fernhaltung alles nichtausweisenden Bestimmens. Der Charakter der Deskription selbst, der spezifische Sinn des logos, kann allererst aus der "Sachheit" dessen fixiert werden, was "beschrieben", d. h. in der Begegnisart von Phänomenen zu wissenschaftlicher Bestimmtheit gebracht werden soll. Formal berechtigt die Bedeutung des formalen und vulgären Phänomenbegriffes dazu, jede Aufweisung von Seiendem, so wie es sich an ihm selbst zeigt, Phänomenologie zu nennen.
>
> (Heidegger 1957: 34–35)

2 This is emphatically *not* to say that this kind of perspectival realism is the only kind of realism in painting.

3 I suspect that few people, for instance, would have trouble recognizing the horse

in Kandinsky's *Lyrically*. See www.tate.org.uk/modern/exhibitions/kandinsky/rooms/room5.shtm.

4 Thanks to Charles Siewart for helping me to put this point in this way.

5

> Das "praktische" Verhalten ist nicht "atheoretisch" im Sinne der Sichtlosigkeit, und sein Unterschied gegen das theoretische Verhalten liegt nicht nur darin, daß hier betrachtet und dort gehandelt wird, und daß das Handeln, um nicht blind zu bleiben, theoretisches Erkennen anwendet, sondern das Betrachten ist so ursprünglich ein Besorgen, wie das Handeln seine Sicht hat. Das theoretische Verhalten ist unumsichtiges Nur-hinsehen. Das Hinsehen ist, weil unumsichtig, nicht regellos, seinen Kanon bildet es sich in der Methode.
>
> (Heidegger 1957: 69)

6 The metaphysical view forms "free abstract structures which surpass schematic intention"; I think that means that they give us a grasp that exceeds any particular intentional directedness toward a thing.

7 We'll look at some examples of the eye moving through the work below. Although I won't discuss it here, an example of the whole body moving with respect to the work is provided by (1926/80), where each gate recedes perspectivally in a way that specifies a different position for the viewer. As one looks at the work, one feels drawn to move around in search of the "correct" position from which to look into each different gate.

8 See, for example, Klee 1979: Chapter 4.1.4: "Abstrakt: Herauslösen bildnerisch reiner Beziehungen."

9 See also Klee 1953: 33:

> Receptively it is limited by the limitations of the perceiving eye. The limitation of the eye is its inability to see even a small surface equally sharp at all points. The eye must 'graze' over the surface, grasping sharply portion after portion to convey them to the brain which collects and stores the impressions. The eye travels along the paths cut out for it in the work.

10 Klee used this technique in any number of other works, including *Engelshut* (*Angel's care* 1931/54 & 55), *Kleiner Narr in Trance* (*Small fool in a trance*, 1927/170), and, one of my favorites, *Zurücklehnende* (*Woman leaning back*, 1929/173).

References

Alberti, L.B. (1966) *On Painting*, trans. J.R. Spencer, New Haven, CT: Yale University Press.

Da Vinci, L. (1970) *The Literary Works of Leonardo da Vinci*, Vol. 1, Jean Paul Riehter (ed.), London: Phaidon.

Descartes R. (1965) "Optics," in *Discourse on Method, Optics, Geometry, and Meteorology*, rev. ed., trans. P.J. Olscamp, Indianapolis: Hackett Publishing.

Franciscono, M. (1991) *Paul Klee: His Work and Thought*, Chicago: Chicago University Press.

Heidegger, M. (1957) *Sein und Zeit*, Tübingen: Neimeyer.

—— (1962) *Being and Time*, trans. J. Maquarrie and E. Robinson, New York: Harper and Row.

—— (1976) *Logik: Die Frage nach der Wahrheit*, Frankfurt am Main: Klostermann.

—— (1985) *History of the Concept of Time*, trans. T. Kisiel, Bloomington: Indiana University Press.

—— (2000) "Die Frage nach der Technik," *Vorträge und Aufsätze*, Frankfurt am Main: Klostermann.

—— (2002) "Der Ursprung des Kunstwerkes," *Holzwege*, Frankfurt am Main: Klostermann.

Klee, P. (1919) *Schöpferische Konfession*, Berlin: Erich Reiss Verlag.

—— (1953) *Pedagogical Sketchbook*, New York: Frederick A. Praeger.

—— (1956) *Form und Gestaltungslehre, Vol. 2: Unendliche Naturgeschichte*, J. Spiller (ed.), Basel: Schwabe & Co.

—— (1961) *Paul Klee Notebooks, Vol. 1: The Thinking Eye*, J. Spiller (ed.), London: Lund Humphries.

—— (1964) "On Modern Art," in R.L. Herbert (ed.), *Modern Artists on Art: Ten Unabridged Essays*, Englewood Cliffs, NJ: Prentice-Hall.

—— (1968) "Creative Credo," in H.B. Chipp (ed.), *Theories of Modern Art: A Source Book by Artists and Critics*, Berkeley: University of California Press.

—— (1979) *Beiträge zur bildnerischen Formlehre*, J. Glaesemer (ed.), Basel/ Stuttgart: Schwabe.

—— (forthcoming) *Pädagogischer Nachlaß*. Originalmanuskripte, Paul-Klee-Stiftung, Kunstmuseum Bern.

Manetti, A. (1970) *The Life of Brunelleschi*, trans. C. Enggass, University Park: Pennsylvania State University Press.

Merleau-Ponty, M. (1963) *The Structure of Behavior*, Boston: Beacon Press.

—— (1964a) "Eye and Mind," in J.M. Edie (ed.), *The Primacy of Perception*, Evanston, IL: Northwestern University Press.

—— (1964b) "Indirect Language and the Voices of Silence," in *Signs*, trans. R. Mcleary, Evanston, IL: Northwestern University Press.

Nietzsche, F. (1968) *The Will to Power*, trans. Walter Kaufmann and R.J. Hollingdale, New York: Vintage.

—— (1974) *The Gay Science*, trans. Walter Kaufmann, New York: Vintage.

Siewert, C. (2005) "Attention and Sensorimotor Intentionality," in D.W. Smith and A.L. Thomasson (eds.), *Phenomenology and Philosophy of Mind*, Oxford: Clarendon Press.

2

PHENOMENOLOGY AND AESTHETICS; OR, WHY ART MATTERS

Steven Crowell

What can phenomenology contribute to aesthetics? My answer to this question will be highly qualified, so I may as well start with something clear and bold: of all philosophical approaches to aesthetics, it is phenomenology that best accounts for why art *matters* to us. Phenomenology uncovers the "meaning" of art. Now, to some caveats. First, it is difficult to speak of "phenomenology" in the singular. Identifying commonalities among thinkers as diverse as Edmund Husserl, Martin Heidegger, Jean-Paul Sartre, and Maurice Merleau-Ponty (to name just a few) is not easy, and phenomenology's contribution to aesthetics will perhaps be more readily apparent in what is distinctive of each author than in what they share. Second, the notion of "aesthetics" is itself complex, concerned as it traditionally has been with both beauty *and* art. The "and" is important, since not everything that is beautiful is art, and not all art need be beautiful. What, then, is the real topic of aesthetics? Since I will be treating it exclusively as philosophy of art, I should say a word in defense of this restriction. This will require a brief look at the history of aesthetics.

The eclipse of nature and the apotheosis of art

In 1735 Alexander Baumgarten, a philosopher in the school of Leibniz, was the first to use the term "aesthetics" to designate a special philosophical inquiry, namely, an inquiry into how we know things through the senses. It was in this context that Baumgarten arrived at his definition of beauty as "sensible perfection." Three things are to be noted about this definition. First, to characterize beauty as perfection indicates its normative character. Beauty is not simply a property of an object, like its color or shape, but belongs to the object as measured against a standard of what it *ought* to be. Second, beauty fascinates us because this adequacy-to-the-norm is not something we grasp in thought (as when we note the adequacy of an object

31

to its concept) but is something *sensed*. This sensuous consciousness of the ideal is manifest as the distinctive pleasure we take in the beautiful. Finally, it is *natural* beauty that has traditionally been most important to philosophers, since beauty in nature was taken as a sign of order and purpose in the world, whereas artistic beauty was thought merely to indicate that the design of the artist had been adequately fulfilled.

The philosophical priority of natural over artistic beauty has a long pedigree. We need only recall how the estimation of beauty differs in Plato's *Phaedrus* and *Symposium*, on the one hand, and in his *Republic* on the other. In the former dialogues, where natural beauty is at issue, Plato sets forth elaborate accounts of how beauty leads the soul to its higher vocation. The attraction I feel at the sight of my lover's beautiful body is not merely brute desire for sexual gratification but something legible, something philosophically meaningful, something in which the soul's desire for truth is already inscribed. Earthly beauty, sensuously apprehended, is already a kind of intelligibility. Of all the ideal forms, writes Plato in the *Phaedrus*, it "is the privilege of beauty, that being the loveliest she is also the most palpable to sight" (Plato 1964: 61) – and to be concerned with it is already a kind of philosophizing. But for Plato this is true only of natural beauty. Beautiful art is seen quite differently. In the *Republic*'s treatment of art, beauty's seductiveness is understood not as a spur beyond the sensuous toward the ideal but as what shackles us to the sensuous itself, fascinating us with a copy (*mimesis*) of the mere appearance of things. Thus Plato condemns artistic beauty for its political implications: in contrast to beauty in nature, art rivets us to the world of deception and dulls the soul's ability to recognize truth in the Idea. Of course, Plato's approach to beauty was far more nuanced than this, but the stark contrasts he set forth defined subsequent philosophical inquiry. Natural beauty was seen as a path to the divine; artistic beauty remained, at best, a handmaid.

This is true even for Aristotle, who nevertheless departs from his teacher in defending the positive philosophical significance of *mimesis*. In noting that the pleasure we take in artistic representation is distinct from that taken in the corresponding realities, Aristotle breaks with the idea that *mimesis* is a copy of appearances. If I can take delight in the artistic representation of things, the seeing of which in reality would disgust me, the source of this delight cannot lie in the depicted as depicted, but in its *being-depicted* as such, in its very character as a representation. For Aristotle, this pleasure is bound up with learning: "the delight in seeing the picture is that one is at the same time learning – gathering the meaning of things" (Aristotle 1964: 100). To gather the meaning of things is neither merely to see how something looks nor to catalogue every detail of some event; it is to grasp the universal in the particular or to recognize the elements that give "unity" to an action. Hence, for Aristotle, "poetry is something more philosophic and of graver import than history, since its statements are of the

nature of universals" (Aristotle 1964: 106). Here Aristotle recognizes that art itself can be a vehicle of truth.

With its vision of a disenchanted nature, modern thought began to undermine traditional foundations of the philosophical inquiry into beauty. By the time of Kant's *Critique of Judgment* (1790) the idea that natural beauty is philosophically important because it signifies divine order had been reduced to the claim that it is the "symbol" of the "morally good" (341). But as if in compensation, Kant's reflection on the beauty of *art* contained a revolutionary insight – namely, that beauty alone is an insufficient standard for evaluating the success of an artwork. Art must in addition possess "spirit," an "animating principle of the mind" that can be understood as "the faculty of presenting aesthetical ideas." Kant defines aesthetical ideas as "representations of the imagination which occasion much thought without however any definite thought, i.e., any *concept*, being capable of being adequate to it" (317–18). With this, Kant identifies what I, following Arthur Danto, will call the "metaphorical" structure of artistic representation. As Danto puts it, art's metaphorical structure insures that

> no paraphrase or summary of an artwork can engage the participating mind in all the ways it can; and no critical account of the work can substitute for the work in as much as a description of a metaphor simply does not have the power of the metaphor it describes.
>
> (1981: 172–73)[1]

Kant saw that art makes a claim on us that is *independent* of the claim of beauty. And because of this independent claim, because of the normative role of "aesthetic ideas," aesthetics could refashion itself exclusively as a philosophy of art, once the fortunes of the concept of beauty had dimmed.

Such a step is already taken by Hegel, for whom "the beauty of art stands *higher* than nature" since nature is "an indefinite subject-matter destitute of any real criterion," while art is "a new birth of mind" in which "mind is exclusively dealing with that which is its own" (1964: 394). Contemplating art, mind recognizes a "reconciliation" of its own conceptual oppositions: matter and spirit, necessity and freedom, universal and particular. Art is thus an "Absolute" mode of truth (388, 424). Nevertheless, precisely because art possesses a metaphorical structure, the truth it embodies lacks its proper form. The egalitarian principle of the modern world demands that truth take the form of scientific concepts, accessible to public scrutiny and legitimation. For this reason art has lost its cultural significance. "Art is and remains for us, on the side of its highest possibilities, a thing of the past" – that is, art no longer really *matters*; it does not deeply inform our cultural practices but has become an object for specialized criticism and "judgment" (392). Thus aesthetics is doubly superseded in Hegel: natural beauty, no longer significant, gives thought no purchase, while artistic beauty, though a

mode of truth, is not autonomous; it is subordinated, just as decisively as in Plato, to the higher claims of science.

Here we touch on a point relevant to our theme, for certainly *one* of phenomenology's contributions to aesthetics lies in its attempt to circumvent Hegel's verdict by freeing art from its subordination to "the concept" without severing its connection to truth. It thereby shows why art continues to matter to us otherwise than as mere entertainment or as a topic for critical judgment.[2] In the remainder of this chapter, then, I will leave nature aside and ask specifically about phenomenology's contribution to the philosophy of art.

Phenomenology and the philosophy of art

Philosophy of art is, of course, a vast field. Glancing at any recent textbook, one will find chapters on defining art; on interpretation, performance, and criticism; on aesthetic experience, taste, and the logic of aesthetic predicates; on the political, cultural, and social dimensions of art; on modes of representation and the various artistic media; on expression and creativity; on the emotions; on the relation of art to its history; and on the question of artistic truth or "message." Phenomenology has something to say about all of these, yet we must be selective. One way to narrow the field is to let topics emerge from what we find to be most distinctive about the phenomenological approach itself. Any characterization of phenomenology will be controversial; I will nevertheless try to construct a schematic picture by contrasting phenomenology with one author's account of the "analytic" approach.

In his recent *Philosophy of Art*, Noël Carroll argues that because "analytic philosophy analyzes the concepts that are fundamental to our practices," and because art is one such practice, "analytic philosophy of art [explores] the concepts that make creating and thinking about art possible" (1999: 5). Carroll goes on to say that "analysis" is essentially the search for necessary and sufficient conditions for the "application" of such concepts (12). We discover such necessary and sufficient conditions by "reflecting on the nature of our concepts" and by employing "logic, definition, thought-experiments and counter-examples (even imagined ones), and deductive arguments." Once discovered, we develop a theory – a "reconstruction" of the concept in question – which we test by seeing whether it "meshes with our considered intuitions." Finally, such a theory is not an empirical (psychological, sociological, etc.) *explanation* of art, or of our concept of art, but a *clarification* of it (11–13).

Described in this generic way, there is considerable overlap between analytic and phenomenological approaches to philosophy, but there are some significant differences as well. First, like conceptual analysis, phenomenology aims at clarification rather than (causal, statistical, etc.) explanation. Whether

you favor a transcendental, hermeneutic, existential, or some other version of phenomenology, you will employ an *epoché* of explanatory theories.[3] A phenomenology of perception, for instance, will focus on the descriptive structure of perception itself and will take no stand on whether it is an evolutionary adaptation, an excitation of the optic nerve, and so on. Second, like conceptual analysis, phenomenology is a *reflective* practice. Unlike conceptual analysis, however, it is not primarily a reflection on concepts but on *experience*; or rather, on the "intentionality" of experience, its "meaning-content" – the way in which things show themselves *as* something. Phenomenology holds that conceptual analysis cannot clarify all the levels of meaning that inform our experience since experience involves aspects that are non-conceptual in character. Despite this difference, the phenomenologist does not reflect on experience in order to describe it in its particularity but to uncover the "essential" or *a priori* structures that inform it, and in this it shares a goal with the analyst's search for necessary and sufficient conditions. Husserl, for instance, did not concern himself with Dürer's print, *The Knight, Death, and the Devil*, in order to explain the psychology of vision, nor did he devote himself to unpacking the meaning or content of the work itself. Rather, he sought to establish the essential elements of seeing something *as a picture*, the complex way that our apprehension of paper and ink yields a layered consciousness of the depiction as well as the depicted. To this extent, phenomenological reflection on the intentionality of pictorial experience must be undertaken prior to any attempt to analyze the necessary and sufficient conditions for *applying* the concept "depiction" *to* some element of that experience.

Finally, phenomenology, like analysis, achieves insight into essences by means of "thought-experiments and counter-examples (even imagined ones)" – a process that Husserl called "free-fantasy variation." Husserl goes so far as to write that "'fiction' makes up the vital element of phenomenology" (1982: 160). What distinguishes phenomenology is that this process is meant to yield an "intuitive" grasp of essences, that is, a kind of understanding based on the direct apprehension of what is understood. But while this insistence on the authority of direct evidential seeing stands in some contrast to the analytic philosopher's reliance on definition, logic, and deduction, such a contrast should not be over-emphasized. Phenomenologists are not barred from using logical argumentation; they reject only the construction of speculative theories that cannot be redeemed against a direct ("intuitive") experience of what those theories are about. But an appeal to "our considered intuitions" is, as Carroll said, an element of analytic philosophy as well. Perhaps, then, the most significant difference between the two remains the claim – defended by analysts but rejected by phenomenologists – that the very *structure* of the meaningful space in which we live, move, and have our being is *logical*, one that can be fully articulated in a deductively organized theory.

It is in the phenomenological concept of "horizon" that this difference becomes most apparent. Originally at home in the phenomenology of perception, it has been extended in several directions. In Heidegger's philosophy, for instance, the "world" has this phenomenologically horizonal character, as does the "lived body" in Merleau-Ponty's – and we could add phenomena such as temporality, language, history, and indeed meaning itself. Two things belong essentially to an horizon in the phenomenological sense: first, it is *holistic*; and second, it is essentially an *interplay* of determinacy and indeterminacy. To say that the horizon is holistic is to say that what emerges within it (or against the "background") remains, in its manner of being given, bound *to* the horizon through necessary connections. These connections are neither causal nor inferential; they have a phenomenologically irreducible character. The rosy tint on the white coffee cup I am looking at now, for instance, is a function of the cup's placement in an horizon that includes my lamp in just this position and the red-bound book behind it. The intentional object of my perception – the cup just as it is given *in* that perception – is thus constituted by its relation to the horizon; it is what it is only within it. And thanks to this holistic structure my cup-perception contains *meaningful* anticipations of further experiences, indications not of what *will* but of what *should* present itself in subsequent perceptions of "the same" thing.

Due to the second aspect of the horizonal structure, however – its interplay of determinacy and indeterminacy – this meaningful anticipation cannot be modeled logically. It is, for instance, nothing like Quine's "web of beliefs," where beliefs are determinate propositional contents related inferentially to one another. The horizon does involve the possibility of determining the indeterminate – I can thematically attend to the formerly indistinctly perceived book behind the cup, for instance. But the "indeterminate surroundings are infinite," as Husserl says, and the horizon is "never fully determinable" (1982: 52). This essential indeterminacy is not simply a matter of our inability to be in all places at once; rather, it is a necessary feature of what it is to have an horizon. Any theory that construed the horizon as an already implicitly determined context of conceptual or inferential relations would miss its horizonal character altogether. In doing so it would miss precisely the way the meaning of our intentional objects is constituted *by* horizonal structures. To pursue meaning solely in terms of a logic of concepts, then, leaves out something important, something of which phenomenology tries to make us aware. And this brings us to the central claim of the present chapter: by situating the search for a definition of art within a reflection on the horizons in which art shows itself, phenomenology helps us to understand why we *care* about what is thus defined, why art *matters* to us.

Analytic aesthetics acknowledges what is at stake here in its distinction between "classificatory" and "commendatory" definitions of art. Sometimes

we use the concept of art in a way that includes both good and bad art. A classificatory definition gives us the analysis of this concept. Sometimes, however, we use the concept so as to *exclude* such a contrast: bad art is not art at all. A commendatory definition gives an analysis of *this* concept. Now it might be thought that a commendatory definition could simply take over the classificatory one and add a further condition – X – that specifies what makes a work good. But that would be wrong, since this would not account for why the "failed" exemplars are not art at all. The term "commendatory" might suggest such an account: in the commendatory use, we have simply chosen to deny the predicate "art" to the works that fail to exhibit the good-making condition. But this won't work either. It is implied in the notion of a commendation that we have a reason for choosing as we do, but this reason cannot simply be the good-making condition itself. If "beauty" is such a condition, I must still go on to explain why beauty *matters* to us such that we would single it out for praise. (A commendatory definition of theft, by contrast, seems to make no sense.) The point is that such definitions aim at a *normative* aspect in the meaning of our experience of art, and it is this that phenomenology, with its attention to the meaning of that experience, is in a good position to disclose.

Rather than go on in this highly abstract way, however, I shall now leave comparisons with other philosophical approaches behind and turn to a couple of specific examples of how phenomenological philosophy of art operates. I shall approach the large phenomenological thesis – that art matters to us fundamentally because it is an irreducible mode of truth – in two steps. First, appealing to Husserl's phenomenology of perception, I will argue that even supposedly non-representational art fits my working defini-tion of art as metaphorical representation. And second, staging an encounter between Heidegger's philosophy and Giorgio Morandi's painting, I will suggest that truth in art is not a matter of illustrating previously established philosophical theses; instead, art is itself an original source of phenomeno-logical insight.

Noticing visual experience

Abstract art has been a mainstay of the artworld for almost one hundred years, but its philosophical significance remains in many ways a puzzle. If artistic representation is understood as *mimesis*, what is it that such paint-ings "imitate"? Some theorists have held that abstract art refutes the claim that art is necessarily a kind of representation, the claim that art must be "about" something. Clement Greenberg's formalism, as well as certain theories of expression, tend in this direction. For these theorists, abstract painting stands under the imperative imposed on poetry by Archibald MacLeish: it "should not *mean* but *be*." But if this is so, what distinguishes such works from things that are not artworks at all? Merely the fact that

they were made by artists? Dissatisfaction with such a position has led some philosophers, including Danto and Hans-Georg Gadamer, to insist on art's representational character. Gadamer, for instance, notes that a picture is like a copy in that it has a relation to an "original." Even abstract art is said to have this representational structure, since it "does not simply detach itself from the relation to 'objectivity' but maintains it in the form of a privation" (1989: 92). Yet art is a distinctive *sort* of representation since, unlike the copy, the picture "is not destined to be self-effacing ... the important thing is *how* the thing represented is presented in it"; the picture is not a copy, for "it *says* something about the original" (139–40). Danto puts the point this way: like all representations, an artwork is "*about* something, or has content, or a subject, or a meaning"; but works of art differ from other representations in that they "use the means of representation in a way that is not exhaustively specified when one has exhaustively specified what is being represented." In short, they "*express* something about their content" (Danto 1981: 139, 148). This double aspect of artistic representation is the basis of its metaphorical character.

Now, much abstract art fits nicely within this definition, but in the 1960s – in response both to the heavy weather of Abstract Expressionism and to its cool antipode, Pop Art – there arose a direct challenge to it: the "minimalism" of Donald Judd, Carl Andre, Dan Flavin, and others. In painting and sculpture, minimalists set about undermining all the conventions by which art posed as a vehicle of meaning, claiming to produce, instead, what Judd called "specific objects," artworks that would resist all interpretation. Various typical features of minimalist work – lack of titles, use of basic geometric forms, seriality, generation by mathematical formula, and so on – conspire to thwart our tendency to look beyond the work, to *think*, and instead encourage intense concentration on visual experiencing itself. As does a traditional sculpture such as the *Laocoön*, for example, a multicolored fluorescent light piece by Dan Flavin draws upon the viewer's bodily engagement, the ability to change position and remark transformations in one's experience. Whereas moving around the *Laocoön* reveals aspects of an unfolding narrative, however, moving within the ambient light of a Flavin piece more closely resembles an experiment in the psychology of vision. Attention is focused not on an unfolding meaning but on the bodily and visual impact of alterations in intensity and hue. But what, then, distinguishes such pieces from actual psychology experiments – perhaps visually identical – conducted in the lab? What distinguishes a cinderblock wall constructed according to one of Sol LeWitt's formulas from the wall that separates me from my neighbor, which just happens to be constructed according to the same formula?[4] Here Husserl's analyses of perceptual experience can help us see how minimalist projects conform, in spite of themselves, to the definition of art as metaphorical representation.

As I write I feel a desire to smoke, so I reach for a cigarette and then look

up to find a light. I notice a box of kitchen matches on the desk, open it, and remove a match. If asked what I see, I will say "a matchbox"; that is what is perceptually given, the intentional object of my act of perception. What interests Husserl in such an everyday experience are the essential elements that give it structure, elements that constitute the *way* the matchbox is given. For instance, the perceptual object is given *as* something (as a matchbox); it has a meaning. This meaning is not entirely a function of what is strictly "seen," however, since it depends on its *horizon*: to grasp something as a matchbox is to take it in relation to numerous other things – cigarettes, for instance – as well as to oneself, as skilled in the use of such things, knowing what to do with them. In the absence of such horizonal references I could never experience something as a *matchbox*. But what sort of horizonal references constitute it simply as something *seen*? One might describe the box's visibility as consisting in (among other things) its being identical, a unity of color and shape properties, existing out there, distinct from my act of perceiving. But this perceptual experience of the simple unity and unchanging identity of the box is not itself a *simple experience*. Phenomenological reflection shows that consciousness of identity is inseparable from a synthesis of ever-changing profiles or aspects (*Abschattungen*) of the box as it appears in the temporal flow of my experience; the visual object *as visible* is just the rule of such synthesis. The unity of properties, in turn, is given through a complex interplay of the horizons of perception and embodiment. The matchbox's own color – this red – is constituted, on the one hand, as the color that appears *so* under certain optimal lighting conditions but which now appears *thus* thanks to the presence of fluorescent light in the vicinity and a shadow from the cup next to it. Perceptual properties are thus the locus of certain "conditionalities" (neither logical nor causal) in the horizonal environment. But these conditionalities are themselves functionally dependent on how I am bodily engaged in the perceptual world. Moving my head induces certain changes in the perceptual profiles of the color; yet I attribute such changes neither to the box, nor to its perceptual horizon, but to myself – thanks to a kind of "psycho-physical conditionality," or rule, that holds between my experience of my own bodily movements and the order of what is perceived. Thanks precisely to these conditionalities, the perceived box is constituted as *out there*, as something *other* than me.[5]

Of course, I attend to none of this when I notice the box of matches lying on the table. The profiles, the continual syntheses, the conditionalities of embodiment, and the relations between thing and environment – all of that is occluded as perception goes out "directly" to its object. Precisely because it is occluded in this way, perceptual experience can yield an intentional object with the meaning "identical visible thing out there." The concept of visual experience, then, must be understood on two levels: a "naive" level where experience effaces itself in favor of a simple encounter with

something "in person"; and a "transcendental" level where the horizonal conditions that make such an encounter possible get noticed. Phenomenology approaches this transcendental level through reflection on visual experience in the naive sense and represents it in the form of verbal descriptions. Is there another way to represent it?

Seen in light of the phenomenology of visual experience, minimalist artworks are not the mere objects their creators deem them to be; rather, they are *deconstructions* of such objects, representations that make explicit the phenomenological elements of their own constitution. Take a sculpture such as Judd's 1991 *Untitled (Large Stack)*, for instance, which is composed of orange anodized aluminum and plexiglass (Plate 5). Its placement against the bare white gallery wall performs an initial gesture of decontextualization: these boxes resist any interpretation that would construe them *as* something because they have been removed from the kind of horizon – the everyday world and my skillful coping within it – whose references support the narrative sort of meaning that normally enables us to experience them as a matchbox, for instance, or as a metaphor for transcendence: "Jacob's Ladder." But they remain visible, and the decontextualization thus has the effect, quite intended by the artist, of highlighting that specific visibility which comes to the fore as the pull of thinking, of intelligibility, weakens.

Further, the dialectic of the one-and-many in the piece (how many "boxes" are there; is it one or ten?) carries a distinct point: Ten identical boxes are "stacked" one on top of the other, separated by identical intervals, in such a way that what the viewer sees at the bottom level – namely, the plexiglass top of the box – will become diminishingly visible as the stack rises, until, toward the top, the hollow bottom, invisible on the lower levels, becomes visible. In between, the hollowness of the bottom and the transparency of the top reveal themselves in an ordered series that reproduces what would take place were one able to move around a *single* such box, experiencing its profiles from various perspectives. The rule governing the seriality of the piece – which is such that it could be continued indefinitely – thus makes explicit the "logic" of the visual profiles in which a single box would be given. Profiles themselves, normally occluded, become thematic. Exploration of the sculpture – viewing it from various distances and various angles – reveals only more of the same: the similarity of each individual component is held constant as each appears in different profiles that are nevertheless inter-related in a rule-governed way. For instance, the rectangular "look" given through a side-view of one of the middle boxes will be echoed as a rhombus on a box three levels higher on the stack. The piece thus displays the two levels of visual experience – the naive and the transcendental – as the "impossible" simultaneity of multiple changing profiles that together yield an identical unchanging thing.

Judd's work itself can thus be said to be a way of *doing* phenomenology,

of making the transition from naive to transcendental visual experience. And for this reason it is not a counter-example to the claim that art is a kind of representation. It *is* not a mere thing because it is *about* mere things – specifically, about the perceptual thing as such. Further, it *says something* about perceptual things – not by asserting it but by displaying them "as," or showing them to be, rule-governed synthetic unities related in complex yet orderly ways to the lived body, perceptual unities constituted in experiences that possess a visual logic independent of the narrative meanings that play over them.

Now if this is indeed the case – and a good deal more would have to be said to make it fully convincing – then the phenomenology of perception has helped us to understand what makes Judd's work a work of art. At the same time, it has suggested something of why art matters to us. For it illuminates how even an artwork apparently so impoverished in meaning as Judd's must be seen as more than a series of aesthetic experiences, how we learn from it, how it helps us "gather the meaning of things." But here Hegel's question imposes itself once more: even if art is indeed a mode of truth, isn't such truth only a poor substitute for conceptual thought? In our case, it might seem that Judd's work merely illustrates an account of vision that is more adequately represented in Husserl's conceptual description. Why, then, should art *itself* matter to us? Isn't it, as Jerome Stolnitz argued, always "cognitively trivial," a vehicle for "messages" that are either banal or better expressed in other ways (1992: 191–200)? Until we are able to see how art – just like science and philosophy – can be seen as an *autonomous* mode of truth, our thesis about phenomenology's contribution to aesthetics cannot be considered established.

Art and truth

I shall now try to establish it through a reading of Heidegger's 1935 essay "The Origin of the Work of Art," a classic example of the phenomenological approach to art. Early in the essay, where Heidegger is motivating the argument to come, he asks a rather odd question: "What in truth is the thing, so far as it is a thing" (1971b: 20)? Here I will lay out only so much of Heidegger's subsequent argument as will allow us to understand why he never gets around to answering that question. I will then try to show how certain paintings by Giorgio Morandi (1894–1964) *do* provide an answer. In this way I hope to defend the main point of both Heidegger's essay and my own: that art is an autonomous mode of truth.

Like analytic aestheticians, Heidegger is concerned to tell us what makes something a work of art. However, Heidegger's approach is oriented from the first toward a commendatory definition, toward what Hegel called art's "highest vocation." Art, properly so called, is a happening of truth. As we saw earlier, this "eminent" possibility cannot be approached through

traditional classificatory accounts, since it is not something that is common to things neutrally (that is, non-normatively) classified as art. Hence Heidegger begins his essay with an *epoché* of three conceptual approaches to a classificatory definition that have dominated philosophical thinking about art since its inception. An artwork cannot be understood as a thing (substance) with a special kind of property, a "symbolic" property; nor can it be properly seen as an occasion for a certain kind of sensuous experience, "aesthetic" experience; and finally, what is distinctive about a work of art cannot be captured in the schema of form-and-content. Each of these "thing concepts," argues Heidegger, "obstructs the way toward the ... workly character of the work," its distinctive being as a *work* (1971b: 31). A work of art seems to lie somewhere between a mere thing and an implement: like a thing, it is self-sufficient (not necessarily in the service of something else), but like a tool it is an artifact. Thus having failed to gain purchase on the work's "workly" character by beginning with the traditional thing-concepts – because, as he says, "the thinghood of the thing is particularly difficult to express" – Heidegger drops the question of thinghood, turning instead to the "equipmental character of equipment" as "clue" to the work's mode of being (1971b: 32). He proceeds phenomenologically: the essence of equipment is not to be discovered inductively but by varying a single example. And because for this purpose "even a pictorial representation suffices," Heidegger invokes a "well-known painting by van Gogh" depicting a pair of shoes (see Plate 6). He then devotes a few lines to describing "the empty unused shoes as they merely stand there in the picture," but he notes that this does not seem to reveal what makes the shoes what they are as equipment, namely, their "usefulness" (1971b: 33).

Of course, no one expects to encounter usefulness in a description of the visual properties of a useful thing like shoes. To grasp it, one must restore the shoes to the horizonal context that constitutes their significance – what Heidegger in *Being and Time* called the "equipmental totality." It is a conceptual necessity that, as Heidegger put it, "taken strictly, there 'is' no such thing as *an* equipment" since an individual implement is what it is only along with other implements to which it is internally linked by "in-order-to" relations (1962: 97). But where do such necessities show themselves, become evident, such that we know about them? Shoes are most themselves when they are in use: "The peasant woman wears her shoes in the field. Only here are they what they are" (Heidegger 1971b: 33). Precisely in such use, however, neither the shoes nor the horizonal relations that constitute their usefulness present themselves thematically and conceptually; they remain hidden or withdrawn. On the basis of what sort of experience, then, do we construct the concepts that clarify this hidden phenomenon of usefulness? Husserl, as we saw, would say that we *reflect* on that experience, making its horizonal structures explicit. In a sense, this is Heidegger's answer too. However, such reflection is exposed to the danger of smuggling

back into the experience reflected upon a structure that belongs only to the thematizing operations of reflection itself. Indeed the *epoché* of traditional thing-concepts that Heidegger mobilized at the outset of his essay was meant, in part, to ward off just this tendency. How, then, is phenomenology to move forward?

Eschewing "observation of the actual use of shoes occurring here or there" – which could never capture equipmental being in its withdrawal – Heidegger turns back to van Gogh's painting and describes what "we notice" there (1971b: 35). On the basis of such noticing, the character of usefulness – which pertains to the implement as an object, so to speak, involved in an horizon of in-order-to relations – is seen to "rest in" a different sort of horizonal nexus, "reliability," which locates the implement in the so to speak "subjective" horizon of life: "By virtue of this reliability the peasant woman is made privy to the silent call of the earth; by virtue of the reliability of the equipment she is sure of her world" (Heidegger 1971b: 34). Now this putative "noticing" – in which Heidegger attributes the shoes to a peasant woman and locates them in her world – has been the occasion of much controversy. The eminent art historian, Meyer Schapiro, for instance, argued specifically against Heidegger that the shoes in question had to be van Gogh's own, thus belonging not to a peasant woman but to someone who "by that time was a man of the town and the city" (Schapiro 1984: 138).[6] But to appreciate the phenomenological point of Heidegger's essay it is necessary to insist that what Heidegger calls "noticing" here is *not* something whose purport could be captured through ekphrasis, through a careful description of what is evident on the surface of the canvas. We should recall that only because Heidegger's previous efforts at describing "the empty, unused shoes as they merely stand there in the picture" *failed* to reveal the being of equipment did he turn again to "notice" the work. Nor, therefore, can this renewed noticing be meant as an exercise in art historical attribution. Is what Heidegger notices in the work a mere free association, then, having no more connection to the painting than the elephant one sees in them has to the clouds?

This difficult question goes to the heart of the matter. First, what Heidegger uncovers as the meaning of the painting does *not* lie in his attributing the shoes to the world of the peasant woman, nor, therefore, in attributing them to any other particular form of life. It lies rather in the *reliability* that somehow becomes evident in the painting, a reliability that would no doubt also characterize the shoes of "a man of the town and the city." And grasping *that* – namely, "shoes-as-reliable" – does not seem like something we simply read into the painting. It seems more like grasping "the metaphor" that, according to Danto, is "always there" in a work of art (1981: 172). Still, Heidegger does not justify his remarks about reliability by appeal to the kind of evidence – van Gogh's intentions, perhaps – that could establish them in some objective way. Rather, they point back to a distinctive

kind of *experience*: "This painting spoke. In the vicinity of the work we were suddenly somewhere else than we usually tend to be" (Heidegger 1971b: 35). It is *this* sort of experience of art that Heidegger wants to explore phenomenologically: not the sort that takes place when we thematize the work as an object for art-historical analysis or critical estimation but the kind we have when we *live* with a work of art, dwell "in the vicinity" of the work and "preserve" its ability to "speak." According to Heidegger, this kind of experience – a thoughtful encounter that is quite other than free association – harbors access to art's "highest vocation," namely, to "an occurring, a happening of truth at work" (36).

The remainder of Heidegger's essay is devoted to developing the concepts that articulate the experience of living with art, an experience that, Heidegger admits, may not even be possible in the age of museum blockbusters and art chosen to match the furniture. Perhaps art no longer has a place in our world.[7] We cannot begin to resolve such issues here; nor, therefore, can we take up Heidegger's most far-reaching thesis, namely, that art matters most because it can be an "origin" in which the "world" of an "historical people" is "established." Nevertheless, his claim that van Gogh's painting spoke – that is, revealed the being or truth of equipment – recalls the more modest yet still philosophically interesting possibility we encountered in reflecting on Judd's work, namely, that art is a distinctive way of doing phenomenology. Exploiting this possibility I shall, in what follows, rely on my own experience "in the vicinity" of Giorgio Morandi's painting in order to address a bit of unfinished business in Heidegger's essay: his attempt to express the "thinghood of the thing." The phenomenology accomplished in Morandi's still lifes can, I will argue, teach us something that Heidegger's discursive phenomenology is in principle incapable of bringing to adequate expression.

Morandi and the pursuit of thinghood

The categories Heidegger introduced in his 1927 *Being and Time* leave no room for a *positive* phenomenology of thinghood and thus provide no means for answering the question, "What in truth is the thing, so far as it is a thing?" The analysis of entities in *Being and Time* begins with how they show themselves in the horizon of our everyday practices – that is, as entities whose intelligibility derives from their use – and Heidegger argues that this usefulness ("readiness-to-hand") defines "entities as they are 'in themselves'" (1962: 98, 101). Thus we find a positive account of equipment, but if we ask what things are apart from this equipmental horizon – ask about the thing "so far as it is a thing" – *Being and Time* provides no answer. Nature appears either as the material out of which items of equipment are made or as a space that receives contour and meaning through our practices; but natural *things* as such – or, more generally, what is merely

"present-at-hand" – are approached only privatively. In the end they are nothing but correlates of the project of natural science, which Heidegger characterizes as "the legitimate task of grasping the present-at-hand in its essential *unintelligibility*" (194). Heidegger's analysis thus appears to support art historian Norman Bryson's remark that "divorced from use, things revert to absurdity," that is, to meaninglessness (1990: 128). In *Being and Time*, then, the being of the thing – thinghood – is just this limit-idea of unintelligibility and as such can be approached only negatively, as the *absence* of equipmentality. Positive concepts to express thinghood are merely formal substitutes, providing no ontological clarification: "entity," "object," "something in general," whatever "is."

By 1935, however, when he wrote "The Origin of the Work of Art," Heidegger had come to appreciate the need for a phenomenological analysis that would illuminate thinghood in a positive way. After all, we do apply the term "thing" differentially. Thinghood is a peculiar "mode of being" – it does not belong to God or to persons, to the "deer in the forest" or "the blade of grass," and even the hammer, shoe, axe or clock are not, properly, "mere things" (Heidegger 1971b: 21). "Lifeless beings of nature" perhaps fit the bill, but if this is so, then in thinking about the thing we seem to have something definite in mind, something Heidegger's essay seems intent on drawing out. After showing that traditional metaphysical concepts cannot grasp what is distinctive about thinghood, Heidegger concludes that because "we never know thingness directly, and if we know it at all, then only vaguely," we "require the work" of art to reveal it (70). Yet nowhere in the essay does he pursue the project of showing how art teaches us about the thingly character of the thing. He offers rich phenomenological analyses of equipment and artwork, but not of thing.[8]

Somewhat surprisingly, the same lacuna is found in Heidegger's essay from 1951 entitled "The Thing." There Heidegger reflects on a particular entity, a jug, in order to bring out how a thing "gathers" the elements of natural and social being into a "world" and so first allows mortals to dwell in the nearness of these elements (1971c: 174, 181). However, it is obvious that Heidegger still sets his sights here on equipment – on the implement as it embodies the potential to resist current social conditions of commodification, consumerism, and disposability – rather than on mere things. The jug's meaning, while no longer that of a tool defined by its place in a nexus of in-order-to relations (as in *Being and Time*), is still understood within an horizon that is human, all too human. What Heidegger has not yet managed to illuminate is what might be called the "indifference" of *mere* things. Should we then conclude from Heidegger's failure that what it means to be a thing cannot be thought positively at all? Do Heidegger's attempts at phenomenology vindicate Bryson's claim that "divorced from use, things revert to absurdity"?

Here we may locate the contribution of Giorgio Morandi's art, for his still

lifes show what Heidegger's discursive phenomenology cannot: that Bryson is wrong. In them we gain an understanding experience of the thinghood slumbering within an implement such as a jug, much as van Gogh's work helped us toward an understanding experience of its reliability. *In* Morandi's painting – "in its vicinity" as Heidegger says – we are able to *think* what ordinarily eludes us and what apparently eluded Heidegger's philosophical reflection: the "truth" or meaning of the thinghood that subtends the useful. As I will try to show, this is because Morandi's still lifes are metaphorical representations that are *about* items of equipment, but are crafted in such a way that these items are pictorially displayed *as* mere things. Through these paintings our everyday (though "withdrawn") understanding of thinghood becomes "noticeable," revealed explicitly in the way the painting works to tell us something about its subject.

Morandi's still lifes occupy a distinctive place in his *oeuvre*, for he practiced only three genres throughout his career, and the other two (flower painting and landscape) often give the impression of still lifes in his treatment of them. The unmistakable elements of Morandi's style have, perhaps surprisingly, given rise to significantly opposed readings. In the earliest Italian monograph, Arnold Beccaria spoke of "Intuition, Purity, Universality, and Interiority" (Solmi 1988: 7). More recent critics have noted a kind of sublimity, a "timeless, suspended" quality, a serene, meditative gaze transfixed by Morandi's "awesomely complete silences" (15, 16).[9] At the same time, these values have been attached to very different views about what motivates the work as a whole. Some see it as a kind of modernism, "a tranquil progression toward increasingly perfect formal achievements" (9). Others – responding to Morandi's "proverbial" isolation, his refusal of "ephemera, fashions, and affected mannerisms," and his interest in the masters of the early Quattrocento (Vitali 1988: 20, 21) – associated his project with anti-modernism and the "Po Valley tradition of 'last naturalists'" (Pasquali 1988: 144).[10] Both characterizations were repudiated by the artist himself, however. If neither formalist nor naturalist, modern nor anti-modern, then what? Is there a common term between the "sublime silences" of the pursuit of form and the "real and solid world" of the naturalist with its "calm and moral fulness"? How are we to account for "the almost unbearable tensions" in Morandi's work that give rise to such contradictory assessments (Solmi 1988: 7)?

The genre of still life was traditionally held in low esteem because, as Joshua Reynolds put it, "it is unable to abstract itself from sensuous particulars and attain the level of general ideas" (Bryson 1990: 170, 175). This very fact, however, provides the essential clue to how truth happens in Morandi's art. His still lifes deploy the genre's prerogatives to accomplish what philosophy – wedded to concepts, to general ideas – finds paradoxical: enabling thought to touch upon something that *eludes* the "general idea." Critics who understand Morandi as pursuing "essence" in the sense of the

general idea are thus subtly but importantly wrong.[11] Instead, as Gottfried Boehm recognized, he follows the trace of something *Begriffsfern*, something alien to the concept. Or, as Lorenz Dittmann observed, "the silence of Morandi's work" is a sign of "an inaccessible reality that rests within itself" (Boehm 1993: 21; Dittmann 1993: 35).[12] How does his work accomplish this?

One clue is found in Morandi's early connection with Giorgio de Chirico and the *scuola metafisica*. De Chirico once explained that metaphysical painting sought "wholly [to] suppress man as a guide." This Nietzschean sentiment – that the everyday order of things reflects a human, all-too-human vanity, far from the truth – underlies his concept of the "enigma" and is expressed in familiar elements of de Chirico's style: its blurring of the distinction between animate and inanimate, the peculiar tension between the earthly and the unearthly in its treatment of light; its broken perspectives and uncanny stillnesses, and so on. In a famous article on the artist from 1922, de Chirico described Morandi's art as a "metaphysics of the common object" that seeks "the enigma of things generally considered insignificant" (de Chirico 1970: 6; Forge 1970: 8), and one can see his influence in Morandi's handling of light, edge, and atmosphere in a still life from 1920 (Plate 7). Yet in his mature style Morandi no longer pursues the enigma by fixing the object in the airless atmosphere favored by de Chirico. Rather, as a typical example from 1943 (Plate 8) shows, he engages in what has been called a "pauperizing" of objects (Solmi 1988: 16).[13] What is the significance of this technical departure? To bring Morandi's mature work into proper focus it is necessary to be precise about the question he poses for himself. De Chirico's approximation of this question – "What is an object?" – remains crucially imprecise. Morandi's question is rather the Heideggerian one: "What is a thing?" His paintings are representations of implements whose manner of representing them shows them as things.

How this manner of representing achieves its metaphorical aim can be understood in different ways. In Heideggerian terms, the painting "speaks" because the way it has of presenting what it is about manages to bring forth the normally occluded horizons of the familiar, the "world," in which what it means to be an implement is constituted. To trace this operation in Morandi's painting, however, it will be useful to follow Norman Bryson's lead and appropriate an analytic framework from Roland Barthes to distinguish between the "denotation" and the "connotation" of an image. Denotation is the "iconographic" dimension of the work. It operates with highly coded schemata that allow for unambiguous recognition of the image as an instance of (say) an Annunciation or a Deposition or a Birth of Venus. Connotation, in contrast, consists of those elements that determine the denoting icon in the direction of a certain particularity or indexicality, yielding what Barthes calls the "reality effect" (1986: 141–48). This they do by addressing a "practical consciousness" that responds to meaningful cues beyond what is needed for mere recognition. Such practical consciousness is

guided by tacit codes "that inhere within the social formation" (in pheno-menological terms, the "world" as horizontal nexus) and cannot be "abstracted" from it: the significance that belongs to the curl of a lip, the squint of an eye, and so on. So long as the relevant social world survives, such codes are readily understood in practice, but when connotative aspects are integrated into an *image* they render its denotation "diffuse, general-ized, potentially but not instantly meaningful" (Bryson 1983: 70, 74). Connotation thus overcomes the typification characteristic of denotation and thereby *comments* on it. We see this in Heidegger's ascription of the shoes in van Gogh's painting to the peasant woman: in the folds and flags of its line, the painting represents the denoted shoes in such a way as to connote age, wear, and the particular materiality of leather, thereby inserting them back into some specific praxis, be it that of a peasant woman or of the urban van Gogh himself. This connotative movement toward a practical world is what reveals the shoes under the guise of reliability, reveals them *as* reliable.

Morandi's painting, in contrast, moves in the opposite direction. The mode of representation in a still life like Plate 8, for instance, allows the everyday implements denoted in the painting to be seen in the guise of "thinghood" by systematically reducing or occluding the expected connota-tive aspects, thereby *inhibiting* the denotata from reaching out toward any human, socio-practical world. If, as Heidegger remarked, "we never know thinghood directly" and thus "require the work," Morandi facilitates such knowing by exploiting the traditional conventions of still life: he *refuses* the well-known techniques whereby still life manifests horizonal connections – those connections that constitute material existence and property in domestic spaces of hearth and hospitality, as well as those that make up the larger social and sacred worlds with which material and domestic existence maintains complex relations of communication.

In a still life by Chardin, for instance (who was an important influence on Morandi), denotata are instantly recognizable – pipe, water pitcher, sugar bowl – and as such are already inserted in a familiar world: the humble yet safeguarding walls of a domestic interior. Morandi's still life from 1920 retains its connection with this traditional iconography. Denoted bread "belongs" here, as does the knife, which references a human hand at home in this world. A work like the 1943 still life, in contrast, is eloquent in its exclusion of all human activity: the toil of the harvest, the skill of manufac-turing, the pleasures of eating, drinking, smoking. Morandi would endlessly repeat this iconography of common implements – ewer, goblet, box, bottle, oil can – in his mature work. In each case the painting allows us to recognize its denotata but resists including them in any human narrative. It is impor-tant that Morandi's implements are often *barely* recognizable as imple-ments; his handling of paint serves, for instance, to occlude the difference between the hollows of a jug's mouth and the solidity of its walls, as if to

deny its functionality. The paintings create for themselves a viewer not entangled in the desire to grasp, wield, or consume; or rather – since any real viewer will be entangled at some level in such desires – these aspects of our ordinary traffic with implements are *thwarted*. They are "there" only as something that is sensed as receding.

This reduction is strongly reinforced at the level of connotation, where the treatment of what is denoted does everything in its power to keep the image from reaching out into some definite world. It is here that the painting takes on the distinctive metaphorical character that permits us to experience the meaning of thinghood. First of all, one may note the suppression of those cues that, as marks of their craftedness, would locate these implements in specific contexts of social value, production, and exchange. Traditional still lifes – such as the *Nautilus Cup* by Willem Kalf – abound with connotative elements thanks to which we encounter not just a rug, but one of a distinctively textured material whose markings signify origin in a definite place accessible to Dutch traders; not just a bowl, but a Chinese porcelain decked out with figures of the owner's Asian counter-parts; not just a cup, but one that tells the story of Atlas supporting the watery world traversed by Dutch trading vessels, and so on. Though not entirely absent in Morandi's work from 1943, markers of social or commer-cial distinction have now been reduced to a beaded edge here, the sugges-tion of a painted label there.

Furthermore, it is hard even to discern how these items were produced – cast, welded, blown, or turned – or how old, how weathered with use, they are. For the painterly marks that would connote their specific materiality have also been suppressed. Traditional still life took great pains to preserve distinctions between the solid transparency of glass and the liquid transpar-ency of what is within, to distinguish glass from ceramic from metal, and to highlight the different textures of flora, fauna, and foodstuffs. Morandi's 1920 painting continues this tradition, as it clearly connotes the differing materialities of ceramic, glass, metal, and wood, and provides markers that distinguish between organic and inorganic. By 1943, however, we are almost entirely unable to discern any material distinctions, thus inhibiting the icon's ability to evoke the horizon, or world, in which it could function as an implement. This effect is further reinforced by Morandi's handling of color – chromatics, tonalities, play of light and shade. As one critic put it, Morandi's "colors seem to turn to ash" (Solmi 1988: 10), creating a tension between strongly defining light and insistent blending of figure and ground. The space in which such figures are deployed is empty – not merely in the absence of allusion to nature or domestic interior but in the *exclusion* of such horizons through the image's way of "seeing solid in void and void in solid" (Bryson 1990: 98).

Beneath the reliability of the implement, then, Morandi's art leads us to an experience of the thinghood of the thing, allows us to understand the

thing's difference from both the empty formal "something in general" of logical semantics and the equally abstract, imponderable "matter" of physics. In blocking the icon's movement out toward the world of the hearth, the field, or the town – thereby thwarting disclosure of the sort of nearness possessed by an item of use, its reliability – the painting brings us back to the different, discursively inexpressible, way in which *things* are near. This process is quite different from Judd's superficially similar project of horizon-inhibition: while Judd *eliminates* the horizon, Morandi allows it to *pass*, to *recede*. For this reason, Judd's work uncovers the visible thing as visible, whereas Morandi's reveals the thinghood of the mere thing.

And yet, though the manner of representing the icon in a painting like the still life of 1943 conspires to silence the voice with which implements speak out into a world, the painting itself is hardly mute. The silence that has so impressed Morandi's critics is not that of the painting but of what it depicts. Indeed thinghood is experienced and understood ("preserved," in Heidegger's language) precisely "in the vicinity" of the *falling* silent of the implement. And while Morandi's painting achieves this disclosure through a reductive process, it is not the merely negative or abstractive one to which thought, unaided by the work, has recourse in its futile attempt to think thinghood with the help of "general ideas." For while it is true that implements "divorced from use" do fall silent, falling silent does not signify *absurdity*, the meaninglessness of what is thus silenced, as it must seem to a thought that identifies meaning exclusively with what can be captured in conceptual form. Falling silent is neither the absence of speech nor the impossibility of speech, but rather a mode of speaking, of making understood, predicable only of something capable of speech (Heidegger 1962: 208). If thinghood is thus intelligible only as the falling silent of the implement, we can understand something of why art matters, for without the work's way of letting this falling silent happen, such an experience must remain inarticulate, unexpressed. What silence signifies in any given case is, of course, understood only by those attuned to who or what falls silent, as in a silence between lovers. But everyone is familiar with *things* and thus can understand what is said when the implement falls silent, even if this only happens in the work of art; even, therefore, if the *truth* of what we experience is available only there.

Notes

1 In appropriating Danto's terminology here I do not mean to imply that my view overlaps with his in every respect.
2 While my theme here will be (one of) phenomenology's contributions to the philosophy of art, it is worth noting that phenomenology has recently been enlisted in support of a renewed philosophy of *natural* beauty as well. In their desire to recover a relation to nature based on something other than modern science and its technological paradigms, some environmental philosophers have

sought to revive the idea of a "legible" or meaningful nature. In this they often draw upon phenomenology. Merleau-Ponty's concept of "flesh," for instance – itself partly derived from a reflection on painting – is meant to pick out a kind of "brute meaning" that informs nature prior to the divisions between subject and object, self and other, mind and matter. See Merleau-Ponty 1964 and 1968.

3 The term *"epoché"* was introduced by Edmund Husserl to denote a procedure whereby the phenomenologist seeks to "bracket" or "suspend" presuppositions – above all, presuppositions about what exists. In exercising the *epoché*, the phenomenologist does not *deny* that atoms and molecules, for instance, exist. Rather, he or she simply refrains from making any use of the assumption that they do. This of course means that the phenomenologist cannot approach art with the goal of explaining it causally by appeal to its molecular structure, and in general it means that the phenomenologist cannot propose any explanatory theories at all, since all such theories presuppose the existence of the entities which are used in the explanation. Instead, phenomenology must limit itself to describing what presents itself *just as* it presents itself. In what follows, something of what this kind of "description" involves should become evident. See Husserl 1982: 167–70.

4 Here I make use of the method of "indiscernibles," which Danto famously employed in *The Transfiguration of the Commonplace*. This method may be seen as an example of the phenomenological practice of free-variation, which should afford insight into what is "essential" to what is thus varied in thought.

5 For the details of these analyses, see Husserl 1989: 60–79.

6 The controversy has been brilliantly extended by Jacques Derrida (1987: 255–382). On Schapiro's deafness to what Heidegger is actually doing in his essay see Gilbert-Rolfe 1995: 143–49.

7 Heidegger 1971b: 78:

> We inquire into the nature of art. Why do we inquire in this way? We inquire in this way in order to be able to ask more truly whether art is or is not an origin in our historical existence, whether and under what conditions it can and must be an origin.

8 Some have argued that his concept of "earth" is meant to be such an analysis, but this cannot be right, if for no other reason than that the "thing" is characterized as the locus of the "strife" *between* "earth" and "world" and so cannot be identified with one of the participants in this strife. A full discussion of this point, though important for understanding how Heidegger's analysis is consistent with the idea that art is metaphorical representation, is beyond the scope of the present chapter.

9 This "silence" is remarked by virtually every commentator. See, most recently, Abramowicz 2004. My own interpretation of its source and meaning will be found in what follows.

10 See Joan M. Lukach (1981: 34) on "the aggressive provincialism of a group that called themselves *strapaese*." Morandi "adopted the tenets of *strapaese*, painting no-nonsense, dry-as-a-bone paintings of the calculatedly ordinary."

11 See, for instance, Luigi Magnani (1981: 17): "Themes and motifs constantly recur in his painting, almost like archetypes, in the way that the *idea* recurs in multiple phenomena which Plato referred to as the participation of the particular with the universal."

12 I provide my own translation here.

13 Joan Lukach (1981: 33) notes the "extreme ordinariness, even dowdiness" of the components of certain still lifes; the "familiar utensils have lost all personality."

STEVEN CROWELL

References

Abramowicz, J. (2004) *Giorgio Morandi: The Art of Silence*, New Haven, CT: Yale University Press.

Aristotle. *Poetics*, in A. Hofstadter and R. Kuhns (eds.) (1964) *Philosophies of Art and Beauty: Selected Readings in Aesthetics from Plato to Heidegger*, New York: Modern Library.

Barthes, R. (1986) *The Rustle of Language*, trans. R. Howard, Berkeley: University of California Press.

Boehm, G. (1993) "Giorgio Morandi: Zum künstlerischen Konzept," in E. Güse and F.A. Morat (eds.) *Giorgio Morandi: Gemälde, Aquarelle, Zeichnungen, Radierungen*, Munich: Pestel.

Bryson, N. (1983) *Vision and Painting*, New Haven, CT: Yale University Press.

——(1990) *Looking at the Overlooked*, Cambridge, MA: Harvard University Press.

Carroll, N. (1999) *Philosophy of Art: A Contemporary Introduction*, New York: Routledge.

Danto, A. (1981) *The Transfiguration of the Commonplace*, Cambridge, MA: Harvard University Press.

De Chirico, G. (1970) "Giorgio Morandi," in *Giorgio Morandi:* [Catalogue of] *An Exhibition of Paintings, Watercolors, Drawings and Etchings*, London: Arts Council of Great Britain.

Derrida, J. (1987) *Truth in Painting*, trans. G. Bennington and I. MacLeod, Chicago: Chicago University Press.

Dittmann, L. (1993) "Licht und Farbe bei Giorgio Morandi," in E. Güse and F.A. Morat (eds.) *Giorgio Morandi: Gemälde, Aquarelle, Zeichnungen, Radierungen*, Munich: Pestel.

Forge, A. (1970) "Introduction," in *Giorgio Morandi:* [Catalogue of] *An Exhibition of Paintings, Watercolors, Drawings and Etchings*, London: Arts Council of Great Britain.

Gadamer, H.G. (1989) *Truth and Method*, trans. J. Weinsheimer and D.G. Marshall, New York: Crossroads.

Gilbert-Rolfe, J. (1995) *Beyond Piety*, Cambridge: Cambridge University Press.

Hegel, G.W.F. (1835–38) *Introduction to the Philosophy of Fine Art*, in A. Hofstadter and R. Kuhns (eds.) (1964) *Philosophies of Art and Beauty: Selected Readings in Aesthetics from Plato to Heidegger*, New York: Modern Library.

Heidegger, M. (1962) *Being and Time*, trans. J. Maquarrie and E. Robinson, New York: Harper & Row.

——(1971a) *Poetry, Language, Thought*, trans. A. Hofstadter, New York: Harper & Row.

——(1971b) "The Origin of the Work of Art," in *Poetry, Language, Thought*, trans. A. Hofstadter, New York: Harper & Row.

——(1971c) "The Thing," in *Poetry, Language, Thought*, trans. A. Hofstadter, New York: Harper & Row.

Husserl, E. (1982) *Ideas Pertaining to a Pure Phenomenology and to a Phenomenological Philosophy, Book I*, trans. F. Kersten, The Hague: Martinus Nijhoff.

——(1989) *Ideas Pertaining to a Pure Phenomenology and to a Phenomenological Philosophy, Book Two*, trans. R. Rojcewicz and A. Schuwer, Dordrecht: Kluwer.

Kant, I. (1790) *The Critique of Judgment*, in A. Hofstadter and R. Kuhns (eds.) (1964) *Philosophies of Art and Beauty: Selected Readings in Aesthetics from Plato to Heidegger*, New York: Modern Library.

Lukach, J.M. (1981) "Giorgio Morandi, 20th Century Modern: Toward a Better Understanding of his Art, 1910–1943," in *Giorgio Morandi*, San Francisco: Museum of Modern Art.

Magnani, L. (1981) "Portrait of Morandi," in *Giorgio Morandi*, Des Moines: Art Center.

Merleau-Ponty, M. (1964) "Eye and Mind," in J. Edie (ed.) *The Primacy of Perception*, Evanston, IL: Northwestern University Press.

—— (1968) *The Visible and the Invisible*, trans. A. Lingis, Evanston, IL: Northwestern University Press.

Pasquali, M. (1988) "Biography," in *Morandi*, trans. A. Ellis, Milan: Sesto S. Giovanni.

Plato. *Phaedrus*, in A. Hofstadter and R. Kuhns (eds.) (1964) *Philosophies of Art and Beauty: Selected Readings in Aesthetics from Plato to Heidegger*, New York: Modern Library.

Schapiro, M. (1984) "The Still Life as Personal Object – a Note on Heidegger and van Gogh," *Selected Papers: Theory and Philosophy of Art*, New York: George Brazillier.

Solmi, F. (1988) "The Art of Morandi," in D. Pertocoli (ed.) *Morandi*, trans. A. Ellis, Milan: Sesto S. Giovanni.

Stolnitz, J. (1992) "On the Cognitive Triviality of Art," *British Journal of Aesthetics*, 32, 3: 191–200.

Vitali, L. (1988) "Giorgio Morandi – A Secret World," in *Morandi*, trans. A. Ellis, Milan: Sesto S. Giovanni.

3

OBJECTIVITY AND SELF-DISCLOSEDNESS

The phenomenological
working of art

Jeff Malpas

Abstract: All artworks have a certain material objectivity. But what is the relation between their character as material and objective, and their being as artworks? This question is not adequately dealt with just by looking to determine what kind of objects artworks are, but requires instead that we attend to the character of artworks as works. In so doing the material objectivity of the work takes on a central importance since it is only through its objectivity that the artwork is able to work as art. The character of artworks as works is explored through consideration of Donald Davidson's account of the working of metaphor as well as Martin Heidegger's account of the 'world-disclosive' character of art in Greek temple architecture. The artwork is understood in a manner that is itself phenomenological in character, but may also be seen to underpin the more particular phenomenology that may be at work in any specific artwork, as a constant self-disclosedness or self-presencing that occurs only in and through the artwork's own material objectivity.

1. What is the relation between the objectivity of an artwork, that is, its material being *as an object*, and its nature *as an artwork*?[1] The relation is surely not an irrelevant or contingent one, and yet it is a relationship the nature of which is not at all self-evident. Indeed, in the case of some artworks, namely those that fall within the category of certain forms of so-called 'conceptual art', it might seem as if the material 'objectivity' of the work is entirely incidental to the work as such – as if the artwork consists entirely in a certain idea, or perhaps nothing other than a certain shape or

form. Yet even purely conceptual works still have to work through some medium or mode of presentation, and the question then returns: what is the relation between that medium or mode of presentation – which now becomes another way of understanding the work in its material objectivity – and the work itself? This question is important for any phenomenological approach to art – and so also to the question of art as itself a mode of phenomenology – since our understanding of the nature of the artwork has a direct relevance to how we understand the artwork to function. Indeed, if art is to be viewed as, at least in some instances, constituting a mode of phenomenology, then the question as to what the artwork is such that it can function phenomenologically is a central one.

2. One might be tempted to say that the relation in question here, at least when understood as indeed a relation between the medium and the work, is, as the use of the term 'medium' implies, just that – the material objectivity of the artwork is the medium for the work, which is to say that it is that through which the artwork works. As it happens, although too strong a distinction between the artwork and its 'medium' or 'mode of presentation' may itself sometimes mislead, the latter part of this answer – that the relation between the artwork and the medium is a relation of 'working though' – while it may appear superficial, does indeed point in an important and fruitful direction. Yet it is not the direction taken by most answers to the question at issue. For the most part, rather than leading to an investigation of *the way in which the artwork works*, the question about the relation between the objectivity of the work and the work itself has often been treated as a question about *the kind of thing an artwork is*.

Many writers have argued, at least in the case of those works that depend upon some form of 'text' (a musical composition, a piece of choreography, a poem or a novel) that requires a performance or 'reading' for its realisation,[2] that the work cannot be identical with its material or objective instantiations, since any one of those instantiations of the work can be destroyed without the work ceasing to exist, while the existence of a different reading or performance of the work need not imply the existence of a different work. Thus, were my copy of Proust's *A la recherche du temps perdu* to be destroyed, the work itself would remain unaffected, while if I listen now to Vaughan Williams' *The Lark Ascending,* I am not hearing a different work, regardless of whether the performance is live or recorded, from that to which someone else may be listening in Melbourne or San Francisco. Moreover, some writers have suggested that the same is true even of artworks such as paintings. Thus Peter Strawson writes, in a famous passage from *Individuals*, that:

it is only because of the empirical deficiencies of reproductive techniques that we identify these [particular objects] with the works of art.

Were it not for these deficiencies, the original of a painting would have only the interest which belongs to the original manuscript of a poem.

(1959: 231)[3]

Similarly, there have been those who emphasise the imaginative or expressive character of artworks. The work thus cannot be the same as its objective or material realisation alone since the imaginative or expressive quality of the work is not the same as any merely objective or material qualities. On such an account artworks are properly imaginative or ideal (though in a different way from those conceptual artists who identify the work with its idea), rather than objective or material entities.[4]

These latter accounts provide us with different ontologies of artworks, but they do so in a particular way, namely, by looking to specify the ontological class or category to which the artwork belongs – which is to say, as I indicated above, by determining the kind of thing with which the artwork can be identified. While such approaches provide one way of thematising the question concerning the nature of artworks, they also tend towards an understanding of that question as one that concerns the conditions of *identity* for artworks and their *individuation*. But this is certainly not the only question that can be asked concerning the ontology of artworks, and perhaps it is not even the right question to ask when it is the nature of the artwork *as an artwork* that is at issue. Whether an artwork is or is not a certain kind of thing need not have any relevance to the question as to how the kind of thing that is the artwork works as art.

Thus, in addition to asking after the generic mode of existence of the artwork, we may also ask after the specific manner in which it exists as art – in so doing we focus, one might say, not on *what* an artwork is so much as on *the way that* it is. Such a focus directs attention to the character of the artwork as precisely a *work*, and so to its dynamic, rather than static character. To focus on the work-character of the artwork is already to move away from the ontological question as a categorical question to one that prioritises activity and process. In relation to its objectivity, *this means understanding the objectivity of the work* (though this is to announce the idea in very preliminary fashion) as that *in and through which the artwork articulates itself as a work*. As Andrew Benjamin puts it, in a discussion to which I shall return, 'While a work may be art, what is of central importance is the *way* that it is art. The move to activity means that priority is given to a conception of the object as articulated within a process' (2004: 11).[5] Priority is given, in other words, to the artwork as a work.

This way of refiguring the ontological question at issue here not only has affinities with Benjamin's own approach to the artwork as articulated in his detailed engagements with specific works, but it is also close to that suggested by Jeffrey Maitland as part of an explicit argument for re-thinking the ontology of the artwork (1975: 181–96). Rejecting the idea

that the question concerning the nature of the artwork can adequately be addressed by focusing on the question of the kind of thing the artwork is (and rejecting, more specifically, the idea that the artwork can be understood as a type or token of a type – the view associated with, for instance, Strawson, and also Richard Wollheim, among others), Maitland argues for a focus on the way the artwork functions or works as an artwork. Yet while I have argued for retaining a focus on the objectivity of the artwork, Maitland argues that the ontological question must be reconfigured:

> in a way that will not prejudice us into thinking that the work of art is some sort of an *object*. Indeed, as long as we persist in viewing art as an object, we will fail to understand the nature of art.
>
> (189)

In fact, it is precisely to pre-empt too ready an assumption that the question concerning the material objectivity of the artwork is indeed a matter of the kind of object that it is that I have so far talked of 'objectivity' rather than, for instance, 'objecthood'. As Maitland would certainly agree, the material objectivity of the artwork is at issue here. The point should not be to disregard such objectivity, but to understand it anew. Thus, rather than abandon the notion of the artwork in its material objectivity, my aim is to rethink that in which such objectivity consists. One way of doing this is precisely through emphasising the character of the artwork *as a work*, something Maitland also does, and to emphasise, in a way that Maitland does not (though I would argue it is nevertheless present in his account), the way in which the work-character of the artwork does indeed operate only in and through the objectivity of the work.

The question of the relation between the artwork and its material objectivity is not a question about the relation between the artwork and the ontological kind to which it may belong, but rather a question about how artworks work, and the role of their material objectivity in that working. Undoubtedly, any attempt to address this question must attend to the actual working of artworks, and so also to our engagement with them. This requires attending, not only to our own experience of individual artworks, but also to the wider critical and interpretative reception of those works. Indeed, given the enormous diversity of artistic practice across not only different creative domains, modes and genres, but also different media, styles and methods of approach, it would seem foolish to suppose that one could provide a single account of the way artworks function as artworks that would address the character of their functioning in any detailed way. To this extent, an emphasis on the process or work character of the artwork already predisposes one towards a critical and interpretive practice in relation to art that is focused on individual works, rather than on artworks in general, and that sees the functioning of artworks as exhibited through the

functioning of those individual works and our engagement with them – a point that is particularly well-exemplified in Benjamin.[6]

Taken to its extreme, however, such a line of reasoning might be thought to amount to a claim to the effect that the process- or work-orientated character of the artwork means that there can be no real ontology of artworks as such – no general account of what an artwork is. Any philosophical encounter with art can only take the form of an engagement with particular works and never with the question of the artwork as such. Yet the claim that artworks can only be adequately understood as art through attending to their character as works, while it may be supported by reference to individual artworks at the same time as it also provides a way to ground a certain mode of engagement with individual works, cannot itself be substantiated without some more general level of argument. Moreover, there are also likely to be certain broader implications of such an approach that deserve recognition and elaboration inasmuch as they may direct or constrain our approach to individual works in specific ways. Recognising the diversity of artistic practice, and the importance of attending to the actuality of that practice as evident in and through individual works, does not then invalidate any more general ontology of the artwork, and does in fact already presuppose such an ontology. Indeed, inasmuch as one may view the approach adopted here as an application of the phenomenological injunction to return 'to the things themselves', to the particular case of the artwork (and, in this respect, the approach itself constitutes the application of a certain phenomenological mode of understanding to the artwork as such), then the fact that the focus on the artwork as a work does not imply the eschewal of any broader ontological commitment can be seen as reflecting something that is more generally true of phenomenology as such – the phenomenological approach is not intrinsically opposed to ontology, but should rather be seen as a particular form of ontology. The particular phenomenological approach adopted here is one that is intended to allow the phenomenon of the artwork itself to come forth, thereby allowing the artwork to exhibit, as it were, its own phenomenology – one that may be said also to underpin the more specific phenomenology that may be instantiated in any particular artwork.

3. Allowing that an ontological approach is not ruled out by the focus on the artwork as work, the initial question with which I began can be put once more: what is the relation between the artwork and its material objectivity? This is a question that I want to approach, at least initially, by a somewhat indirect route – one that operates by looking at the working of a phenomenon that is close to the working of art as such, but is more circumscribed in its operation. The phenomenon I have in mind is the working of metaphor. It is not that I will be suggesting that artworks should be understood as metaphorical in character, far from it, but rather that the way that metaphor

works may provide us with a clue to the way in which artworks also work. The analysis of the working of metaphor is, in fact, particularly instructive for the understanding of the working of objectivity in art, since the analysis of metaphor raises explicitly the question of the relation between something that is analogous to the artwork, namely the metaphor, and its 'objective' character. In the case of metaphor this can be construed as a matter of the relation between the metaphor itself and the specific sentence or sentences in which the metaphor is expressed. Certainly all that we are immediately presented with in a metaphorical utterance (I take 'utterance' here to include both the written and the spoken) are words or sentences uttered within a particular context. Any account of the nature of metaphor thus needs to explain the relation between the metaphor and its linguistic base.

Of course there are some complications here. We might say that the objectivity of the metaphor consists, not in any words or sentences, but in certain marks as they may appear on a surface – as ink on paper – or a set of sounds (in the case of something spoken). This is an instructive point to consider, since it raises an important issue concerning the notion of objectivity as it is being employed here. Earlier I took the objectivity of the artwork to be, implicitly, a matter of a certain material presentation, for instance: paint on canvas; shaped stone or wood; sounds; an assemblage of things found. But what we actually take the material presentation to be surely depends on what we wish to distinguish it from. In the case of our viewing of some painting we may say that the object presented is simply a canvas, to which paint has been applied, surrounded by a frame. Strictly speaking, however, such a description of the object does, in fact, go beyond what we may say is actually given in perception. Moreover we may even judge that it goes beyond what is materially presented – since one might argue that what is presented is not canvas, paint and frame at all, but rather certain arrangements of colour, texture and shape within our visual field.

In fact it seems that there is no unique or uncontroversial way of specifying the 'objective' component in any presentation. Instead what we take to be an objective description capturing just what is materially presented is most often a description of what is presented at a level immediately below the level at which our attention is primarily directed. Thus, if what we are looking at is one of Cezanne's late paintings of Mont Saint-Victoire (a particularly apt example since there the very appearance of the object is itself deconstructed into its phenomenologically most basic elements), then we will take the arrangement of paints of various colours and textures on canvas to be what is materially present (Plate 9); if it is the appearance of certain textures or colours of paint that is of interest, we may take the material presentation to consist just in certain combinations of reflected light differing in hue, in brightness and in saturation. Similarly, if it is

metaphor that is the focus of attention, then we will look to words or sentences; while if it is the words or sentences themselves that are of interest we will look to the marks or sounds (or perhaps to arrangements of letters or of phonemes) as the material presentation on which the words or sentences supervene. Of course, in each case, these presentations occur within a particular context or horizon – they are determined within a larger framework of significance – although it is not the context of horizon of presentation that is thematised.

Exactly how to explain the nature and working of metaphor has been no less controversial a topic than the question of how to understand the nature or working of art. What has generally been assumed, however, is that just as it has often been supposed that the work of art cannot be identical with any material object, neither is the metaphor identical with just the words or sentences in which it is expressed. This has the consequence, of course, that as words and sentences are identified, in part, by their meanings, so the metaphor cannot be identical with the meaning of the sentence or sentences in which it is expressed. Yet insofar as metaphor is regarded as more than a mere ornament of language, it seems that metaphor must stand in some important relation to meaning – to the cognitive content that belongs to it. The result has been that metaphor has often been taken to be identical with some meaning that is other than the meaning of the words or sentences involved. Thus many theories of metaphor have been led to develop accounts of 'metaphorical meaning' that attempt to explain how one sort of meaning, the metaphorical, is generated from another sort, the literal, where the literal meaning is the usual or conventional meaning of the words or sentences in which the metaphor is expressed. Thus, just as the recognition that the artwork is not identical with any material object leads, for instance, to the concept of the artwork as an idea distinct from the material instantiation or realisation of that idea, so the recognition that the metaphor is not identical with the literal meaning of the words or sentence leads to the concept that the metaphor is identical with some sort of special metaphorical meaning.

It may be, however, that the contrast between literal and metaphorical meaning can be of only limited help in understanding the nature of metaphor. Indeed, it may well be that the notion of 'meaning' has no clear application outside the realm of linguistic meaning and that linguistic meaning is first and foremost a matter of literal meaning, that is, of meaning as determined by convention. That is not to say that the notion of meaning has no application outside that realm, only that the further removed it is from the linguistic and from the conventional or literal the less useful the notion will be – and this, of course, applies to art in general as much as to the special case of metaphor being considered here. Thus the notion of metaphorical meaning, insofar as it is removed from the literal, will be, not empty, but certainly less useful in enabling an understanding

of metaphor. Yet if we accept that metaphor is more than just linguistic ornament, but deny that it is identical either with the literal meaning of the words or sentences, or with any metaphorical meaning, what can we say that metaphor is?

One solution is to deny that metaphor is properly understood in terms of meaning at all. Or rather; recognising that the metaphor can only work through the meaning of the words and sentences in which it is expressed, to say that the only meaning a metaphor has is its literal or conventional meaning, while denying that the metaphor is itself identical with such meaning. Of course metaphors may also give rise to new ideas and thoughts that may in turn be expressed in literal language, but that is not to say that the metaphor is identical with those thoughts or ideas. Rather the metaphor is, on this account, something like an event of 'seeing' that is brought about through a particular use of language; to create a metaphor is to *do something* with language much as a painter may *do something* with paint and canvas. And in both cases what results is not something to be understood as consisting in some particular cognitive content. In the case of some artworks, of course, most obviously so in the case of abstract visual compositions, whether in painting or elsewhere, but also in many auditory and musical works, we may be hard pressed to identify anything that could even plausibly be taken to be a candidate for such content; more generally, in the case of any artwork or metaphor, the attempt to capture some 'content' that belongs to the work or metaphor will always be less than the work or metaphor itself. It would be no less foolish to assume that one could, without loss, replace Emily Dickinson's lines:

> Hope is the thing with feathers
> That perches in the soul,
> And sings the tune without the words,
> And never stops at all

with any paraphrase (and in what would such a paraphrase consist?), than it would be to suppose one could, in similar fashion, adequately replace Picasso's *Les Demoiselles d'Avignon* (1907), or any other work, with a detailed, but lengthy description (and in what would such a description consist?). The problem here is not that the content at issue somehow exceeds the capacity for propositional expression,[7] but rather that the works are not identical with, or exhausted by, anything that could be specified in terms of the 'content' of those works. Even the interpretations of the works that might be given as part of a critical engagement with them would not be sufficient fully to characterise that in which those works consist.

The theory of metaphor that I have been employing here is, of course, that of the American philosopher Donald Davidson. Davidson views metaphor as more than mere linguistic ornament and as an important element in

all forms of linguistic expression – it is, he says, the 'dreamwork of language' (1984: 245) – but he denies that metaphor can be understood as operating through some specifiable *content*. Using the distinction between 'what words mean and what they are used to do' Davidson argues that metaphor is a matter of what is done with words, 'it is something brought off by the imaginative employment of words and sentences and depends entirely on the ordinary meanings of those words and hence on the ordinary meanings of the sentences they comprise' (247). Metaphor, he says, 'makes us see one thing as another by making some literal statement that inspires or prompts the insight' (263).

Insofar as Davidson emphasises the nature of metaphor as a kind of 'seeing as' or 'showing', so he makes much of the comparison between metaphors and images, pictures or even maps.[8] I have moved in the other direction: from the picture and the image, and from art in general, to the case of metaphor. While my aim has been to use the comparison in order to understand something about the nature of art, the comparison also reflects back on metaphor itself. Consideration of metaphor in relation to art in general reinforces the account of metaphor suggested by Davidson. Just as the metaphor cannot be identified with the words and sentences in which it is expressed, nor with the meanings of those words or sentences, neither can the artwork be identified simply with the materials out of which it is constructed, nor with the material object or event in which it is embodied. Yet in neither case can the work be understood as consisting in some content, meaning or *idea* over and above what is presented in the words or sentences, or in the paint, canvas, movement, sound or stone. The metaphor has to be understood in terms of what it *does* rather than what it *is* and the same is true of the artwork. Of course, as Davidson acknowledges with respect to metaphor, to say that art involves a sort of showing or revealing is not to say anything especially new, nor, in that simple form, is it to say anything very revealing itself. The real interest is in seeing in what such revealing or showing might consist and the manner in which it is achieved.

In discussing Davidson's account of metaphor, Marcia Cavell writes that 'at its best, a metaphoric use of language is a case of saying something literally false which none the less inspires a revelation' (1986: 495). Davidson himself notes that the majority of metaphors are indeed literally false. But he also notes that there are some metaphors that are literally true ('no man is an island', 'business is business'), and indeed, 'since the negation of a metaphor seems always to be a potential metaphor, there may be as many platitudes among the potential metaphors as there are absurds among the actual' (1984: 258 n.10). Thus it is not the patent truth or falsity of what is said that makes an otherwise ordinary utterance into something metaphorical. Rather it is that 'the ordinary meaning in the context of use is odd enough to prompt us to disregard the question of truth' and instead to understand what is said in terms of a rather different intention on the part

of the speaker than the stating of some fact. We take an utterance as meta-phorical, therefore, because that is the best way to make sense of the speak-er's intention – we take the speaker to be trying to direct our attention in a certain way, to prompt us to a certain way of seeing. What enables meta-phor to work, then, is that there is a tension or conflict between what is liter-ally said and the context in which it is said. We might say that metaphorical utterances are other than they appear. On the one hand, metaphors are, in one sense, literal statements, since metaphors can be constituted by nothing other than such statements. On the other hand, metaphors are not literal statements, since they do not consist in any statement of fact, but rather make use of literal statements to achieve something else. The 'objectivity' of the metaphor is thus a source of tension in the metaphor, and so also that by means of which the metaphor works: the tension between the objectivity of the metaphor that is its literal meaning and the context in which that objectivity is presented or in which it is set is what enables the 'opening up' or disclosedness that characterises the metaphorical use of language.

The Davidsonian emphasis on understanding metaphor in terms of what it does – in terms of its process- or work-orientated character – connects directly with the approach to the artwork, noted briefly above, that is proposed by Maitland (and, in a slightly different way, by Benjamin). In arguing against approaches that treat artworks as 'ideal' entities apart from their material objectivity, Maitland claims that such approaches do not properly address the question of the nature of the artwork. He argues that this is evident once one focuses on the question as to what it is with which we engage when we engage with an artwork – what it is we appreciate when we 'appreciate' an artwork. Maitland's approach here is, one might say, 'phenomenological' in a way that Davidson's is also – both ask us to attend to what actually happens in the experience of art or of metaphor. In the case of the artwork, Maitland claims that the work of art has to be understood as 'more a *doing* than a being or having. When we appreciate a work of art we appreciate its performative presence, what is *at work* in the work' (1975: 192). While different artworks involve different sorts of 'performative pres-ence', while they work in different ways ('A Rauschenberg painting is a different sort of performative presence', says Maitland, 'than a Stella or Van Eyck. Paintings perform differently than music' [192]), all artwork is a working or a doing, and this, writes Maitland, is as much true of a poem as it is of a painting or a piece of music: 'The poet does not simply utter state-ments *about* the world or make his art correspond to or represent reality. The poet's words do something: They make present a world' (192).[9] This, of course, is much the conclusion that Davidson also reaches about the nature of metaphor. Moreover, Maitland's argument to this conclusion, and not only his phenomenologically inclined approach, is very close to the argu-ment Davidson himself deploys – both Maitland and Davidson deny that artworks or metaphors can be understood as merely identical with what I

have termed their objectivity, and yet neither can they be identified with something additional to that objectivity (to this end Maitland distinguishes between the 'is' of constitution and the 'is' of identity – artworks are not identical as artworks with that which constitutes them in the same way that metaphors are not identical as metaphors with the literal statements that make them up). In the case of both Davidson and Maitland, the emphasis is on what Maitland calls the 'performative' – Davidson's is what might be termed a 'performative' theory of metaphor – and Maitland's use of that term can itself be seen as drawing on elements from the philosophy of language, and so from a context in which Davidson's work is immediately situated.[10]

4. While the emphasis on the performative in Maitland's approach can be seen to connect with English-speaking philosophy of language, of which Davidson is one representative (Maitland refers specifically to J.L. Austin [Maitland 1975: 192]), the immediate inspiration for Maitland's focus on the artwork in its character as a work is the famous 1936 essay by Martin Heidegger 'On the Origin of the Work of Art'. In that essay Heidegger begins with the question about the nature of art in a way that already brings to the fore the character of the artwork as a work, and yet also attends to the character of the artwork as a thing. Heidegger's claim, however, is that the being of the artwork as a thing, its being in terms of what I have called here its 'objectivity' (although this is a term that sits somewhat awkwardly in the Heideggerian context),[11] derives from its character as a work:

> The thingly in the work should not be denied out of existence; rather given that it belongs already to the work-being of the work, it must be thought out of that work-being. If this is so, then the path to the deter-mination of the thingly reality of the work runs not from thing to work but from work to thing.
>
> <div align="right">(Heidegger 2002: 18; 1994: 25 [29])[12]</div>

Heidegger's point here is that we cannot understand the artwork through first trying to analyse what it is on the basis purely of its material objectivity (indeed, on the basis of the argument I set out above, what we take to be a specification of the material objectivity of a thing is dependent on how we understand the thing in the first place – on that which we are attentive to in the thing). It is only when we comprehend the artwork's character as a work that we can understand how its material objectivity stands in relation to its character as an artwork.

Heidegger's own account of the artwork is centrally focused on the Classical Greek temple – usually taken to be the second temple of Hera, originally thought to be of Poseidon, at Paestum, itself the subject of a number of works by artists, notably Piranesi and J.M. Cozens (Plate 10).[13]

His account emphasises the way in which the artwork stands in a particular place and in specific relation to that which is configured around it. Thus Heidegger begins his description of the artwork that is the temple by stating that 'A building, a Greek temple, portrays nothing. It simply stands there in the middle of the rocky fissured valley', and in what follows the character of the temple as 'standing there' ('*Er steht einfach da*', '*Dastehend ruht das Bauwerk*', '*Das temple gibt in seinem Dastehend*') is repeated again and again (2002: 20–21; 1994: 27–29 [30–31]). What stands there is the artwork in its material objectivity, and in its standing-there (we may say its 'being-there') the objectivity of the work establishes itself in relation to that which also takes a stand around and in relation to it. The temple-work is not the instantiation of something ideal, nor is it a type or a token-of-a-type – it is a singular thing that stands in its singular located-ness. Heidegger claims that the artwork that is the temple, in language echoed by Maitland, 'opens up a world', and it does so through freeing up a 'space' in which 'all things gain their lingering and hastening, their distance and proximity, their breadth and their limits' (2002: 23; 1994: 30–31 [34–35]).

Two elements play a role in this 'spacing' or 'opening-up': earth and world. In their most basic form (the terms have a number of dimensions to them),[14] world refers to that which the artwork opens up as the realm of relatedness in which things appear, while earth refers to the material objectivity of the artwork into which the work is set – what we might think of as its very 'standing-there' (Heidegger 2002: 24; 1994: 31–32 [35–36]). As world is essentially disclosure, so too is earth (as might be indicated by the impenetrability associated with the material and the particular) essen-tially concealing. Heidegger understands the way the artwork works as consisting in the opposition between these two elements:

> World and earth are essentially different and yet never separated from one another. World is grounded on earth, and earth rises up through world. But the relation between world and earth never atrophies into the empty unity of opposites unconcerned with one another. In its resting upon earth the world strives to surmount it. As the self-opening it will tolerate nothing closed. As the sheltering and concealing, however, earth tends always to draw the world into itself and to keep it there.
>
> (2002: 26; 1994: 35 [37])

Although Heidegger describes the opposition between world and earth as 'strife' (*Streit*) (2002: 25; 1994: 35 [37]), he also emphasises that it is not discordant or destructive, but rather an opposition in which the two elements come into their own.

It is in and through the artwork that world and earth are brought into

productive opposition. Moreover, as I have characterised matters here, the opposition between world and earth is an opposition in which the material objectivity of the artwork plays a central role. The opposition in question is indeed one that occurs, in part, between the material objectivity of the work, and that which is opened up in relation to that material objectivity, which includes the material objectivity of the work itself (in the same way, earth appears as earth in the opening up of world), but which also includes its character as art. In a brief discussion of his own focus on the work character of art, Andrew Benjamin writes:

> The term 'work' opens up in two inter-related directions. On the one hand it announces the presence of the object – the object of interpretation or the object of criticism. The object is the work. Equally, however, there is the work's activity. Its self-effectuation as an object. 'Work' both as a named presence and as a conceptual motif dominates Heidegger's approach to art ... work has an active ... disclosing ... role ... The limit of Heidegger's approach, however, is that disclosure always opens more than the work. In so doing the work has to open up beyond itself. As such the actual materiality of the work comes to be effaced in terms of what it shows.
>
> (2004: 36, n.3)[15]

There are two points I would take from Benjamin's comments here. The first, and perhaps most important, is the way the distinction he makes between the work as referring to the presence of the object (its material objectivity) and to the work's activity – which Benjamin terms its '"self-effectuation" as an object'. We might think of this as a distinction between the *being* of the work 'as object' and its *coming-to-be* 'as object'. The distinction is one that Benjamin explicitly takes as moving towards an essential indeterminacy that belongs to the artwork – while the artwork is a material object, its materiality cannot be assumed, but is instead placed in question through the working of the work as art – its working is its appearing or coming-to-be and this is never complete, never 'finished'. The second point concerns Benjamin's claim that Heidegger's account leads towards the self-effacement of the objectivity of the artwork (this is specifically inasmuch as the artwork is understood as always opening itself up in a way that goes beyond the work itself – in the terms echoed by Maitland, the artwork opens up a world, and that world is more than just the artwork).

These two points are connected, since the tendency towards the self-effacement of the objectivity of the work is itself connected with the character of the work as objective and as active or disclosive. What is suggested here is, in fact, a tension or opposition within the character of the work that is identical to that which appears, at least in part, in Heidegger's emphasis on the strife that the artwork sets up between world

and earth. But in that case, we ought to view the tendency towards the effacement of the objectivity of the work as something that is not peculiar to Heidegger's account (although there may still be elements in that account that are idiosyncratic to it), but rather part of the way in which the artwork itself works. Indeed, one may argue that such self-effacement is possible because of the essential indeterminacy that belongs to the artwork and that arises out of its character as both being and coming-to-be. If the artwork is disclosive, then independently of whether it discloses anything beyond itself, what it must also disclose is its own twofold character as both object and work. This is certainly true of the artwork in Heidegger's account, in which the material objectivity of the artwork, its character as earth, is itself disclosed in the opening up of world. Indeed, the very resistance of earth itself to such opening up (the tendency of earth to concealment) is only evident in that disclosedness. Yet the opening up of world, since it also involves a certain transcendence of the material objectivity of the work through which such opening up is realised, also tends inevitably towards an effacing of that objectivity. Thus the disclosedness that occurs in the artwork tends to be understood as moving one away from the material objectivity of the work, and so also away from the work in its disclosive. However much some such effacement of objectivity may occur in Heidegger, the latter shift seems most evident in the common tendency to view artworks as actually constituted by some meaning, content or idea that the artwork is intended to disclose or else to embody or express.

5. The key idea in Heidegger's account of the nature of the artwork, and in Benjamin's, regardless of the difference that may also obtain, is the idea that the artwork contains or gives rise to a certain tension between the objectivity of the work and its active or disclosive character. But how does this tension arise? It should already be evident that the Davidsonian account of metaphor, in spite of enormous differences in style and vocabulary, exhibits close affinities with the account of the artwork found in Heidegger. On the Davidsonian account, metaphor also exhibits a tension between two elements, the literal meaning of what is said and the context of the saying. The literal meaning of what is said corresponds to the material objectivity of the metaphor – certainly there is nothing else immediately given in the metaphorical use of language other than the words themselves and the literal meaning that they bear – but what is said is set in a context with which those words, and their saying, appears in tension, with which it appears inconsistent. The context itself, of course, must already be opened up by the use of language in the first instance – the context appears as one in which something is indeed said, in which something is, in fact, asserted. So the objectivity of the metaphor – a certain utterance that carries a meaning in virtue of the words themselves– opens up the context with which the

objectivity of the metaphor is also in tension. That tension provokes a further opening up that is, one might say, a revisioning of the original utterance in its context, a revisioning that displaces the original linguistic act and our understanding of that act, so that a new space of possibilities is opened up, but opened up in a way nevertheless attuned to the original words and their meaning. A similar dynamic surely operates in the case of the artwork (although the opening up need not require an actual inconsistency as its means of realisation). It seems, in fact, that we should distinguish between two moments in the disclosedness that belongs to world, and that is opened up through earth. The setting of the artwork in its locatedness, its standing forth in its material objectivity, already places the artwork in relation to a context, already brings it into a certain minimal relatedness with that which surrounds it (and that relatedness may, of course, change as the manner of the setting of the artwork into place may change).[16] Yet while the artwork already stands in relation to that context, it also retains its own material objectivity in a way that, in various respects, conflicts with that context. The temple thus does not simply lose itself in the rocky plain in which it is set, but stands out on the plain, already stands in a certain way that is counter to it.[17] We might say that the strife between world and earth thus already occurs in the incipient emergence of the artwork as art, at the very point at which it is first set into and so stands out against its world. It is thus not simply the tension between the objectivity of the artwork and its disclosive character as a work that is operative in the artwork, but a tension within the objectivity of the work itself. The objectivity of the work both closes off, that is, remains resistant to any disclosure (in the same way as the metaphor, in its literality, seems to refuse our understanding through its very inconsistency with the context in which it presents itself), but it also opens up. The latter occurs through the very way in which the artwork, in its objectivity, places itself within a setting, so that both its own objectivity and the setting of that objectivity become evident, and so that the work in its setting are together opened up as a new space of possibilities. It is this new space of possibilities, open, yet also constrained, that then opens out into what Heidegger calls 'world'. In its open-ness and its concomitant constraint the establishing of that space of possibilities is also the establishing of a certain *topos* – a place.[18]

On this account, it is in and through the material objectivity of the artwork that the disclosedness of the artwork occurs. Since this disclosedness, whatever else it might be, is itself a disclosedness *of the artwork*, so it is also a form of self-disclosure. Moreover, inasmuch as the self-disclosure of the artwork works through the way in which the artwork, like the metaphor, resists and at the same invokes its own setting, so the self-disclosure of the artwork is both a disclosure of the work in its material objectivity, and yet also a disclosure that goes beyond that material objectivity. In summary form, we may say that the manner in which the artwork works is through

the self-disclosedness of the material objectivity of the work, a self-disclosedness in which that material objectivity constantly transcends itself. This self-transcendence does not mean that the artwork transcends itself in the direction of something other than itself, instead it transcends itself in the direction of the possibilities that the artwork itself enables and that belong to it. This is what the metaphor also does – the possibilities it opens up are not transcendent of the metaphor inasmuch as they depend upon the words used, and may even be said to direct us back to those words.

Since the disclosedness that is essential to the artwork is only possible in and through the material objectivity of the work, so in any engagement with the work all that there is to be attended to is given in the objectivity of the work as such. For this reason, one might say to engage with an artwork as an artwork is always to engage phenomenologically – it is to allow oneself to be drawn into the working of the work as it works out in and through the work's objective character – while similarly every artwork can also be said to constitute a form of phenomenology in its very working as an artwork. Yet as we have already seen, what counts as that in which the objectivity of the work consists is itself indeterminate – and this is also, of course, true of metaphor. This means that the phenomenological process of self-disclosure that occurs in the artwork can never be conceived as operating at any one level or in terms of just one set of elements. Indeed, the material objectivity of the work, that in and by means of which it first and most immediately presents itself, is never just a matter of any one mode of presentation or, indeed, of any one medium. The painting presents itself as paint on canvas, as an array of light and surface, *as a certain history*. Indeed, it is important to note that the material objectivity of the work may indeed be construed, so long as it is not separated from the other modes of its presentation, as including the way in which the artwork already presents itself within a tradition, a history, a culture. Robert Rauschenberg claims that 'All material has history. All material has its own history built into it' (Rose 1987: 58), and even material may present itself in terms of its history. This occurs most obviously in the case of metaphor since the very appearance of certain sounds as having a particular meaning, to say nothing of their appearing as words, is already for those sounds to embody a historicality, a conventionality and an intentionality.[19]

The focus on the material objectivity of an artwork does not mean, then, that the character of the work as something *made*, and so as standing within a human frame of significance, is rendered irrelevant. But the human significance of the work, its significance as an artwork, has to be grounded in the material objectivity of the work – there can be no appeal to anything that is extraneous to that objectivity. The historicality, conventionality *and* intentionality of the work can only be given in the work's material objectivity – in what appears in the artwork. This automatically rules out certain approaches to artworks as constituting real engagements with those works

in their character as works – for instance, I would argue that certain so-called 'metaphorical' readings of artworks in which the viewer looks to find in the artwork a metaphor for an aspect of the viewer's life or experience often import into the work something that may not properly belong to it. Our personal reactions to works are not always to be construed as part of the work itself, and there must always be a question as to whether some reaction is a function of the artwork, or is rather a matter of our own construction of the work in a particular and perhaps idiosyncratic way that is only incidentally connected with the work as such. This applies no less to the artist than to the viewer in the sense that the intentions of the artist are relevant to the artwork just inasmuch as they are expressed in and evident through the artwork itself. What an artist may tell us about the work apart from the work – for instance, the artist's own *post facto* explanations of the work – have no privileged status in determining the character of the work. Once the work has been set into its own space, it is the work itself that is authoritative, in its objectivity, and nothing else. Since the artwork works only through its objectivity, so the artwork exhibits an autonomy that resides in its objectivity.

The autonomy of the artwork is nicely demonstrated in relation to one of Rauschenberg's works (Plate 11). In 1955, Rauschenberg took a quilt, a pillow and part of a sheet, and fixing them to a stretcher, proceeded to apply paint of various colours to the cloth surfaces. The resulting work, titled *Bed*, has been described by Rauschenberg as 'one of the friendliest pictures I've ever painted. My fear has always been that someone would want to crawl into it' (Tomkins 1981: 137). Most viewers of the work saw it very differently, however, with the almost universal tendency being to see it as a bed in which some horrible crime had been committed – the bed was thus taken as an image of violence and murder. Does Rauschenberg's rejection of the violent reading of *Bed* count against that reading? – Only to the extent that it can be grounded in the objectivity of the work itself, and not merely because the rejection is Rauschenberg's.[20] Significantly, the point at issue here is exactly analogous to one found in Davidson concerning a more general autonomy of linguistic meaning. While the meaning of an utterance is dependent, according to Davidson, on the speaker's intentions in the act of utterance, speakers have no authority over the meanings of their utterances beyond that original act of saying. Meaning is given in what is said, in the words as uttered in a specific situation, not in some additional act of meaning or intending (2001a: 3–14, esp. 10–14). This does not make the intention of the speaker irrelevant to meaning, but it does mean that we have to be clear as to exactly what intention is relevant – it can only be the intention of the speaker as expressed in the utterance itself. Similarly, while the intention of the artist in the work is a key consideration in the interpretation of the artwork, it can be construed as determinative only as it is expressed in the artwork itself. There is thus no special significance that can

be accorded to an artist's reading of his or her own work as that is given independently of the work.[21]

This point also has relevance to the dispute over Heidegger's reading, in 'The Origin of the Work of Art', of one of Van Gogh's still-life paintings of a pair of shoes (since Van Gogh painted a number of works that appear to fit the description Heidegger offers [see Plate 6], it is unclear which painting Heidegger had in mind – or whether he had a specific picture in mind at all) (2002: 13–15; 1994 18–21 [22–24]). Meyer Schapiro claimed that Heidegger simply got the painting wrong since he treated the shoes depicted as belonging to a peasant woman whereas the shoes actually belonged to Van Gogh himself (Schapiro 1994b: 135–42; 1994a: 143–51).[22] Part of the problem in adjudicating in this dispute is that it is not at all obvious that the identity of the actual shoes that figured as the models for the shoes depicted is relevant to the reading of the work. While one may argue that the identity of the shoes forms part of the context in which the artwork sits, this is by no means self-evident. In fact, one might say that the essential point that is in dispute between Schapiro and Heidegger is exactly how the objectivity of the Van Gogh painting should be construed. What is in question is not, contrary to appearances, the actual history of the objects depicted (as if, *contra* Schapiro, the matter could be resolved by the methods of historical inquiry), but rather the history of the artwork in which those objects figure. Inasmuch as Schapiro views the matter as indeed a matter of the history of the depicted objects, then to that extent one might argue that Schapiro fails to address the artwork itself (in which case one might argue that the dispute actually serves, not to discredit Heidegger, so much as to demonstrate the limitations in Schapiro's own 'empiricist' approach to art history). On the other hand, inasmuch as one may take the dispute here to originate in the irresolvable indeterminacy that attaches to the objectivity of the work, so the dispute may be taken as a simple illustration of the way in which the objectivity of the work will always support multiple readings.

6. The relation between the objectivity of an artwork, that is, its material being *as an object*, and its nature *as an artwork*, is not a relation between two different things – there is only the artwork, and the artwork is given *in* its material objectivity. This means that talk of the objectivity of the work as the medium or mode of presentation of the work – of the sort to which I alluded at the start of this discussion – is limited, though not inappropriate, since the objectivity of the artwork is not separable from the artwork in the way in which it may be assumed a medium or mode of presentation is separable (and which allows talk of the same thing being given in more than one medium or mode of presentation). The material objectivity of the artwork is the 'medium' for the work in that it is that in which the working of the artwork – its self-articulation, its self-disclosure, its self-transcendence – occurs, but what occurs is also the working of that very objectivity and

nothing else. The understanding of the material objectivity of the artwork is itself transformed here. The material objectivity of the artwork is not its 'stuff', not merely some inert 'material', but is its own dynamic self-disclosure as that which occurs in a singular, placed occurrence. In this sense, the artwork is identical with its objectivity, but with its objectivity as this self-disclosing, self-transcending occurrence. Yet as the objectivity of the artwork is its own self-disclosing, so one might also say that the artwork is never simply identical with itself, and so never simply identical with its objectivity either, since it is always in the process of self-disclosure, always in the process of its own self-transcendence.

It is the tension that is evident here that is the underlying source of the dynamism that is essential to the way the artwork is art, and so to what Benjamin refers to as the artwork's own self-articulation as object, to its own 'becoming-object', its own coming to objective presence. Especially significant given the Heideggerian reading of the artwork, however, is the fact that the artwork never comes to an objective presence that is not also unfolding towards such presence. *The artwork is thus a constant self-presencing.* This is what I take properly to lie behind Maitland's rejection of the idea that the artwork can be understood as an object. Benjamin argues that the artwork need not disclose anything other than itself and this I take also to point towards the character of the artwork as self-presencing or self-disclosing. Yet precisely in this, the artwork also discloses something that is of ontological significance, independently of the artwork itself, for it discloses something of the nature of objectivity as such. While it is displayed in a particularly significant and self-evident way in the artwork, the self-presenting that occurs in and through objectivity is characteristic of objectivity as such. To grasp the nature of objectivity is also to grasp the way in which it is never simply given in any final and immediate presence. Objectivity, and perhaps we should also say, materiality, is itself a constant unfolding and opening up of itself.[23] One of the achievements of art is the disclosing of such self-disclosedness as it occurs in its material objectivity, and this achievement is one that is itself essentially phenomenological in character, but since such disclosing of self-disclosedness is also that on which the artwork depends for its being as art, so what is disclosed is also the phenomenological underpinning of the artwork.

Notes

1 'Objectivity' is being used here in a deliberately idiosyncratic fashion that is not intended to imply any notion of factual correctness, and is 'ontological' rather than 'epistemological' in its orientation. 'Objectivity' refers to the way in which an object is an object – to its being (or becoming) as object – in a way that is intended to direct attention away from a concern with identity or individuation conditions and on to the question of the object in its active or process-character.
2 The role of the 'text' here is significant, since the more the work is constituted by

its performative element, the more it may be thought to be constituted by its particular material realisation – for example, in some improvisational musical or poetic works.

3 As I note below, this general line of argument is also taken up by, among others, Richard Wollheim (1968).

4 See, for instance, R.G. Collingwood (1938).

5 See also Benjamin 1994.

6 What characterises Benjamin's work is a very close engagement with individual artists and works that operates within a particular theoretical frame, and yet refuses the tendency to approach the works in a way that would reduce those works to mere exemplifications of the general theoretical approach that is at issue. The attention is thus given to the works as such rather than as they indicate or show something else (although this does not mean that Benjamin rejects any larger theoretical engagement, only that he sees that engagement as necessarily worked out in close relation to the engagement with the works themselves). This is a point on which Benjamin himself draws a distinction, which is also a point of disagreement between his approach and that of Heidegger (see Benjamin 2004: 36, n.3).

7 I would argue, in fact, that content is always capable of propositional specification (which is not to say that all content is grasped in propositional terms), and would reject accounts that attempt to analyse the situation at issue here in terms of any notion of non-proposition or non-conceptual content – although such accounts need not be incompatible with my overall argument. On the issue of non-propositional or non-conceptual content more generally, see my comments in 'On Not Giving Up the World: Davidson on the Grounds of Belief' (Malpas 2008); a longer discussion of the issue is contained in my 'Acção, Intencionalidade e Conteúdo' (Malpas 2005: 345–358).

8 See especially Davidson 1984: 263.

9 Maitland's position, along with my own as set out here, may be seen as having some affinities with that of Arthur Danto (1981), in that both place an emphasis, although in different ways, on the event- or process-character of art. The key point in my argument is that this event- or process-character has to be seen as itself occurring in and through the objectivity of the work, rather than being somehow apart from it.

10 The emphasis on the performative aspect of language is central to the work of speech act theorists such as J.L. Austin and John Searle. Davidson is most definitely not a speech act theorist, but he is certainly attentive to the performative aspects of language. Maitland's own 'performative' conception of the artwork should not be confused with the 'performative' approach that Michael Fried identifies as central to 'minimalist' or 'literalist' approaches in contemporary art exemplified in the work of such as Donald Judd or Robert Morris, and which Fried also criticises – see Fried 1998: 148–72. It should be noted that the way Fried talks in this essay, especially towards its end, about ideas of objectivity and presence stand somewhat apart from my own discussion of those ideas here.

11 It should not, for instance, be construed (though it may be easy to do so) in terms of the 'object' that stands always 'against' a subject – see Heidegger's comments in the 'Appendix' to Heidegger 2002: 53; Heidegger 1994: 70–71.

12 The page reference in square brackets refers to the original 1950 edition.

13 The work reproduced here is by J.M. Cozens, *The Two Great Temples at Paestum* (watercolour, ca. 1783, Victoria and Albert Museum, London), and shows the two Paestum temples as desolate ruins with three figures apparently fleeing before them. Piranesi's drawings of Paestum, almost gothic in character, also focus on the temples' ruinous condition. It is, indeed, its quality as a ruin, and so

as evoking not merely a picturesque beauty, but also mortality and monumental decline (presented with especially dramatic power in Cozen's work) that makes the temple such a point of focus for these eighteenth-century interpretations. In contrast, Heidegger's account depends on envisioning the temple in its original state as a functioning centre of civic and religious life. Although Heidegger is often taken to have the Paestum temple in mind, Babette Babich discusses Heidegger's essay using the temple of Apollo at Bassae as her example (see Babich 2003). Vassilis Ganiatsas of the School of Architecture at the National Polytechnic University in Athens has suggested to me that there are a number of reasons for thinking that, if Heidegger does have a specific temple in mind, it is Bassae rather than Paestum: the Bassae temple stands alone; it is a much more significant and unusual temple than that at Paestum; and Heidegger himself visited Bassae a number of times during his visits to Greece in the 1960s (which suggests that he had a special interest in the place).

14 They relate directly, for instance, to the Apollonian and Dionysian elements in art distinguished by Nietzsche – see the discussion of this in Young 2001: 40.

15 Benjamin goes on to say that, for this reason, specific works are, in Heidegger, 'located in what could be described as a logic of exemplarity. It is not surprising in this regard then, when Heidegger introduces Van Gogh's painting, he does so with the preparatory words; "we take as an example").'

16 Thus an artwork that is thought to be well understood may take on a new character when set alongside other works or into a new locale. The actualisation of such new modes of understanding – the lighting up of works in new ways – is a major concern of curatorial practice (or, at least, it ought to be). The fact that a work may appear different when placed in contiguity with other works or surroundings should not, it must be emphasised, detract from the centrality of the objectivity of the work in its being as a work – when a work is seen differently then the difference seen must be a difference evident in the work itself, even though it may be a difference that was not previously evident. As Jonathan Holmes has pointed out to me, a striking example of the way in which the character of a work may change significantly according to its setting is provided by Courbet's *The Painter's Studio, Real Allegory Determining a Phase of Seven Years in My Artistic Life* (1854–55). When this work was moved from the Louvre to the newly opened Musée d'Orsay in 1986, the perception of the painting changed considerably. Whereas it had appeared in the Louvre as an endpoint in the great clash between Classicism, Romanticism and Realism, when placed among the impressionist works brought from the Jeu de Paume, it seemed (along with the *Burial at Ornans*) instead to be the first great and emphatic statement of early modernism opening up the world to Impressionism and Symbolism.

17 See Vincent Scully's account of the way the Greek temple can be seen to contradict the landscape in which it is set (Scully 1962: 2–3).

18 On the role of place in Heidegger's thinking, see my *Heidegger's Topology: Being, Place, World* (Malpas 2006: 10–13).

19 There is an interesting parallel here with Davidson's account of the basis of intentionality – Davidson argues that a difference in causal histories between two speakers can make for a difference, not only in the content, but in the very intentional character of their behaviour. See Davidson 2001b: 15–38, esp. 32–33.

20 See the discussion of *Bed* in Leggio 1992: 79–117.

21 As Janet Wolff writes from a somewhat different perspective:

> The author as fixed, uniform and unconstituted creative source has indeed died. The concept of authorial dominance in the text has also been thrown open to question. But the author, now understood as constituted in language,

ideology and social relations, retains a central relevance, both in relation to the meaning of the text (the author being the first person to fix meaning, which will of course subsequently be subject to re-definition and fixing by future readers), and in the context of the sociological understanding of literature.

(1981: 136)

22 Interestingly, the real issue that it seems to me Schapiro unintentionally raises here concerns the nature of still life as such, and the way in which the still life often involves the depiction of objects that have a dual significance both as the objects or things that they are and as things that are owned by, and so stand in a certain relation of intimacy with, the artist (even if the relation of intimacy consists purely in the objects' use as still life models). I have in mind here not only Van Gogh's shoes, but also, for instance, the skulls that appear in some of Cezanne's works, and that were part of the collection of objects to be found in his studio.

23 One might construe this as an alternative way of putting the essential Heideggerian point concerning being: being is being-present, but it is not merely that; more adequately thought, being is the constant coming to presence of the present (and here 'present' encompasses both a sense of the temporal present as well as spatial 'presentness'). See Malpas 2006: 10–13.

References

Babich, B. (2003) 'From Van Gogh's Museum to the Temple at Bassae: Heidegger's Truth of Art and Schapiro's Art History', *Culture, Theory & Critique* 44: 151–69.

Benjamin, A. (1994) *Object Painting: Philosophical Essays*, London: Academy Group.

—— (2004) *Disclosing Spaces: On Painting*, Manchester: Clinamen Press.

Cavell, M. (1986) 'Metaphor, Dreamwork and Irrationality', in E. LePore (ed.) *Truth and Interpretation: Perspectives on the Philosophy of Donald Davidson*, Oxford: Basil Blackwell.

Collingwood, R.G. (1938) *The Principles of Art*, Oxford: Clarendon Press.

Danto, A. (1981) *The Transfiguration of the Commonplace*, Cambridge, MA: Harvard University Press.

Davidson, D. (1984) 'What Metaphors Mean', in *Inquiries into Truth and Interpretation*, Oxford: Clarendon Press.

—— (2001a) 'First Person Authority', in *Subjective, Intersubjective, Objective*, Oxford: Clarendon Press.

—— (2001b) 'Knowing One's Own Mind', in *Subjective, Intersubjective, Objective*, Oxford: Clarendon Press.

Fried, M. (1998) 'Art and Objecthood', in *Art and Objecthood: Essays and Reviews*, Chicago: University of Chicago Press.

Heidegger, M. (1994) 'Der Ursprung des Kunstwerkes', in *Holzwege*, Frankfurt-am-Main: Klostermann.

—— (2002) 'The Origin of the Work of Art', in J. Young and K. Haynes (trans. and eds.) *Off the Beaten Track*, Cambridge: Cambridge University Press.

Leggio, J. (1992) 'Robert Rauschenberg's Bed and the Symbolism of the Body', in J. Elderfield (ed.) *Essays on Assemblage, Studies in Modern Art 2*, New York: Museum of Modern Art.

Maitland, J. (1975) 'Identity, Ontoloogy and the Works of Art', *Southwestern Journal of Philosophy* 6: 181–96.

Malpas, J. (2005) 'Accão, Intencionalidade e Conteúdo [Action, Intentionality, and Content]', J. Sàágua (ed.) *A Explicacão da Interpretação Humana*, Lisbon: Edições Colibri.

—— (2006) *Heidegger's Topology: Being, Place, World*, Cambridge, MA: MIT Press.

—— (2008) 'On Not Giving Up the World: Davidson on the Grounds of Belief', *International Journal of Philosophical Studies* 16, no. 2: 201–15.

Rose, B. (1987) 'An Interview with Robert Rauschenberg', in *Rauschenberg*, Vintage Contemporary Masters Series, New York: Random House.

Schapiro, M. (1994a) 'Further Notes on Heidegger and Van Gogh', in *Theory and Philosophy of Art: Style, Artist and Society*, New York: Braziller.

—— (1994b) 'The Still Life as Personal Object – A Note on Heidegger and van Gogh', in *Theory and Philosophy of Art: Style, Artist and Society*, New York: Braziller.

Scully, V. (1962) *The Earth, the Temple and the Gods: Greek Sacred Architecture*, New Haven, CT: Yale University Press.

Strawson, P. (1959) *Individuals*, London: Methuen.

Tomkins, C. (1981) *Off the Wall: Robert Rauschenberg and the Art World of Our Time*, New York: Penguin.

Wolff, J. (1981) *The Social Production of Art*, London: Macmillan.

Wollheim, R. (1968) *Art and its Objects*, New York: Cambridge University Press.

Young, J. (2001) *Heidegger's Philosophy of Art*, Cambridge: Cambridge University Press.

4

HORIZON, OSCILLATION, BOUNDARIES

A philosophical account of
Mark Rothko's art

Violetta L. Waibel; translated by Joseph D. Parry

Mark Rothko has become one of the most important artists of Abstract Expressionism in twentieth-century American art. Scholarship on his work is, accordingly, voluminous. One might expect that a philosophical approach, like this particular attempt, would speak to the beauty and sublimity of this work, especially after Barnett Newman's (Rothko's colleague) 1948 programmatic "The Sublime Is Now." In that article Newman distances himself from European art, which he saw as the continuation of the ancient Greek conception of beauty. Barnett himself turned aside from European panel painting, and with his large-scale wall paintings—that were meant to be viewed from the closest distance possible—he sought to produce in the viewer an unmediated experience with the sublime. With Rothko it is even more appropriate to interpret his paintings in connection with the concept of the sublime, designed as they are for the most part on a similarly large scale. In fact, this kind of work is now being done in Rothko scholarship.[1]

I will take a critical position on the aesthetic questions concerning the beautiful and the sublime in Rothko's works only at the end of my investigation here. First, I wish to set up some antinomic structures that are reconciled in Rothko's work in a specific way, but also whose interdependent demarcations and transgressions I wish to examine:

1 With respect to the classical paintings Rothko began to produce in the late 1940s, much has been said concerning their fields of color that the viewer assimilates from, as it were, actual-reality into art-reality. I want to explore how through these fields of reality a dialogic game with the boundaries and crossings of these modalities of the real and the ideal is kept in motion.

2 But Rothko seeks in his works to engage his viewer in yet another dialogue. In his 1947 article, "The Romantics Were Prompted," he describes what we today consider his pre-classical paintings as dramas of abstract figures that nevertheless renounce in different ways than Greek tragedy does their claim to be instances of mediating the transcendent; they call forth, if you will, the transcendent in immanence in other ways. It is the unanimous opinion of his interpreters that tragedy is preserved as a fundamental category in his classical paintings inasmuch as they are experienced as the realms of the sacred not only in the formal fields of the *Seagram Murals* (most of which can be seen in London in the Tate Modern Gallery); in the *Harvard Murals*; in the paintings in the *Phillips Collection* or the *Houston Chapel*; and also in a number of single wall paintings that, despite their two-dimensionality, strike the viewer as fields of color. Rothko remarked in the late 1950s that for his entire life he had painted Greek temples.[2] He understood his paintings as organisms and imputed to them their own will and passion for self-assertion. One's experience of paralysis and isolation in the modern world is transformed and dissolved through the living breath of his artworks. The boundaries and crossings of the realms of the real and of art, of artistic intention and the viewer in dialogue with the artwork, of immanence and transcendence as the expression of the tragic in human existence, and of the rigidity and liveliness of the organic, are what I wish to explore as a way of introducing Johann Gottlieb Fichte's theory of the "*schweben*" (oscillation, hovering, floating, suspension)[3] of the imagination between the finite and the infinite, as he coined the term in his early *Wissenschaftslehre*.[4] The structure of Fichte's working model seems to be especially well suited to a consideration of Rothko's art from a phenomenological perspective. Indeed, from a phenomenological perspective, and with an assist from Hölderlin, I will conclude this chapter by offering briefly and only suggestively Fichte's working model as an alternative to Kant's aesthetic judgment of the beautiful (the play of imagination and understanding), as well as the sublime (the play of imagination and reason).

Fichte's theory of the suspension of the imagination as an interpretational model

Only the root principles of a full-fledged theory of the aesthetic have come down to us from Fichte; despite the fact that it was truly a preoccupation of his to record them, he never carried out his plan to do so systematically (see Waibel 2000: 297–317). The working out of his theory of the imagination in his early *Wissenschaftslehre* nevertheless offers a promising model for interpreting artworks. The most important point of departure for this promise is

found in the fact that the very basis of the entire *Wissenschaftslehre* is that the imagination is the faculty that brings and holds together in "oscillation" the mutually opposed and exclusive spheres of the subjective and the objective, the "I" and the world (according to Fichte, the "Not-I"), the intuition and the observed:

> Die Einbildungskraft ist ein Vermögen, das zwischen Bestimmung, und Nicht-Bestimmung, zwischen Endlichem, und Unendlichem in der Mitte schwebt; ... Dieses Schweben der Einbildungskraft zwischen unvereinbaren, dieser Widerstreit derselben mit sich selbst.
>
> (Fichte 1969: 360)

> [The imagination is the faculty that oscillates in the middle between that which is determinate and that which is indeterminate, between that which is temporal and that which is eternal. ... This oscillation of the imagination between that which is not able to be integrated, this conflict of the same with itself.][5]

Fichte's statement here is a grounding determination of the concept of intuition that allows us to set forth a theory of aesthetic intuition. And as I will show, this phenomenon is particularly well suited for an interpretive approach to modernity, which, as is well known, saw itself as the prescribed medicine for the stranger, the alienated, and the disconcerted.

In order to make explicit how this foundation of all knowledge, the intuition, comes into consciousness through the imagination, Fichte felt impelled to bring the philosophical roots of the ideal and the real into opposition to each other. The specific point of mediation between them is achieved in critical idealism. Always paired, realism and idealism offer rationally grounded explanatory models for how knowledge is established in the intuition, though these models are often formed with theoretical biases—a problem which Fichte sought to avoid. From the perspective of the ideal, the thinking subject controls the act of intuiting something. Consequently, Fichte conceptualizes his account of the intuition in terms of the relation of substances to their opposites, accidents. In its freedom and spontaneity the "I" is a substance in relation to its accidents—that is, its particular representations, intuited objects—each of which is a concrete act of thought. From the perspective of the real, this theory regarding the subject and its acts of representation is then broadened by Fichte to affix to the subject its concrete, intuited objects. In this way the subject comes to stand in a causal relationship with the object: the object produces the conditions that enable the intuition to be a cause of an effect in the subject. Both of these optional ways of accounting for how representation occurs by means of the intuitive faculty—that, on the one hand, are always already an interpretive thought and, on the other hand, stem from perceptions that are

produced by the emotions—support a constructive framework for the process of thought and become increasingly distinguished from each other at a conceptual level.

The process for the self-construction of the imagination takes its beginning from the fundamental linkage of the I and the Not-I, of consciousness and being, which for Fichte is outside of or transcends consciousness. Fichte's methodological calculus is performed by analyzing the original antinomy of both parameters as a conceptual contradiction, and one which, therefore, can be abolished by means of a suitable mode of differentiating the parameters. He engineers this dialectical play of contradiction and *aufhebung* (sublation, resolution) that swings between the realistic supposition of cause and the idealistic supposition of substantiality into becoming the complex structure that is the imagination, perpetually carrying on its work contained, configured, and, if you will, suspended in oscillation.

The philosophical problem that Fichte tries to come to terms with here is the question of how the essential otherness of the actions of representation, which are immanent within consciousness, and the givenness of objects which exist outside of consciousness—or, one might say, that transcend consciousness—might nevertheless be brought into functioning as an ensemble in the workings of the intuition. Of course, this assumes that the mind performs intuitions, and that the beheld objects are not identical with consciousness. Said another way, the question becomes how the simultaneous existence of immanence and transcendence in consciousness is made possible by the intuition. I do not have time here to rehearse all of the individual steps Fichte takes in his reconstruction. I might mention, however, that in order to come to terms with the question concerning the form and matter of substance and causal relations, the activity of consciousness (spontaneity) and the activity of the object ("check"),[6] one must begin by defining and then proceeding with a step-by-step investigation of how to delineate the boundaries and how to determine what constitutes a transgression (crossing over the boundaries) with respect to the qualitative difference between the "*Momenten*" (moments, elements) of consciousness and those of being. These boundaries place before us a "*Zusammentreffen*," an encounter, a concurrence of the contrasts that are qualitatively unrelated and estranged to each other, and this encounter/concurrence both happens to the imagination, and is also allowed to happen by the imagination. The border crossings (or in its more literal sense, transgressions) are conceived by Fichte as a "*Zusammenfassen*" (to unite, integrate), which ultimately is performed by the imaginative faculty that is active within his paradigm of consciousness. In this way a representation can be created in the intuition and, at the same time, a consciousness-transcending object can be deposited outside of consciousness.

Realistically seen, the imagination produces a unity of subject and object that, viewed from the idealist perspective immanent within consciousness,

changes itself into a unity of the subjective and the objective. Consciousness—which is, again, outside of being—is, on the one hand, determinable by being, and on the other hand, it is essential to consciousness to grasp and determine the activity of consciousness through concepts. In this way Fichte comes to the thesis that the imagination is essentially an activity of consciousness that finds itself in eternal oscillation in an exchange between determinability and determination:

> Dieser Wechsel des Ich in und mit sich selbst, da es sich endlich, und unendlich zugleich sezt—ein Wechsel, der gleichsam in einem Widerstreite mit sich selbst besteht, und dadurch sich selbst reproduciert, indem das Ich unvereinbares vereinigen will, jezt das unendliche in die Form des endlichen aufzunehmen versucht, jezt, zurükgetrieben, es wieder ausser derselben sezt, und in dem nemlichen Momente abermals es in die Form der Endlichkeit aufzunehmen versucht—ist das Vermögen der *Einbildungskraft*. Hierdurch wird nun völlig vereinigt Zusammentreffen, und Zusammenfassen. Das Zusammentreffen, oder die Grenze ist selbst ein Product des Auffassenden im, und zum Auffassen.

<div align="right">(Fichte 1969: 359)</div>

> [This exchange of the I in and with itself, because it finally and forever sets itself in simultaneity—an exchange that similarly stands in conflict with itself, and thereby reproduces itself in that the I that wishes to reconcile the irreconcilable,[7] now attempting to take the eternal upon itself in the form of the temporal, now repulsed, sets itself again outside of itself, and in this adversarial moment again tries to take the form of the temporal upon itself—is the faculty of the imagination. Through this process *Zusammentreffen* and *Zusammenfassen* are fully united. The *Zusammentreffen*, or the boundary, is itself a product of that which is comprehended in and for the purpose of comprehension.]

The "oscillation of the imagination between that which is irreconcilable" is, as Fichte emphasizes, a "conflict of itself with itself," a conflict between an internal and external image, between evaluative affection[8] and withdrawal to gain a neutral perspective of the facts, between expectation and the freedom to allow for the unexpected.

Fichte's conception of the oscillation of the imagination can be understood as a foundational model for the reception of the artwork that requires that one respect the boundaries both in the viewer's act of perception (the check) and interpretive processing (spontaneity), but also in the clarified intention of the artist and the actually achieved result within those particular boundaries that delineate the permissible as well as the unpermissible crossings or "transgressions" of these parameters.

The world of the image and the world of reality

The image that I wish to use to develop my consideration of a phenomenology of experiencing an image hangs in the Tate Modern Gallery in London (Plate 12). It is one of the many *Untitled* works for which the information concerning their creation suggests a date between 1950 and 1952 (Anfam 1998: 338, "1447, No. 16 [?] {Untitled} 1950"). It is in an upright format, painted in oil on canvas and measures 190 × 101.1 cm, and is considered to be among the images he produced on the theme of "Landscape/ Matter/Environment." It belongs to the earlier smaller images done by Rothko and other painters of Abstract Expressionism, among whom especially Rothko, Clifford Still, Barnett Newman, and Jackson Pollock can be held up as the artists who imprint their style on this school more formatively than any of the other important representatives.

The picture *Untitled 1447, No. 16 [?]* can be described in this way: it is, as all of Rothko's classical images are, structured in horizontally and oppositionally stacked areas, or one might say, expanses of color. These color-areas are not monochrome, neither are they demarcated by clean lines, as is the case, for instance, with Barnett Newman's work. The colors are much more applied as a glaze, and they change in tone because they let deeper layers of color shine through the surface tone. The edges of the color-areas recall an untrimmed or torn piece of hand-made paper. In *Untitled 1447, No. 16 [?]* an opaque cloud of olive green hovers over the very top of the canvas but begins to break up over the top of a warm ochre towards and downward from the right side of its horizontal middle. The olive green to ochre-toned area ends slightly above the middle and allows a thinly applied, softly colored lemon yellow to emerge, as if it were shining out from the background. The somewhat larger lower half of the picture begins at the yellow background stripe with a color-area whose background color is a brightly lit orange, but over which, again especially towards the right side, lie layers of another color, this time a strong maize-yellow. At the top edge of this lower color-area a pink color shines forth here and there. Spots of green peek through on the left and on the underside of the area. Finally, under this middle area is a somewhat narrower color-area (a swath in comparison)—appropriately so relative to the top, olive green expanse—in a raspberry red to pink color that occasionally breaks up over a violet-blue tone. These two color-areas on the lower half of the picture again do not actually run up against each other directly, but instead are separated by the same green that is interspersed in the orange-maize yellow swath. Moreover, this green frames the entire area of the picture. On the top edge of the painting the green becomes increasingly identical to the olive-toned area, so that it functions as an internal framing of the work in actuality on only three sides. At the top the color-frame, identical to the color-area,

disappears as a border. Towards the left the green frames the picture with a clearer contour; towards the bottom the green, in fact, doubles in width and functions as a foundation; and towards the right it becomes very narrow and is less easily detected.

The viewer, as she draws towards the picture, sees at first, as described, three horizontally stacked color-areas that are brought into one by the internal frame, but opening up outward at the top. The two lower color-areas starkly contrast with each other in that the warm orange-maize yellow and the cooler (in effect) raspberry-pink-violet-blue stand in conflict with each other. However, against the upper olive-green area they come together into a unified block as the green that appears within the orange stands out and the pink returns from the upper edge of the orange-maize area. The glazed, playfully nuanced color-areas display a pulsating vitality of color. They catch and hold the viewer's perceiving eye, and, indeed, the viewer can always discover new correspondences between the emerging colors, only the most conspicuous of which I have here described as examples. The two upper color areas, which are not actually framed, work in contrast to the other bordered sides as if they are open and invite the viewer's eye to imagine the picture continuing beyond its boundaries.

As they play off of each other nothing in these color areas is presented as composed, and yet the viewer, inclined by the suggestion of particularly colored spaces, cannot quite lose the sense here of beholding a fantastical color-landscape. In *Untitled 1447, No. 16 [?]* the suggestion is especially insistent, even though this effect is characteristic of so many of Rothko's images. The yellow, delicately lit color-expanse creates the effect of a horizon between the upper and lower blocks, which draws the eye of the beholder into a bright and promising depth (in other images the horizon is hidden behind, as it were, a screen of dark beams. The orange-maize and olive-ochre of both of the color blocks effect an earthy heaviness against the exhaled, hovering, light yellow: transcendence in immanence.

The horizon—long since bereft of its mystery through our modern knowledge of geology, astronomy, and optics—gets back its original secret. It draws our glance into the distance and optically forms a line that commonly belongs to both the heavens and the upper layers of the earth. These regions, then, seem to share a common boundary, over which the one region passes to the other, and from which we nevertheless know that this effect functions relative to the vantage point of the viewer.

I speak here strictly of a suggestion, and not of an illusion. Rothko's composition allows the viewer to discern this suggestion in the delicate yellow between heavy blocks of color, for it is not a spatial illusion, an "as if," that Rothko presents. An illusion not only would contradict the fundamental "intuition" of abstract expressionism, but it also would in no way even correspond to the experience of seeing that the viewer may have with the painting. The viewer can perceive what has begun here as a description

of the image, whereby in that very description are already contained principles of interpretation and, further, the beginning of a space of image-description that allows for further observations. However, despite the ways in which we might differentiate its steps or processes, perception never remains what it was at the point of comprehending what has been seen. Rather, the understanding seeks to determine the connections that give order and continuity to the image in order to subsume what has been seen under principles or concepts. One cannot separate this trajectory from a basic description of perception in general, but at the same time, the viewer increasingly ties her experience with the image together with her own experience of being in the world. Her artistic experience is bound up with all that lies on the individual's horizon of life experience.

Most city-dwellers have at some point had the experience of leaving the narrow street-canyons of their big cities, with their restricted views, in order to let their gaze wander into the distance of an open landscape or over the sea, where the straight line of the horizon halts that gaze, forcing itself on the viewer in this "picture." Certainly, an atmospherically rendered painting of William Turner connects itself much earlier and more spontaneously to the imagining of a landscape than the horizontally structured color expanses of Rothko's, formatted both by height and width. And yet in a longer viewing of his classical pictures, his suggestions of color-fields urge themselves on us sometimes as a landscape. Why is this a suggestion and not an illusion? Because Rothko's design of these color-fields never lets us forget that they are, in fact, color-fields. Wherever certain elements that produce a sense of three-dimensionality let themselves be discovered, other elements are present that emphasize the work's two-dimensionality. The ochre in the upper olive-green field and the maize yellow in the lower orange field both push themselves diagonally from the right side outward towards the center of the picture to a place over the middle of the yellow edge of the horizon. One is reminded of a mirror-image correspondence of a "heavenly" light or the illuminated parts of clouds and their reflection on the ground, while the rest of the color swath displays a darkly clouded sky and the resulting shadows on the surface of a lake or the ground. This diagonally structured, mirror-image correspondence of bright and dark color fields, which appear to play around the work's vanishing-point lines, conflict with the vertically directed glaze strokes and pulls back, as it were, this illusion of depth in the area. The comprehensibility of the function of the colors makes present both the phenomenal reality of the color and the process of applying *farbe* ("color" and "paint" in German), and it enters into self-conscious interplay with the understanding, in that one tries to identify here the rendered "objects" that emerge over and above the colors and the color-fields as a landscape. This illusion, trying to install itself, will nevertheless also be momentarily destroyed.

A game, or better, an oscillation in the imaginative faculty takes place

between the phenomenal reality of the image and the illusion of a land-scape, and this oscillation is apprehended as such in constant motion. The heavy green of the upper color-field plays between the imagined, heavy cloud layer and that which the painter has executed: overlapping glazings of oils. Rothko aptly describers his paintings as "abstract, direct, and concrete" (Polcari 1991: 145)—"abstract" because they stand in contrast to representational painting; "direct" because they aim to effect certain emotional processes, which I have yet to address; "concrete" because these processes proceed unmediated from the phenomenal reality of the image.

In yet another way Rothko brings the viewer into an oscillation between the space of the image and that of phenomenal reality. The horizontally ordered two-dimensionality, the inner framework, the softly vertical and horizontal contours, produce a calm, a silence from which one cannot pull oneself away when one engages in a sustained, concentrated view of the work. The design of the work towards this even horizon binds itself to the imagining of a calm sea and, further, a contentment that cannot be mistaken for motionlessness, emptiness, or stiffness, for the nuanced realm of the color glazes conveys a strange inner motility, an interior pulsating of life. The frame underscores the experience of an enclosed wholeness, it works like a fence that the viewer captures in the internal motion of the paint, and she is thereby released from the space of phenomenal reality, and lets herself forget that which is happening around her in the Tate Modern Gallery in the moment of concentration. The soft contours of the horizontal and vertical color boundaries strengthen the experience of a quiet, peaceful pulsating of life that has an effect on the condition and the consciousness of the viewer, which extends itself within the borders of her body. The con-centrated observation of the image produces an interplay between her location in the exhibition space, the space in the painting, the space in her consciousness, and finally, the space within her body.

The dramatic staging of the paintings of Rothko as normative horizon

Thus far in this chapter I have placed the artistic perception of colors and form in relation to the suggestion of the three-dimensional surroundings of the viewer evoked by the painting. This art of evoking the experience of three-dimensionality or depth is the beginning of a dialogue that the viewer conducts with the painting. Some may indeed enjoy this very experience. But Rothko, who clearly wanted this to be the primary effect of his works and knew how to achieve this outcome, explained in unmistakable terms: "I'm *not* an abstractionist. ... I'm not interested in relationships of colors, forms or anything else ... I'm interested only in expressing basic human emotions—tragedy, ecstasy, doom, and so on" (Polcari 1991: 144). Beyond the sensory perception of spatiality, painting for Rothko had a mythological

and a pantheistic religious significance in the most abstract sense, and it was essential to him that his paintings conveyed this to the viewer. Despite the abstraction of its represented objects, and beyond the concreteness of its colors and forms, Rothko aimed in his images at what he considered to be the horizon of human existence. In earlier paintings Rothko rendered explicitly mythological themes and figures, such as *Sacrifice*, 1943; *Tiresias*, 1944; *Archaic Fantasy*, 1945. But he also intended his abstract compositions to express a sense of fate in human existence. Familiar with and intellectually connected to Greek antiquity, Greek tragedy (especially Aeschylus), and the Eleusinian mysteries, Rothko claimed not only that he spent his whole life painting a Greek temple, but also that he considered his paintings to be dramas, as he explained in his essay, "The Romantics Were Prompted" in the winter of 1947–48: "I think of my paintings as dramas; the shapes in the pictures are the performers" (Breslin 1993: 239).

He goes on to illustrate more precisely what he means by this claim through an historical explanation:

> Without monsters and gods, art cannot enact our drama: art's most profound moments express this frustration. When they were abandoned as untenable superstitions, art sank into melancholy. It became fond of the dark, and enveloped its objects in the nostalgic intimations of a half-lit world. For me the great achievements of the centuries in which the artist accepted the probable and familiar as his subjects were the pictures of the single human figure—alone in a moment of utter immobility.
>
> But the solitary figure could not raise its limbs in a single gesture that might indicate its concern with the fact of mortality and an insatiable appetite for ubiquitous experience in face of this fact. ... I do not believe that there was ever a question of being abstract or representational. It is really a matter of ending this silence and solitude, of breathing and stretching one's arms again.
>
> (Breslin 1993: 240–41)

Though shunning the transcendental in its instances of mediation (the horizon is a form of the transcendent in the immanent), just as it shuns superstition or simple melancholy, Rothko's dramatic art also wishes to surpass the progress made by Modernism with its figures frozen in alienation. Knowledge of the tragic dimension is for him knowledge of the close proximity between life and death, and thus, our nearness to the totality that surrounds our existence. The question remains whether or not the classical paintings of Rothko can be interpreted as representations of the tragic, of the ecstatic, of "doom," be it with or without an understanding of the painter's self-understanding. In order to answer this question it makes sense to give further consideration to another of Rothko's musings in this essay:

Pictures must be miraculous. … The picture must be for [the artist], as for anyone experiencing it later, a revelation, an unexpected and unprecedented resolution of an eternally familiar need:

> On shapes:
> They are unique elements in a unique situation.
> They are organisms with volition and a passion for self-assertion.
> They move with internal freedom, and without need to conform with or to violate what is probable in the familiar world.
> They have no direct association with any particular visible experience, but in them one recognizes the principle and passion of organisms.
>
> (Breslin 1993: 240)

The artwork, the mirror of principles and passions of organisms, is also a mirror of those organisms' life impulses and their vulnerability, their individuality and their integration into a totality that both preserves and destroys them. Reduced to this simple formula, the modern artwork can be grasped as a staging of the tragic in a more comprehensive sense.

Also, what the uninformed viewer of Rothko's paintings may grant is their respective uniqueness. They stand out almost always from other paintings, even when Rothko happily wanted them to be displayed by themselves. Indeed, the sensations that Rothko's art awakens by virtue of the way that the colors create the effect of space very nicely fits with Hölderlin's concept of the "transcendental sensation," which he ascribed to our experience with the meaningful artwork in his reflections in Über die Verfahrungsweise des poëtischen Geistes (On the Methods of the Poetic Spirit). Such sensations are (on the model of Kant's aesthetic judgment) subjective in general and thus presumed to be the same to be had in everyone; they are suspended in the middle between the extremes of possible sensations and are therefore designated by Hölderlin as beautiful, holy, and godly. If we superimpose Hölderlin's idea onto Rothko's claim, along with the effects described above that emanate from the paintings, we can say with respect to these sensations that they are neither subjectively melancholy, accusatory, resigned to one's doom, nor greedy, violent, shocking, or sarcastic. One can experience them much more as an organic whole, just as our way of talking about Rothko's work in the description of the image above concerned the breathing, the pulsating life that is effected by the play of the shining-through of the work's colors. The images take their effect on our sensibility in a measured, restrained, even arresting way. One can hardly think of such a solemn measuredness in any other way than as something which proceeds from a knowledge of the utter fragility of human existence, of our vulnerability, exposed and threatened as we constantly are to and by dangers and hazards. The measured play of colors, the simplicity

of form, and the vertically and horizontally arranged composition are unified to awaken beautiful, holy sensations, and can accordingly be brought into actuality within the shadow of the Greek temple in its plain beauty and external abstraction. The dominance of the rectilinear stripes in both vertically and horizontally formatted works pull one's glance not towards an undetermined, breathtaking height, but rather embrace the viewer in an unbounded realm of color as a place of refuge, and sometimes also one of hiding. And if one's gaze is steered towards a horizon in the distance, one nevertheless does not lose oneself, but returns back into the reality of the colors. Despite its abstract presentation, our experience with this art produces the sensations of the holy, beautiful, godly; indeed, the *values* of the transcendental sensation, the sense of restraint that one apprehends in oscillation that achieves that which Rothko missed in the frozen simplicity of the works of his predecessors, the nearness of life and death.

However, Rothko says, "I would like to say to those who think of my pictures as serene, whether on friendship or mere observation, that I have imprisoned the most utter violence in every inch of their surface" (Breslin 1993: 355). Yet in contrast stands another of Rothko's statements—that he wanted to be "intimate and human" in his painting (Polcari 1991: 144–45). Whichever biographical experiences may have moved Rothko the painter to have captured violence in his paintings, he has, indeed, "captured" and spell-bound it, just as the tragic poets spell-bound the helplessness of human existence into their tragedies and in the process, at a minimum, made dramatic constellations and sensations comprehensible. As with Kant, Rothko's paintings can be much more easily conceptualized as a pleasurable free play of the imagination with the understanding, in other words, as artworks of the beautiful, as the pleasurable/unpleasurable play of the imagination and the reason that exceeds human measure in the experience of the sublime. But for Rothko himself, his large compositions bear the sign of that which is organic and whole within themselves; they pull the viewer into their spell, they surround her as a Greek temple does, at times hiding the sacrificial sites, but overwhelming her, however, not with fear and surprise, nor with their incomprehensibility and ominous size, as do gothic cathedrals.

In such a way can Hölderlin's distichon concerning Sophocles be transposed on to Rothko without diminishing it:

> Viele versuchten umsonst das Freudigste freudig zu sagen
> Hier spricht endlich es mir, hier in der Trauer sich aus.
> <div align="right">(Hölderlin 1998: I, 271)</div>

> Many have tried, but in vain, with joy to express the most joyful
> Here at last, in grave sadness, wholly I find it expressed.
> <div align="right">(Hölderlin 1994: 53)</div>

Notes

1 See, for instance, Ihmdahl 1989; Golding 2000: 195–232.
2 See Polcari 1991: 141.
3 Trans. note: *Schweben* is an impossible term to translate into English with just one word. Its more common definitions include oscillation, suspension, and hovering or floating. In my translation of Fichte's terminology, I have followed Daniel Breazeale's glossary of terms in his *Fichte: Early Philosophical Writings* (Ithaca, NY: Cornell University Press, 1988) and so will render *schweben* as "oscillation." I recommend to our readers that they keep "suspension" in mind as an almost equally accurate translation for the present examination of Rothko's art.
4 "Die Einbildungskraft ist ein Vermögen, das zwischen Bestimmung, und Nicht-Bestimmung, zwischen Endlichem, und Unendlichem in der Mitte schwebt; ... Dieses Schweben der Einbildungskraft zwischen unvereinbaren, dieser Widerstreit derselben mit sich selbst" (Fichte 1969: 360).
5 Trans. note: This and all translations of Fichte are mine.
6 Trans. note: Fichte's term here is "*Anstoss,*" the word used for starting or initiating something (the word used, for instance, for the starting kick in a soccer match). It can be used more figuratively to mean an impulse or impetus. But in Fichte it carries the idea of limitation, restraint, containment, and so Breazeale translates it as "check."
7 Trans. note: "irreconcilable"—more literally, "unify that which is disunited."
8 Trans. note: Waibel's word here is "*Zueignung*" to suggest in the concept of affection the notion of "drawing towards."

References

Anfam, D. (1998) "The Works on Canvas," in *Catalogue Raisonné*, New Haven, CT: Yale University Press; Washington, DC: National Gallery of Art.

Breslin, J.E.B. (1993) *Mark Rothko: A Biography*, Chicago: University of Chicago Press.

Fichte, J.G. (1969) *Grundlage der gesammten Wissenschaftslehre 1994/95*, I, 2, in R. Lauth and H. Jacob (eds.) *Johann Gottlieb Fichte Gesamtausgabe der Bayerischen Akademie der Wissenschaften*, Stuttgart: Fromann Holzboog.

Golding, J. (2000) *Paths to the Absolute: Mondrian, Malevich, Kandinsky, Pollock, Newman, Rothko, and Still*, The A.W. Mellon Lectures in the Fine Arts, 1997, Washington, DC: The National Gallery of Art; Bollingen Series XXXV, 48, Princeton, NJ: Princeton University Press.

Hölderlin, F. (1994) *Poems and Fragments*, 3rd Ed., trans. Michael Hamburger, London: Anvil Press Poetry.

——(1998) *Sämmtliche Werke und Briefe*, ed. M. Knaupp in 3 Volumes, Darmstadt: Wissenschaftliche Buchgesellschaft.

Ihmdahl, M. (1989) "Barnett Newman: Who's Afraid of Red, Yellow and Blue III," in C. Pries (ed.) *Das Erhabene: Zwischen Grenzerfahrung und Größenwahn*, Oldenbourg, MI: Weinheim.

Polcari, S. (1991) *Abstract Expressionism and the Modern Experience*, Cambridge: Cambridge University Press.

Waibel, V.L. (2000) *Hölderlin und Fichte: 1794–1800*, Paderborn: Schöningh.

5

REPRESENTING THE REAL

A Merleau-Pontyan account of art and experience from the Renaissance to New Media

Sean Dorrance Kelly

Introduction: two interpretations of Realism

In Balzac's story "The Unknown Masterpiece," from 1831, there is a tale that speaks to the aspirations of many artists. Froenhoffer, the protagonist, has spent ten years working in secret on his great masterpiece, a reclining nude. When unveiled, the still-unfinished work is an almost completely impenetrable mass of colors and shapes. At one end of the painting, however, is a foot of such exquisite beauty and reality that it seems to jump off the canvas into real life. The success of this foot lies not merely in its being a faithful image of some more vivid original. Rather, it seems, Froenhoffer has managed to put on canvas something the experience of which is identical to the experience of the real.

Froenhoffer was the ancestor to a tradition in French painting that came to fruition half a century later. When Cézanne read Balzac's story, for instance, he is said to have exclaimed with joy, "Froenhoffer, c'est moi!" The work of Cézanne and the Impressionists, though different in many respects, was alike in that both were committed to Froenhoffer's radical goal of producing on canvas the thing *as it is presented in our experience of it*. It is not enough for these artists to *imitate* reality, to produce a copy of it; their aspiration is, as Froenhoffer himself says, to produce in us, the perceivers of reality, "the self-same phenomenon that is presented by objects."

This aspiration has long gone under the heading of Realism in art historical circles, a label that is, as I will explain shortly, somewhat misleading. As a technical term in art history Realism refers both to the quotidian subject matter and the positivistic theories of the late nineteenth-century Impressionists. It is the painting of real scenes from daily life, rendered by means of a real, which is to say scientific, method. But as a generic term realism is used equally to refer to the accurate, detailed depictions of nature

that one finds in such seventeenth-century masters as Caravaggio and the great Dutch genre painters. Indeed, the development of linear perspective in the Early Renaissance is usually cited as the principal advance towards realism in painting. Realism, in this generic sense, is typically taken to refer to the reproduction on canvas (or in other artistic media) of things as they really are.

Many of the artists of the High Renaissance understood the aspirations of their work in these realist terms. They constantly exhorted one another to "paint from nature,"[1] and recommended the careful and detailed study of the physical makeup of their various subjects. Leonardo, for instance, argues for the "necessity of anatomical knowledge" to the painter. He suggests that only "the painter who has obtained a perfect knowledge of the nature of the tendons and muscles ... [including] which of them, by swelling, occasion their shortening, and which of the cartilages they surround" (da Vinci 2002 [1651]: 100) – only a painter who has attained such detailed knowledge of human anatomy will properly be able to paint any part of the human body. As the representation on canvas of what there really is, in other words, painting requires the scientific study of nature itself.[2]

This realist understanding of the artists' work, as is well known, found its theoretical foundation during the Renaissance in Aristotle's philosophy of art. Aristotle, following Plato, thinks of all art as imitative. On this view a painting is designed to imitate its subject just as a tragedy is designed, as Aristotle says, to be "essentially an imitation ... of action and life, of happiness and misery" of its characters. For this reason it is most essential that a painting accurately portray the form or shape of its subject, for "the most beautiful colors laid on without order," quoting from Aristotle, "will not give one the same pleasure as a simple black-and-white sketch of a portrait" (Aristotle 1954: 231–32; 1450b: 1–3). A painting is, in the first instance, in other words, an imitation of the form of the thing.

As an imitation, a painting is less real than the thing it portrays. This claim is, of course, at the center of Plato's dismissive account of art in Book X of the *Republic*. Recall that the most universal imitator, according to Plato, the one that "makes all the things that all the other kinds of craftsmen severally make" (Plato 1974: 596c, 1–2), is the mirror. With this object, as with the tools and skills of a painter, Glaukon admits that he could make all things appear. "But I could not make the things themselves," he says, "as they truly are" (596e, 2–3).

Aristotle does not insist with the same vehemence as Plato that imitations are less real than the things they portray. Perhaps this is because the *Poetics*, unlike the *Republic*, is not a work of metaphysics. But the idea that imitations are inferior in some sense or another is built deeply into Greek folk knowledge, especially as it is embodied in the classic myths. It is true, of course, that Narcissus falls in love with a mere reflection, an imitation of reality. But the moral of this story is certainly not that reflections are better

than life. For recall that this love was the perverse punishment that Aphrodite rendered for Narcissus' rejection of the nymph Echo's advance. And Narcissus' fruitless attempts to approach the beautiful reflection led ultimately to his own despair and death. Or recall Perseus' strategy for beheading the awful Medusa. By looking only at her reflection in Athene's mirror, rather than looking directly at her face, he was able to escape being turned into stone. The *image* of Medusa's face did not have the power of its original.

The attempt to produce images that have the same power or force as reality, I claim, lies at the true foundation of the realist conception of painting. Thus Constantijn Huygens, the great seventeenth-century Dutch Renaissance Man and father of the famous scientist Christian Huygens, writes with amazement, but also uneasiness, about the awesome head of Medusa painted by Rubens. This painting caused so much consternation among its viewers that the friend of Huygens' who owned it kept the painting covered and therefore, as it were, powerless (Alpers 1987: 22). Rubens' portrayal, in other words, had such an effect on its viewers that the painting seemed to contain the awful power of the original, a power that was lost even in its mirror image.

It is well known among cognitive neuroscientists now that the recognition of facial expressions is tied directly to affective response in normal subjects.[3] When a normal subject sees a facial expression of fear or horror or menace, for example, it elicits in him immediately an appropriate affective response. This affective response to the expression lends it a feeling of reality, and neuropsychological patients in whom the perceptual experience is dissociated from the affective response complain that the objects they are confronted with appear to them to be unreal.[4] Perhaps it is for this reason that Michael Fried, the art historian, has suggested that a certain kind of affront or attack on the viewer is characteristic of realism in the extreme. "The definitive realist painting," he writes, "would be one that the viewer literally could not bear to look at: as if at its most extreme, or at this extreme, the enterprise of realism required an effacing of seeing in the act of looking" (1987: xx). Caravaggio's work in particular often contains this kind of affront, according to Fried, and never more so than in his own Medusa. Perhaps it is this, Fried suggests, that accounts for that painting's "peculiar centrality to the realist canon" (xx).

Fried's theory of realism is intriguing but it seems to me too limited. For the power to wound or affront a viewer is only one of the powers that an image may have. Emotional responses to an image run the entire gamut from fear to joy, and the story of Zeuxis, one of the most famous painters of ancient Greece, is perhaps not irrelevant here. Zeuxis' paintings were so realistic that birds flew down to peck at a bunch of grapes he had painted, and according to one tale Zeuxis himself died laughing at a comical picture of an old woman he had drawn.

If realism is not tied directly to horror, however, it seems quite reasonable to think that it is tied to some response or other in the viewer. But now we have moved from the claim that painters aspire to produce objects as they really are to the claim that painters aspire to produce things that affect their viewers the way real things do. Realist painting on this view is not so much about how real the images are, in the metaphysical sense preferred by Plato, but rather about how perceptually forceful they are. Painting, in other words, is akin to a theory of perception.

The painters of the High Renaissance – perhaps still under the influence of the pervasive Aristotelianism of the day, despite Ficino's forays into Plato – seem to have been rather confused about this. It has long been understood, and was at least implicit in Leonardo's own work, that the development of the laws of perspective in the Renaissance paralleled, and in some sense were analogous with, the development of the scientific knowledge of the anatomy of the eye. By the time of Johannes Kepler's *Paralipomena* of 1604 the theory had become explicit that vision is, or is brought about by, the formation of a picture of the thing seen on the concave surface of the retina (Alpers 1987: 34): "Ut pictura, ita visio," Kepler wrote (Alpers 1987: 36; Kepler 1937: 153), or "As it is in the picture, so too is it in sight." But what there is, and how we perceive it, are different things altogether, and the Renaissance painters sometimes took their charge to be the more ambitious Aristotelian one of representing reality itself rather than the more reasonable one of recreating our perceptual experience of it. The Renaissance artist, Pygmalion-like, seems to take the creation of reality itself as his goal. As Leonardo says in the Notebooks, "The painter strives and competes with nature" (da Vinci 1970: 332).[5]

Giorgione, the great Venetian painter from the early sixteenth century, presents perhaps the most perfect example of an artist who takes his task to be the representation of reality itself, rather than of something that recreates our everyday experience of it. Giorgione was certainly one of the great realist painters of the Venetian Renaissance. Adopting the Aristotelian idiom, Vasari writes about him that "he fell so deeply in love with the beauties of nature that he would represent in his works only what he copied directly from life" (1965: 272). Giorgione's own Aristotelian conception of the realism in his work is well illustrated by a story that Vasari relates.

The Paragone, or Comparison of the Arts, was one of the great debates of the Renaissance. It pitted sculpture against painting in a competition for the title of Superior Art. There were a variety of issues at play in the debate. Leonardo, for instance, argues for the superiority of painting partly on the grounds that it is the more intellectually demanding art (da Vinci 1970: 329). But perhaps the leading question of the debate is whether sculpture or painting is better at creating realistic representations. In this it might be thought that sculpture has the edge, since, after all, its product is a fully three-dimensional work, while paintings are merely two-dimensional

projections. Giorgione, however, made a bizarre move in the debate. He claimed that the three-dimensionality of a sculpture was actually a draw-back, since the viewer must walk around the object in order to see all its sides. The painter by contrast, he claimed, can present at a glance the front, back, and both profiles of a painted figure. The sculptors were astonished and doubtful about this claim. Vasari tells the tale:

> After he had made those sculptors rack their brains, Giorgione solved the problem in this way. He painted a man in the nude with his back turned and, at his feet, a limpid stream of water bearing his reflection. To one side was a burnished cuirass that the man had taken off, and this reflected his left profile (since the polished surface of the armor revealed everything clearly); on the other side was a mirror reflecting the other profile of the nude figure. This was a very fine and fanciful idea, and Giorgione used it to prove that painting ... can show in one scene more aspects of nature than is the case with sculpture.
>
> (1965: 276)

What is interesting about this story is what it shows about Giorgione's conception of his art. It is true, of course, that an object has a front, a back, and two profiles. That is what the object really is. Furthermore, in normal cases we see objects *as having* full three-dimensionality: the world does not look as if it is filled with flat façades. But we do not normally *see* all the sides of an object, at least not explicitly, unless we take the time to walk around it. Giorgione's clever painting – perhaps like the works of the analytical Cubists four centuries later – is an attempt to present to the viewer what there is all at once, rather than to create in the viewer the everyday experi-ence of the real.

Mirrors, detachment, and absorption

Giorgione was not, of course, the first painter to use mirrors in his paintings to reflect various hidden aspects of reality. Giorgione's own mirror paint-ing has apparently been lost, but the use of mirrors from Van Eyck to Velasquez has been commented on abundantly in the literature. In Jan Van Eyck's famous *The Marriage of Giovanni Arnolfini* (Plate 13), from 1434, the artist not only represents the back side of his subjects in the mirror on the wall behind them, but represents himself in the mirror as well. Furthermore, on the wall above the mirror he is not content merely to sign his name for attribution; rather he writes the full sentence, in Latin, "Jan Van Eyck was here," as if to indicate that behind every subject painted stands the unseen painter-creator himself.

Over two centuries later, in 1656, Diego Velasquez brings the painter and his task even more clearly to the fore. *Las Meninas* is a painting of

Velasquez himself, among other things, caught in the act of executing a painting. The subjects of the represented painting, we have been taught to understand, are the Royal couple King Philip IV and his wife Mariana. We can tell this because, although the large canvas on which Velasquez is working shows only its back side to us, the mirror on the wall at the rear clearly reflects the royal couple on whom the painter's gaze resides. Where Van Eyck subtly hinted at his own presence in the portrayal of the Arnolfini couple, Velasquez paints himself primarily and only hints subtly at the presence of the royal couple being portrayed. According to Foucault's influential interpretation of *Las Meninas* from over 35 years ago, however, the real subject of the painting is not just the painter but the nature of representation itself. Foucault's full interpretation is complicated and controversial and anyhow goes beyond what I wish to emphasize here. For our purposes it is sufficient to note what everyone, I suppose, will grant; that *Las Meninas* presents an intellectual puzzle about the relation between the viewer and the scene represented, and encourages the kind of detached contemplation about its subject matter to which it has in fact given birth.

Much of the literature on mirrors and reflections in Renaissance art focuses, as in the case of Van Eyck and Velasquez, on the clues that reflected images give us to the subject matter or intended meaning of the painting. But reflections are sometimes used in a different way too. In Albrecht Dürer's famous *Self-Portrait* from 1500, Dürer presents himself in the image of Christ. Many viewers have been struck by the extraordinary liveliness of the sitter's gaze, with eyes that seem genuinely to be focused upon the viewer. Dürer has accomplished this effect in part by painting not only the whites, iris, and pupil of the eyes, but also the tiny reflection of a lighted window which they throw off. This innovation gives Dürer's portraits a depth and reality that had not been achieved to that point. But these reflections are not themselves meant to be the object of our gaze; we are not meant to look at them directly, and still less to consider them as clues to the underlying meaning of the painting. Rather, they play a background role in the image, giving perceptual reality to the face that they enliven. In this way Dürer's innovative use of reflections in the eye marks an advance in the tradition of realism as perceptual power.

Sometimes the overall composition and subject matter of a painting, however, can be one desideratum in determining what our perceptual response to it will be. Michael Fried has argued, for instance, that paintings that depict subjects absorbed in thought or activity may be particularly apt to draw us in the way real scenes do. "[E]specially in the work of Vermeer and Chardin," Fried writes, "the seeming obliviousness of one or more figures to everything but the objects of their absorption contributes to an overall impression of self-sufficiency and repleteness that functions as a decisive hallmark of the 'real'" (1987: 43).

Consider, for example, Chardin's painting *Soap Bubbles* of 1733 (Plate

14). In it a young man, jacket torn, is leaning out over the edge of a window sill blowing a soap bubble through the end of a long straw or pipe. The bubble has reached enormous proportions, it almost seems to "swell and tremble before our eyes," as Fried remarks (1980: 50), and the young man's whole being is focused on the delicate globe of soap hanging tentatively at straw's end. Behind him is a small child peering at the bubble over the sill, which the young man is using to steady his torso and hands. We seem to have entered the action at a pregnant moment, when the bursting of the bubble is imminent. In this way the painting, though it depicts only a single instant in time, is experienced as on the verge of continuing on. As Fried writes, the painting comes "close to translating literal duration, the actual passage of time . . . into a purely pictorial effect" (50).

Fried argues that absorptive themes play an increasingly important role in Realist painting from the seventeenth to the nineteenth centuries. What is important about this from our perspective is that the emphasis on absorptive themes reflects an insight into the nature of perceptual experience itself. For not every part of every activity or event is experienced as equally important. Despite the current technological mania for editing out all but the crisis points in any televised presentation of an event, anyone who has watched a baseball game from start to finish is familiar with the idea that its level of focus can ebb and flow. Moments of absorption are those moments in an event or activity in which the agent's level of focus is at its highest; when watching people at such moments of focus or absorption, as in the case of the young man blowing the soap bubble, we see the future of their actions explicitly as imminent. By concentrating on absorptive themes, the Realist tradition, from Vermeer and Chardin to Jean-Baptiste Greuze and Thomas Eakins, was presenting themes that have greater power to affect us perceptually. For they were highlighting moments that distill a certain perceptual truth, the truth that in perceptual experience each moment, as the French philosopher Maurice Merleau-Ponty writes, "traces out in advance at least the style of what is to come" (1961: 416). Part of what it is to see the young man blowing the soap bubble, in other words, is to feel prepared for the impending moment, the moment in which the bubble bursts.

In addition to absorptive themes or subjects, however, perceptual experience itself can be absorbed or detached. One can try to paint not just the young man who is absorbed in blowing the soap bubble, as Chardin did, but the young man's experience of the soap bubble when he is absorbed in blowing it. His experience of the soap bubble, no doubt, is different from ours. When we look at it the bubble seems to swell and tremble. Indeed, we can focus on its swelling and trembling, try to gauge how Chardin brought about this amazing effect. But for the young man absorbed in the activity the swelling and trembling of the bubble, never mind its color and shape, are not themselves experienced, at least not as such. Were he to be distracted for a moment and to notice these features he would no doubt lose

his focus and composure. One cannot both be absorbed completely in the activity of blowing the soap bubble and also at the same time detached from the activity in the way necessary to comment on or notice the features of the bubble one is blowing.

The difference between the detached and the absorbed experience of an object is familiar to us all. Consider it from the first-person point of view. What is your experience like of the steps on a staircase, for example, when you're focused completely on getting quickly down the stairs? If you are busy contemplating what the color of the carpeting looks like or where exactly the best spot is to place your foot, or even the imminent arrival of the next step, then you are almost guaranteed to take a tumble. To be focused on the staircase in the way that one must be – in other words, in order to descend it quickly and effectively – one must avoid viewing the stairs in a detached or spectatorial attitude. The absorbed or engaged attitude is the perceptual attitude we adopt with respect to objects when we see them as things in our meaningful environment.

The detached perceptual attitude, by contrast, is the attitude one takes when one not only has a perceptual experience of a thing, but at the same time pays attention to the details of the very experience one is having. In the detached attitude one pays attention not to meaningful things, but rather to the way things look. Since the Renaissance, painting has traditionally been the home of the detached perceptual attitude; and the relationship between mirrors or reflections on the one hand and detached observation on the other is built right into the birth of Renaissance art.

Consider the famous story about Brunelleschi's initial discovery, or re-discovery, of the laws of perspective in the early part of the fifteenth century. Filippo Brunelleschi, the famous architect and designer of the cupola at the top of Florence's Cathedral, was one of the early Renaissance experimenters with the art of perspective. In about 1415, on one of his trips back to Florence, Brunelleschi had the bold idea to set up a flat mirror on an easel inside the doorway of the Cathedral.[6] Looking into the mirror he had a perfect view of the octagonal Baptistery that was situated directly behind him. Focusing on the image of the Baptistery in the mirror, Brunelleschi outlined the shape of the great building following precisely the lines of the image it cast. (Parenthetically, if we are to believe David Hockney's stunning and controversial thesis, many of the great realist paintings of the Renaissance were produced by a more sophisticated version of a method like this, projecting an image of the scene into a camera obscura and then tracing its outlines [2001]). In either case a technique like this requires that the painter force himself to adopt a detached perceptual attitude with respect to the image he is copying, to see its outlines instead of the thing it is.

The laws of perspective, then, are the laws for drawing things as they are experienced in the detached perceptual attitude. But we have seen already

that things look different when we are engaged with them absorbedly. It is difficult, perhaps even paradoxical, to imagine trying to produce images that capture our engaged experience of objects, since after all this experience is one we have when we're not paying attention to the experience itself. What would it be like to paint objects as they look when we're coping absorbedly with them? To pose this question is to make explicit the idea that realist painting has more to do with our experiences of objects than it has to do with the objects themselves. And the challenge of creating images that affect us the way objects do when we are coping absorbedly with them is the challenge that Cézanne seems to have set himself at the end of the nineteenth century and that Picasso may have picked up as well in the middle of the twentieth.

Cézanne and Picasso

It is often said that Paul Cézanne's paintings are realist. And yet, at first glance this claim is puzzling. For paintings like *La Table de Cuisine*, from 1888–90 (Plate 15), or *Still Life with Glass, Compotier and Apples* from 1880, look nothing like the realism of Caravaggio or Vermeer. And, perhaps more relevant for the modern viewer, they look nothing like the kind of high resolution photo-realism we have come to expect from even our least expensive digital cameras. Indeed, a quick analysis of such paintings shows that they contain what appear to be a variety of painterly faux pas: there are significant distortions in perspective, the objects lack clear defining outlines, the colors tend to run into one another, and occluded objects are often continued improperly. What, then, did the poet Rainer Maria Rilke mean when he spoke of the "limitless objectivity" of Cézanne's painting (Agee 1985: 50–51)? Or the novelist D.H. Lawrence when he praised the dynamism, fullness, and perceptual realism of Cézanne's work, a realism that he said was not available to those images produced "by the laws of Kodak" (1998: 172).

For one thing the realism of Cézanne's paintings is often considered realistic by comparison with the airiness and lack of substance found in the Impressionist paintings that were being produced at the time. As is well known, in the famous series of paintings from 1894 that Monet produced of the Rouen Cathedral at various times of day, Monet renders the change in lighting as a change in the color of the building. The emphasis of the Impressionists was no longer on the development of techniques of perspective, as in the Renaissance, but rather on the influence of lighting on objects. But like the Renaissance painters, the Impressionists looked to the information available in the retinal image as a clue to how one ought to paint realistic scenes. It is certainly true that as the lighting changes the wavelength of light reflected off an object onto the retina changes as well. As a nearly literal representation of the light cast onto the retina, therefore,

these images may be fairly accurate. But they are not like our everyday experiences of the Cathedral at all. An object does not look like *it* changes color as the sun goes from directly overhead to the more angled light of the afternoon. Only by adopting a detached attitude can we experience changes in lighting as changes in object color. In everyday experience, because of a phenomenon that psychologists call "color constancy," objects maintain their color throughout gradual changes in lighting context. The retinal image, in other words, is not the ultimate clue to everyday, absorbed experience. The objects in these Impressionist paintings, because they seem not to be *lit* by the sun but rather *changed* by it, do not have the weightiness or independence that real experienced objects have.

Cézanne was certainly influenced by the Impressionists. He spent much of the decade of the 1870s working with the Impressionist Camille Pisarro, and it is undeniable that his style changed during that period. Many of the early paintings from the 1860s were imagined scenes – often violent or disturbing scenes of murders or rapes – while during the 1870s he came to focus much more insistently on scenes from life. But Cézanne is importantly different from the Impressionists too, as Merleau-Ponty was perhaps the first to recognize.[7] For Cézanne's stated goal, "To astonish Paris with an apple," is the goal of producing images of objects that are experienced as having weight, heftiness, and independence. These are genuine features of our engaged experience of objects, rather than features of the retinal image, and the failure even to recognize the goal of producing images that give rise to this kind of experience is perhaps why Cézanne considered the strict perspectival renderings of the French academic salons to be dishonest madness.[8]

Painting images that are experienced as weighty objects, Cézanne discovered, requires breaking some of the strict academic rules of painting. Consider the fact, for instance, that Cézanne often paints the various parts of a single object as if they were seen from different points of view. Erle Loran has created a diagrammatic representation of this for *La Table de Cuisine* (Plate 16). Notice, on the diagram, that the front of the fruit basket is presented as seen from straight on, position Ia, while the opening of the fruit basket is presented as if it is seen from above, position II, and the handle of the basket is presented as if it is seen from the side, position IIb. Naturally this is not accurate as an account of what image is projected onto the retina. But it does capture something important about our everyday engaged experience. For overflowing fruit baskets look, well, overflowing, and this is true even if we are not actually looking at them from above where you can get a good view of their contents. Even if you are looking at the basket from the side, which is the predominant viewpoint of this picture, an overflowing fruit basket looks like it has a lot of stuff in it. Cézanne has tried to give you this impression in a two-dimensional rendering by showing you both the basket from the front and its contents from above,

simultaneously. Or consider the handle. Handles, in everyday experience, look graspable. Indeed, as the psychologist J.J. Gibson pointed out, and recent neuroscientists have confirmed, graspability is one of the primary features of the environment that we can see.[9] To emphasize this Cézanne has turned the handle towards us so that it gives the impression of being available for the hand. The basket, thus, is a kind of classical *figura serpentina*, a twisting figure who is seen from the back but glances over her shoulder to show simultaneously both back and front.

The art historian Leo Steinberg has argued that Picasso uses just this kind of serpentination to display the volume of his figures in his 1954–55 variations on Delacroix's *The Women of Algiers* (Plate 17), as well as in such studies of nude figures as the one he provides from 1939–40 (Steinberg 1972: 18). This technique, which sounds superficially like Giorgione's strategy of presenting all the sides of the object at a glance, is actually used to very different effect in Cézanne's work, and possibly, if Steinberg is right, in Picasso's post-Cubist work as well. For in these more recent artists the use of multiple perspectives comes naturally out of the perceptually driven desire to capture aspects of our everyday experience of objects rather than out of the metaphysically driven desire to present the features of the object as it is independent of us.

The realism of Cézanne's paintings can be compared favorably along these lines to the photographic-like realism of the Baroque as well. From close-up the verisimilitude of Caravaggio's *Basket of Fruit* from *c.* 1597 fruit is remarkable; at very close range the worm-hole in the apple, for instance, almost seems to be a hole in the canvas. But, as David Hockney points out, the farther away you go from the image the more difficult Caravaggio's apples are to see. By contrast, a Cézanne still-life image gets clearer and stronger as you back away from it. Whereas Caravaggio's image loses its three-dimensionality and seems to recede into the picture-plane, Cézanne's seems to jump out at you, to, as Hockney says, "occupy your space" (2001: 189). Cézanne's apples achieve almost the effect of Froenhoffer's foot. They are experienced as real things, not just as exquisitely rendered images.

Hockney's explanation for Cézanne's kind of realism is interesting but limited. He points out that the perspectival renderings of the Renaissance are monocular – in his view, as I have already mentioned, they were literally traced from an image that came through the single lens of the camera obscura – whereas Cézanne is concerned with the binocular vision that gives rise to genuine human experience. When we see an object through two different lenses, as normal perceivers with two eyes do, the images are in competition with one another, and this gives the experience of the object a certain kind of ambiguity that Hockney suggests is the essence of Cézanne's technique.[10] I certainly agree that the binocular nature of human perception is part of what Cézanne is sensitive to, and it goes some way to

explaining the depth of the pictures he creates. But the full story of perceptual experience, as Merleau-Ponty argues, goes beyond its binocularity to include the rich and complicated fact that we are active, embodied perceivers in the world, and Cézanne seems to have been sensitive to this richer fact as well.

New Media

The New Media movement of the last 15 or 20 years has in some ways, ironically, attempted to return to the classical metaphysical ambitions of the Renaissance, at least on some interpretations. Perhaps the phenomenon at the heart of New Media, the phenomenon that has come to link television, radio, telephone, movies, the internet, email, and so on, is the phenomenon of digitalization. At some point in the foreseeable future, all the movies, music, phone calls, images, and texts that reach a household will be delivered by optical fiber networks and standardized by bit format. The essence of each of these transmissions, it has been argued, is its information content, a feature of the data that is completely independent of us and is clearly measurable using the resources of Information Theory. The information content of an image, for example, tells us everything there is to know about that image; and furthermore, by comparing the information content of the image to the information content of the thing represented we can measure precisely how far we have strayed from the realm of the real. In such a world there will be no Paragone, or Comparison of the Arts, because there will be no difference between media at all. As Friedrich Kittler, perhaps the most extreme defender of this view, writes:

> The general digitization of channels and information erases the differences among individual media. Sound and image, voice and text are reduced to surface effects, known to consumers as interface. ... Inside the computers themselves everything becomes a number: quantity without image, sound or voice. And once optical fiber networks turn formerly distinct data flows into a standardized series of digitized numbers, any medium can be translated into any other. With numbers, everything goes. ... [A] total media link on a digital base will erase the very concept of medium. Instead of wiring people and technologies, absolute knowledge will run as an endless loop.
>
> (1999: 1–2)

A philosophy of New Media like Kittler's goes so far away from thinking of art in terms of experience that it defines away even the difference between the various media in which artworks can be produced. As my colleague Mark Hansen has pointed out, in a forceful critique of Kittler's view, such a theory focuses on digital media as "sites of disembodiment" in

101

which, in the post-medium condition, human perceptual capacities become completely irrelevant to the pure flow of data that defines all sound, image, voice, and text.[11]

We have already seen enough to know something about why such a view cannot be right: it misses something essential about pictorial representation, or at least about the particular kind of realistic pictures that have played such a central role in the history of art. For if an image becomes realistic in virtue of the power it has to affect us perceptually, as I have been arguing, then the degree of realism afforded a pictorial representation, surely one of its essential features, cannot be calculated independently of our embodied engagement with the image itself.

Perhaps the best example of New Media art that is sensitive to this fact is some of the recent work by video artist Bill Viola, with which I will conclude. Viola's *Quintet of the Astonished* is a digital video from 2000. To produce the video, which is part of Viola's *Passion* series, he filmed four men and a woman on high speed film at approximately 16 times faster than normal. During the filming the five actors go through a series of extreme emotional changes over the course of about a minute. By digitally converting the film to video and then projecting it at normal speed, the finished work is approximately 16 minutes of emotional intensity. For this sort of reverse time-lapse technique has the effect of supersaturating the images with ordinarily imperceptible affective content, the micro changes in facial expression that normally occur so quickly that we don't even notice them.

What is extraordinary about the video, and what makes it relevant for our purposes here, is that each of these frames is imbued with an affective content that we could not have known about had we seen the events at normal speed. In still images from the film, what is shown occurred in 1/384th of a second, and yet the affective content of the images not only reads perfectly well, it seems to extend well beyond this nearly instantaneous temporal frame. As Viola says, the experience of the still image as overflowing beyond its instant and as exuding a rich plenitude of emotion led him to conclude that "emotions are outside of time" (Hansen 2004: 264). Although they are outside of time, however, they do not exist outside of the medium in which they are displayed. For the emotional content of the images is lost completely in the disembodied characterization of the information that makes them up.

In this one film, then, we have echoes of the realism of Caravaggio's *Medusa*, which attacks the gaze with an emotionally intense expression, and also a reference to Chardin's *Soap Bubbles*, which by catching the agent in the midst of engaged activity seems to extend beyond the instant it represents. (This goes beyond, by the way, the more obvious and explicit references to the devotional imagery of the fifteenth and sixteenth centuries.) Moreover, the particular affective import of Viola's video, and therefore the particular kind of realistic quality it exudes, depends entirely on the

speed at which the video is projected. For this reason it is no exaggeration to say that the video reads very differently, indeed *has* very different qualities, when played at various different speeds. And this is true even though the exact same digital information is contained in each presentation of it. If the realism of an artwork is tied to its perceptual power, as I have been suggesting, then Viola's work builds on a rich history of realism in art.

The techniques and resources of New Media, far from divorcing art from embodied experience, instead give us a whole new range of tools for exploring the nature of experience itself. In this way, I believe, they afford us new opportunities to adopt the phenomenological attitude towards ourselves, the attitude that Merleau-Ponty described as "wonder in the face of the world."

Notes

1 See, for example, Leonardo da Vinci 2002, §365, p. 265, entitled "That a man ought not to trust himself but ought to consult Nature." This volume was originally published in 1651, though it was of course written during Leonardo's lifetime (1452–1519).
2 Given this late fifteenth-century exhortation, it is perhaps surprising that the accurate depiction of the cerebral cortex was not even achieved in Vesalius' magnificent *De Humani Corporis Fabrica* almost half a century later (1543, 1555). Even Vesalius seems to go out of his way to represent the cortex, following Galen's second-century description, as coiled like the small intestines, with no standard pattern. This is no doubt in part because of the standard view at the time that the cerebral convolutions were entirely irrelevant features of the brain. See Clarke and Dewhurst 1996, especially chapter 6 on cerebral convolutions.
3 See the work of Ralph Adolphs and Antonio Damasio.
4 In the case of those suffering from Capgras' Syndrome, for example, the patient reports a loved one to look exactly as she always has, but to have had her identity taken away.
5 Hereafter referred to as da Vinci, *Notebooks*, followed by volume, section, and page number in the Dover edition.
6 For this version of how the experiment is likely to have been run, see Pendergast 2003: 133. I believe the original source of this story is the biography of Brunelleschi written in the 1480s and attributed to Antonio Manetti.
7 See Merleau-Ponty 1964.
8 Hockney reports this as Cézanne's view in Hockney 2001: 195. Cézanne expressed this view himself often, if I'm not mistaken, in the letters.
9 See Gibson 1979.
10 See Livingstone and Conway (Sept. 16, 2004): 1264–65 on how Rembrandt was stereo-deprived.
11 See Tim Lenoir's foreword to Hansen 2004.

References

Agee, J. (trans.) (1985) *Rainer Maria Rilke – Letters on Cezanne*, New York: Fromm International Publication Corporation.

Alpers, S. (1987) *The Art of Describing: Dutch Art in the Seventeenth Century*, Chicago: University of Chicago Press.

Aristotle (1954) *Poetics*, trans. I. Bywater in *The Rhetoric and the Poetics of Aristotle*, F. Solmsen (ed.), New York: Random House.

Clarke, E. and Dewhurst, K. (1996) *An Illustrated History of Brain Function: Imaging the Brain from Antiquity to the Present*, San Francisco: Norman Publishing.

Da Vinci, L. (1970) *The Notebooks of Leonardo da Vinci*, 2 vols., J.P. Richter (ed.), New York: Dover Publications.

——(2002 [1651]) *A Treatise on Painting*, trans. J.F. Rigaud, New York: Prometheus Books.

Fried, M. (1980) *Absorption and Theatricality: Painting and Beholder in the Age of Diderot*, Berkeley: University of California Press.

——(1987) *Realism, Writing, Disfiguration: On Thomas Eakins and Stephen Crane*, Chicago: University of Chicago Press.

Gibson, J.J. (1979) *The Ecological Approach to Visual Perception*, Boston: Houghton Mifflin.

Hansen, M.B.N. (2004) *New Philosophy for New Media*, Cambridge, MA: The MIT Press.

Hockney, D. (2001) *Secret Knowledge: Rediscovering the Lost Techniques of the Old Masters*, New York: Viking Studio.

Kepler, J. (1937) *Ad Vitellionem paralipomena, quibus astronomiae pars optica traditur*, in W. van Dyck and M. Caspar (eds.), *Gesammelte Werke*, vol. 2, Munich: CH Beck'sche Verlagsbuchhandlung.

Kittler, F. (1999) *Gramophone, Film, Typewriter*, trans. G. Winthrop-Young and M. Wuts, Stanford, CA: Stanford University Press.

Lawrence, D.H. (1998) "Art and Morality," in M. Herbert (ed.), *Selected Critical Writings*, Oxford World Classics, Oxford: Oxford University Press.

Livingstone, M.S. and Conway, B.R. (Sept. 16, 2004) "Was Rembrandt Stereo-blind," *New England Journal of Medicine* 351: 1264–65.

Merleau-Ponty, M. (1961) *Phenomenology of Perception*, trans. C. Smith, New York: Routledge and Kegan Paul.

——(1964) "Cezanne's Doubt," in H. Dreyfus and P. Dreyfus (eds.), *Sense and Non-Sense*, Evanston, IL: Northwestern University Press.

Pendergast, M. (2003) *Mirror Mirror: A History of the Human Love Affair with Reflection*, New York: Basic Books.

Plato (1974) *Republic*, trans. H.D.P. Lee, Harmondsworth, UK: Penguin Books.

Steinberg, L. (1972) *Other Criteria: Confrontations with 20th Century Art*, New York: Oxford University Press.

Vasari, G. (1965) *Lives of the Artists*, trans. G. Bull, New York: Penguin Books.

6

THE JUDGMENT OF ADAM

Self-consciousness and normative orientation in Lucas Cranach's Eden

Wayne Martin

> When it is stated in Genesis that God said to Adam, "Only from the tree of knowledge of good and evil you must not eat," it follows as a matter of course that Adam has not understood this word, for how could he understand the difference between good and evil when this distinction would follow as a consequence of the enjoyment of the fruit?
>
> (Søren Kierkegaard, *The Concept of Anxiety*)

This is an essay about an old painting, an even older story, and a perennial philosophical problem. The story is the Biblical one of Adam and Eve in the Garden of Eden; the painting is a work by the Northern Renaissance painter, Lucas Cranach the Elder. Cranach was painting five hundred years ago, at the height of the Protestant Reformation, at a time and place where the proper route to Christian salvation was the most pressing and fiercely disputed issue of the day. In the midst of these disputes the story of Adam and Eve became for a time a topic of intense scrutiny and controversy – among both theologians and painters. The immediate reason is not far to seek: if one is looking for a proper account of the prospects for man's salvation then one must surely begin with a clear understanding of the circumstances of his Fall. But while the issues I take up in what follows shall of necessity bear on theological questions, the problem I want to pursue is not so much theological but philosophical – and specifically phenomenological. I would like to consider what this old painting of this familiar story might show us about the structures of conscious experience, and in particular about the structure of self-consciousness in human acts of judgment.

Part of the motivation for my investigation comes from the suspicion that we operate with a rather partial and one-sided understanding both of the

phenomena of self-consciousness and of the history of attempts to understand them. There is a tendency to think of self-consciousness as a characteristic theme of specifically *modern* philosophy – a theme inaugurated by Descartes, subjected to doubt by Hume, transcendentalized by Kant, and set out in social and historical terms by Hegel. This modern concern persists into recent times, particularly in connection with problems of self-reference and self-identification. But what about the history of self-consciousness *before* the modern period? How was self-consciousness understood prior to the seductive Cartesian account which did so much to set the agenda for subsequent discussions? My hope and working hypothesis is that we might enrich our understanding of the *phenomena* of self-consciousness by recovering some of the history that has often been overlooked, and by investigating the range of problems and concerns that emerged there.

Once the project is set out in these terms, it should be obvious that the *Genesis* narrative will have to come in to our account. The Biblical account of Adam and Eve is, among other things, an attempt to recount the origin of shame. The narrative reaches its crisis at the moment when Adam and Eve suddenly become aware of their nakedness and accordingly feel the need to hide themselves. Shame, I believe, is a very fundamental form of self-consciousness; moreover, it is an example of one of the constituent phenomena of self-consciousness that tends to be marginalized or overlooked in the standard history of the subject. The story of Adam and Eve is surely *the* central self-consciousness narrative in the pre-modern western world. So it makes sense to begin an alternate history more-or-less *in the beginning*.

But then why Cranach? The full answer to this question will have to emerge as we proceed. Part of the answer is that Cranach himself had a deep and continuing interest in Adam and Eve as a painterly theme. The standard Cranach catalog lists over thirty extant paintings on this subject, executed over a period of decades (Friedländer and Rosenberg 1978).[1] Several others are known to be lost or destroyed. If one adds in the woodcuts and surviving pen-and-ink drawings, the total rises to more than fifty. Astonishingly, there is very little duplication among these dozens of works. Among the major paintings no two are exactly alike, each exploring different moments in an unfolding tale or re-imagining the central figures and actions in a variety of different ways. This sort of sustained attention yields insight – at least when undertaken by a master of Cranach's stature.

But there is another reason that Cranach's paintings stand out among the hundreds or thousands of Adams and Eves in the standard western canon of fine art. Crucially, Cranach represents the scene in Eden as a circumstance that requires an act of *judgment*. Cranach seems to have been deeply concerned with the theme of judgment, and particularly in circumstances in which the task of judgment is forced upon us. The concern is perhaps understandable for a painter who lived out his life in the crucible of the

106

Reformation. Cranach lived and painted in a world that was immersed in a deep crisis over true faith. And unlike other world-historical crises, where the outcome might be determined on the battlefield, or in the palace, or in the distant chamber of some deliberative council, this was a crisis that effectively demanded of every individual that he make up his own mind. Should I follow the teachings and practices of the established church or strike out in a radically new and uncharted theological direction? Here is a task of judgment from which there can be no escaping; moreover it is a judgment in which one's very salvation (to say nothing of the socio-political status quo) hangs in the balance.

I have elsewhere explored Cranach's famous series of paintings of the fateful *Judgment of Paris* (Martin 2006: ch. 5). In several of those works Mercury leans menacingly over Paris, pressing a staff to his breastplate, forcing him to pass his fateful judgment. In the Garden of Eden, Cranach also finds a circumstance of forced judgment, though in this case a deeply puzzling and paradoxical one. In many of Cranach's paintings of Eden we see his various Adams in a common pose: clutching an apple and scratching his head. What is he doing? He is thinking, or *trying to think* anyway. He is deliberating, deciding, trying to reach a judgment. A judgment about what? About whether to eat the fruit, in the first instance; about which way to go at this original existential crossroads. Sometimes Eve is handing him the apple; sometimes he is plucking it from the tree for himself; in a few cases Eve holds it directly to his mouth to feed him. And poor Adam is trying to decide what to do next. Like Paris he faces a forced judgment, and like Cranach's Paris he does not seem to be well-equipped for the task.

In order to appreciate the depth of Adam's problem, it is crucial to remind ourselves of exactly what Adam *lacks*. Recall the basic elements of his situation. God has set up the first couple in very comfortable surroundings. There are a number of crucial details about Eden that shall concern us, but the central fact concerns the one limit that God establishes for life in the garden. As it happens, the first divine commandment in *Genesis* is a dietary restriction: Adam and Eve are not to eat the fruit of one particular tree. Two trees are mentioned in the text: the Tree of Life and the Tree of Knowledge. But there is at the outset no proscription against eating from the Tree of Life. (It is only *after the Fall*, when Adam and Eve are expelled from the garden, that they are denied access to that fruit.) So the original proscription applies *only* to the Tree of Knowledge. But even to call it the Tree of Knowledge is misleading. It is a tree of one particular kind of knowledge: *the knowledge of good and evil.*

> And the Lord God commanded the man, "You may freely eat of every tree of the garden; but of the tree of the knowledge of good and evil you shall not eat, for in the day that you eat of it you shall die."
>
> (*Genesis* 2:16–17)[2]

So what does Adam lack as he faces the task of judgment in Eden? He *seems* (I emphasize the qualification here, to which we shall have to return) to lack two things. He lacks self-consciousness, which emerges only as the outcome of the story. And he lacks knowledge of good and evil, which he obtains only as the result of eating the forbidden fruit. One of my main concerns in what follows is to understand the relation between these two deficiencies.

Three problems

One way to make progress on big unmanageable themes is to look for theoretically tractable problems. So what are the problems or puzzles in this area? At least initially, I want to focus on three.

Adam's ethical problem: The first problem is Adam's problem. He has to decide what to do. I call this an ethical problem because I think of ethics as being concerned very generally with the problem of knowing what to do. So what should Adam do? He's got God's command on one side; he's got the prompting of his wife on the other. He's got to choose between the two most important figures in his still-new life. And he's got to choose, among other things, between abstinence and indulgence, and between ignorance and knowledge. So what should he do? In posing this ethical problem we shall have to be careful to distinguish two different ways of posing the question. We can ask, from *our* perspective, what it would be best for Adam to do. But we also have to try to consider the question from Adam's perspective: given what *he* knows and given what he *lacks*, how should *he* go about deciding what to do?

A phenomenological problem: This brings us to the second problem – or rather: to a whole thicket of problems. For as we have seen, one of the crucial things that Adam seems to lack is knowledge of good and evil. This is part of what makes the ethical question for us so different from the ethical question for Adam. *We* have a rich and complex capacity to draw ethical distinctions, to orient ourselves in normative space. So when *we* think about Adam's ethical problem we bring all that normative orientation to the task. Hence *we* might say: he ought to refuse the apple, because God forbade it, and because he owes obedience to his creator. Or *we* might say: he ought to *eat* the apple, because knowledge of good and evil is itself a very fundamental good, and God's attempt to deprive him of that knowledge is itself a form of reprehensible enforced subjugation. And then, once both of these thoughts have occurred to us, we might go about the tricky business of trying to adjudicate between them. But of course neither of these thoughts can occur to Adam, if indeed he is deprived of the knowledge of good and evil. With this we confront a first version of the phenomenological problem, which we might initially formulate as follows: What can it be like to deliberate (to undertake to form a judgment about what to do) in the absence of

self-consciousness and the normative orientation provided by knowledge of good and evil?

A theological problem: Some version of the phenomenological problem is my ultimate target here. But I propose to approach it indirectly – in large part because I simply don't know how to approach it directly. My indirect approach takes me by way of a specifically theological problem, which in the end will occupy quite a lot of my attention. It will take some effort to find a suitably refined formulation of the theological problem, but we can start with some rough approximations. One might pose the puzzle in the context of God's curse on Adam and Eve (*Genesis* 3:14–19). Here one might ask: How can such a spectacularly disproportionate punishment possibly be considered just? Or to put the point slightly differently, but in a way that really presses the issue: How could anyone who imposed such a punishment possibly be considered good? Yet another framing of the question might appeal to authorial strategy. Let's assume that Moses (using that name here as a convenient device for referring to the author or authors of *Genesis*) intended the story of the Creation and the Fall to establish, among other things, an account of God as worthy of respect, obedience, and worship. Working with this assumption we can then ask, in effect, how the story was meant to succeed at this task, given what would seem to be a profound divine injustice perpetuated at the outset. But I am not satisfied with any of these formulations, mainly because they all focus our attention on the issue of God's curse. The nub of the problem that shall concern me lies not in the punishment but in the original commandment. God *forbids* Adam from acquiring knowledge of good and evil! How can we make sense of *that*?

It is important to pause at this point in order to let this question sink in. For many of us, the story of Adam and Eve is one of those well-worn and utterly familiar stories about which we may never have had occasion to think very seriously. Or if we have thought about it seriously, our thinking may have focused on the spectacular act of creation, and then on the transgression, banishment, and irrecoverable loss. We tend to pass over the matter that crucially concerns me here. Even among serious and active believers within the Judeo-Christian tradition it is surprisingly common to find confusion over which fruit was actually forbidden. Among Cranach's own contemporaries, no less a figure than Erasmus makes a basic theological error on just this point. Addressing himself to the issue of Eve's temptation by the serpent, he writes:

> In Eve obviously not only the will was weakened, but also reason and intellect, the fountain of all good or all evil. It seems that the snake succeeded in persuading her that the Lord's prohibition to eat *from the tree of life* was vain.
>
> (Erasmus 2005: 20)

But of course it was not the tree of life that was forbidden; it was the tree of the knowledge of good and evil. Or consider the case of St. John Chrysostom, an influential early Christian commentator on Genesis, and an important figure in the Eastern Orthodox church. His *Homilies on Genesis* (third century AD) provide a line-by-line commentary on the Eden narrative. Regarding the commandment at *Genesis* 2:17 he writes simply, "No great difficulty in this instruction" (Chrysostom 1992: 186). But there *is* a great difficulty, and it is one that places enormous pressure both on our basic understanding of the Judeo-Christian God and on our understanding of the circumstance of Adam's judgment.

I realize that I am now treading on dangerous ground. I want to be clear that I don't intend to use these theological problems to mount some kind of challenge to Judeo-Christian theism. There is an obvious way in which they could be used to that end, but that is not my purpose here.[3] Instead I want to think about this from within the Judeo-Christian theological tradition. In that context (which is certainly the context from within Cranach paints) the theological challenge is to think through the puzzle, and to explore the various ways in which it might be approached, dismissed, or resolved.

In thinking about this, I find it useful to frame the issues as a theodicy problem. A traditional theodicy comprises a theology and a cosmology intended to reconcile the apparently inconsistent orthodox commitments concerning the existence of evil and the power and goodness of God. I shall not here be concerned with the problem of evil in the usual sense, but with a variant of the theodicy challenge that applies specifically to the story of Adam and Eve. The crucial link lies in the idea that the *Genesis* narrative, like the existence of evil, presents us with a certain kind of fundamental obstacle to comprehending the goodness, justice, and what we might call the worship-worthiness of God. Accordingly one is faced with the task, so to speak, of "justify[ing] the ways of God to man [or to (human) reason]" (Milton 2003: Book 1, 26). And of course that is exactly the business of theodicy, traditionally understood. In the case of the *Genesis* narrative, the challenge is to propose an interpretation of the story which yields a worship-worthy God. The problem in this case is not so much that God *allows* evil to exist, but that God himself seems to *perpetrate an injustice*.[4]

But why exactly should the Eden story present a theodicy problem at all? I have already hinted at this, but it is worth trying to state the puzzle more explicitly. In doing so it helps to think about the events in Eden as a defense lawyer might. After all, doesn't the basic circumstance in Eden look suspiciously like a set-up? If only Adam and Eve had the benefit of good legal counsel, they could surely have had the whole case against them dismissed as entrapment. They were placed in the garden alongside the tree; they were given the command not to eat of it; *but they were specifically denied what they needed in order to recognize that eating from the tree would be a bad thing to do*. If they don't have knowledge of good and evil then surely

110

they don't know what good is. In that case they cannot know that following God's commandments is good, so they can hardly be blamed for eating the fruit they found there. So how can God hold them responsible for doing what they did? Why would he have denied them exactly the knowledge they needed in order to navigate the circumstance in which he placed them? And if he did indeed hold them responsible in such a circumstance, how can we then think of such a God as just and good? These last questions may sound rhetorical but they are not meant to be. I want to take these as serious theological questions and think carefully about the options that are available for answering them.

I hope it is beginning to become clear that there is an important point of intersection between the theological problem and the phenomenological problem. If a bird eats the last fruit from my cherry tree I may be disappointed and even angry. I might decide on various measures to try to protect my fruit in the future. But it wouldn't really make sense for me to hold the bird *responsible* or to punish it for what it had done; it was just doing its birdish thing. If, on the contrary, my neighbor breaks into my garden to eat the last of my cherries, I hold *him* responsible. Why? Well it seems to me that the crucial fact about my neighbor is that he *decided* to do what he did. His action was an expression of his decision about what to do, and of his judgment about what is worth doing. By my measure that by itself brings him into the realm of ethical assessment, thereby engaging a range of "reactive attitudes," to use Strawson's phrase (1963), that would be wholly inappropriate if applied to the bird. In just this way, the theological and phenomenological problems intersect. The intelligibility of God's stance toward Adam seems to presuppose that Adam's action itself is judgmental. If this is right then it seems that a solution to the theological problem must implicate the phenomenological problem. What can it be like for Adam to deliberate, how can he undertake an ethical judgment, if he lacks self-consciousness and knowledge of good and evil?

Cranach's Adam and the theodicy problem

With this theoretical framework in hand I turn now to consider Cranach. I want to show that Cranach worries about these sorts of questions, and that in his paintings of Eden he explores some answers. In the first instance I propose to use Cranach to explore the theological problems, but my hope is then to use his work to leverage some insight on the phenomenological problems as well. In doing so my attention will center on one painting in particular: Cranach's 1526 painting of Adam and Eve, which since 1947 has been in the care of the Courtauld Institute in London (Plate 18). In what follows I shall refer to this work simply as "the Courtauld Cranach" or "the Courtauld *Adam and Eve*."[5] In it we see Adam and Eve on a single wood panel, standing on either side of a very phallic tree. They are surrounded by

111

a number of animals; the serpent hangs from the tree. At the center of the painting is the apple, already bitten, which Eve is handing to Adam, who is shown in Cranach's preferred pose, scratching his head and pondering his dilemma.

In thinking about Cranach's approach to the theodicy problem, the first thing to note is the way in which he makes the problem harder. As we have seen, a theodicy problem arises in this context because God holds Adam responsible for an ethical judgment that he must make without the cognitive capacities he would need in order to make it well. Cranach makes this problem harder by making Adam's fall seem like a foregone conclusion, perhaps even a necessity. Was it *ever* possible that Adam might have kept to his observance of God's command, given the way God had devised the circumstances? Cranach's rendering strongly suggests that the answer is no. The first hint of this comes in the look of bewilderment that Cranach gives to Adam. In sharp contrast to Eve, whose face clearly reflects her new-found state of knowing, Adam's expression seems to be one of bafflement. This is a theme that is explored in a number of Cranach's Eden paintings, where Adam is sometimes made to seem either bestial or infantile.[6] If Eve is knowing and alert, Adam has the look of someone still waking up from a deep sleep. But what really seals Adam's fate here is the way in which Cranach renders Eve. In short, Eve is presented in such a way as to suggest a very strong allegiance with the serpent. The two share a common curving form, which was not at all standard in contemporary representations of Eve. And in Eve's eyes we can see an unmistakable echo of the shape of the eyes of the serpent. As we shall see again and again, part of the genius of the Courtauld Cranach lies in the subtlety of this sort of detail, but in a number of other works Cranach is *much* more explicit. In the Courtauld Cranach we see the woman as a kind of snake, but in a series of works Cranach presents the snake as a woman – with the upper body and head of a woman set atop the tail of a serpent.[7] In one particularly striking woodcut the two figures are virtually twins of one another (Plate 19).[8] It should be clear that this makes Adam's whole situation all the more dire. After all, Eve is his only companion, the only one with whom he might try to think through his decision. Moreover, the Biblical text makes much of how she is specifically introduced as a fitting companion for Adam, after he failed to find any suitable companion among all the other animals of Eden. So as Adam now faces this hideous and momentous decision, the deck seems utterly stacked against him: he lacks the knowledge and experience he desperately requires, and his one obvious ally and companion is in some kind of deep metaphysical alliance (or even identity) with the serpent.

Here we have come close to one of the heated theological debates of Cranach's own time. For the idea that the Fall was necessary was in fact the position of one of Cranach's closest friends, the godfather of his daughter, father of his godson, and the subject of several of his most famous portraits:

PLATE SECTION

Note to reader: full titles, name of the artist and further details for these plates can be found on page vii of the preliminary matter. Published with permission (see pages xiii–xv).

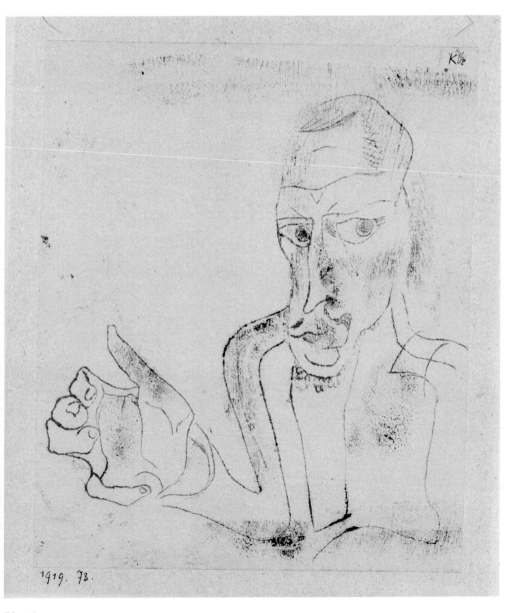

Plate 1

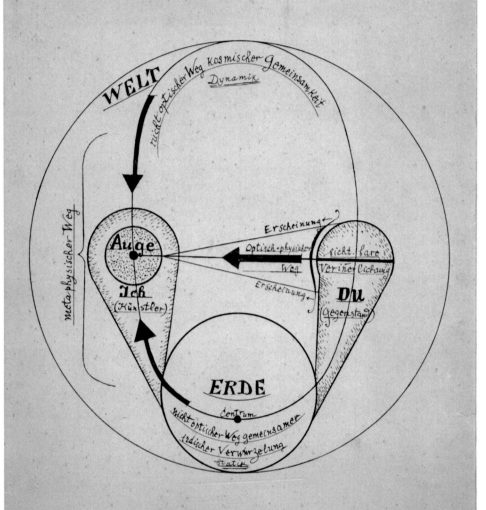

Plate 2

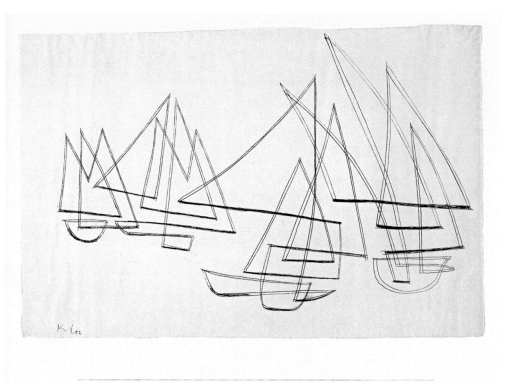

Plate 3

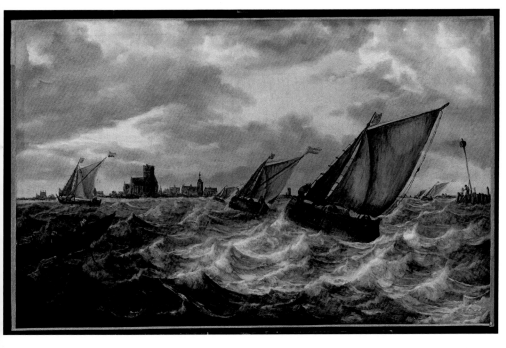

Plate 4

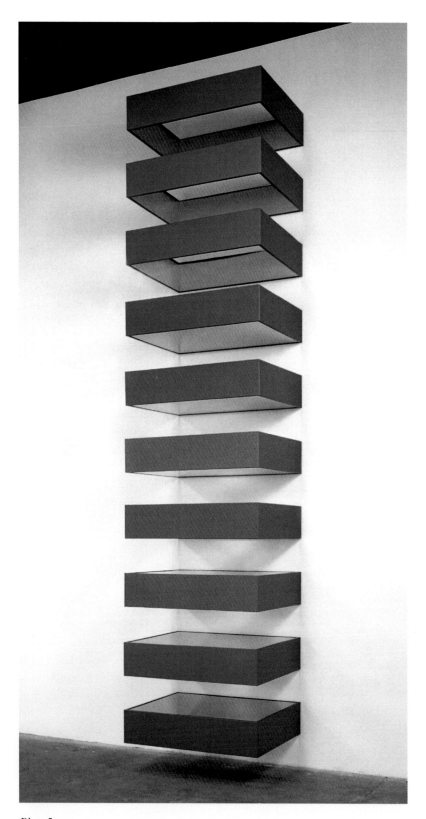

Plate 5

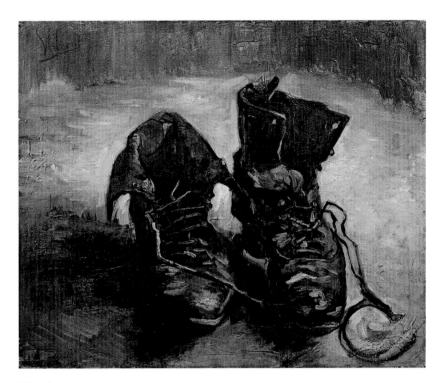

Plate 6

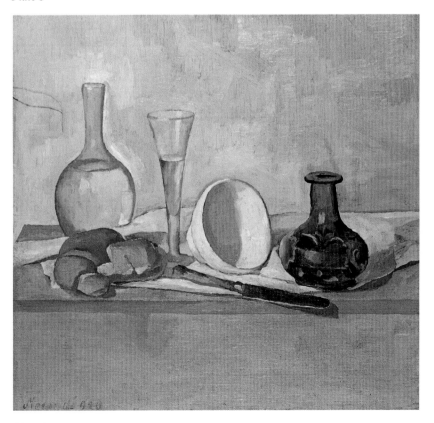

Plate 7

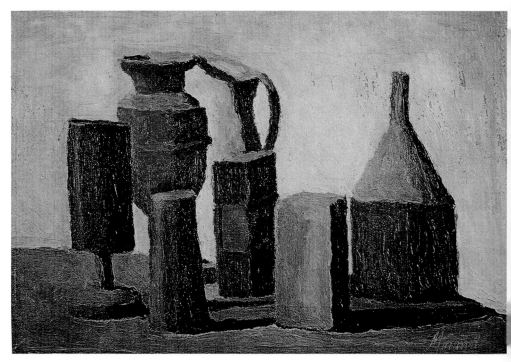

Plate 8

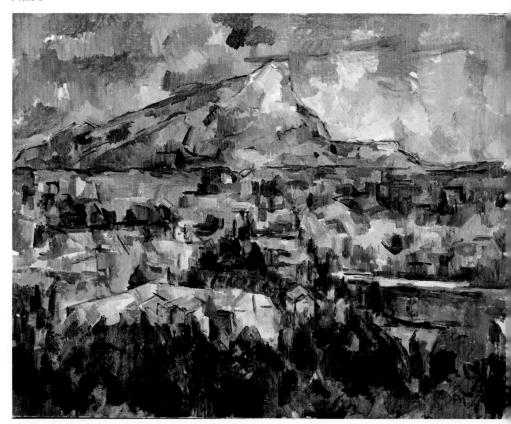

Plate 9

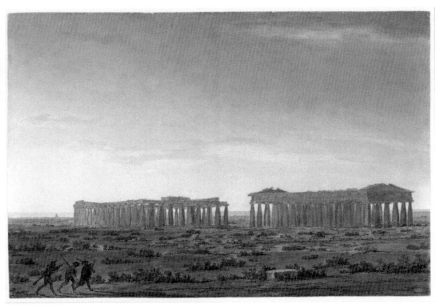

Plate 10

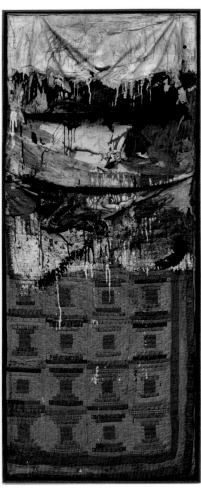

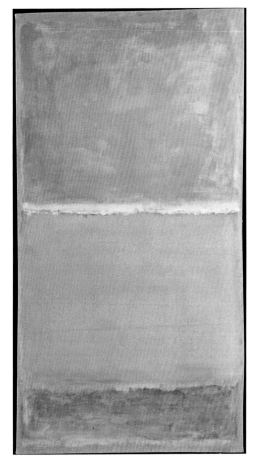

Plate 11

Plate 12

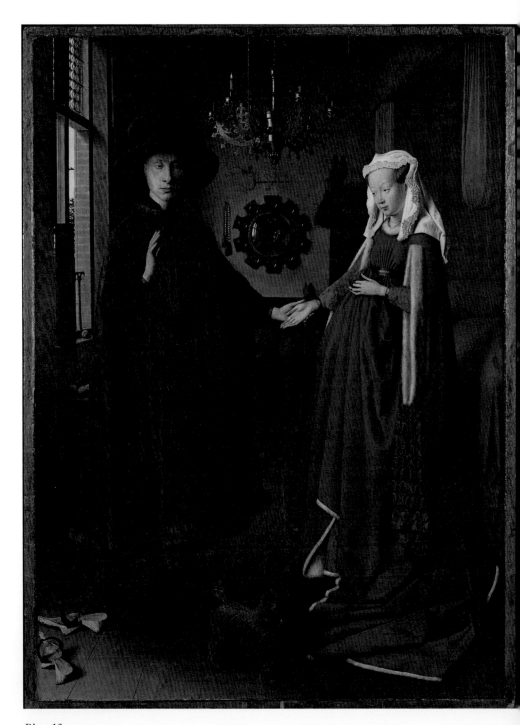

Plate 13

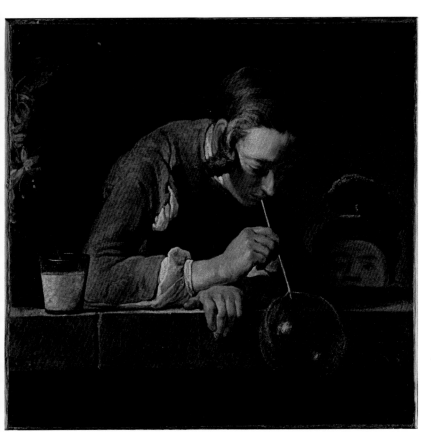

Plate 14

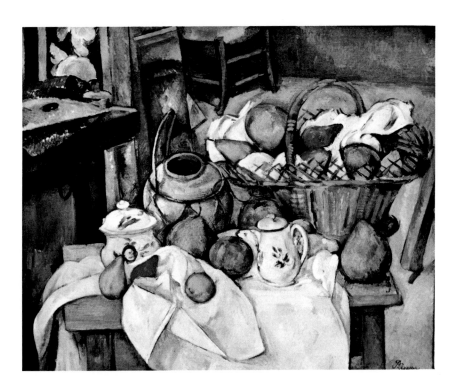

Plate 15

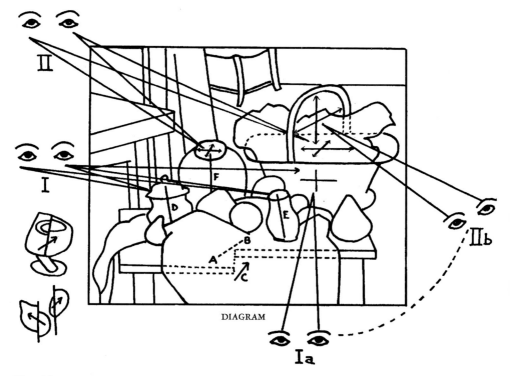

DIAGRAM

Plate 16

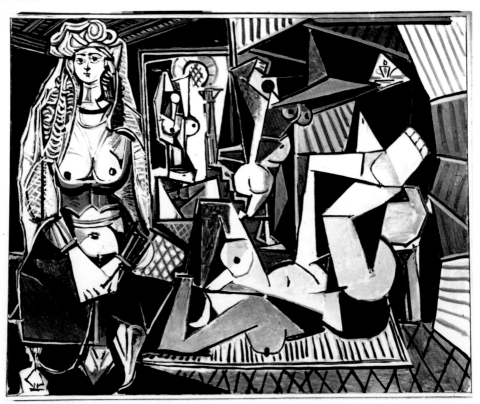

Plate 17

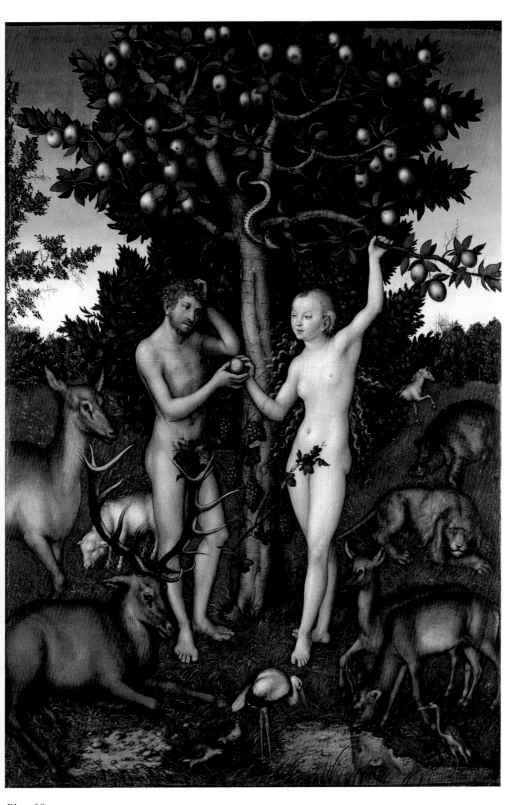

Plate 18

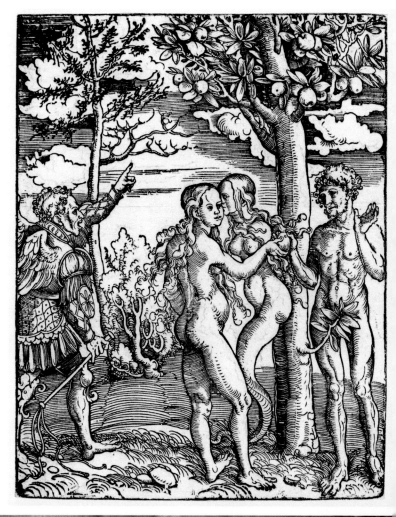

Plate 19

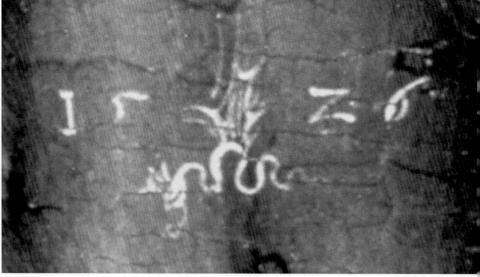

Plate 20

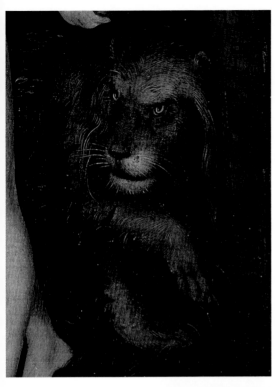

Plate 21

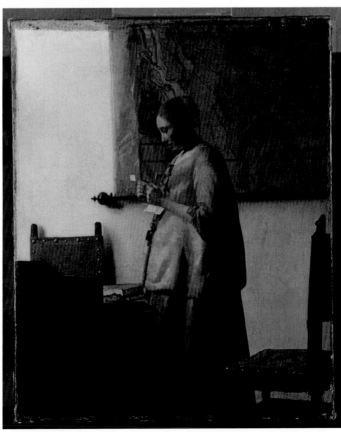

Plate 22

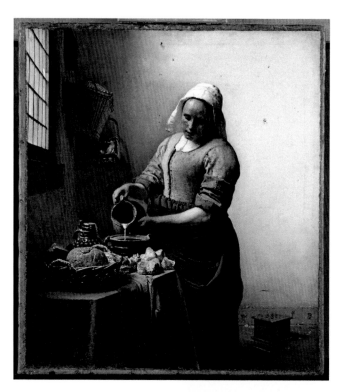

Plate 23

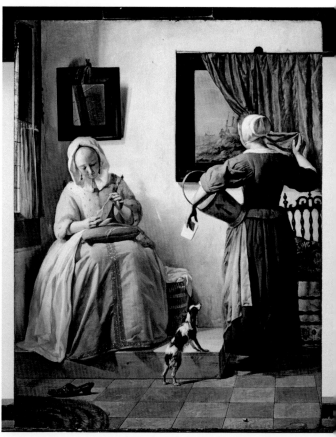

Plate 24

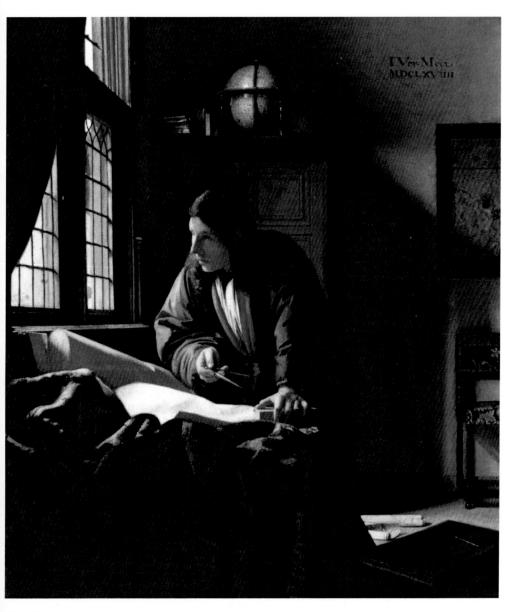

Plate 25

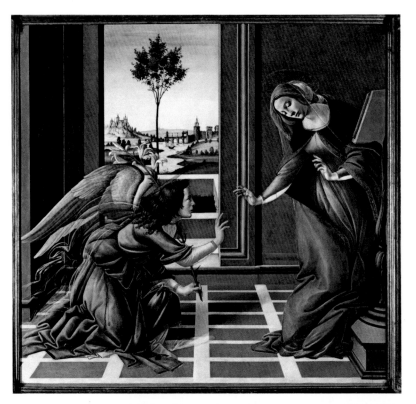

Plate 26

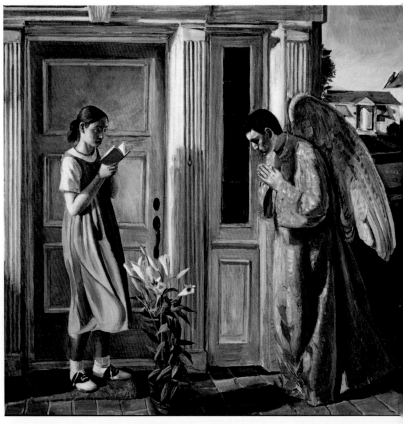

Plate 27

the Protestant Reformer, Martin Luther. Luther himself wrote at great length on the Fall. At Wittenberg his lectures on *Genesis* went on for ten years, filling in the end thousands of manuscript pages. In the 1520s Luther was engaged in a heated public exchange with Erasmus, in which he argued uncompromisingly *against* the possibility of human free will.[9] Both in 1525 and in 1526 (the year of the Courtauld Cranach), Luther sat to have his portrait painted by his friend.[10] I imagine the conversation in that studio turning to a topic of deep common interest: the circumstance of Adam in Eden.

But I am in danger of veering off into fiction, so let me try to get back closer to the facts. At the very least we can say that Cranach makes our theodicy problem harder – or better: that he takes up Luther's particularly hard framing of the challenge. God, it seems clear, has set Adam up for the Fall. He fails to supply Adam with knowledge of the difference between good and evil and he expressly forbids him from acquiring it for himself. And then, to make matters worse, he creates a companion who is deeply in league with the tempting serpent. Poor Adam doesn't stand a chance. So how can Cranach possibly justify the ways of such a God to man? As a first step in tackling this question it will be useful to consider a crucial detail in Luther's approach to this difficulty.

Luther and the tree of knowledge

In framing our theodicy problem I have placed the emphasis specifically on God's injunction to Adam: the prohibition against eating the forbidden fruit. And as we have seen, the problem gets its sharp edge because of the particular tree whose fruit God forbids. Suppose God had simply forbidden the eating of cherries, for instance. Adam would then have been denied a particular pleasure, to be sure; he would still have faced an ethical problem in deciding whether to obey his creator. But we wouldn't face the theodicy problem as we now face it. It is because the prohibition applies specifically to the tree of the knowledge of good and evil that God's instruction seems tantamount to a *proscription on moral knowledge*. It is largely this implica-tion that makes Adam's situation seem so dire – and makes God's design seem so perverse. It is interesting, then, that it is just this implication that Luther's account is carefully contrived to avoid. Let me briefly consider how this works in detail.

Genesis 2:9 is where we first hear of the two trees in Eden: "Also the tree of life was in the midst of Paradise, and the tree of the knowledge of good and evil." In his commentary on *Genesis*, Luther goes on at considerable length about this particular passage, starting with a surprisingly detailed excursus on the particular powers of the *first* tree: the tree of life. Remember that the fruit of the tree of life is *not* forbidden; according to Luther it plays a crucial role in sustaining Adam and Even in their life in the

garden. Not only does it assure "a long and healthy life in a state of perpetual youth" (Luther 1958ff: vol. 1, 93), it also provides a wide range of specific medicinal benefits. Luther himself is particularly interested in its powers as an aid to digestion. At one point he writes of Adam: "He would have eaten, he would have drunk; and the conversion of food in his body would have taken place – but not in such a disgusting manner as now" (Luther 1958ff: vol. 1, 92).

But what about the other tree, the crucial tree, the tree of the knowledge of good and evil? Luther's comments on this matter begin with an observation about its name. Whereas the tree of life took its name from the specific nutritional and medicinal properties associated with its fruit, Luther claims that the second tree took *its* name *"from the event which lay in the future"* (Luther 1958ff: vol. 1, 93, emphasis added).[11] The event which Luther has in mind is of course the event of the Fall. Here again it is crucial to keep our epistemic accounting straight. *We know* that the second tree was to be the site of the fateful transgression and expulsion. So *we know* the role that the tree was destined to play in Adam's initiation into moral knowledge. But of course *Adam* didn't know any of that at the outset; so the name only makes sense in retrospect. From this asymmetry in the matter of nomenclature, some rather significant consequences follow. In order to see them we will now need to think not just as defense lawyers but as semantic theorists.

Allow me to take a rather formal approach to this particular part of the problem. I want to make use of a semantic distinction between what I will call a *de dicto* and a *de re* imperative. To see the relevant distinction, let's briefly switch mythological traditions. Imagine a mother advising her son on matters of love and marriage. Perhaps her name is Jocasta. Let's suppose that Jocasta sits down with her son and instructs him, saying "Don't marry the first girl you meet." Here we have a *de dicto* imperative. Jocasta doesn't know *which* girl her son will meet first; but her imperative applies to that girl, whoever she turns out to be. But now suppose Jocasta goes on to tell her son: "And for heaven's sake, don't marry me!" In this case we have a *de re* imperative, since it applies to one particular woman, no matter what else may be true of her. The crucial thing is that the *de dicto* imperative specifies the forbidden object in virtue of a particular description that applies to it. The *de re* imperative specifies its object in a way that is independent of further description – in this case by indexical ostension.

With this semantic distinction in hand we can now construct two quite different versions of God's injunction about eating the forbidden fruit. In both cases the injunction applies to the same object, but that object is picked out in two quite different ways. Recall again the formulation at *Genesis* 2:17: "of the tree of the knowledge of good and evil you shall not eat[.]" On a *de dicto* interpretation, God's imperative applies to the tree in question in virtue of its being the tree that satisfies the relevant description.

It is *precisely* because it is the tree of the knowledge of good and evil that God's imperative applies to it. Understood as a *de re* imperative, however, the command applies to that tree no matter what kind of tree it is. Here it might help to imagine God and Adam, standing together in front of the tree; God points and says simply "Don't eat from *that tree*."[12] If he goes on to call it the tree of the knowledge of good and evil, he uses this expression strictly as a proper name rather than as a reference-fixing definite description.

What I want to propose, then, is that on Luther's account of the name of the tree, God's imperative is best understood as a *de re* imperative. It really doesn't matter *what kind* of tree it is; all that matters is that God's commandment applies to it. The *de dicto* imperative is at best intelligible retrospectively, if Luther is right about the matter of its name. How does this help with our theodicy problem? The key thing is that on the *de re* interpretation of the imperative, we no longer have license for the implication that caused so much trouble, since God's command is *not* to be understood as a proscription on moral knowledge at all.

So why *did* God prohibit eating of this particular tree? To this Luther also has a brilliant answer. They *needed* that tree, he claims, every bit as much as they needed the tree of life. Why? *It was their temple* – a place where they could express their "worship and reverence toward God" (Luther 1958ff: vol. 1, 94).[13] Luther:

> [God] now builds him, as it were, a temple that he may worship Him and thank the God who has so kindly bestowed all these things on him. Today in our churches we have an altar for the administration of the Eucharist, and we have platforms or pulpits for teaching the people. These objects were built not only to meet a need but also to create a solemn atmosphere. But this tree of the knowledge of good and evil was Adam's church, altar, and pulpit. Here he was to yield to God the obedience he owed, give recognition to the Word and will of God, and call upon God for aid against temptation.
>
> (Luther 1958ff: vol. 1, 94–95)

In short, Adam worships God specifically through the exercise of his own restraint. Here it is crucial that Adam has *no reason* to abstain from the fruit save for the fact that God had prohibited its consumption.

I won't go further into the details of Luther's rather expansive discussion of these matters at this stage.[14] I want to return to consider two other aspects of his position below, but for now we have seen enough to recognize one crucial element of his approach to the theodicy problem – an element of which we shall find traces in Cranach's art. By itself, however, Luther's ingenious account of the tree cannot suffice to resolve the theodicy problem altogether. Certainly he takes some of the sharp edge off the challenge by

providing an escape from the particularly unpalatable idea that God's first commandment is to proscribe moral knowledge. But we are still left with a residual version of the puzzle, as long as we still allow that Adam gains his knowledge of good and evil only as a consequence of his transgression. Even on Luther's account, it is only when Adam eats from the tree that he gains his moral knowledge. That, after all, is how Luther thinks the tree got its name. But if Adam *gains* his moral knowledge upon eating the fruit, then surely he *lacked* it prior to his transgression. Theologically this is still a problem, since it means that God placed Adam in a grave circumstance requiring ethical judgment, yet failed to supply him with the knowledge he needed to understand his ethical challenge. Phenomenologically we are left with effectively the same problem as ever, insofar as Adam faces his momentous task of judgment *prior* to the acquisition of the self-consciousness and ethical knowledge that came about only as a consequence of his decision. So the question is: Can we make sense of such an act of judgment? I turn now to Cranach to look for help with these matters.

Cranach's serpent

So what if anything does Cranach have to say or show about our theodicy problem? We have already seen the ways in which he makes the problem seem harder, emphasizing Adam's apparent incompetence, Eve's alliance with evil, and the seeming inevitability of the Fall. But does he have any suggestions about how the problem might be solved? In broaching this question I want to start by thinking specifically about how Cranach *signs* his painting – the most direct and literal way in which he puts his own mark on the ancient story.

The first thing to note in this connection concerns the *placement* of Cranach's signature. In most of his other paintings Cranach follows the usual practice of placing his signature somewhere along the bottom margin of the canvas or panel. But in his paintings of Eden Cranach often takes a very different approach. In the earliest woodcut of Adam and Eve he identifies himself by showing his own personal coat of arms nailed to the tree of knowledge alongside the emblems of his patron – almost as if he were claiming the tree as a possession (Campbell 2007: no. 12). In the Courtauld Cranach the placement of the signature is more subtle but if anything even bolder: he shows his signature on the central stem of the tree of knowledge, just below the point where the branches spread out from the trunk (Plate 20). It is presented there almost as if Cranach himself had been present in Eden, and had managed to carve his graffiti directly into the bark of the forbidden tree. The second point to note about Cranach's signature concerns its form. Indeed in this instance we can only speak of a *signature* in the most literal sense of the word. Cranach does not sign the painting with his

name, or even with his initials, but with his own stylized personal symbol. And what sign does he adopt? It is the sign of the serpent.

Already in 1508 – shortly before his earliest surviving woodcut of Adam – Cranach had been formally granted the symbol of "a crowned and bat-winged serpent" to use as his personal heraldic symbol. In many (though by no means all) of his subsequent paintings, he uses it in place of his name to mark authorship of his works; eventually it would become the hallmark for his enormously successful workshop. In the context of a painting of Eden, however, the sign of the serpent takes on a special significance; as we have seen, Cranach goes out of his way to exploit it. To one of his pious contemporaries, and indeed even for us, it is disturbing, even shocking, to note that the painter of this work seems to ally himself so explicitly with the figure in the story associated with the devil and evil. Here is Cranach, in the guise of a serpent, carving his name on the sacred forbidden tree, aligning himself with the tempting snake, who hangs from the branches just above. Before thinking about just what this must mean, we should first recognize the ways in which Cranach uses the form of his serpent to tie together different elements of the picture. For once we are alerted to the form of Cranach's symbol, we begin to see it iterated elsewhere in the painting. Its form is in the snake itself, of course, which is itself echoed in Eve's lithe and curving form. But it is in Eve's hair that the serpentine form is perhaps most spectacular, and in which the formal connection to Cranach's symbol is most evident. The serpent that Cranach uses as his own emblem is quite stylized and simplified: a simple curved line, up and down and up again, with a few sparse lines to indicate wings and crown. This same curving form, in much the same rhythm and scale, is repeated over and over and over again in Eve's corkscrew hair. So Cranach shocks us – or at least he shocks me. Here is a presumably pious Christian, exploring this foundational Biblical story, but presenting it in a context that brings woman, the serpent, the painter, and painting itself into a systematic symbolic alignment. To all appearances it is an alignment with evil. Now this alignment is not accidental, or so I want to argue, shocking though it may be. But neither does it represent a departure from Cranach's deeply Christian vision. Indeed I believe that it provides a crucial clue to his theodicy. Let me take these three points in turn.

The alignment is not accidental. There is relatively little direct information about the source or basis of Cranach's coat of arms. We do know that Cranach traveled to Nuremberg to be granted his heraldic letter in person by the Elector (Campbell 2007: 10). His armorial brevet – the document establishing his heraldic rights – is dated January 8, 1508 (Friedländer and Rosenberg 1978: 18), but traces of his experimentation with the symbol can be found much earlier.[15] Some scholars have speculated that the choice of emblem may have been connected with Cranach's interests in alchemy. It is possible that Cranach's brazen association of his snake with the tree of knowledge was intended as a cryptic advertisement of his possession of

forbidden and secret alchemical knowledge.[16] In the context of the *Genesis* narrative, however, the snake is of course the tempter, and also (at least by tradition) the deceiver. Here we should recognize that there is indeed an important sense in which Cranach – now specifically as painter rather than as alchemist – really is in deep allegiance with the snake. For of course the art of painting is itself an art of deception, making us see Eden where in fact there is only oily wood. And in Cranach's case it is a sort of seduction as well. Among his contemporaries, Cranach was celebrated for his sensuous human figures, and his rendering of the figures in Eden itself figures as a kind of seduction of the eye of the viewer. (In this connection it is instructive to contrast Cranach's rendering of Adam and Eve with that of his contemporary and rival, Albrecht Dürer. Dürer's figures seem designed to inspire; Cranach's to arouse.) In this sense, then, the alliance or symbolic allegiance of snake, woman, and painter is perfectly apt. In the context of Cranach's theme and execution here, all three are seductive deceivers. Indeed we might even say that the technique of Cranach's signature serves to place the work in the long tradition of the allegory of painting: through his use of the serpent Cranach lets the painting make a point about the art of painting itself.

But nonetheless this alliance with the serpent does *not* represent a break from Cranach's deeply Christian allegiance. This was my second point. We can see this by following out the final iteration of the serpentine form in the painting. It is present not simply in Cranach's signature and in the snake, not simply in Eve's form and hair. We find it once again, albeit this time much less conspicuously, in the tendrils of the vine that grows up from the base of the tree of the knowledge of good and evil. These tendrils, I want to suggest, form one of the keys to the painting. It is quite important, I believe, that they are *not* painted to be conspicuous. If one looks for serpentine forms in the painting, one will find them first in the serpent, then in Eve and her hair, later in Cranach's signature, and only finally in the tendrils of the vine. In this progression we can trace the cultivation of a problem and the proposing of a solution.

As we have seen, the centerpiece of Cranach's 1526 painting is the tree of the knowledge of good and evil. Its central stem provides the strong vertical center of the painting, dividing Adam from Eve. And of course the tree itself provides the setting for the action of the scene. Growing from the base of the tree Cranach places a robust vine, strong enough to stand and climb and sustain its own weight, though it is in full leaf and weighted down with large clusters of ripe grapes. One function of the vine is obvious: its leaves are strategically placed so as to preserve the modesty of the two figures, in the usual mode of the period. But in this case the vine has a further, unmistakable iconographic significance as well. In Cranach's world, a grape vine is immediately recognizable as a symbol of the Eucharist – of the blood of Christ and the sacrament of holy communion. As we shall see in fuller detail

below, this is one of a cascade of Christian references in the painting. While the setting of the story may derive from the Judaic Torah, Cranach's rendering of the scene – and, I shall argue, his solution to the theological problems it presents – is unmistakably Christian.

What place does this reference to the Eucharist have in the theological structure of the painting? The basic answer is fairly straightforward. The vine here is a reference to the blood of Christ, and to the wine drunk at holy communion. (Recall here Luther's point about the tree as Adam's altar.) In this way it refers to the so-called "new covenant" – the new deal between God and man marked by Christ's death and resurrection. The painting itself is a representation of the old covenant – or perhaps we should say instead: the *original* covenant. We can think of a covenant as an agreement or promise or contract governing the relation between God and man. In the Old Testament account of the wanderings of the tribe of Israel, the basis of the covenant is God's law (*torah*), as given to Moses. God promises the Israelites protection and guidance and a homeland; in exchange he demands that they conform to the Mosaic Law. But of course the Mosaic covenant is not yet part of the story in *Genesis*. In Eden man's relation to God is governed by a prior covenant. God creates man, provides him with the garden, and creates a partner for him; but he also makes demands on his human creations, conditions governing their life in Paradise.

Once we express the circumstances in these terms, we can also formulate a revised statement of our original theological difficulty. The basic theological problem is that this original covenant is a bum deal, since Adam has been created without the basic cognitive and ethical capacities that are needed in order to keep to his side of the bargain. What does Cranach have to say about this? His solution comes into view precisely when we follow the traces of his own personal emblem – from signature to snake to woman to tendril. From the very tree which marks the terms of the original covenant springs a plain sign of the new covenant to come. From a Christian perspective that new Covenant is *required*, for the original covenant placed an impossible demand on human beings, given their distinctive nature as they had been created. I propose that we see the theology of the Courtauld Cranach in exactly these terms: as a visual rendering of the Christian new covenant as a fulfillment of an original covenant that was impossibly flawed when considered in isolation from that subsequent fulfillment.

Once we approach the painting in these terms we can see that the whole work is – unsurprisingly – saturated with Christian imagery. Here is a first level where the animals must come into our analysis. Start with their number. If we set aside the serpent, there are twelve of them: four birds and eight mammals. The choice of animals is laden with significance and is the subject of much discussion; their placement is also of considerable importance. Without entering into some of the more speculative aspects of this sort of analysis, a few observations are worth making. The number

of the animals makes clear reference to Christian theology. Twelve was of course the number of Christ's disciples; so to cast Adam alongside twelve companions is to echo a standard thought of Medieval Christianity – that Christ was the "new Adam." One of the twelve is black, a reference to Christ's betrayal by Judas. Among the animals we find a lamb and a lion – a standard symbol for the Christian hope for peace. There is the stag front and left – a position of intimacy in a painting, and a traditional emblem of Christ. The lamb itself comes into direct relation with the stag, whose fearsome antlers threaten both Adam's genitals and the neck of the lamb. Here recall that the lamb is another a symbol of Christ, and a reminder of the blood sacrifice. The most distant animal, far back and to the right, is a white horse emerging from the thicket. Although I have seen no explicit discussion of this point in the iconographic literature on the painting, this seems to me a plain reference to Christ's resurrection, as a white (blameless) animal emerges from bushes (tomb). Its right front leg is raised implausibly high – an odd gesture that only makes sense iconographically. In the picture plane the white hoof is raised immediately above the body of an ominous black boar: the risen Christ conquering Satan and evil. The placement of the white horse itself has a dramatic formal effect on the work as a whole, for it gives the whole image a depth of field that it otherwise lacks, with the other figures – both human and animal – pressed up against the front of the scene. Within the theological framework that we can now see emerging, this spatial distance signifies a temporal distance. For the events which will fulfill the action in the foreground lie in a still distant future. In sum: the array of animals is carefully contrived so as to embed the Hebrew story of the Fall in a thoroughly Christian context, and in this way to propose an essentially Christian solution to our theodicy problem. In short, we can only understand the events in Eden by remembering that they mark the beginning of a long story; God's goodness and mercy become visible only when we consider the whole arc of the Judeo-Christian narrative.

It is not my purpose here to assess the theological adequacy of this Christian approach to the theodicy problem, nor to follow out the many further theological and ethical questions it raises. What matters for now is to recognize that and how Cranach engages the theodicy problem and constructs the painting so as to explore a solution. But even if we allow that Cranach has shown us a vision of divine justice by this device, we are still left to wonder about poor Adam. Where does Cranach's grand Christian narrative leave him?

Ontological self-consciousness

Up to this point we have been focusing mainly on theological issues raised by Cranach's painting, but I want now to tackle some of the phenomenological problems as well. How (if at all) can we make sense of Adam's

fateful judgment *as an experience*? And what (if anything) does Cranach's painting show us about this matter? I propose to start on these questions by considering not Adam himself, but the natural setting of Adam's judgment as Cranach portrays it. Here it is crucial to notice something of which Cranach's painting insistently reminds us, namely that the events in Eden were events not only in the history of man but in the history of nature. By this I mean that the events of the Fall were to have consequences not only for *human* existence (and for man's relationship to God) but also for the being of nature itself. This is a point that figures in the text of *Genesis*, particularly in the framing of the curse. Recall that when God comes to pronounce his punishment he curses not only Adam and Eve (the transgressors) and the serpent (the tempter); he also curses the earth itself. "*Cursed is the ground because of you*; ... thorns and thistles it shall bring forth for you" (*Genesis* 3:17–18, emphasis added). In introducing thorns and thistles, God is not simply adding a few extra species to his flora. Weeds were not simply *absent* in pre-lapsarian Eden; they were ontologically impossible. Nothing in Eden could have been a weed, given that the plant world as a whole was good without qualification (*Genesis* 1:12) and had been blessed specifically for fulfilling the needs of the creatures who dwelt there (*Genesis* 1:29). But if nature had hitherto been a bountiful and beneficent domain, now it is to be hostile territory which must be battled and subdued in order to reap a harvest. Thorns and thistles can well serve as the emblem for this new ontological order in the natural world.[17]

How does this transformation of nature figure in Cranach's vision? When we look closely, we see that he explores it quite systematically. We see one trace of it in the color of the sky, which shows the familiar hues of nature in transformation. In the various trees of the Garden, a few bare branches bear witness to a change of season that is already underway. But it is in Cranach's animals that this transformation in the natural order is explored most subtly and fruitfully. For the moment I propose to concentrate on one animal in particular: Cranach's lion.

Cranach himself had never seen a lion in person, but lions figure in several of his paintings of Eden, and in a number of other works besides. In the medieval bestiaries, the lion is always the most important animal – the king of the beasts. But more importantly for our purposes the lion is by nature a carnivore, a predator, a hunter. His whole nature, the traits that befit him, the distinctive forms of endeavor and excellence and pleasure appropriate to him – all this is organized around the task of the hunt, the kill, the eating of fresh, still-warm meat. But what about lions in Eden? Are we to imagine them chasing down a deer and tearing it limb from limb, leaving the carcass for a host of lesser animals and scavengers? Certainly not in Cranach's accounting. As we have already seen, in Cranach's paradise, the lamb can lie down with the lion; the deer can drink quietly and utterly without fear from the pond where the lion lurks nearby. The stag sits

with his rack of antlers, undisturbed by the presence of his natural predator immediately at hand. In all this we find the strangely unnatural circumstance of Eden; we also find an important part of the structural tension in Cranach's composition. For of course all this is about to be shattered. The peaceful coexistence is about to change. For now, Adam is scratching his head, but as soon as he bites all the rules will be changed; the result will be a transformation of what nature is, a transformation in the being of nature.

But the key point I want from all this concerns not so much the being of nature in general but rather the very specific being of the lion. *For the lion knows.* Among all the animals in Cranach's Eden, the lion knows what is about to happen – and he is *ready*. He may be lying – or only half lying, half crouching – but he is not at rest. And for the lion, we can now see, this immanent change in the order of nature is a change for the good – for *his* good, for the good of him, given the sort of thing that he is. Think about it: for a hunter, for a predator, for the carnivorous consumer of still-warm meat . . ., well . . . *Eden is hell!* The lion has *not* been able to live according to his distinctive nature; he has *not* been able to exercise the forms of activity befitting the kind of being that he is; he has been denied the things that are appropriate for him. And what has he had to eat? Grass? A few leaves? Fruit? Not even a lousy lizard or bug! (The text of *Genesis* is quite explicit in specifying that the animals in Eden are to be vegetarians.)[18] Indeed now that we think about it, doesn't Cranach's lion look a bit on the gaunt side? Isn't he hungry? Deeply, essentially, metaphysically hungry? But not for long. As soon as Adam takes a bite from that apple the whole order of nature will change. And there, right there, is a plump, unknowing and ever-so-tasty-looking doe: the lion's first solid meal since creation. Notice the lion's gleaming eyes; notice his paws: rear legs poised for the leap, front claws extended, scratching at the ground, head down, waiting for the release for his constraints. Cranach may not have had first-hand experience of lions, but he certainly knew the look of a housecat readying to pounce. (See Plate 21 for a later, more explicit rendering of the lion along these lines.)

Suppose we accept this. The theological transformation brought by Adam's act has consequences for the animals; it is an event in the history of nature; it brings about an ontological transformation; it is good for the lion. How does any of this help with the phenomenological or theological problems from which we began? Allow me to make what may seem an extravagant suggestion. Haven't we in effect just attributed a certain kind of self-consciousness to Cranach's lion? Hasn't Cranach shown us a lion which is in some sense aware of itself, of what kind of being it is, and which accordingly knows exactly what it should do with a plump doe just within claw's reach? I broach these thoughts in the form of questions, since I want to be careful not to make anything in my argument depend on a particular answer to them. But let's suppose for a moment that we think of the lion as possessed of a certain kind of self-consciousness. What kind of self-

consciousness would it have to be? It is not the kind of self-consciousness that will shortly accrue to Adam and Eve; the lion certainly does not know that it is naked and it shows no sign of shame! Nor is the thought that the lion is possessed of the kind of psychological self-presence that would concern the later Cartesian tradition. The form of self-consciousness that is relevant here is what I propose to call *ontological self-consciousness.* As a first attempt, let me define this term as follows: to be ontologically self-conscious is to have a distinctive kind of awareness of one's own being – in particular an awareness of the kind of being one is and about what is good (what is fitting) for a being like that. Notice here that ontological self-consciousness and normative orientation go hand in hand, thus suggesting a possible link between Adam's twin deficiencies.

Once we are attuned to ontological self-consciousness we can recognize that it is very much in play in pre-lapsarian Eden. Cranach's lion has it, I submit; but more importantly: so does Adam. The evidence for this comes from Adam himself, particularly in the words he utters in his pre-lapsarian state. *Genesis* reports only one speech by Adam prior to the Fall, in the final verses of *Genesis* 2. God says at *Genesis* 2:18 that it is not good for man to be alone, and announces his plan to "make a fitting helper for him." At verses 19 and 20 God then creates the animals (in this version of the story their creation comes *after* the creation of Adam), bringing each to Adam, who names them. But no fitting helper is found. Verses 21 and 22 then report on the creation of Eve. It is at *Genesis* 2:23 that we find the only words attributed directly to pre-lapsarian Adam. And what does he say?

> This at last is bone of my bones
> and flesh of my flesh;
> this one shall be called Woman,
> for out of man this one was taken.

This is a passage of considerable importance for my purposes, since in Adam's own speech we can expect to find some hints about his original condition, and in particular about just what he knew prior to eating the apple. And what does he know? He knows, first, what kind of thing he is – for it is only in virtue of this knowledge that he can recognize Eve as belonging to that same kind. And second, this pre-lapsarian knowledge provides him with normative orientation. In particular, it provides him with the orientation he needs in order to recognize both that none among the other animals would make fitting helpmates for him, and that Eve *is* a fitting mate. So Adam, even *before the Fall*, is represented as ontologically self-consciousness: he is aware of the kind of being he is, and he finds himself with a normative orientation grounded in that self-awareness.

One might suppose that we are here within reach of solutions to the problems with which we began. Recall in particular that our theodicy problem

received its sting from the thought that God failed to provide Adam with moral knowledge – or even actively proscribed its acquisition. It was this same thought that made the phenomenological problem seem so vexing: what can it be like to pass judgment on a matter such as this without the benefit of self-consciousness and the normative orientation provided by knowledge of good and evil? But if we take into account Adam's ontological self-consciousness then these problems may admit of resolution. *If* God had failed to provide Adam with ethical knowledge then his treatment of him would have been grossly unjust. But by making Adam ontologically self-conscious he provided him with a very fundamental and powerful form of normative orientation – even if he did not burden him with the explicit and direct experience of good and evil that would come in the wake of the Fall. The lion, in knowing what kind of thing *it* is, can recognize suitable prey and knows the appropriate thing to do with it; Adam, in knowing what kind of thing *he* is, recognizes Eve as a good (fitting, appropriate) mate. So perhaps Adam's pre-lapsarian self-consciousness also suffices for recognizing the majesty of God when brought face to face with *it*, and so for knowing immediately that it is good (fitting, appropriate) for him to obey divine commandments. With this solution to the theodicy problem we might also find a model for thinking about the phenomenology of pre-lapsarian judgment. Adam's ontological self-consciousness gives him a capacity to discriminate and choose appropriately among the options that are presented to him; that much is clear from his discrimination of Eve from among all the potential mates with which he is presented. But as an act of judgment this is not unlike a lion's choice of prey. Both the lion and Adam are endowed with an innate ability to recognize what is fitting for them and to be drawn toward such things in an appropriate manner. In so doing they answer the challenge of choice by relying on a primitive and visceral discriminating response to their environment: *here is something fitting for me, given the kind of thing that I am.*

But we must beware of moving too quickly here; for at least two obstacles stand in the way of this sort of solution. A first problem concerns the adequacy of ontological self-consciousness for the distinctive sort of deliberative circumstance Adam now faces. After all, we don't normally think of lions as being capable of *judgment*, even if they can discriminate and choose appropriate prey while hunting. And part of what seems to be lacking is the capacity to reflect and adjudicate between deeply conflicting considerations and interests. Yet it is just such a conflict with which Adam finds himself confronted. Here it is significant that Adam's pre-lapsarian exercise of ontological self-consciousness comes in the context of an essentially animal choice: the recognition of an organism in his environment as the right sort of thing to have as a mate. A hungry lion sees a fitting doe within reach and so pounces; a lonely Adam recognizes a fitting mate and so bonds with her. In both cases the choices are fitting, and grounded in a sense (however

inchoate) of the kind or way of being of the one who discriminates. But it is far from clear that the primitive ethical orientation and self-knowledge that underwrites these choices can suffice to navigate the vexing ethical problem about the apple. In this way both the theodicy problem and the phenomenological question reassert themselves.

There is a second problem that comes into play if we try to follow this lead in coming to terms with Cranach's painting as a whole. To this point I have been assuming that Adam must be endowed with at least as much self-knowledge and normative orientation as that which we find in the lion. But it is far from clear that this is how Cranach himself sees it. Indeed arguably Cranach's Adam is decidedly worse off than the animals of Eden when it comes to self-consciousness and moral knowledge. Consider first the placement of the animals. Cranach's lion, as we have seen, shows signs of self-knowledge and basic ethical knowledge; but by its position it is associated with the figure of Eve, who has already eaten from the forbidden fruit. The other animals closest to Eve are the pair of roe deer and the two wading birds. These four animals are all arrayed around a pond or puddle, from which one of the deer is drinking. The puddle reflects the eye of the deer, in a striking visual trope for self-consciousness. And of course wading birds spend much of their waking lives gazing into the water. So in the animals most closely associated with Eve, Cranach again and again reinforces the theme of the reflective self. When we look to Adam's side of the tree, by contrast, we see that the puddle is dry and unreflective, and that these tropes of self-consciousness are absent. On this basis we might well take Cranach to be *contrasting* Adam and the lion precisely where we had been relying on their ontological similarity.[19] This suggestion is borne out if we undertake a systematic survey of the eyes in Cranach's painting – a task that can now be carried out with considerable sophistication using the Getty's Cranach Comparison Study Tool.[20] What emerges is a striking asymmetry. With the exception of Adam, all the eyes in the painting are rendered so as to show a reflection of light in the iris. The effect is most striking in Eve, where the reflection, rather anomalously, shows the mortise and transom of a lighted window. But the same device of bright white paint set against a dark background can be found in the eyes of the lion, the deer, even the birds and the distant horse. Adam's irises, by contrast, are utterly dark, reflecting no light whatsoever. Once again Cranach would seem to be *contrasting* Eve and the knowing animals with the unknowing Adam. So while the lion may indeed know what it is and what it should get up to, Cranach's Adam seems utterly bereft. Indeed the more one studies the painting the more this comes to seem his most fundamental feature.

But I don't mean to suggest that this line of interpretation is itself bereft, and in what follows I want to argue that ontological self-consciousness is indeed at the heart of Cranach's concerns in the painting. Indeed – though I shall not be able to argue for this here – I think that ontological

self-consciousness is the major form of self-consciousness that concerned pre-modern traditions. But if we are to develop this approach to Cranach's painting then we need to know more about the distinctive mode of being of pre-lapsarian Adam.

Two Lutheran controversies

Before coming to my conclusion I want to exploit two further leads from Luther. Both emerge in the context of very high profile controversies in the period immediately prior to Cranach's composition of the Courtauld *Adam and Eve*. One concerns matters in what we can broadly call Luther's aesthetic theory; the second bears quite directly on the issue of self-consciousness.

It was in 1522 that Luther emerged from the so-called Wartburg Captivity – the period during which he lived in hiding in Wartburg Castle following his condemnation by the Diet of Worms. The year in Wartburg Castle was an intensely productive one for Luther; it was there, among other things, that he produced his ground-breaking German translation of the New Testament. During this time Luther and Cranach remained in close contact. One of Cranach's most famous portraits dates to this period, with Luther portrayed in his bearded alter-identity as Junker Jörg.[21] When Luther's New Testament was published in September of 1522, the Book of Revelation was illustrated with a series of Cranach woodcuts. But during Luther's absence there was a period of intense civil unrest in Wittenberg, as radical elements in the Reform movement, taking up ideas from Luther's own earlier writings and sermons, moved in increasingly radical directions. The Winter of 1522 in particular saw a series of riotous iconoclastic mobs, traveling from church to church destroying images and icons, including (much to Luther's horror) crucifixes. There was a very real sense in which the reform movement threatened at this point to turn into utter anarchy, just as the Catholic authorities had long warned. It was word of this chaos that brought Luther out of hiding. Upon his return to Wittenberg he delivered eight sermons over the course of eight days – the so-called *Invocavit Sermons*.[22] Given the circumstances it is unthinkable that anyone of any standing in Wittenberg could have ignored what Luther had to say. Given the nature of their friendship and collaboration, it is all-but-certain that Cranach himself was in the congregation. Once again in 1525 there was an outbreak of violent iconoclasm, this time led by an erstwhile follower of Luther's, Andreas von Bodenstein Karlstadt. This time Luther replied with an intensely polemical work entitled, *Against the Heavenly Prophets in the Matter of Images and Sacraments* (Luther 1883ff: vol. 18, 62–214).[23] Given that one of the central issues at stake concerned Cranach's own professional activities (the representation of God!) we can safely assume that Cranach knew *exactly* what Luther had to say on that occasion as well.

It is in the context of the iconoclastic controversy that Luther found himself forced to take up broadly aesthetic issues – about the nature of aesthetic experience, about the character of artistic representation, and of course on the central disputed issue concerning the morality of artistic production. In doing so he sought to carve out a moderate position, a third way between the purported idolatry of Catholic aesthetic practice and the radical iconoclasm of some of his admirers and followers. For obvious reasons, much of the dispute centered on the proper interpretation of the Second Commandment:

> Thou shalt not make unto thee any graven image, or any likeness of any thing that is in heaven above, or that is in the earth beneath, or that is in the water under the earth.
>
> (*Exodus* 20:4)[24]

Karlstadt and his iconoclastic followers argued that the commandment was unambiguous and uncompromising in its banning of images. But Luther insisted that the Second Commandment does not mean quite what it may seem to mean, arguing that what is properly banned is not the *making* but only the *worship* of images.

Two points in the dispute are relevant for our purposes. The first, interestingly, concerns serpents. For a crucial part of Luther's argument, indeed in many ways the final nail designed to close out his case, concerns the so-called brazen serpent described in *Numbers*, chapter 21. In the course of their wanderings, the Israelites are at this point besieged by serpents, sent by God in punishment for their complaining. The serpents bite the people, and many die. The Israelites seek help from Moses, who sets up a brazen serpent on a rod. The crucial passage is *Numbers* 21:8: "Then the Lord said to Moses, 'Make a seraph figure and mount it on a standard. And if anyone who is bitten looks at it, he shall recover.'" It is not entirely clear exactly what a seraph is, but by tradition it is understood that Moses erects a bronze serpent on the sort of pole that would be used to carry a battle standard. In the iconoclastic controversy this passage is of obvious importance, and Luther argues convincingly that the ban on images must be read in such a way as to make sense of this episode. If God here *commands* Moses to make a graven image, then the Second Commandment cannot be quite as straightforward and complete a ban as the iconoclasts make out.

The issue of iconoclasm was both dangerous and persistent in the sixteenth century, and Luther accordingly finds that he must return to it again and again. When he does so he repeatedly adverts to this story of the brazen serpent, which he sees both as a refutation of the iconoclast's radical position and also as an important link between the Old and New Testaments.[25] But from what we have said so far it should be clear that it bears on the interpretation of Cranach's *Adam and Eve* as well. For

Cranach in 1526, iconoclasm was a palpable threat – both to his increasingly successful business and perhaps even to his personal safety. In such a context the image of a serpent mounted on a pole (tree) serves as potent emblem: it is a reference to Luther's argument (which at that point had been recently and emphatically restated in *Against the Heavenly Prophets*) and it is a symbol of the legitimacy of the artistic enterprise, even in the face of the ongoing violent attacks upon it. So we need to add one more point about Cranach's serpent on the tree. Along with all its other significance it serves as a symbol of defiance against the iconoclasts, and as a kind of emblematic refutation of their central Biblical argument.

So far so good. But to this point what we have found in Lutheran aesthetics are essentially negative claims: images should not be worshipped; images are not to be banned. Is there any positive content to Luther's theory of art? I think that there is. At the heart of Luther's response to the iconoclasts we find a simple and oft-quoted maxim: "*Non est disputatio de substantia, sed usu et abusa rerum.*"[26] Paraphrasing: what matters about a work of art is not the thing itself but its use or abuse. This may now seem trivial or even trite, but it turns out to be quite important. It is clear that for Luther the central *abuse* of art is idolatry – or indeed anything that might lead to idolatry. But then what would be a proper *use*? In the polemical work of 1525 Luther proposes this answer:

[I would not condemn] those who have destroyed [images], especially those who destroy divine and idolatrous images. But images *for memorial and witness*, such as crucifixes and images of saints, are to be tolerated. And this is shown above to be the case even in Mosaic law. And they are not only to be tolerated, but for the sake of the *memorial and the witness* they are praiseworthy and honorable.

(Luther 1883ff: vol. 18, 74)[27]

By itself this may not seem much to go on, but it does suggest an important adjustment in our approach to Cranach's painting. So far our interpretation has focused exclusively on the *representational content* of the painting; but to approach it in Luther's terms we must think about its *use* by the sort of viewer for whom it was presumably intended. And in particular we should ask about what kind of "memorial and witness" it might be intended to provide.

The second heated Lutheran controversy from this period was of course the dispute with Erasmus over free will. I shall not here enter into the details of this very public quarrel, which itself threatened to divide Luther's Wittenberg circle.[28] I confine my comments to one particularly striking point in this rather acrimonious exchange. As we have already noted, Erasmus had in 1524 published an anti-Lutheran tract defending free will; Luther responded in 1525 with *On the Bondage of the Will* – his ardent

defense of an uncompromising metaphysical determinism. Unlike later debates on these topics, the debate between Luther and Erasmus was conducted almost entirely at a theological level and centered on the proper interpretation of scripture. One crucial point of controversy in the exchange came to focus on the image of man standing *in bivio* – at a crossroads of choice.[29] As Erasmus sees it, the Bible is filled with gripping tales of man standing at an existential crossroads: Adam's story is one instance, but we can also think of Abraham (whether to sacrifice Isaac), Job (whether to blaspheme), Peter the Apostle (whether to deny Christ), and so on. As Erasmus sees it, God is forever placing man at a crossroads of choice; that is a central message of scripture and a fundamental feature of the human situation. But what could be the sense of being placed at a crossroads if we lack the capacity to choose? Wouldn't it have been perverse – indeed ridiculous – for God to have placed man at the crossroads if he had denied him freedom of the will?

To my ear this sounds like a pretty convincing argument (at least within the agreed confines of the debate), but Luther offers a startling reply:

> Truly, therefore, we are at a crossroads, but only one way is open; or rather no way is open, but by means of the law it is shown how impossible one of them is, namely the way of good, unless God gives the Spirit, and how broad and easy the other is if God allows us to take it. It would not be ridiculous, therefore, but a matter of due seriousness, to say to a man standing at a crossroads, "Take which way you like," – if he was either inclined to imagine himself strong when he was weak, or was contending that neither road was closed.
>
> (Luther 1883ff: vol. 18, 677)[30]

I find this a very disturbing passage. Luther here effectively embraces the paradox that Erasmus had used for his *reductio* of the determinist position. According to Luther, God *does* put man at the crossroads; he *does* effectively say "Take which way you like"; and yet he *does not* endow the man at the crossroads with free will or the capacity to choose. In fact there is only one path available. What can be the point of such a perverse contrivance? Here we are very close indeed to the nub of the theodicy challenge. And Luther's answer seems to be that such a contrivance is *not* perverse, is not "ridiculous," as Erasmus had alleged; rather it is a circumstance *designed by God to provide the man at the crossroads with a kind of self-knowledge or self-awareness* – or as I would put it: to teach him something about his own ontological constitution.

This is a thought that is echoed in a number of related passages in the Lutheran corpus, and was certainly a Lutheran doctrine with which Cranach was familiar. Consider the following three passages as exemplary:

[God's commandments] are intended to teach man to know himself, that through them he may recognize his inability to do good and despair of his own ability.

(Luther 1883ff: vol. 7, 52)[31]

St. Paul concludes here that, if we understand the law properly and comprehend it in the best possible way, then we will see that its sole function is to remind us of our sins, to kill us by our sins, and to make us deserving of eternal wrath. Conscience learns and experiences all this in detail when it comes face to face with the law.

(Luther 1545: 334a)[32]

The purpose of every word of scripture and every action is to effect the change by which every man becomes spiritually a sinner, and this change must take place in our self-awareness and self-esteem.

(Luther 1883ff: vol. 52, 233)[33]

All three passages bear in one way or another on forms of self-consciousness: self-recognition, self-knowledge, self-awareness, conscience, self-remembering. But there is something that seems almost hideous in these passages – not simply in the pessimistic claim that man is unable to do good, but in the disturbing suggestion that God's laws are *intended to produce despair*, that God sets out "to make us deserving of eternal wrath," that the aim of scripture is that "every man becomes a sinner." This, I find, is one of the darkest corners of Luther's theology; but it is in this dark corner that we find the setting for his distinctive account of the phenomenology of self-consciousness.

For Luther, the key in all this is to understand the function of divine law. On Luther's account God never expects his commandments to be obeyed; he knows full well that they will not *and cannot* be. This is not simply an instance of divine foreknowledge; it derives rather from the nature of the commandments themselves, and from the nature of the being to whom they are directed. Luther:

For example, the commandment, "You shall not covet," is a command which proves us all to be sinners, for no one can avoid coveting no matter how much he may struggle against it. ... As we fare with respect to one commandment, so we fare with all, for it is equally impossible for us to keep any one of them.

(Luther 1958ff: vol. 31, 348)[34]

So what is the function of divine law, if not to produce obedience? Why would God make laws that he knows cannot be obeyed? Luther offers two interconnected answers:

130

Therefore in order not to covet and to fulfill the commandment, a man is compelled to despair of himself, to seek help which he does not find in himself elsewhere and from someone else.

(Luther 1958ff: vol. 31, 348)

For Luther, God's laws ultimately fulfill their function only when they prompt the Christian's turn "to seek help ... elsewhere and from someone else." But in order to do so they must first perform a more fundamental function: *the law brings man to despair*, and it is only in such despair that man comes face-to-face with his wretched constitution. In short, on Luther's account, God's commands to man were carefully contrived to produce not obedience but a self-conscious understanding of our own condition, specifically by showing us that we do not and cannot satisfy the demands we find placed upon us.

Self-consciousness and ontological despair

This is not an essay with a happy ending. By way of conclusion I want to return once more to Cranach's painting, this time taking our lead from Luther's aesthetic maxim by focusing on the *use* of the painting, and on its function as a distinctive kind of memorial or witness. Clearly this is a hazardous strategy. It would be folly to speculate about the ways in which the painting was used by its originally intended viewers; we don't even know who those intended viewers were. Nonetheless I want to suggest that the painting itself *projects* a certain kind of use, and in so doing functions as a distinctive sort of memorial or witness. Let me elaborate my interpretation in three stages.

First stage: To think about Cranach's painting in relation to its viewers is to see it as an invitation of sorts. We might say that the painting invites its Christian viewers into Eden itself, the beautiful lost garden of paradise. But this is not quite right; we are not invited *into* Eden; Cranach's Eden remains closed off to us, as it has been for all human beings since the Fall. But we are invited to *gaze* upon Eden, *into Eden*, invited perhaps to a nostalgia for Eden, invited to contemplate all that has been lost. And it is not simply Eden that invites our gaze; it is the figures of Adam and Eve themselves – beautiful, seductive human bodies. But there is a further and more fundamental invitation at work here as well: *the painting invites us to identify with Adam*. It may be that this feature of the work is more pronounced for a male viewer, but it is an invitation that is surely intrinsic to the work itself. The painting captures the moment where everything turns on Adam's choice. His fate, our fate, the fate of everything hangs in the balance. To gaze upon the head-scratching Adam is thus to find oneself scratching one's own head. What should he do? What *can* he do? What would *I* do?

Second stage: But if the painting invites us to identify with Adam, to take

up his circumstance, to contemplate the choice that faces him, there is also a way in which the painting rebuffs any attempt to take up that invitation. Indeed it makes it impossible for us to do so. Cranach's rendering of Adam cuts him off from us, emphasizing his difference and his distance from our situation. This effect is most immediately present in the blank look of Adam's face, in his eyes, which refuse any reflection. But its deeper roots lie in Adam's circumstance itself, which the painting carefully memorializes. Adam doesn't have what we have; he doesn't have what Eve has; as we have seen, he doesn't even have what Cranach's animals are shown to have. We simply *cannot* project ourselves into his situation because the very self-consciousness and normative knowledge that *he lacks* are so fundamental to the kind of beings that *we are*. We might as well try to imagine what it is like to be a bat.

I want to propose that this dialectical tension is central to the effect of Cranach's work: the painting issues an invitation to the viewer, but we find it impossible fully to take it up. And in encountering this impossibility we are brought face-to-face with just how dire Adam's circumstance is. As we have seen, this is a major theme of the painting. Adam is placed in a circumstance of judgment, but he is a deeply incompetent judge. He lacks the gleam of knowledge in his eye; he lacks a firm knowledge of the difference between good and evil. And the company he keeps will seal his fate. Adam's situation is hopeless; he is subjected to a command that he cannot possibly hope to fulfill.

Third stage: But with this last thought we can now recognize a resolution to this dialectical tension. For here we find a sense in which we *can* after all identify with Adam; we *can* take up his situation. Not as someone who faces the task of judgment without the benefit of normative orientation; *that* really is unthinkable. But we can identify with Adam as someone who is held accountable to a standard that he cannot possibly hope to satisfy. For Luther and his followers, that is *exactly* the situation of mankind – both before and after the Fall. We are all like Adam in this respect, in being subject to a law that we cannot keep. Indeed for Luther, *that is our distinctive ontological condition*. We are accustomed to think about Judeo-Christian wretchedness as a *result* of Adam's fall, our inheritance of the original sin in Eden. Yet Cranach shows us that even pre-lapsarian Adam is wretched in this sense, being likewise incapable of adhering to the laws to which he is subject. Through this dialectical tension, the work does its work, making itself available to be used in a very particular way: as a remembrance and memorial of our own ontological condition, which we share even with pre-lapsarian Adam.

Let me here leave the theology behind. We have seen enough, I hope, to recognize that Cranach explores an elaborate solution to the theodicy problem. Whether that theodicy yields a God who is worthy of our worship is a matter that must be left to each to decide. But the lesson I want to draw

is neither theological nor ethical but phenomenological. For along with everything else, what Cranach's painting brings into view is a vision of a distinctive form of human self-consciousness. Recall that the *Genesis* narrative culminates with the emergence of shame – the explosion of self-consciousness into the innocent of world of Eden. What exactly are Adam and Eve ashamed of? It would be natural to answer that they are ashamed of what they have done, of their act of transgression. But that is not the answer provided by the text: they are ashamed of their nakedness; they are ashamed of *what they are* and have discovered themselves to be. My aim here has been to use Cranach's accounting of Eden in order to bring this form of self-consciousness into view for further investigation. It is a form of self-consciousness that is ontological, normative, and despairing. It is ontological insofar as it involves an awareness not so much of one's existence as of one's essence or mode of being. It is normative insofar as it tells us not simply what we are but where we stand, how we measure up against the standards of success that belong to us. And it is despairing insofar as it involves awareness of an essential and inescapable failure – of being subjected to an infinite demand that we cannot possibly complete for ourselves.[35]

Now one might think that such self-conscious despair would have to be a derivative form of self-consciousness. Surely one would first have to be conscious of oneself in order subsequently to appreciate one's wretched condition. But I am not sure about this. In its most unguarded and unqualified form, my hunch is that Luther (at least) thinks of this kind of despair as marking both the beginning and the core of human self-consciousness. Allow me to conclude with a mundane analogy to suggest how this might make sense. Think of the circumstance of waking from a sound sleep in order to find that one is overheated: perhaps one has a fever, or the furnace has been left on, or there are simply too many blankets. In such a circumstance one emerges into a state of self-awareness, and as one does, the primary content of that self-awareness is the realization that something is wrong. This self-awareness prompts a motor-response: one kicks off some blankets in order to recover one's thermal equilibrium. There is here a single unified complex experience. The awareness of oneself comes along with an implicit awareness of a norm – a norm to which one is not conforming. The self, the norm, and the failure all emerge at once in one's experience, wrenching one out of one's prior unconsciousness and into a normatively oriented self-awareness. Prior to that emergence one is simply not self-aware at all.[36] But there is also a sense in which the norm is basic among the three elements of this phenomenological package. For both the self and the failure appear as they do because of their reference to the norm that has been violated. For Luther and Cranach, I want to suggest, the primary manifestation of self-consciousness involves an analogous complex awareness of self, of norm, and of failure. The norm is divine law; the failure

is human wretchedness. The crucial difference is that no motor-response can suffice to bring about conformity.[37]

Notes

1 Further references to this catalog are given with the abbreviation FR. According to Friedländer and Rosenberg, Cranach's earliest painting of Adam and Eve (FR no. 43, Alte Pinakothek, Munich) dates from 1510–12. Shade (1974) argues that the Warsaw *Adam and Eve* (FR no. 44, National Museum, Warsaw) is even earlier. A woodcut presently in the British Museum dates from 1509 (Campbell 2007, no. 12). Dating the last of the Cranachs is a matter of considerable difficulty because of the problem of distinguishing his own works from those of his workshop. According to Friedländer and Rosenberg, Cranach continued to produce paintings on this theme as late as 1549.

2 For primary citations from *Genesis* I have used the third edition of *The New Oxford Annotated Bible* (2001).

3 For the idea that revealed religion must be assessed by applying a moral critique, see Fichte 1792 / 1978.

4 There is of course a long theological tradition which flatly refuses the challenge of theodicy. (The ways of God are mysterious to man.) My own view is that there are important limits to such refusals, perhaps particularly so in the context of the Reformation, with its prime directive to the Christian to read the sacred scriptures *for himself*. To read seriously is to grapple with the paradoxes and puzzles of the text, and to wonder what they mean; to read responsibly is to ask whether and how the God represented there is worthy of our recognition. Nonetheless, there may be those for whom the very asking of such questions is a form of impiety; this essay is not for them. There is another theological tradition which avoids the theodicy problem by simply denying the goodness of God – at least as concerns the God of *Genesis* and the earlier Semitic myths to which it is related. On this view the Mosaic God is primarily to be feared for his power, rather than respected for his moral goodness. I cannot join these debates here; both raise a host of serious ethical, theological, and hermeneutic questions that go beyond the scope of this essay.

5 A very high resolution digital reproduction of the Courtauld Cranach has recently been made available as part of the Getty Center's online Cranach Comparison Study Tool. At this writing the tool can be accessed here: www. getty.edu/museum/conservation/cranach_comparison?index.html.

6 An example of the bestial Adam can be seen in *Adam and Eve*, 1508–10? (Musées des Beaux-Arts, Besançon; Brinkman and Dette 2007, no. 116); the best example of the infantile Adam is the lost pen-and-ink drawing of 1525–26, formerly at the Staatliche Kunstsammlungen, Dresden (Campbell 2007, fig. 31).

7 See for instance the tableau of 1530: *Adam and Eve in the Garden of Eden* (Staatliche Kunstsammlungen, Dresden; FR no. 202).

8 Cranach, *The Fall of Man*, 1523 (The British Museum; Campbell 2007, no. 13).

9 The key texts are Erasmus, *De libero arbitrio* (1524) and Luther, *De servo arbitrio* (1525).

10 Cranach produced portraits of Luther on many occasions and in a variety of media. At least one of the portraits (City Museum and Art Gallery, Bristol; Brinkman and Dette 2007, no. 40) is dated 1525, just a year before the Courtauld's *Adam and Eve*. Several others are dated 1526 (examples: Wartburg Stiftung, Eisenach; National Museum, Stockholm). The year 1525 was also the year of Luther's marriage, which Cranach commemorated with several joint

portraits (FR nos. 187–90). Luther's son was born in 1526; Cranach was the godfather.

11 Luther here cites Augustine in support of this claim, and on several other crucial details of his interpretation. See in particular *De Genesi ad litteram* (fifth century AD); for an English translation see Augustine 1982. Augustine's account of the tree of knowledge is found in Book 8.

12 One of Cranach's Eden tableaus seems to portray just such a divine ostension: *Adam and Eve in the Garden of Eden* (Staatliche Kunstsammlungen, Dresden; FR no. 202).

13 This claim was also central to Augustine's treatment of these matters.

14 Certainly it merits much closer attention than I have been able to give it here. It is worth noting that Heidegger at one point singles out the third chapter of Luther's *Lectures on Genesis*, along with Kierkegaard's *The Concept of Anxiety*, as the texts that had provided the most penetrating accounts of the phenomenon of anxiety [*Angst*]. Martin Heidegger 1962, fn iv to Div. 1, ch 6.

15 A particularly important case is the *Crucifixion* of 1502 (Metropolitan Museum, New York; Brinkman and Dette 2007, no. 7), which Cranach signs using an abstract angular symbol that (at least in retrospect) is a clear analog of the later serpent.

16 There is a small body of art historical scholarship that interprets Cranach's paintings as secret alchemical recipes. See for instance Nickel 1981.

17 On the ontology of weeds, see Pollan 1991.

18 *Genesis* 1:29–30:

> God said, "See, I have given you every plant yielding seed that is upon the face of the earth, and every tree with seed in its fruit; you shall have them for food. And to every beast of the earth, and to every bird of the air, and to everything that creeps on the earth, everything that has the breath of life, I have given every green plant for food."

19 I am grateful to Béatrice Han-Pile for pressing this line of objection.

20 See note 5, above.

21 *Martin Luther as Junker Jörg, Disguised as a Country Squire* (Museum der Bildenden Künste, Leipzig; FR no. 148.)

22 Martin Luther, *Eight Sermons at Wittenberg* (1522) in Luther 1883ff: 10/3, 1–64; translation in Luther 2007: vol. 2, 231–65.

23 Translation in Luther 2007: vol. 3, 151–302.

24 I have followed the familiar King James translation for this passage.

25 For some specific examples of Luther's appeal to the brazen serpent, see the third of the *Eight Sermons at Wittenberg* (1522) and the first main section of *Against the Heavenly Prophets* (1525) in Luther 2007: vol. 3: 165. On the broader theological significance of the serpent, particularly in connection with Christ's invocation of the serpent at *John* 3:14, see *Luther's Sermon Preached on the Day of the Holy Trinity, 1522*. Cranach includes images of the brazen serpent in a series of works dealing with the theme of *The Law and the Gospel*, and in a number of other works. Perhaps most importantly, it figures crucially in the complex self-portrait (*The Weimar Altarpiece: Crucifixion with the Law and the Gospel*; FR no. 434) completed by his son after his death. For a discussion see Koerner 1993: 406ff.

26 *Sermons on the Five Books of Moses* in Luther 1883ff: vol. 28, 554. In commenting on this principle Koerner writes: "Luther did not accept or reject images because of any immanent power, good or evil, they might possess. Rather, he judged them *by their effect on the viewer and by the uses to which they were put*" (Koerner 1993: 364, emphasis added). See also Stirm 1977: 47.

27 *Against the Heavenly Prophets.* See also Luther 2007: vol. 3, 169, emphasis added.

28 Melanchthon in particular, who was a close associate of Luther's and portrait-subject for Cranach, was notoriously caught in the middle of the dispute. The various editions of his theology textbook, the *Loci Communes*, exhibit his struggles to come to terms with this question. For an incisive accounting see Graybill 2002.

29 For an account of this trope see Koerner 1993, ch. 16: "*Homo interpres in bivio*: Luther and Cranach." In this paragraph and the ones that follow I am enormously indebted to Koerner's rich analysis.

30 *De Servo Arbitrio.* Quoted at Koerner 1993: 396.

31 *On the Freedom of a Christian.* See also Luther 1958ff: vol. 31, 348; Luther 2007: vol. 2, 24.

32 See also Luther 1994: 116–17.

33 See also Luther 1958ff: vol. 25, 217–18; Luther 2006: lxvi.

34 *On the Freedom of a Christian.* See also Luther 1883ff: vol. 7, 52; Luther 2007: vol. 2, 24.

35 For a further discussion of infinite demands, see Martin 2009.

36 Here is a different example, and one that brings us closer to the concerns of the *Genesis* narrative. Think of the familiar anxious dream sequence where one suddenly realizes that one is naked or inadequately dressed in a public or formal setting. Here again we find an instance of self-consciousness that involves the co-emergence, in a single phenomenological package, of self-awareness, awareness of a norm, and awareness of one's failure to conform to the norm.

37 Earlier drafts of this essay were presented at the Essex Philosophy Writing Workshop, the Society for Existential Philosophy, the California Phenomenology Circle, and the Philosophy Society at the University of Sussex. I am grateful to Harvard University, California Polytechnic University, and the Royal Institute of Philosophy for financial support for these presentations, and to the audiences for their helpful feedback. The list of friends, colleagues, and students who have helped me with this material is by now too long to complete, but I wish to mention in particular Béatrice Han-Pile, Dan Watts, David McNeill, Laurie Bussis, Joan Taylor, and Leslie Tait. Laurence Reed first brought my attention to the issue of judgmental incompetence in Cranach, and directed me to the Courtauld Cranach. Garrett Miller provided extensive research assistance. I wish to dedicate the chapter to the memory of my friend and colleague Mark Sacks (1953–2008); our last afternoon together was spent discussing Adam in Tuffnel Park.

References

Augustine (1982) *Augustine: On the Literal Meaning of Genesis*, 2 vols., trans. J.H. Taylor, New York: Newman Press.

Brinkman, B. and Dette, G. (eds) (2007) *Cranach: Exhibition Catalogue*, London: Royal Academy of Arts.

Campbell, C. (ed.) (2007) *Temptation in Eden: Lucas Cranach's Adam and Eve*, London: Courtauld Institute of Art.

Chrysostom, J. (1992) *Homilies on Genesis 1–17*, trans. R. Hill, Washington DC: Catholic University Press of America.

Erasmus (2005) "The Free Will," in *Erasmus–Luther: Discourse on Free Will*, trans. and ed. E.F. Winter, New York: Continuum.

Fichte, J.G. (1792) *Versuch einer Kritik aller Offenbarung*, Königsberg: Hartung.
——(1978) *Attempt at a Critique of All Revelation*, trans. G. Green, Cambridge: Cambridge University Press.
Friedländer, M. and Rosenberg, J. (1978) *The Paintings of Lucas Cranach*, Ithaca, NY: Cornell University Press (revised and translated edition of 1932 *Die Gemälde von Lucas Cranach*, Berlin: Deutsche Verein für Kunstwissenschaft).
Graybill, G.B. (2002) *The Evolution of Philipp Melanchthon's Thought on Free Will*, Oxford University D. Phil thesis.
Heidegger, M. (1962) *Being and Time*, trans. J. Macquarrie and E. Robinson, New York: Harper & Row.
Kierkegaard, S. (1980) *The Concept of Anxiety*, trans. R. Thomte, Princeton, NJ: Princeton University Press.
Koerner, J.L. (1993) *The Moment of Self-Portraiture in German Renaissance Art*, Chicago: University of Chicago Press.
Luther, M. (1545) "Vorrede auff die Epistel S. Paul: an die Römer," *Biblia: Das ist: Die gantze Heilige Schrift, Deudsch Auffs neu zugericht*, Wittenberg: Hans Luft, 331–35.
——(1883ff) *D. Martin Luthers Werke, Kritische Gesammtausgabe*, 57 vols., J. Knaake *et al.* (eds.), Weimar: Böhlau.
——(1958ff) *Luther's Works*, 55 vols., J. Pelikan *et al.* (eds.), Saint Louis: Concordia.
——(1994) "Preface to Romans," in J. A. Morrison, *Martin Luther: The Great Reformer*, revised by Michael McHugh, Arlington Heights, IL: Christian Liberty Press, 102–22.
——(2006) *Lectures on Romans*, Wilhelm Pauck (ed. and trans.), Westminster: John Knox Press.
——(2007) *The Selected Writings of Martin Luther*, 4 vols., T. Tappert (ed.), Minneapolis: Fortress Press.
Martin, W. (2006) *Theories of Judgment: Psychology, Logic, Phenomenology*, Cambridge: Cambridge University Press.
——(2009) "Ought but Cannot," *Proceedings of the Aristotelian Society*, 109: 103–28.
Milton, J. (2003) *Paradise Lost: A Poem in Twelve Books*, ed. M.Y. Hughes, Indianapolis: Hackett Publishing.
Nickel, H. (1981) "The Judgment of Paris by Lucas Cranach the Elder: Nature, Allegory, and Alchemy," *Metropolitan Museum Journal*, 16: 117–29.
Oxford University (2001) *The New Oxford Annotated Bible*, 3rd edn., Oxford: Oxford University Press.
Pollan, M. (1991) "The Weeds are Us," in M. Pollan (ed.), *Second Nature: A Gardener's Education*, New York: Atlantic Monthly Press.
Shade, W. (1974) *Die Malerfamilie Cranach*, Dresden: Verlag der Kunst.
Stirm, M. (1977): *Die Bilderfrage in der Reformation, Quellen und Forschungen zur Reformationsgeschichte*, Gutersloh: Mohn.
Strawson, P.F. (1963): "Freedom and Resentment," in *British Academy Lecture*, London: British Academy (reprinted in Strawson, P.F. (1974) *Freedom and Resentment and Other Essays*, London: Methuen).

7

DESCRIBING REALITY OR DISCLOSING WORLDHOOD?

Vermeer and Heidegger

Béatrice Han-Pile

Seventeenth century Dutch painting is generally approached through two complementary angles: first, through the culture and mores of its time. According to Simon Schama (1987), Dutch painting was the mirror in which the dominant customs and values of a then fully expanding society of artisans, navigators and merchants were reflected. The recurrence of certain themes (such as depictions of water and polders, scenes of banqueting or in inns) had the function of expressing and exorcising great terrors (flooding, hunger); correlatively, the representation of domestic scenes is explained in reference to the gradual establishment of an ethics centred on the family, simplicity, honesty and labour – the famous Protestant ethics analysed by Weber. In the same vein, Clifford Geertz's culturalist view insists on the impossibility of interpreting Dutch painting independently of the context which it is held to translate into symbolic terms (1976: 1475, n. 91). The most representative sample of this line of work is probably the symbolist reading of E. de Jongh (1971: 143–94),[1] for whom the objects, actions and scenes of private life shown almost invariably have a verbal equivalent in Jacob Cats' then highly fashionable books of Emblems.[2]

The second line of interpretation criticises this approach as being too contextualising and seeks to focus on the nature of the representations themselves. The main problem is then to understand how Dutch art distinguishes itself from its illustrious Italian counterpart.[3] According to Svetlana Alpers (1983), in contrast with the transalpine focus on history and the presentation of myths or religious episodes, Dutch painting in general (and Vermeer's work in particular, which is deemed 'exemplary' by Alpers)[4] is based upon a descriptive, realist approach to the world.[5] She points out that the Dutch abandoned Alberti's perspectival method of pictorial construction in favour of a different tradition (cartography, for which they were well known)[6] and technology (the *camera obscura*, a then recent discovery).[7] For

138

her, Dutch painting is thus characterised by an objectivity close to that of the natural sciences, a 'detached or perhaps even a culturally unbiased view of what is to be known in the world' (Alpers 1983: 163):[8] it is deemed an art of description – an art of space and not of time.[9] By challenging the supremacy of the Italian model, this reading allows many of the pictorial features particular to Dutch representations to be given their own value. However, it rests on two unquestioned hypotheses: first, the idea that the understanding of spatiality at work in the paintings is purely mathematical. In this regard, whether the construction of space should follow the principles of Alberti or those of Kepler makes little difference: in both cases the represented space is modelled on Cartesian extension. The second hypothesis is that the main significance of the paintings is epistemological: thus 'the aim of Dutch painters was to capture on a surface a great range of knowledge and information about the world' (Alpers 1983: 124).[10] This is by no means an isolated view: in particular, many interpreters have emphasised Vermeer's alleged 'uncanny naturalism' and some have even interpreted his work as a 'way of deriving certain knowledge from uncertain circumstances ... and finding truth in a world of doubt' (Huerta 2005: 17).[11]

In what follows, I shall focus on a small set of examples taken from Vermeer's work (*Woman in Blue Reading a Letter* [1663–64], *The Milkmaid* [1658–60] and *The Geographer* [1669]) to challenge the relevance of these assumptions and more generally to suggest an alternative to both contextualist and realist readings. Before I proceed, however, let me make two disclaimers: first, I do not mean to deny the interest of these interpretative lines, nor their ability to highlight important aspects of the works. Yet somehow neither gives us a sense of how we relate to the paintings as *artworks*: in each case they are taken as artefacts and decrypted according to external principles. Little attention is given to the reasons why we react to *these* particular artefacts in a different manner than, say, to the Plantin press in Antwerp (which lends itself beautifully to contextualist interpretations) or to Jacques de Gheyn's extraordinarily detailed botanical and animal drawings of the same period (which are driven by the ideal of objective representation).[12] Equally, there is no attempt to analyse the specific mode of existence of the depicted objects, nor the ways in which we respond to them: yet understanding these may be key to grasping why these particular paintings are considered artworks rather than items documenting a specific historical period. However (and this is my second disclaimer), I certainly do not want to claim that my own account holds the ultimate truth about the paintings examined, let alone about Vermeer's work in general. I only intend to bring to the fore what happens when we look at three of Vermeer's paintings, and suggest possible reasons why they strike us as artworks.

My reading is Heideggerian in spirit. However – perhaps somewhat unexpectedly – it is not directly inspired by Heidegger's reflections on art and

will only be related to these fairly late in the chapter: it emerged from my direct interaction with the paintings. As I was looking at the works, I was struck by the fact that my perception of them simply did not fit the contextualist or the realist frameworks: the space and the objects shown seemed internally organised by the practices of the characters depicted. Both the order in which I apprehended the various items on the canvas and the relations established between them followed patterns that seemed inexplicable by mere spatial contiguity. At the same time, I became aware of how my understanding of the scenes was affected by the strong emotional climate generated by each painting. It dawned on me that perhaps these works that tell no story and depict no illustrious characters were performing a role similar to that of fundamental ontology itself, albeit in a radically different manner: they were *presenting* (rather than articulating, as in *Being and Time*) what it means to be in a world. Yet while it helped me to understand my encounter with the paintings, this intuition immediately raised many tricky questions: first, *how* was such a presentation possible? Was it the result of a psychological identification with the characters? And if not, how did it come to be? Second (and correlatively), *what* was presented by the works? All I could *see* were depicted objects and characters. What was *their* mode of being? Was there something about it which allowed them to point towards the unrepresentable? Third, *what* was this transcendent element exactly? Heidegger tells us that artworks disclose a world. But what I was seeing in the paintings wasn't just any kitchen or bedroom: all the representations bore the marks of their temporal and geographical inscription. So was I glimpsing the world of the Dutch golden age? But how could that be anything but a lost world to me? Was Heidegger right then to say that artworks from the past are 'gone by' and inoperative outside their own context? And yet my experience of the Vermeer paintings did seem to rest on my grasping something that went beyond their representational content. So what was that?

In what follows, I shall begin by looking at two of the paintings mentioned above through a contextualist and realist lens;[13] in doing so, I shall highlight both the usefulness and the limitations of these analyses before turning to the phenomenological interpretation and questions evoked above. I shall suggest that what the paintings make palpable to us is an existential structure which transcends the particularities of the various historical worlds and which we can therefore relate to, namely what Heidegger calls their *worldhood*. I shall develop the implications of this and conclude by asking how this particular case study relates to Heidegger's own reflections about art in general (in particular in view of the fact that Vermeer's works do not conform to what Julian Young calls the 'Greek paradigm'[14] established in *The Origin of the Work of Art*).

Woman in Blue Reading a Letter (Plate 22) takes up a traditional theme of Dutch iconography, that of someone intruding on a lady who is reading

or writing a letter.[15] According to Walsh, it is an illustration of the 'illness without remedy' from which pregnant ladies languished (i.e the pregnancy itself!) and the presence of pearls, symbols of purity, probably indicates the legitimacy of the pregnancy (1973: sec. 3, n. 31). From the same contextualist perspective, the presence of the map on the wall, detailed enough to be identified,[16] is explained by the importance of the Dutch cartographic tradition and is meant to connote their contemporary maritime power. Correlatively, the spatial organisation of the painting is panoramic (the table and chair extend beyond the edges of the canvas, an effect which is often the result of the use of the *camera obscura*) and rigorously structured around the female figure by the vertical and horizontal lines of the table and chairs (the angularity of which accentuates *a contrario* the roundness of the figure, the hands of the reader being visually held by the horizontal bar of the map). The general impression of balance is further reinforced by the fact that the space between the left side of the map and the wall is almost identical to that which separates the back of the lady and the right side of the canvas, which places her in the geometric centre of the picture.[17] *The Milkmaid* (Plate 23) can be interpreted along similar lines: the representation of servants at work is another constant in Dutch art.[18] The presence of the foot warmer (bottom right corner) and that of the small cupids on the tiles on the wall could be seen to symbolise the warmth of domestic love, itself connoted by the maternal character of the woman who offers bread and milk. The placing of the vanishing point behind the right elbow of the maid surreptitiously emphasises the importance of the gesture. The space of the painting is structured by the two containers suspended in the left corner: the metal one, inclined towards the spectator, guides the eye towards the jug and the bread, while the wicker basket, angled towards the right, draws the attention back towards the stove, the conjunction of the two dimensions creating an effective illusion of depth, itself emphasised by the shadow of the nail on the wall.[19] Finally, the dotted paintwork with its white specks, on the handle of the bread basket, suggests that Vermeer used a *camera obscura* as the latter is known to create the appearance by refraction of a white halo on the surface of objects.

Thus these paintings can be approached through their integration in a specific iconographic tradition, an emphasis on realism and the construction of space according to geometric principles and the scientific innovations of the time. Yet the importance of cultural elements should not be overestimated: while the theme of the letter is certainly traditional, the treatment that Vermeer gives it in *Woman in Blue* is extraordinarily decontextualised. There is no identifiable light source. All the narrative clues that are present in similar scenes painted by Jan Steen or Gabriel Metsu have been erased (Snow 1994: 4): nothing allows us to fathom where the letter comes from, nor what it says, not even the effect that it produces on its reader.[20] Nor is the representation truly realistic: the female figure casts no shadow, unlike

the chair and the map which are lit in exactly the same way.[21] As for the *Milkmaid*, the theme itself is not traditional – in fact this is the only known example in Dutch painting (Mauritshuis 1995: 110); and while the foreground composition seems to conform to the then current taste for still lives and vanities, it does not include any of the symbolic foods usually represented (such as oysters for lust, crabs for misconduct, grapes for pre-marital chastity, overripe fruits for decomposition, onions for trifles that make us cry, etc.). Nor does it obey the conventions of the genre, which would have the same food depicted in different states (for example lemons are often presented whole and sliced, so as to indicate the fate of all mortal things). It is thus dubious that the painting was intended to give a moral lesson to the spectator. X-ray examination shows that here too a map attached to the wall in the background was painted over (Mauritshuis 1995: 110), again reducing to the minimum any contextual indications. Furthermore, given that the light comes from the window on the left, as indicated by the shadows of the baskets and the face of the woman, it was not very realistic to lighten the *right* side of the wall which then seems to be the object of a direct illumination, itself made unlikely by the shadows on the ground of the milkmaid and the foot warmer. Finally, the top of the table is angled upwards in an exaggerated manner (unless the table is slanted, which is unlikely), probably to draw the spectator's attention to the jug (this is accentuated by the fact that the milkmaid is looking down).

One could multiply these examples: they indicate both the interest and the limits of the realistic and contextualist lines. Although they point out some pertinent and interesting features, one is left with the sense that something important is missing. But what is that? To try to find out, let's return to the paintings and look afresh. So what do *Woman in Blue* and *The Milkmaid* show? Blue cloth, a half opened box, pearls, the usual elements of a feminine interior; kitchenware and simple foods. Objects, then, and characters: a woman reading, a maid pouring milk. Nothing extraordinary, nothing interesting even, from the standpoint of historical painting: situations so average that seventeenth century Dutch people could experience them daily without giving them much thought. But this, then, might be precisely a good starting point: in these paintings, practices and objects that are usually covered up by their everyday usage are called forward to a new visibility. But what kind of visibility is this? And what is the mode of being of the depicted objects?

It may help here to turn briefly to *Being and Time*. As is well known, Heidegger distinguishes explicitly between three modes of being: first, Dasein, the mode of being of entities for whom being itself is an issue. Entities that have Dasein as their mode of existence comport themselves in such a way that an understanding of being and of themselves is embodied in their practices, and this without the need for conscious thematisation. To use an example given by Bill Blattner, just by walking on the pavement

rather than on the road or on my neighbour's lawn, I open up the space in which I move in specific ways: I differentiate between various areas, some of which are safe (the pavement) or not (the road), some of which legitimate or not. I also convey a certain understanding of myself, for example as someone cautious, mindful of other people and respectful of regulations. By contrast, if a Sony robot dog happened to walk on the same pavement, the normal inference would be that this is just chance or a result of its programming, and that this behaviour does not presuppose or denote any particular understanding of the world.

Contrary to Dasein, the second mode, readiness-to-hand (*Zuhandenheit*), is not self-interpretative: it is the mode of being of entities which is disclosed by the manner in which we use them within the wider context of an equipmental totality (for example the hammer in the workshop). What is characteristic of this mode is that if the activity goes smoothly, the entities encountered are not thematised by us: if I am in my kitchen and need to stir something in a cooking pot, I'll grab an appropriate tool and so long as it stirs, it won't make any difference to me and thus I won't notice whether I'm using a wooden or silicon spoon. As Heidegger puts it, 'the "things" which are closest to us are ... encountered in the concern which makes use of them without noticing them explicitly' (1962 §15: 97). Importantly, ready-to-hand entities are not encountered in isolation: they presuppose a complex network of assignments,[22] a point to which I'll come back later. Just like the entities that rely on them, these 'assignments themselves are not observed: they are rather "there" when we concernfully submit ourselves to them' (1962 §16: 105). Finally, the third mode of being, presence-at-hand (*Vorhandenheit*), is the mode of being of objects which are explicitly thematised as such by our reflecting on them: present-at-hand objects emerge for the observer as decontextualised, discrete entities offered to the scrutiny of a disengaged spectator. Should this scrutiny take a scientific form, then the entities will appear as having specific, measurable properties (such as size, weight, shape, etc.).

So to get back to our original question of what the paintings show: how are the entities depicted by Vermeer disclosed? Strictly speaking they are not Dasein since by themselves they do not convey any self-interpretation: this is obvious in the case of objects such as the jug or the bread, which would not be considered as Dasein in the real world anyway, but it equally applies to the represented human figures: the real milkmaid would certainly have qualified as Dasein, but just as the concept of a dog does not bark (as astutely pointed out by Spinoza), in the same way the painted milkmaid does not ek-sist (to use Heidegger's term). Nor are the depicted entities ready-to-hand: by virtue of their being represented, none of them is usable for us, and unless faced with trompe-l'oeil effects (which Vermeer uses rarely), we are aware of that fact: unlike the pigeons famously deceived into pecking at Zeno's grapes, we would not try to drink the milk poured from

143

the jug. So are the depicted entities present-at-hand? At first sight this seems to be the most promising hypothesis: although the objects and characters are not real (in the sense of spatio-temporal presence), their representations are fully exposed to our gaze. We can leisurely assess their shape, colour or size and work out their mutual positions in space and their relations to the real world, or seek to reconstruct their symbolic meaning by referring them to their historical context. In fact, this is exactly what the realist or contextualist interpretations do. But is this really the main way in which we relate to the paintings? Or even the most immediate way? Do we stand back and look at the objects and figures on the canvas in the detached manner of the realist or the contextualist?

Let's return to *Woman in Blue*. For one thing, our perspective on her is not a view from nowhere: we are seeing her from below, and from the opposite end of the table. How is this possible? If we look at the positioning of the two chairs (and in particular the one on the right of the painting) in relation both to the reader and the angle at which we see her, we realise that we are viewing her as we would if we were sitting *inside* the depicted space, on a third chair positioned opposite the map and next to the table. The panoramic aspect of the scene, which extends beyond the sides, top and bottom of the painting and thus is not closed in by the canvas (contrary to what happens in Italian *vedute*, for example), facilitates our being drawn into the space opened up by the positioning of the chairs and our perspective on the reader. Thus our relation to the woman in blue is not that of a detached observer who stands outside the painting: we belong to the virtual space deployed on the canvas to such an extent that our place in it is specified by the internal arrangement of the scene. Our perspective on her is not an abstract ideal point, as in perspectival constructions, but a *situated* position. Furthermore, we are drawn in by her reading. Her gaze directs us to the letter. What does it say? There is no movement in the painting, everything is suspended to her occupation. We can reflect on this and discover, for example, that this mood of distance, this intense turning inwards which brackets all other activities is reinforced by the use of cold colours that stand out on a white and ochre background – blue (the two chairs, the bar of the map, the dress) and silver (the pearls, some of the nails on the chairs, the reflection on the brass of the map). We can also see that the impression of suspension in time and space is emphasised by the absence of any Cartesian reference points in the painting (no floor, ceiling, etc.). We can note that the overall impression of immobility is reinforced further by the fact that the main shapes in the painting are all static and closed (as opposed to open curves, diagonals or hyperbolas): they are either rectilinear (the map, the chairs, the table) or well circumscribed and solidly planted on the ground (the reader herself). Yet all these various facts only became apparent to us because in the first place our involvement with the painting allowed our attention to focus on aspects which otherwise would have remained hidden.

So are the depicted figures and objects really disclosed as present-at-hand? Insofar as I can adopt the attitude of a dispassionate, detached observer, perhaps. But as we have seen above, there is something in the painting which calls for a different response: I project myself into the scene. In order to answer the question above, we now need to focus on this process. What is meant by such projection? Is it simply, or even primarily, a case of psychological identification with the characters depicted? It seems unlikely. Such forms of identification usually require that the figure or person one identifies with should be individualised by a set of specific propositional attitudes or character traits which are deemed valuable and motivate the desire for projection. This process is often supported by a narrative that allows these traits to surface. Thus in Stendahl's novel *The Red and the Black*, Julien Sorel identifies with Napoleon: he admires his courage, his intelligence, his decisiveness and acuity of judgement, his total dedication to making his dream of the European unification come true. For Julien, these qualities are evidenced by reports of Napoleon's statements and by what he knows of his life; against this background, some specific events (such as his victory at the Arcole bridge) acquire a symbolic dimension which encapsulates the heroic features Julien identifies with, in particular, Napoleon's self belief and energy. Variations on this sort of identification are elicited by many sixteenth and seventeenth century artworks. This is particularly clear in the case of Italian painting, where the required character traits are often provided by the viewer's knowledge of the story the scene refers to. Consider Fra Angelico's *Annunciation*: if not for the title and/or the biblical background it evokes, it would be very difficult to work out what is going on in the scene. Furthermore, the expression of the Virgin Mary is per se rather undecipherable: she is both attentive and pensive, but little more can be said. Yet knowing who she is and the sad future that will unfold for her and her son helps us flesh out the undertones of her expression (as humble and sorrowful, almost mourning in advance the death of her son) and creates a strong sense of sympathy with her. Even in Dutch paintings, where there is no obvious narrative to support the psychology of the characters, similar factors are often at play. Thus Gabriel Metsu's *Woman Reading a Letter with her Maidservant*[23] (Plate 24) is very close in theme to *Woman in Blue*: yet to viewers of the period there were many clues in the painting that would help understand the psychology of the characters. Thus they would know that the letter is a love letter from the stormy seas on the painting unveiled by the maid (note that the unveiling itself is rather theatrical, as if to explicitly present an illustration of the lady's inner turmoil as she is reading the letter). They would also know that the person who sent it is far away because this was traditionally signalled by the inclusion of another painting within the painting (a symbolic representation of absence). They would have reason to think that the letter comes from the lady's husband because of the shoe lying on the floor, which alludes to Dutch sayings and

emblems of the period emphasising the virtues of domesticity (not wearing shoes is staying at home, as a good wife should).[24] So they would likely understand that the lady received a love letter from her husband, himself still at sea and possibly in danger (the storm). This would help them to flesh out her expression and to sympathise with her worry and faithful longing for her husband (itself symbolised by the intent and rather sad posture of the little dog, looking up with its tail tucked between its legs).

Yet the Vermeer paintings provide very little in the way of idiosyncratic features or narrative. There is no recognisable story. The situations evoked are decontextualised and devoid of moralising purposes which would single out specific psychological traits. Unlike the truculent or jovial figures depicted in tavern scenes of the same period, the characters are not drawn to elicit definite reactions such as hilarity or indignation: they are emotionally opaque. While it is possible to attribute to them specific thoughts or intentions, there seems to be little to guide or motivate such attribution. In fact, the identity of the figures seems irrelevant to the paintings, and this to such an extent that most of Vermeer's works can only be referred to, not by the names of the places or characters depicted, but by the activities shown (*Woman Writing a Letter*, *The Slumbering Maid*, *Woman Playing the Guitar*, *Officer and Laughing Young Woman* etc.).[25] Thus while the paintings may allow for weak forms of the psychological identification described above, it seems unlikely that the type of projection they invite should be *grounded* in the latter. So what happens then? I would suggest that what matters and draws us into the paintings is not *who* the characters are, but what they *do*. The depicted figures are all engaged in some form of daily activity we can understand unreflectively, without any need for symbolic decryption or recontextualisation: although it may have been by electric light or out of a plastic bottle, we have all read letters or poured milk before. This unreflective and immediate grasp is facilitated by the very anonymity of the characters and the absence of specific contextual elements which would over-determine the scenes. It is also encouraged by the fact that the characters do not look at us, which would create personal contact and interrupt the flow of their engagement with their practices. In this context, for us to project ourselves in the paintings means to *understand* the practices depicted. Such understanding, in turn, is not tantamount to having an insight into the psychology of the characters or to cognising how to do what they do. It requires us to be able to intuitively open up the network of relations and possibilities associated with the practices themselves, a peculiar ability which is afforded to us by our competence in performing similar practices. Thus such projection is *existential* rather than psychological in that it rests on our ability to be in the world and to press ahead into our own possibilities.

However this presents us immediately with a paradox: after all, newspapers and magazines afford us daily opportunities to see practices from the

outside and we don't give them a second glance. Yet the paintings capture our attention thoroughly. So there must be something in the depicted practices themselves which attracts us. In my view, what draws us in is the *style* of the practices: not just what the characters do, but *how* they do it. The practices are not simply intelligible to us in the pragmatic manner suggested above: they seem expressive of a way of being which is in a large part independent from the intricacies of the characters' putative inner life but which is embodied in their comportment. Such expressivity is implicitly normative: the stylised practices do not merely denote the characters' competence at performing certain activities. They communicate to us an implicit understanding of how these activities *should* be done, an understanding which is conveyed by the specific nature of the stance or gestures shown on the canvas. As we shall see, what appeals to us in the case of Vermeer is both the fact *that* the depicted practices display a high degree of style, and the *sort* of style they have. What do I mean by style? Style is notoriously elusive and resists full articulation. Hubert Dreyfus defines it functionally, as what 'opens a disclosive space and does so in a threefold manner: (a) by *coordinating* actions; (b) by determining how things and people *matter*; and (c) by being what is *transferred* from situation to situation' (Dreyfus 2005: 408). In each painting, the manner in which the characters engage with their own practices displays these characteristics. Irrespectively of what the represented Dasein might be thinking, the manner in which they read or pour conveys a very strong mood of peaceful concern and intense absorption with what they do. This coordinates the actions of the characters across the paintings (thus giving them a common style) and allows both the activities and the objects involved (like the letter or the jug) to matter. The overall (transferable) impression is one of harmony and *care*, about both the activity itself and the world in which it takes place. For reasons which I shall return to in the conclusion, this care is deeply attractive to us. For the moment, however, let me focus on how the style of the practices orientates the manner in which we perceive the scene and allows the various objects represented to stand out in particular ways.

Consider *The Geographer* (Plate 25): we see him slightly from below, perhaps from a sitting position on a stool next to the one depicted on the right. Like the chairs in *Woman in Blue*, the curtain on the left subtly invites us in and provides a visual transition that helps homogenise our own space and that opened up by the painting.[26] This space itself is both orientated and dramatised by the geographer's bodily stance: his dynamic posture grabs us. He is leaning intently forward and yet does not look at us but at something we cannot see. Suddenly, and in spite of our own inability to know what is seen, that particular spot *matters* to us. The direction of his gaze is at ninety degrees to that of the compass he is holding in his right hand, and our own line of sight intersects roughly at forty-five degrees from each: this draws us further into the space of the painting (by deepening it and establishing

further continuity with ours) and increases our sense of dynamic tension. The compass itself points towards the geographer's left hand, firmly closed upon a book: this (and the table it rests upon) grounds the painting and provides a sense of solidity from which the dynamic space can unfold. The weighty way his hand clutches the book draws our attention to the equally heavily bunched up folds of the carpet on the table, which convey the same sense of movement and self-contained energy (whereas a tidy, smooth surface like the milkmaid's table is peaceful and static). Both compass and book draw our attention to the opened metal square on the stool, which itself points towards the roll and paper on the floor. These draw us back to the blindingly white parchment on the table (which is parallel to them and similarly coloured) and thus (through the reflection of the light on his right thumb) back to the geographer himself.[27] This renews our awareness of the tension expressed by his posture and deploys further energy lines (for example, from the left side of his face to the light flooding from the window to its reflection on the globe on the cabinet behind him). Thus the objects depicted are not perceived in an atomistic way, as discrete entities coexisting in a neutral, geometrical space: they are disclosed through the geographer's style, his concerned, energetic and inquisitive attitude. Although none of these objects is in movement, the geographer's stance opens up a dynamic web of relations whereby all the tools of his trade are linked. In another context, for example in a vanity where they often feature, representations of the same objects would be perceived very differently, as the harbingers of death and the marks of the folly and emptiness of human knowledge.

So is the geographer disclosed as present-at-hand? And what about his compass? Because of our projective understanding of the depicted practices, both acquire a paradoxical mode of being. They are present-at-hand in the minimal sense that they are represented on the canvas in a way that is open to visual inspection. Yet our projective grasp of his practices discloses the geographer as a virtually ek-sistent Dasein engaging with his world in a meaningful way. In the same way, we see the depicted tools both as present-at-hand for us *and* on the background of his involvement with the world: we are sensitive to their equipmental character in a way which would not be possible if we were ourselves engaged in the activity that discloses them. Interestingly, this is doubly similar to what happens in another kind of liminal situation described in *Being and Time*, that is when the user of a tool is unexpectedly faced with various forms of resistance. First, Heidegger observes that in such cases:

> the modes of conspicuousness, obtrusiveness and obstinacy[28] all have the function of bringing to the fore the characteristic of presence-at-hand in what is ready-to-hand. But the ready-to-hand is not thereby but *observed* and stared at as something present-at-hand; *the presence-at-*

hand which makes itself known is still bound up in the readiness-to-hand of equipment. Such equipment still does not veil itself in the guise of mere things.

(Heidegger 1962: G74, my italics)

Thus if my spoon breaks as I stir the stew, or proves to be too short, it suddenly emerges to presence-at-hand but in a way which is still coloured by my previous equipmental engagement with it: it doesn't work as a tool any more, but it is not quite an object I could relate to in a decontextualised, neutral way yet. I am annoyed with it; I am sensitive to its sudden lack of usefulness rather than to its own independent qualities. In a similar way, the objects depicted by the paintings are disclosed to us on the background of the characters' engagement with them, and our perception is coloured by this involvement. The milkmaid's careful gesture discloses the bread and the milk as valuable; the geographer's stance conveys that the acquisition of knowledge is a worthy activity, and this inclines us to regard the tools of his trade, not as the symbols of the futility of human enterprises, but as important technical innovations. Similarly, although the pearls on the woman in blue's desk have a higher intrinsic value than the letter, her absorbed reading discloses the latter as more valuable. Thus the paintings present us neither with equipment nor with, as Heidegger puts it, 'mere things', but with ambiguous representations that bear some of the characteristics of each: they have the visibility of present-at-hand objects and yet just like ready-to-hand entities they are made relevant to us by specific practices.

The second similarity with equipmental breakdown is that this ambiguity draws our attention to the complex network of relations presupposed by the practices. Importantly, this network is independent from the characters' putative thoughts or desires, which is why it (and the associated practices) can be grasped with very little or no psychological identification with particular individuals. In *Being and Time*, Heidegger shows how all ready-to-hand entities are such by virtue of belonging to an 'involvement whole' (*Bewandtnisganzheit*): the latter is structured by various relations (mainly in order to, where-in, where-of, with-which, towards-which and for-the-sake-of which (1962: §16). When taken as a formal whole and related to Dasein as their ultimate for-the-sake-of-which, these relations form what Heidegger calls the worldhood (*Weltlichkeit*) of the world (1962: G27).[29] One way of articulating the difference between world and worldhood is to point out that while neither is an entity, the first is a horizon which is contextually dependent on historical practices (which in turn presuppose its existence); by contrast, worldhood is the structure which is involved by all historical worlds or sub-worlds.[30] In normal situations of fluid equipmental use, the relations that comprise worldhood are operative but not thematised. But in the case of equipmental breakdown these relations acquire a

higher degree of visibility: as the equipment slowly emerges as present-at-hand, in the same way some elements of the involvement whole come to the fore – for example as I burn myself I realise that the spoon I grabbed was made of metal, not wood or silicon (and thus become aware of its where-of), that its length is inappropriate for stirring (which highlights its in-order-to) and so on. As Heidegger puts it, 'the context of equipment is lit up, not as something never seen before, but as a totality constantly sighted beforehand in circumspection' (Heidegger 1962: 103).

Up to a point, something of the same order happens in the Vermeer paintings. The milkmaid's gesture and the direction of her gaze focus our attention on the jug she holds and the milk that flows from it. This in turn highlights the other objects on the table (the bread, the basket, the pitcher) and their relations both to each other and to the milkmaid herself. The former are governed by specific in-order-tos (thus the basket, pitcher and jug are all containers; bread and milk provide nourishment), and the latter, by various for-the-sakes-of-which (feeding the household, fulfilling her task as a milkmaid, etc.). Following the implicit thread of these relations, the scope of our gaze widens to the rest of the room. More equipmental connections appear (the basket and the pail hanging on the wall are also containers), the foot warmer is for the sake of warming up the milkmaid's feet. At the same time, we develop an awareness of the diversity and texture of the materials depicted (the where-of of the objects): the gleaming clay of the jug, the pearliness of the milk, the coarseness of the cloth ... These materials themselves resonate in a coloured network which reinforces the correspondences between the objects: the blue of the tablecloth and that of the apron, the drops of light on the breadbasket and the reflections on the pail, which themselves evoke the yellow of the woman's dress and so on. As our gaze wanders from jug to basket, we become aware of the kitchen itself as the environment in which all these relations coalesce (their where-in). The more we look at the painting, the more the network of relations widens, and the more it widens, the higher our awareness of it becomes. The milkmaid appears as the focal point of a potentially infinite set of relations which cannot themselves be depicted but which my projective understanding of her activity and posture makes me sensitive to.

However there are three important dysanalogies between the cases of equipmental breakdown and that of the paintings. For one thing, the ambiguity of the depicted objects is not the result of any *defect* or lack on their part. They are not broken tools: it is constitutive of their nature to be disclosed in this paradoxical manner (as ready-to-hand for another Dasein and yet present-at-hand for us in a way which is coloured by our projection onto the practices of that other Dasein). Second, in the kitchen or workshop our ambiguous perception of the defective equipment (as present-at-hand but on the background of our ready-to-hand involvement with the world) is only *temporary*: soon we find another way of using it or use something else,

and the tool fades back into inconspicuousness. Not so with the depicted objects: the ambiguity does not resolve itself. Furthermore, it is precisely because it does not resolve itself that we are drawn to explore the network of relations presupposed by the various not quite ready-to-hand objects displayed on the canvas. Third – and this is perhaps where the most important dissimilarity lies – in the case of equipmental breakdown, 'with this totality [worldhood] the world announces itself' (Heidegger 1962: 103). Which world? Not any world: *my* world. Not as my private world (as this would only make sense metaphorically), but as the world I share with the other Dasein that live in my culture. When prompted by the equipmental breakdown, I am able to 'fill in' the formal structure of worldhood without any difficulty and beyond doubt about my understanding of the world (whether I am right *that* the world is truly as I understand it is a different question). I can articulate what I already implicitly understand, namely why one cooks, with what, for the sake of what and so on. But in the case of the painting, it is impossible for me to attribute any *reliable* content to the assignments I have become aware of. Perhaps the for-the-sake-of-which of the pouring is to prepare a morning meal, but for all I know it could be to sell the milk, or to make butter, or more crucially to fulfil some other purpose that I have no idea of. Perhaps a whole dimension of the painting is closed off to me so completely that I am not even aware of it because the range of existential possibilities open to the milkmaid is out of my reach. Although I may hazard a few guesses and even happen to be right, the understanding of being that was spontaneously shared by the various Dasein of her time is closed to me. Clearly it is what contextualist interpretations try to recapture, but such an understanding cannot be reconstructed in a theoretical way: knowing about the meaning of particular objects or symbols is not the same as experiencing that meaning directly through one's practices (and letting the experiencing guide these practices).

So *which* world is it that 'announces itself' with the worldhood disclosed by the paintings? It can be neither the world of the Dutch golden age nor the one we ourselves belong to. I would suggest that it is a hybrid, imaginary world born from our attempts to fill in the formal structure of worldhood, which the paintings make us aware of through our grasp of the practices depicted, with elements of the world we live in. Strictly speaking, it is not a world at all as it is not shared by other Dasein. It is our projective understanding of what the world of seventeenth century Holland, as instantiated in a milkmaid's kitchen, might have been. Because of the way worldhood transcends particular sub-worlds and is thus common to all, we are still able to grasp the structure of intelligibility underlying the depicted practices and to project ourselves in the way analysed above. Yet at the same time almost every detail in the paintings makes us aware, often painfully, of the inadequacy of our projection: the characters' clothes, the objects that surround them, all these point directly to another epoch in a manner which we cannot

ignore. We are thus placed in a strange, *unheimlich* (not at home) position: on the one hand, we grasp the practices depicted and the structure they rely on well enough to become sensitive to what the paintings cannot show directly, namely the existence of a world as the horizon of significations to which the practices and related objects belonged. On the other hand, we're equally aware of the fact that for all our efforts, the original meaning of these practices and objects is inaccessible to us. A fictitious world arises, from and beyond the represented objects, which at the same time points towards what it cannot be: the *lost* world of the Dutch golden age. Thus our grasp of its ontological lineaments is accompanied by a strong sense of the inadequacies of all the projections that are now available to us. From this arises an impression of loss and loneliness and a keen perception of the fragility of everything human.

To some extent, this phenomenon is similar to what happens in the case of anxiety: recall that in such instances Dasein becomes incapable of engaging with its world any more. Because of this sudden breakdown of *Befindlichkeit*, the structure of worldhood comes to the fore in an estranging manner.

> The utter insignificance which makes itself known in the 'nothing and nowhere' [of that in the face of which one has anxiety] does not signify that the world is absent, but tells us that entities within the world are of so little importance in themselves that on the basis of this *insignificance* of what is within the world, *the world in its worldhood is all that still obtrudes itself.*
>
> (Heidegger 1962: 231, second italics mine)

Thus things and people are still intelligible to Dasein, but somehow they do not matter any more. Dasein is made aware that this is a deficiency both by its former ability to engage with the world and its acquired sensitivity to the norms implicitly conveyed by that world: although it is incapable of caring any more, Dasein knows that it did before. It also knows what should matter to it. The more incapable of caring it is, the more the worldhood of the world looms over it and oppresses it with demands which it cannot meet. In the paintings too worldhood comes to the fore, and in the same way (although for different reasons) the world it was instantiated in appears as something we cannot relate to: we understand its structure well enough to realise that there was such a world, but we also sense that it is closed to us. Like anxious Dasein, we are faced with a world which we don't belong to and are helpless in the face of this phenomenon. The reason why we don't feel anxious, however (or at least not necessarily so), is that our awareness of the fact that this world is lost prevents it from making *demands* on us: it would not make any sense for us to feel compelled to engage with the world of seventeenth century Dutch men or women – this would be analogous to

Don Quixote's deluded desire to live in the past world of chivalric deeds. Thus while in both cases we become sensitive to worldhood, in anxiety, Dasein is faced with the loss of its connections to its *own* world; through the paintings, we are made aware of our inability to reach a world that was never *ours*.

In this chapter I have tried to offer a phenomenological alternative to both contextualist and realist approaches to Vermeer's paintings, in the hope that this would help us understand better their nature as artworks. This analysis revealed both the ontologically disclosive nature of the paintings and the projective process whereby we become sensitive to the style of the depicted practices. As in the cases of equipmental breakdown or anxiety analysed by Heidegger, albeit in a different manner, the paintings make us aware of the formal structure of assignments presupposed by the practices – the worldhood of the world. Correlatively, the style of the practices orientates our perception of the paintings in ways which the theoretical attitude underlying both the contextualist and realist approaches cannot capture. Yet at the same time various elements in the paintings make us aware that the projective understanding of the world that organises our perception is hopelessly anachronistic and cannot capture what the depicted practices might have encompassed in seventeenth century Dutch society. Thus the sense of world which arises from the works is accompanied by a keen awareness of the inadequacies of the projection.

In conclusion, I now wish to stand back and offer a few reflections on the implications of this phenomenological analysis for Heidegger's views about artworks. Prima facie, it confirms one of Heidegger's main claims, namely that artworks characteristically perform an ontological form of disclosure that goes beyond what they actually represent (or beyond their immediate phenomenal appearance in the case of non figurative artworks). Yet whereas Heidegger thinks that this disclosure consists in the opening up of a world, what emerges from our encounter with the Vermeer paintings is that they *fail* to do so. However, this does not mean, *pace* Heidegger, that they have become inoperative (or to use Blanchot's very apt term, *désoeuvrées*): the paintings make us sensitive both to an ontological structure that goes beyond the depicted objects (worldhood) and to the fact that we cannot reach its former instantiation (the lost world). To understand this proximity to and distance from Heidegger, we must remember that *The Origin of the Work of Art* is concerned with the relation of a whole people to the artworks *of its own time*. Thus most of the artworks evoked (the Greek temple, the cathedral) are massive in scale and were meant for permanent collective display: this heroic and public dimension is what allowed them to perform to the sort of world articulation that Heidegger deems characteristic of great artworks: they presented a people with the major ontological and ethical lineaments of its own understanding of the world (or in the case of world re-configuration, brought forward a new paradigm from existing marginal practices).[31] This

153

exclusive emphasis on the relation between artworks and the community they belonged to led Heidegger to the pessimistic conclusion that once they are removed from their native context and exhibited in a museum, artworks of the past cease to be artworks in the sense that they are unable to disclose the world in the way they once did.[32] Thus:

> world withdrawal and world decay can never be undone. The works are no longer the same as they once were. It is themselves, to be sure, that we encounter there, but they themselves are gone by. As bygone works they stand over against us in the realm of tradition and conservation. *Henceforth they remain merely such objects.*
>
> (Heidegger 1971: 41, my italics)

The premise is certainly right: as we have seen, the world the Vermeer paintings belonged to is gone, and they won't resurrect it. However the conclusion that the works *themselves* are 'gone by' does not follow. On the contrary, the ontological disclosure performed by the Vermeer paintings is significant at least in two ways: first, by bringing to the fore the structure of worldhood, they enhance our awareness of what being in the world entails. Whether our projective understanding of the world hinted at by the paintings is *correct* or not (in the sense of matching a seventeenth century Dutchman's putative understanding of that world) is, in my view, fairly irrelevant: what matters is that the Vermeer paintings are able to lead us beyond the visible to what articulates it.

Heidegger's later reflections on art, and in particular on Cézanne and Klee, indicate that this view may have not been as uncongenial to him as may seem from the perspective of *The Origin of the Work of Art* only, which brings me to the second reason why the ontological disclosure performed by Vermeer's paintings is important. According to J. Young, the main drive for Heidegger's development after 1936 was the desire to understand artworks which, like Cézanne's or Klee's (or for that matter, Vermeer's), do not have 'world-historical significance'[33] and this, without falling into the trap of subjective aesthetics. This led him to recontextualise his approach to art within the new framework of his critique of metaphysics as resulting from a 'fundamental mistake':

> [the] failure to see the dependence of truth (as correspondence) upon the world disclosure that happens in, and only in, human ... forms of life. Because of this, one fails to see the *projected* character of one's horizon of disclosure ..., one takes its articulation to be *the* uniquely correct articulation of the fundamental structure of reality itself. ... The art which is important for our 'needy times' is art which provides an antidote to metaphysics.
>
> (Young 2001a: 124, Young's italics)

In this light, what is important about both Cézanne and Klee is not so much that they should articulate a paradigm for their contemporaries but that they show *all of us* the 'worlding' of the world, and this in such a way that its projected character remains evident throughout the experience of the work. Thus Cézanne's *Mont Saint-Victoire* (Plate 9) materialises itself out of perceptual chaos and yet trembles on the brink of dissolving back into an abstract jumble of lines and colours. Similarly, Klee's ambition was to 'deform the world of natural appearances' so as to go back to the *Ur-bildliche*, the origin of the pictorial (Young 2001a: 159), the forming powers that generate the visible. His work reinforces Cézanne's tendency to abstraction but remains focused on letting objects emerge from abstract patterns and hover on the verge of intelligibility. In both cases, 'we take the "step back" so as to become aware not only of the project*ed* but of the project*ing*' (157).

Although Vermeer's paintings are not abstract and thus do not show how a world emerges from chaos, they perform a structurally similar kind of ontological disclosure: they highlight the *un-worlding* of a past world. They prompt and allow us to imagine the world of the Dutch golden age, and yet in the same movement make us aware of the fact that it is out of our existential reach. The poignancy of such un-worlding is emphasised by the way in which the *worth* of what was lost comes to the fore. As indicated above, the practices depicted share a common style which is one of deep *care*, for the activities themselves, the objects involved and the world they belong to.[34] This is particularly obvious in the case of the *Milkmaid* but equally visible in the intensity of the geographer's stance and woman in blue's quiet concentration. All three of them fit in harmoniously with their world. Furthermore, their care allows the objects they use to emerge for us in yet *another* way: not just as ready-to- and present-at-hand in the ambiguous mode described above, but also as 'things', to use later Heidegger's vocabulary, as focal points that gather their world further around them. Thus far from being realistic, Vermeer's paintings give us an idealised depiction of how one can be *at home* in one's world.[35] This ideal aspect explains the scarcity of individual features and contextual elements I pointed out earlier (since both would get in the way of the idealisation) and is further emphasised by the golden, Arcadian light that suffuses all three paintings. Its cosy radiance enhances the impression of being at home and generates a sense of wonder akin to what Heidegger notes about the festival in Hölderlin, the 'wonder that around us a world worlds at all . . ., that there are things and we ourselves are in their midst, that we ourselves are' (Heidegger 1982: 64). In this regard, perhaps one of the paradoxes of Vermeer's paintings is that such wonder should not require a heroic step out of the drabness of 'everydayness' (as in the festival) but on the contrary attach itself to the most ordinary, often insignificant practices. Yet it is precisely this homely character which allows the works to shed a new light on our *own* everyday life and

practices, and thus afford us an opportunity to understand and possibly change them. In doing so, the paintings fulfil a similar kind of goal to that of *Being and Time* itself; yet whereas the changes enabled by the latter require reflection and conscious thought, by showing us a form of dwelling as both 'caring for and being cared for' (Young 2001a: 129) the paintings can prompt us to alter our practices unreflectively.

Thus the paintings present us with a transfiguration of the everyday which explains our deep attraction to their world and makes them relevant to our own lives. Yet there is (even) more to the ontological disclosure they perform. Our sense of wonder is tinged with melancholy. The way in which the figures belong to their world intensifies our own sense of homelessness. Beyond this, our inability to deploy their world emphasises its fragility, and by extension the transience of *all* worlds. It is not a vast jump to see from the precariousness of that lost world that one day ours will be lost too. I believe that it is not even a logical inference: just as ruins, for Schopenhauer, make the passing of time and our own mortality directly perceptible to us, in the same way our sadness at the loss of the Dutch world intuitively leads us to feel that ours is destined to the same end. Thus whereas Cézanne's and Klee's work show us how worlds emerge out of chaos, the Vermeer paintings point towards the inherent fragility not just of the Dutch golden age, but of *all* worlds, towards their dependence on historical practices that may become less prominent or even cease to exist. They make our own thrownness and finitude palpable. Thus the 'fundamental mistake' of metaphysics is averted: the Vermeer paintings make it impossible for us to believe that the world we live in is the only possible one. That they are able to do so almost four centuries after they were created is, notwithstanding Heidegger, a testimony to their enduring power as artworks.

Notes

1 See also de Jongh 1974: 166–91, and de Jongh 1975–76: 69–97.
2 For example *Silenus Alcibiades*, Middelbourg, Royal Library of The Hague, 1618.
3 Generally speaking, Italian art rests on the primacy of two elements. The first is well known (see Panovsky 1991) and concerns the geometric construction of space according to the principles of Albertian perspective. Space is considered as infinitely divisible and calculable extension, in which figures and objects are distributed according to the mathematical relationships defined by a framework established by the vanishing point and horizon line. The second distinctive feature of Italian painting lies in its emphasis on narratives and storytelling. Based on the representation of great human actions, biblical or historical, it is a painting of time in that its principal function is to immortalise an event or series of events (cf. ubiquitous depictions of the various scenes of the life of Christ). Consequently, Italian painting is centred on the representation of the human body, its actions and expressions. It draws on a repertoire of postures and gestures that dates back to Antiquity and which feeds most traditional representations (such as, for example, those of the Massacre of the Innocents) and

allowed artists to display their virtuosity in the rendition of human emotions (such as Herod's cruelty, the harshness of the soldiers, the mothers' despair, the pathos of the death of the children, etc.). The – easily recognisable – protagonists generally command the organisation of paintings that are meant to highlight their worth, and in which the geographic or historical context only appears as architectural background, or is glimpsed in a *veduta*.

4 Alpers 1983: 222: 'The place that Vermeer's works have had in this book leaves no doubt about what I take to be their exemplary role in the definition of the art of describing.'

5 See for example Alpers 1983: xx:

> A major theme of this book is that central aspects of 17th century Dutch art – and indeed of the northern tradition of which it is part – can best be under-stood as being an art of describing as distinguished from the narrative art of Italy.

6 The cartographic tradition excludes the adoption of a single point of view and offers a non perspectival representation of the world. For example, the division of the picture surface into squared zones, which is central to the Albertian tradi-tion as it allows the visualisation of perspectival lines, fulfils a very different function in northern painting: it enables the division of space into small zones in which people and buildings are represented from different perspectives. (See for example *Le polder Het Grootslag près d'Enkhuizen* (anon., Enkhuizen, Zuiderzeemuseum). On the use of cartographic techniques in Dutch painting of the golden age, then by Philippe Koninck and even Piet Mondrian see Alpers 1983: 119–69.) Correlatively, the position given to the spectator is often from a bird's eye, that is aerial and most importantly in movement, which doubly dero-gates from Albertian principles. The views of ports give another example of this resistance to these rules: in most cases the outline of the town hugs the coast from a horizontal perspective and yet is seen from above, in a doubling of perspective which is contrary to Alberti's principles.

7 As indicated by Huerta (2005: 25), early versions of the *camera obscura* consisted of darkened rooms with a small hole to admit light. This produced an inverted image of the exterior scene on the wall opposite the aperture. In the seventeenth century it was discovered that placing a convex lens over the aper-ture and using a movable screen would produce a brighter image and improve the focus. The resulting image shows optical effects not visible to the naked eye (such as white, pearl-like reflections on objects) and is saturated with colour. Contrary to perspectivism, centred on the vanishing point and ordered from a single point of view, the *camera obscura* gives a spherical vision of the world that displays itself before the gaze of a spectator that has lost his privileged position. The consequence is the impossibility of fitting most Flemish paintings into the Albertian framework: landscapes and interiors overflow the sides of the canvas, exceeding the circumscribed cubic space. The world is no longer a theatre for human action and its narratives, it is rather a panorama where things and men find their own places.

8 See also Alpers 1983: 162:

> Huygens ... also pushed aside the historians of the world in the interest instead of binding knowledge to the vivid appearance of things seen. To the Dutch way of thinking, pictures, maps, history and natural history had common means and ends.

9 Thus there are very few history paintings in Dutch art of this period (Rembrandt being a notable exception). The focus is not on characters, let alone on the

human body, but on places – fields, villages, landscapes, towns and interiors. Far from being a privileged figure, the microcosm in which Italian Renaissance thinkers deemed the macrocosm reflected, man appears as only one element in a wider context. He is not really the focus of the representation (with the obvious exception of portraiture). This reversal of the hierarchy of men and things is also shown by the privileged status given by the Dutch to *lumen* (the light which emanates from or is reflected by objects), rather than to *lux* (the light allegedly emitted by the human eye in its exploration of the world and from which Italian painters modelled the contours of objects). Correlatively, the artists' attention was drawn to the things themselves, towards the minute representation of details, textures and materials (hence the frequent use of microscopes to refine the rendering of objects, and the fashion of 'fine' painters such as Gerard Dou).

10 Cf. also: 'The pursuit of natural knowledge in the 17th century provides a model for the consideration of both craft and high art' (Alpers 1983: 24).

11 For an extreme version of this sort of epistemological reading, see Huerta 2005. Huerta claims that Vermeer's approach was resolutely 'naturalistic', focused on the acquisition of knowledge and thus governed by the desire to depict reality faithfully:

> Vermeer's approach to knowledge acquisition bears a marked similarity to the methods of Kepler and Huygens. ... Vermeer's solution was to adopt a 'concentric method', returning again and again to the same subject matter, refining and subdividing his maps of reality so as to more precisely describe it.
>
> (Huerta 2005: 17)

The claim that Vermeer's paintings are naturalistic in intention and effect is very common among commentators. See also Arthur Wheelock, *Johannes Vermeer*, which expands on Vermeer's 'uncanny naturalism' (102 sq), and Lokin 1996.

12 See for example *Four Mice*, Rijksmuseum-Stichting, Amsterdam, or the depiction of insects in his *Drawing Book*, Fondation Custodia, Collection Frits Lugt, Institut Néerlandais, Paris.

13 I have restricted this analysis to two paintings only for lack of space.

14

> Great art, we have seen, is art which first, brings world out of background inconspicuousness and into the explicitness of foreground clarity (call this the 'truth' condition); second, endows it with an aura of 'holiness' (the 'earth' condition); and third, gathers together an entire culture to witness this charismatic presencing of world (the 'communal' condition). In view of the focal significance of Greek tragedy and the Greek temple in its construction, I shall call this conception of art the 'Greek paradigm'.
>
> (Young 2001a: 65)

15 See for example Metsu, *Woman Surprised While Writing a Letter*, or Vermeer's *Reader*.

16 It is a map of Holland and Western Frieze, drawn by Balthasar Florisz van Berckenrode in 1620 and published by Willem Jansz Blaeu. Cf. Mauritshuis 1995: 136.

17 X-ray plates show that Vermeer intentionally enlarged the map on the left hand side.

18 Cf. for example Nicolas Maes.

19 Cf. Snow 1994: 10.

20 Another painting of the same subject (*The Reader*) attests to the same intention to lose obvious symbolic elements: X-ray examination reveals that in an earlier

version a representation of Cupid was attached to the wall, which would have given the viewer a strong clue as to the nature of the letter. By removing it (even at the risk of destabilising the composition as Cupid was placed at the vanishing point), Vermeer clearly indicates that the importance of the picture is not connected to any obvious symbolism.

21 There is a similar effect in *A Lady at the Virginal and a Gentleman*: one should see a shadow on the left top corner of the wall since there is also one in the corner of the window: yet there is none. In the same way, the tiles on the right are in shadow while the white pitcher that sits on them isn't, which reinforces its importance for the composition but is hardly realistic in spirit.

22 Thus a spoon is made of (say) wood, designed in order to stir for the sake of preparing meals.

23 National Gallery of Ireland, Dublin, Beit collection.

24 This is noted by Wayne Franits with reference to another painting which shows a shoe lying on the floor, Caspar Netscher's *The Lace Maker* (see Franits 1993). The thimble lying on the floor could also by symbolic of the virtues of domestic life.

25 There are a few but not many exceptions, in particular the *View of Delft* and early works such as *Diane and Her Companions* or *Christ in Front of Martha's and Mary's House*.

26 This is also the case in other paintings by Vermeer, in particular *Girl Reading a Letter at an Open Window*, *Lady Writing a Letter with her Maid*, *The Love Letter* and the *Art of Painting* where a similar effect is produced by a different means, namely the positioning of a thick curtain at the front of the painting: the curtain functions as a transition from the viewer's space into that of the painting and thus establishes virtual continuity between the two.

27 Note the subtlety of Vermeer's use of light here: the right side of the Geographer's face is directly exposed to the light flooding from the window, which is so strong that one would expect the left side of the man's face to be deeply shadowed. Yet the white parchment on the table works as a reflective surface which projects a softer light back onto the geographer's face, thus allowing Vermeer to depict it in a much more expressive way than otherwise.

28 In *Auffälligkeit*, the tool is encountered as unusable or un-ready-to-hand, for example because it is damaged. In *Aufdringlichkeit*, we have the same tool in front of us but we want another one: on this background the first one becomes obstrusive. Finally, in *Aufsässigkeit*, the tool is neither missing nor un ready-to-hand but it 'stands in the way' of our concern (Heidegger 1962: G74. We must attend to it before doing what we really want (for example, mixing colours before we can paint).

29

> The world itself is not an entity within the world; and yet it is so determinative for such entities that only insofar as 'there is' a world can they be encountered and show themselves, in their Being, as entities which have been discovered. But in what way 'is there' a world? ... Does not Dasein have an understanding of the world – a pre-ontological understanding which indeed can and does get along without explicit ontological insights?
>
> (Heidegger 1962: G72)

30 Thus 'worldhood itself may have as its modes whatever structural wholes any special "worlds" may have at the time: it embraces in-itself the *a priori* character of worldhood in general' (Heidegger 1962: G64). Note that the claim that worldhood is a priori should not be read in a metaphysical way, as entailing that worldhood can exist before and independently of any actual world. What is

meant by it is twofold: although it can be artificially separated from its embodiment in a particular world by and for the purpose of reflective analysis, the structure of worldhood only exists as instantiated in a particular world. And conversely, anything that qualifies as a world must exhibit the distinct features of this structure. Whether Heidegger is right to think of worldhood as a priori is a hotly debated point. The Vermeer paintings certainly exhibit the sort of worldhood that he analysed in *Being and Time* but it may be pointed out that even though there are very significant differences, they are not that culturally removed from our own world and that therefore the structural continuity may be explained in terms of the empirical persistence of similar practices (rather than by the transcendental dependence of all practices on worldhood).

31 Thus the temple indicates 'what is brave or cowardly, what is noble and what is fugitive' (Heidegger 1971: 44). It points out towards an understanding of being which is intrinsically normative (cf. Young 2001a: 25 sq). Young rejects the 'Promethean reading' (attributed to Hubert Dreyfus, see 2005: 52 sq) according to which the artwork would *create* a world. Perhaps in reply to this, Dreyfus has provided a more nuanced account of the possible relations between artworks and world (articulation, reconfiguration). See Dreyfus 2005: 407–19.

32 Both the emphasis on the relation between an artwork, its people and its time on the one hand, and the claim that there are no great works any more on the other hand are deeply Hegelian in spirit. Cf. Bernstein (1992), and Young (2001b).

33 As in the case of Van Gogh's shoes, their scale was too small. They were meant for private display and thus could not have performed the sort of heroic world-articulation that Heidegger had in mind with the temple or the cathedral.

34 I owe this observation to Edward Pile.

35 Another way of expressing the same idea would be to say that they *dwell* in their world. Cf. 'Building, Dwelling, Thinking': 'the fundamental character of dwelling is ... sparing and preserving' (*Poetry, Language, Thought*: 149). As astutely pointed out by Julian Young (2001a), in this context *schonen* is dual-aspected: on the one hand, the dweller is 'preserved from harm and danger ..., safeguarded' (ibid.) and on the other, s/he 'safeguards each thing in its nature'. Thus 'dwelling is, in brief, both caring for and being cared for' (129).

References

Alpers, S. (1983) *The Art of Describing: Dutch Art in the Seventeenth Century*, Chicago: Chicago University Press.

Bernstein, J.M. (1992) *The Fate of Art: Aesthetic Alienation from Kant to Derrida and Adorno*, University Park: Pennsylvania State University Press.

De Jongh, E. (1971) *Rembrandt et son temps*, Brussels: Palais des Beaux-Arts.

—— (1974) 'Grape Symbolism in Paintings of the 16th and 17th Centuries', *Simiolus* 7: 166–91.

—— (1975–76) 'Pearls of Virtue and Pearls of Vice', *Simiolus* 8: 69–97.

Dreyfus, H.L. (2005) 'Heidegger's Ontology of Art', in *Blackwell Companion to Heidegger*, H.L. Dreyfus and M.A. Wrathall (eds.), Oxford: Blackwell.

Franits, W.E. (1993) *Paragons of Virtue: Women and Domesticity in Seventeenth Century Dutch Art*, Cambridge: Cambridge University Press.

Geertz, D. (1976) 'Art as a Cultural System', *Modern Language Notes* 91, no. 6: 1473–99.

Heidegger, M. (1962) *Being and Time*, trans. J. Macquarie and E. Robinson, Oxford: Blackwell.

——(1971) *Poetry, Language, Thought*, trans. Albert Hofstadter, New York: Harper & Row.

——(1982) *Hölderlin's Hymne 'Andenken,' Gesamtausgabe*, Vol. 52, Frankfurt am Main: Klostermann.

Huerta, R.D. (2005) *Vermeer and Plato: Painting the Ideal*, Lewisburg, PA: Bucknell University Press.

Lokin, D. (1996) 'Views in and of Delft', in M. Kersten and D. Lokin (eds.), *Delft Masters, Vermeer's Contemporaries: Illusionism through the Conquest of Light and Space*, Swolle: Waanders.

Mauritshuis (Hague, Netherlands); National Gallery of Art (US) (1995) *Johannes Vermeer*, The Hague: Royal Cabinet of Paintings, Mauritshuis; Washington, DC: National Gallery of Art.

Panovsky, E. (1991) *Perspective as Symbolic Form*, trans. C.S. Wood, New York: Zone Books.

Schama, S. (1987) *The Embarrassment of Riches: An Interpretation of Dutch Culture in the Golden Age*, London: Collins.

Snow, E. (1994) *A Study of Vermeer*, Berkeley: University of California Press.

Walsh, J., Jr. (1973) 'Vermeer', *Metropolitan Museum of Art Bulletin* 31: Sec. 3.

Wheelock, A. (1981) *Jan Vermeer*, New York: Abrams.

Young, J. (2001a) *Heidegger and Art*, Cambridge: Cambridge University Press.

——(2001b) *Heidegger's Philosophy of Art*, Cambridge: Cambridge University Press.

8

PHENOMENOLOGICAL HISTORY, FREEDOM, AND BOTTICELLI'S *CESTELLO ANNUNCIATION*[1]

Joseph D. Parry

A knowledge of the history of a painting is crucial for a full understanding of the meaning of that work, including an understanding of how a particular work can be a source of phenomenological insight. But in this chapter I will explore what a painting can tell us about history in a phenomenological understanding of being. For the philosophers Martin Heidegger and Maurice Merleau-Ponty, history can tell us a great deal about the freedom of being, and so I wish to show here that a painting, too, especially a painting of an historical subject, can give us insight into the freedom of being. Two key, specific tasks that are central to history's interest in freedom are at stake in my essay: helping us take responsibility for and a stand on history, and helping us understand freedom as the power to break with the world we find ourselves in. In fact, because a history painting can give us a special kind of experience with history in its decisive moments and, therefore, with a concretely configured moment of freedom, I wish to suggest here—and I only have space to suggest, rather than argue—that a work of painted history has a greater capacity than a work of written history does to demonstrate's freedom's power to perform a task that Heidegger thought was fundamental to philosophy: radicalize the question of being.

The painting I wish to focus on is Sandro Botticelli's *Cestello Annunciation* (c. 1489–90), which hangs in the Galleria degli Uffizi in Florence, Italy (Plate 26). The subject of the Annunciation itself, but also this painting in particular, prompts us to ask key questions about the very nature of human agency and freedom that informs this event in history. I want to begin by considering the subject of the Annunciation and to introduce this amazing painting. I will then look to Heidegger and more especially Merleau-Ponty in *Phenomenology of Perception* and, to a lesser extent, "The Crisis of Understanding" to help us understand how history can be a philosophically significant mode of inquiry into freedom in the

context of our understanding of the relation of beings. But for a full under-standing of the question of freedom and its relevance to my inquiry, I will also turn to Heidegger's *The Essence of Human Freedom: An Introduction to Philosophy* and *On the Essence of Truth*. At that point, I will return to Botticelli's painting and introduce a modern treatment of the scene, John Collier's *Annunciation*, to explore how the process of interpreting the work unleashes the "strength and strike force" (Heidegger) of freedom to make us rethink our understanding of the meaning of being in its relations.

The Annunciation as history

The Annunciation marks a moment of significant change in history, and thus, the event reveals something of the logic that governs the way history is conceptualized. As the Christian-Western tradition has configured world history, the Annunciation is the moment when an old world ends and a new one begins, when the book that both comes from that old world and indeed symbolizes that world—the Old Testament, the old covenant between God and His people—comes to a conclusion, and an anticipated, prophesied new world and a new book/covenant begins: the New Testament. The basic composition of this event, in fact, engages a question that has been of tremendous interest to philosophers, including those concerned with phenomenology: is the forward-in-time motion of human history, its "progression" through epochs, to be understood as a continuous flow, or do history's epochs represent ruptures with the past epoch? This is an impor-tant question and it will bear on my analysis throughout this study. But my specific interest here is in the way that The Annunciation allows us to think about how we conceptualize the phenomenon of human agency in history itself. The Annunciation is an instance when an embodied human being named Mary is confronted with an opportunity to act in a way that is supremely important to the meaning of her own existence and to all of humankind's. And yet this "opportunity" is essentially presented to Mary as already "historical" as this moment unfolds, as if her place in history had already been written. It is not just that we already know how the story goes and how it is going to end when we consider the Annunciation. The question I wish to pose here is: why is this event the "Annunciation," the Announcement, the "Have You Heard the News about Your Future, Mary," rather than an invitation, "Would You be Willing to . . .?" God does not ask Mary if she will become the mother of His Son; she is simply told *that* she will be that mother. And by the same token, before anyone takes up a pen or a brush to render the scene, The Annunciation is already given to us as an occurrence embedded within a question concerning what human agency and freedom are within the givenness of Mary's existence. It is to this question that I want to first draw our attention.

Like all historical figures, we only know Mary as someone who is always

already someone of historical significance, situated within the givenness of her place in world history. But Mary stands out as one who in her debut moment on history's stage is poised on the threshold of radical change—physical change (she is about to become pregnant), but also a profound alteration in the way she thinks, and therefore we think, about herself, her world, her body, and the very meaning of her existence. Italian Renaissance artistic treatments of this scene are especially noteworthy for the way in which they rivet our attention on Mary at this very threshold. At this moment Mary is becoming a being-who-will-be-known for certain attributes and qualities. She is being transformed into the being who will be known as the proto-typical disciple of Christ, the first who not only humbly acquiesces to her divinely ordained lot in life, but who does so to God in the flesh. Though she will be Jesus's mother, she submits herself already at this moment to be his first, most consistent, and perhaps most thoughtful follower no matter what happens to her son and God. Botticelli will gesture at the pain that awaits her, as well as Him, in the *Cestello Annunciation* in the tree that springs from the angel's head. At the same time, the Annunciation raises Mary to alight temporarily on the highest order of being—divinity itself—and thus she embodies a sense of possibility for humans that very few, if any, other figures in any culture or system of thought I know of comes close to. In this story Mary will commingle her essence with the being who created her to create a new being who is both creator and created, ruling and ruled, divine and human, immortal and mortal, Spirit and physical matter. Though this experience does not fundamentally change the mortal existence Mary will continue to live thereafter until her death, the meaning of what she is as a mortal being is profoundly changed and elevated by means of her participation in this event. The greatest of all beings chooses her to create His Only Begotten Son, through whom He intends to effect a similarly elevating change for all of His other created human beings—redemption—a work, in fact, which Christians believe most fully manifests the being of God. In the larger story of Christian world history that begins with the Fall of Adam and Eve, Mary is admitted through the otherwise impenetrable wall that has separated God from His children since the Fall. She is readmitted into the presence of God, not just to worship Him or receive instruction, but to join with Him in the most intimate act available to any two beings in all of creation.

Paintings of the Annunciation, like Botticelli's, inevitably take up both the givenness of Mary's existence and her response to that givenness when they take up this scene. And Italian Renaissance Annunciation paintings—of which Botticelli's work is an especially good example—often make the question an emphatic one by conspicuously looking at Mary at a moment when she responds to her situation, and perhaps her situatedness, ambiguously. Though our assumption is that Mary is depicted here in the middle of acting out a scripted role, the work as it stands nevertheless generates a

certain kind of dramatic force, if not full-fledged conflict, in the way that it gives us a world that seems to stop as her response to Gabriel and to God hangs in the balance. But in her decisive moment Mary's bearing does not so much put the decision that she will make, or is now making, in question (though it is by no means impossible for such questions to occur to us while we view the painting). Rather, it poses a different set of questions about the nature of the decisions that are laid before her each time she takes up her destiny as the Mother of the Son of God, questions to which the answers are neither obvious nor simple. Paintings of historical events, of course, do not ask every question that is important to history, above all, the question concerning whether an event that has been handed down to us by history (both as having happened, and also as an event that is significant) did, in fact, actually happen. That the Annunciation happened, and that this happening has been and continues to be significant—a significance which is reiterated by the very creation of a painting of this subject—is also given. And yet, a painting by its very nature represents when a happening happens. Botticelli in particular displays keen interest in representing what it means for Mary that this event happens the way it happens *as* it happens. Our understanding of the painting is still oriented to how things turn out in the story. Nevertheless, at its most fundamental level, the meaning of this event in this painting remains a happening happening, an occurrence occurring in Mary's body, the unfolding of her embodied experience in the events within the event we call the Annuncation as they unfold.

What is happening specifically in Botticelli's *Cestello Annunciation*? Because it is a painting, and not a written narrative, an honest answer is: several things at once. Whereas the narrative of the Annunciation in the Bible (the putative source for this story) delivers it in a cumulative sequence of smaller events—the temporality of which also imputes a sense of causality—the painting presents us with something more temporally and logically-causally complex. I am looking at a moment somewhere *in medias res* in the story; at my first glance, this painting only seems to be able to give us a particular moment in the story, even if that moment seems only to make sense if we already know (and are perhaps reminded by features in the work) what just happened in the story before this moment and what will happen in the next. A call of some sort has already been given, and we can only see Mary's bearing, Mary's body as that which registers a response to this call. But which call? The story gives us several options, several moments: Gabriel appears to Mary, salutes her, Mary reacts internally to the way the angel salutes her, Gabriel delivers his message, Mary asks a question about how this is all going to happen, Gabriel offers his explanation, Mary expresses her acceptance, Gabriel leaves. The story opens with Gabriel entering in ("ingressus") to Mary, hailing her as one into whose existence God has already intertwined Himself. The angel "ad eam dixit have gratia plena Dominus tecum benedicta tu in mulieribus" ["says to her,

Hail, you who are full of grace. The Lord is with you. Blessed are you among women."] (Luke 1:28). Is this the moment Botticelli shows us? In scripture and in Botticelli's painting Mary is "disturbed" at this moment. In the scriptural text, Mary is disturbed at what he says—"turbata est in sermone eius"—and she "thinks" about the "kind (or manner) of salutation" she has just heard: "et cogitabat qualis esset ista salutatio" (1:29). It seems to be a sign of her humility and modesty that she is so disturbed. Gabriel's greeting could hardly have been delivered in less laudatory terms. Mary is someone who is already "full of grace," she is a being "with whom God *is*," and one who "*is* blessed among women" (my emphasis). Indeed, the back-story that centuries of tradition provided for Mary (her "immaculate conception," stories of her saintly childhood) takes its cues from the poised, intelligent, and faithful young woman whom we see on display in her scriptural moment of origin, even though it functions narratively as the background explanation for this moment. Nevertheless, Botticelli's Mary is distinctively animated in her semi-circular posture, which leans her upper body towards the angel as her hips and knees stretch her lower body away from him. Is that what we're seeing—an image of her "turbulent" inner state?

Or is Mary now moving from the initial disquiet at the salutation to the moment when she is beginning to frame the question with her body, "quomodo fiet istud quoniam virum non cognosco?" ["how (or in what manner) will this (statement of yours) be performed (or accomplished), since I do not know (am not in a sexual relationship with) a man?"]. As she twists her torso—indeed, her womb—both away from and towards Gabriel (opening her robe to him), does her contorted body articulate the question of the moment, and at the same time, act out the future that Simeon prophesies to her in the temple (the sword that will pierce her soul also, Luke 2:35)? In any event, we are becoming aware that this painting is not a snapshot, and that we might be thinking about its relationship to time anachronistically (after photography) if we are trying to decide which particular moment we're seeing. There is a sense of time in the image, and perhaps we can see the painting as a conflation of the moments that comprise this event. For that matter, it also takes time to look at a painting. With paintings we often talk about the phenomenon of where the eye first lands, and then how our eyes follow a kind of likely trajectory around, across, and/or through the painting as its lines, forms, colors, and textures lead us. We certainly don't have to follow the painting where it seems to lead us, and we can never be sure if the way the painting leads us will be the same for other viewers. For me, my eye seems to alight first on the space just above Gabriel's outstretched right hand in the upper right corner of the concrete wall outside the room where the scene actually takes place. I then tend to follow the weight that Gabriel's figure seems to introduce into the painting. I'm not sure that it's always exactly down the line of the outside wall, which

very quickly intersects with the right edge of the opening, and then down to Gabriel's hand, then to the left down and up his arm, and around and down the line between his wings and his robe to the lower left corner of the painting, but I tend to move in a downward left direction. But then I fairly quickly bounce back in the opposite direction, up and right to Mary's outstretched hand and arm, around to the left across her neck and face, then back down the right edge of the opening in her robe, and down to her bending knee and hidden feet. I think I finish by following the horizontal lines of the floor to the center vertical line, upward, picking up Gabriel's lily staff and then following the tree outside upward until its branches and leaves disperse my focus somewhat. I say, "I think," because I'm thinking about how I do this, rather than doing it un-self-consciously. Nevertheless, my self-awareness does serve the purpose of attuning me to the fact that I can and, indeed, must choose where I want to go from here.

That is the choice before me: where does it make sense (from how the painting is constructed) to go from where I am now looking in order to make sense of the painting as a whole? Though I can certainly make my eye go "anywhere" that strikes my fancy within, of course, the physical limitations of my being as I stand in the Uffizi Gallery in the Botticelli room, the itinerary of my eye within the painting is not one of my own invention. I follow a path the painting gives me in the way it presents its formal features and relations. But what is distinctive about a painting is that my path is not the only path the painting makes available. Now, I certainly ought to explore what kind of interpretive narrative might emerge from the path my eye took through the painting to see what the artist might have wanted to emphasize as this Annunciation unfolds before us. But the initial itinerary of my eye by no means exhausts the interpretive possibilities made available in the complex network of relations that are figured in this work of art, and I would argue that in order to get to know a painting thoroughly, we would explore as many pathways of seeing the work as the work itself seems to offer. The kind of contextualizing work that we do with these paintings—patronage, connoisseurship, and so on—can help us identify some interpretive probabilities, but such matters do not determine the freedom that I exercise as I simply look around in the painting to make sense of it. To be sure, there is a certain work of reconciliation that must go on in our attempt to understand a work of art that both has its own history and is itself about history. Indeed, if I wish to make my argument understandable and persuasive to other scholars of art, it will be my burden to reconcile what I read as given in the painting with what our received, given sense is of the artist in his cultural and ideological contexts painting a Christian subject.

But surely, we want history to do more for us than merely perform functions of cultural bookkeeping? Surely, history has a very large role to play for us today as a mode of understanding the past as meaningful in our present and making us more attuned to what we anticipate in our future?

167

When we study an "artifact" in its historical, cultural, and intellectual contexts—as Michael Baxandall has done with Botticelli's *Cestello Annunciation* and the contemporary sermons on how to view religious paintings that Fra Roberto Caracciolo da Lecce, under the patronage of the Medici family, delivers in Florence—even if we could somehow recapture, as Baxandall attempts to do, "the fifteenth-century classes of emotional experience" within which "fifteenth-century pictorial development happened," surely our interest in or understanding of Botticelli's work would not be fulfilled (Baxandall 1988: 56)? And even if we could somehow establish that Botticelli intended to render Mary as disturbed or disquieted ("turbata") by the angel's arrival, "not from incredulity but from wonder, since she was used to seeing Angels," as Fra Roberto taught, is it not our very focus on Mary in her body before us at the moment of our seeing her, twisting both towards and away from the angel, that allows the painting to exercise its ability to question in the present, to open up a space for questions to form around the vectors that virtually carry her into a future the painting orients itself towards, but which we will never see? Whatever context we bring to the painting in order to think it, is not its meaning ultimately rooted in the way that Mary's body speaks to our own bodies and our own embodied experience in taking up the world that opens itself before us at every turn?

Phenomenology's answer to these questions is an emphatic yes. But before I explore the painting further, as well as the questions I have posed about how a painting can do philosophically significant history, I would like to pause to consider more carefully what it is that history can tell us that is of philosophical significance, in the first place. For that we turn next to Heidegger and Merleau-Ponty for an understanding of what history becomes when it takes up questions about the meaning of being in its relations.

History as phenomenology

In his "Introduction" to *Phenomenology of Perception* Maurice Merleau-Ponty says: "True philosophy consists in relearning to look at the world, and in this sense a historical account can give meaning to the world quite as 'deeply' as a philosophical treatise" (1962: xxiii). For thinkers like Merleau-Ponty and Heidegger the meaning that history can give the world comes in the form of a question: what is possible in human existence? History is not concerned with the past for its own sake, but rather with what the happenings of the past tell us about what can happen in our present concerning the future that lies before us. The subjects of our historical inquiry, like Botticelli's Mary and perhaps like us in the act of doing history, are beings focused on and attuned to *that which is about to happen*. Now, we still want to know what happened in the past, too, in concrete detail because that past

is very much part of our present, having shaped our culture—for example, its institutions, its values, and, indeed, its accepted modes of institutionalizing and valuing what we should do and know in human society. But we study history not just because it can give us insight into why we do things the way we do them. As Heidegger said in *Being and Time*: "Only because the central theme of historiography is always the *possibility* [his emphasis] of existence that has-been-there, and because the latter always factically exists in a world-historical way, can historiography demand of itself a relentless orientation toward 'facts'" (Heidegger 1996: GA 395). Heidegger felt that we can only form a sense of what we are striving to become based on what the past tells us about what we have been. Thus, in doing history we are sorting through what we have been in order to formulate our choices for what we would like to be. Mary, for instance, has been such an important historical figure for our culture precisely because of the possibilities for human existence that her life exemplifies.

Because so much is at stake *for us* in Mary's actual lived experience in the world, we want to know what the specific details, circumstances, contexts were in which her past happened. Even if we do not feel a personal stake in her life, any kind of understanding of Mary will always be both informed by our understanding of what has happened, and also contextualized and constrained by the world-historical situation in which that which has happened, in fact, happened. Further, we are also ourselves contextualized and constrained within our own world-historical moment that determines what we recognize in the present as important about the past for the benefit of our future. Indeed, a past moment of human history does not make itself comprehensible to us as an instance of what once but now no longer exists. We make sense of a moment in the past as a moment configured by its future, by a sense of possibility that emerged from the concrete contexts and contingencies of the moment—however they were recognized and interpreted—and that opened itself to and was seized upon by someone moving towards his/her future in a particularly determined way. Indeed, history is a source of insight into what matters in our present world. Our very ability to recognize something important in the past means that it is also important to us in the world of our present concerns. The present draws on the past to inform our sense of possibility for the future, but it also prescribes what it is about the past that is meaningful for that projected future because it answers deficiencies we perceive in the here and now.

Because history matters in this way Heidegger and, in even more explicit terms, Merleau-Ponty want to make sure that history grounds its sense of meaning in that which really does give meaning to our being. History must attend to the "factical" world of our being, which includes things like our social and cultural contexts, for events happen and people act in particular circumstances and situations. However, above all of the contexts to which history must be attuned is that most determinative of existential

contexts—the body. Being in my body is the "primordial situation" of my being. As is well known, phenomenology rejects the Cartesian grounding of meaning in the thinking, conscious self, the famous *cogito ergo sum* ("I think, therefore, I am"), and the mind/body dualism that it establishes as the "given" feature of our being. Merleau-Ponty's pointed rejoinder to Descartes is: "The world is not what I think, but what I live through" (1962: xviii). The world that we "relearn to look at" is the world of my actual, embodied, lived experience. But as is also well known to phenomenologists, Cartesian dualism has profoundly influenced some of the most basic ways we understand being and being in its relations. As Mark A. Wrathall observes, even philosophers who do not accept this dualism still find themselves "constrained" by these terms as they, for instance, try to redefine the relation between the mind and the body, but in so doing, preserve the mind/body, mental/physical dualism as a fundamental conceptualization of the self (2005: 111). This problem is most clearly evident in the sciences, where both the self and world are objectified totalities that we can manipulate as such in our study of them, but it is also present in history and philosophy itself. Phenomenology's job is to help us do the careful, hard work of rethinking the most basic terms in which we explore what it is and means to be human as we are in our bodies. In Merleau-Ponty's words: "all of [phenomenology's] efforts are concentrated upon re-achieving a direct and primitive contact with the world, and endowing that contact with a philosophical status" (1962: vii).

However, borrowing its conceptual framework from science, history has tried too often to derive laws that govern the behaviors of people and cultures. In addition to the significant ethical concerns we might have about this attempt to devise predictability theorems for human "subjects," we should also be very concerned about any attempt to conceptualize the world we live through—the relational context in which everything in the world has meaning—in terms of causality. To do so is to make the big mistake of grounding meaning in, as Heidegger says, "*one* ontological determination of beings among others" (2002: 205). As we will see in Heidegger's understanding of the freedom of being, being must be conceptualized in its openness to possibility within the world without predetermining what possibility is. This is no mean task—even to use the article "that" with my last use of "possibility" in the previous sentence, which English grammar would ordinarily require, would be a mistake, for it would fix the concept of possibility as predetermined options. Even though people and events show up in the world as always already meaningful when we encounter them, we do not and, indeed, cannot already know what that meaning is as expressed as a causal or rational concept. Just as each artifact we uncover on an archaeological dig has meaning, especially in relation to each other, though we may not know what that meaning is, every being and action in the past has meaning. In a parodic jab at Sartre, Merleau-Ponty declares: "Because we are in the

world, we are *condemned to meaning* [his emphasis], and we cannot do or say anything without its acquiring a name in history" (1962: xxii). If beings are, as Sartre said, "condemned to be free," that also means that beings are not free of or from meaning. In fact, Merleau-Ponty states that it is *"precisely because it is always history as it is lived through* [that] we cannot withhold from it at least a fragmentary meaning" (1962: 522).

I live through my existence in my body. My body is always already there, as is my bodily familiarity with the world, my experience in my body moving in and through it.[2] I already know how to act in this world. In my body I bear myself forward into the world already primed to make sense of it in certain ways. I perceive size, dimension, relations in ways the world has pre-determined, even when the moment yields sensory information—for example, one object appears smaller than the other—that could lead me to other perceptions or actions if I stopped to think about it. If I want to thread a needle, and after several futile attempts, bring the needle closer to my eye, I do not experience the eye of the needle as somehow bigger than it was before. I may think that my deficient eyesight is to blame for my failures thus far, and so I compensate by bringing it closer, but I do not think that I have altered the physical structure or dimensions of the needle itself. In fact, what may be giving me trouble with the needle is that because I only rarely perform this action, I'm trying to think about how I should do it. Ordinarily, I do not stop to think about how I perceive the world, and even if I did, I could not explain all of the simultaneous processes that go on in my body as I "unthinkingly" walk down stairs (as anyone knows who has tried to think how they walk down stairs). In fact, it is the world as I encounter it in my body that motivates me—and not the other way around—to take hold of it in certain bodily ways that I am perhaps only barely aware of. The needle and the thread require me to comport myself in certain ways in order to gain the full use of those objects. I take up both objects because I want to sew a button on my shirt, but I do not determine how they will be used to accomplish my task. They determine the way they are to be used for me. At the most elemental level of my existence, I do not perceive the world out of a sense of motivation that I determine as a reason or cause for doing what I do. The motive to perceive the world in a certain way is given to me by the world itself. The world, as it were, extends to me a way of existentially grasping it that, for that matter, enables me in the first place to perceive the world that I take up.

Of course, history may not be overly concerned with how we do or do not explain to ourselves how we sew on buttons or walk down stairs. Nevertheless, history, too, must take into account the ways in which the world that we live through and in which we exist in our bodies among other embodied beings is the grounding condition in which all meaning occurs. In history, as in all modes of human inquiry, meaning is constantly occurring in ways that we cannot constitute by means of rational or causal concepts.

Whether we are talking about the most basic physical phenomena of our world, or about the intensely, intricately complex interactions of human beings in particular historical environments, rational or causal concepts do not fully explain, much less predict, what happens in the being of beings. For Merleau-Ponty, "historical meaning is not a law of the physico-mathematical type," but rather "that formula which sums up some unique manner of behavior towards others, towards Nature, time and death: a certain way of patterning the world which the historian should be capable of seizing upon the making of his own" (1962: xx). In history we seek the thing in its particularity, that which is "unique" in a culture's "manner of behavior towards" what he identifies as four fundamental aspects of being—others, Nature, time, and death. Why he chooses these four phenomena is not something he elaborates on, and to do so anyway would take us beyond what we can adequately treat here. But in terms of the structure of what the historian does, she does not simply look for a pattern, much less *the* pattern, but rather for "a certain way of patterning the world" that she recognizes as such, and in recognizing it, simultaneously recognizes that her ability to recognize a pattern originates in the structures of her own being-in-the-world.

In fact, what Merleau-Ponty explains here is what we can also call by Heidegger's important term, a (historical) "clearing." The "clearing" for Heidegger occurs when that which configures and thus gives us our sense of meaning and significance—forces, ideas, assumptions which usually stand back in an occluded background of our being—steps forward not so much into the light, but rather as the light that guides what and why humans do what they do.[3] As Hubert L. Dreyfus states it, the clearing is where "things and people can show up as mattering and meaningful for us" because we have been able to come to "a background understanding of what matters and what it makes sense to do." But as Dreyfus explains further: "We do not create the clearing. It produces us as the kind of human beings we are" (Dreyfus 1993: 296). Thus, my job as an historian is to try to think the background of my world—the background that, again, I live through as one that has already primed my sense of what is and is not important—as I try to discern the background of the world I study through its foreground of actions and actors. I engage myself with the foreground of lives, places, events of a cultural and temporal other in order to allow the background to emerge on its own terms, in its "uniqueness," as a way of facilitating the presumably "unique" background of my own time and culture to peek through the clouds. Yet the respective backgrounds of past and present do not simply show up as discrete entities. Indeed, what gives meaning to and thus ultimately justifies a study of a culture's "unique manner of behavior" or "way of patterning the world" is that there is, in fact, some kind of unity to human experience in/of the world that has borne the beings of the past and present, even though no one being, no one set of beings, no one mode

of "relearning to look at the world" will ever be able to comprehend that unity. As Merleau-Ponty says: "Considered in the light of its fundamental dimensions, all periods of history appear as manifestations of a single existence, or as episodes of a single drama—without our knowing whether it has an ending" (1962: xxii).

Now, we might well ask what this kind of history looks like in actual practice. Shortly, I will return to Botticelli's *Cestello Annunciation* to show how this work does the work of history, but before doing so, I want to consider the example that Merleau-Ponty uses in *Phenomenology of Perception*—Napoleon Bonaparte's becoming the emperor of France—to suggest what difference phenomenology can have on a familiarly historical subject.[4] So often in history, a figure like Bonaparte is conceived of as a force, a larger-than-life figure who moves politicians and armies to do what they do. We think of the Napoleonic wars as an expression of Napoleon's personal will. To be sure, from the outset Merleau-Ponty reminds us that the people and events we study in history are already meaningful; the actions and events that comprise Bonaparte's making himself "Emperor and conqueror" opens itself already ensconced within "a horizon of significance," and so we approach Napoleon in history already with a sense of what he means in and to the history that continues to unfold into the present. In fact, this situation obtains for Bonaparte himself within "his" own historical moment; Bonaparte and everyone else acts within a sense of unfolding significance that no one devises or owns, but rather takes up. Bonaparte does not "make history" in a phenomenological understanding of history. Rather, Bonaparte the individual "takes up" a course of action that the world and the contingencies of the time and situation made available to "an" individual: "It is the concrete project of a future which is elaborated within social coexistence and in the One before any personal decision is made" (Merleau-Ponty 1962: 522–23).[5] Merleau-Ponty's use of the term, "project" deserves some explanation here. A project for Merleau-Ponty is a technical term for an outline of a way of projecting oneself into the world that the world itself holds out as meaningful. It's the design, the blueprint for enacting a way of being that the world "prepares" and that I take on. "Becoming France's Emperor" is Bonaparte's project because he was the one who took it on. Referring to this project, Merleau-Ponty writes: "Something is being prepared which will perhaps come to nothing but which may, for the moment, conform to the adumbrations of the present" (1962: 522). A project like this is a particular response to a call from the world to take it up in a certain way, with a certain "comportment" to the world that it, not Bonaparte, determines.

A project, then, is an instance, a coming-to-pass of a moment when perception of the world is "carried" into movement into the world. Such an instance is of tremendous philosophical importance. It represents the taking shape of a move from being "For Oneself" to being "For Others"

(Merleau-Ponty 1962: 151, 525), and it allows us a way of talking about being in the terms that Heidegger came to value; that is, not as a thing or a state, but as a happening, or in a much richer, multi-faceted term he uses, an *Ereignis*: an event of appropriating, enowning that which I encounter. We understand Bonaparte's actions as a moment in which the past and the future "presences" as a way of being-in-the-world; a moment that invites, even demands a response; a decision to belong to being. Even though Napoleon seems to have chosen a course of action that we may rightly question in hindsight, and even condemn, we can still only understand what Napoleon was doing at that moment by constituting the decisive moment as one in which he responds to a call that being issues. We have to assume that since this action made sense both to Napoleon and also to his many supporters, then this call is not issued to any one person in particular—as if that one person were the only one who could take up this call—but to many people who, involved in the concerns and practices of this moment, saw this decision as one that made sense. Indeed, we cannot safely assume very much at all, if we want to keep the openness of possibility, in fact, open in our historical inquiries. Bonaparte's rise was by no means inevitable, nor, for that matter, was the rise of a dictator the only possible way that history could have gone. We cannot assume that the decision came down to an either/or proposition, nor that the decision was one whose consequences were known to Bonaparte. The most we can say is that he has "taken command of history" and "leads it, for a time at least, far beyond what seemed to comprise its significance" (Merleau-Ponty 1962: 522).

Now, it's not that we do not care about what the consequences were of this fateful moment, and it's not that we are somehow disallowed from judging the actions of the past. As we have already said, we look to the past to help us look to our future. And as we will see later in this chapter, Merleau-Ponty directly addresses the issue of making ethical judgments in the work of history. It is because we want to understand what has been possible for us in the past, so that we can make our own decisions for our future, that we want to understand how certain courses of action showed up as important or desirable in the world of lived experience. It is because we want to break with our past, with our collective participation in its violence, its despots, its hypocrites, that we study the past in its particularity. We care about Bonaparte's moment in history because it was a decisive moment— because it was a moment when a whole realm of choices and possibilities opened up to him in such a way that the exigencies of that moment allow "the givenness of given beings—including ourselves—[to] come into question for us" (Polt 2005: 383).[6] This was a moment when we can glimpse through the foreground of the particular actions, decisions, and concerns of 1799 France at least an aspect of the background that allowed this particular decision to be one that was meaningful and important, in the first place. In fact, there's much about this foreground that we cannot know for certain.

Perhaps all we can know for certain is *that* it made sense in 1799 France to do what Bonaparte did, and so all of our attempts to understand what he did and why he did what he did orient themselves to the more general questions about what and why it made sense for someone to do this. As the culmination of a project that didn't have to be, but in being and in its way of being, 1799 France and even Bonaparte himself become a place where "an exchange between generalized and individualized existence" occurs. Phenomenological history is interested in the *thats* of history, along with as many *whats* as it can know, because, of course, each "that" is the "that" of a "what," and vice versa, each "what" is the "what" of a "that." Again, our very ability to recognize what happens is conditioned by the circumstances and contexts of our being, and our very ability to become attuned to these circumstances and contexts is made possible in our concrete engagements with the world. But ultimately, what this process manifests is something that is absolutely fundamental to an understanding of being: the freedom of being.

Merleau-Ponty has a few more things to say to us about history and freedom before we are in a good position to return to Botticelli's painting in order to see what this work has to tell us about the same topics. But first, we need to understand what he does and does not mean by freedom. And since he seems—at least to me—largely to rely on a Heideggerian account of freedom, I wish to turn now to Heidegger to understand how he treats the question of freedom in the context of his larger—indeed, largest—philosophical concerns.

Freedom

As alluded to before, we have to be very careful when we talk about freedom. When Heidegger or Merleau-Ponty say that history is the study of freedom, they do not mean that freedom is history's object of study, or that it is a privileged possession or tool of historical inquiry. Before we are in a position to understand what history's relationship with freedom is, we have to have a better understanding of what the inherent difficulties are in any attempt we make to think freedom. What is the freedom of being, according to Heidegger? Well, it turns out that a better way of asking this question is actually: What is at stake in the question of freedom? The answer is: everything. Heidegger addresses these truly high stakes directly in *The Essence of Human Freedom: An Introduction to Philosophy* (EHF) and *On the Essence of Truth* (OET). In fact, Heidegger's claims are somewhat surprising in EHF, a text based on a lecture course he gave at the University of Freiberg in the summer of 1930, first published only in 1982 (as Volume 31 of the *Gesamtausgabe*), and first translated into English in 2002. He states there that "*freedom must itself, in its essence, be more primordial than man.* ... Human freedom now no longer means freedom as a property of man,

but *man as a possibility of freedom* [emphasis his]" (93). He concludes this work with the striking declaration that "the question concerning freedom is the *fundamental problem* of philosophy, even if the *leading question* thereof consists in the question of being" (205). It certainly sounds here as if Heidegger is making at this moment at least something of a shift in his thinking. All of the Heideggerian horizons we thought we could glimpse in *Being and Time*—the authentic way of being-towards-death, the "mineness" (*Jemeinigkeit*), the "being-in-the-world," and the "being-with" (*Mitsein*) that formed the ontological pillars of his philosophy—the background, in other words, that his philosophy tries to glimpse through the foreground of our technological age, seem suddenly to become a middleground, an intermediary, to a new background.

Now, as radical as these statements sound—and I will return to the idea of "radical-sounding" momentarily—we need not rush to conclude that Heidegger has turned his previous work completely on its head.[7] As his chosen introduction to philosophy, Heidegger wishes in the lectures in EHF to "lay the whole of philosophy before us," but do so from "within a particular perspective" that is adequate to this task (2002: 10). The particular perspective he chooses is, appropriately, the relationship of causality and freedom as articulated by Immanuel Kant. Heidegger will suggest that this approach is a way of aligning philosophy's way of being with being itself. But to accomplish this philosophy must have "strength and strike-power": "Perhaps the *strength and strike-power of philosophizing* rests precisely on this, that it *reveals the whole only in properly grasped particular problems*" (10). To not do this—to follow "the popular procedure of bringing all philosophical questions together in some kind of framework, and then speaking of everything and anything without really *asking*, is the opposite of an introduction to philosophy, i.e., a semblance of philosophy, *sophistry*" (10). What this treatise becomes, then, is a "radicalization of the leading question" of being and, therefore, philosophy; a "challenge" to the way that we and even he has conceptualized philosophy; and a "violent redirection of our gaze" (88–93). So, on the one hand, EHF is a carefully argued treatment of the problems that Kant's understanding of freedom introduces into the problem of freedom. On the other hand, it enacts the "strength and strike-power of philosophizing" that Heidegger describes by taking on philosophy as a whole. The reason Heidegger addresses himself to Kant on freedom is because Kant is the first to "explicitly" connect "the problem of freedom ... with the fundamental problems of metaphysics" (134). Kant's approach to freedom, then, illustrates metaphysics' and, thus, philosophy's general movement toward enthroning "the self as a self-determining end" (Sorial 2006: 209), and thus away from being-in-the world.

But Heidegger's answer to Kant and the metaphysical tradition is not just a counter-argument. In flipping the terms in which Kant places freedom—that freedom lets causality be, rather than causality lets freedom

be—I would argue that Heidegger means to disorient, rather than reorient, philosophy. In his conclusion to EHF Heidegger tells us that he took us through Kant's terms of understanding freedom to show us how fundamentally inadequate these terms are:

> The problem of freedom as causality has now been discussed. But it has not been shown that causality is a problem of freedom, i.e. that the question of being is built into the problem of freedom. Our basic thesis has not been established.
>
> (2002: 204)

The reason that Heidegger's thesis has not and cannot be proved is because phenomenology is ultimately interested in essence—in this case, the essence of freedom, which exists prior to any "*one* ontological determination of beings among others"—and "essence," he says, "is not capable of straightforward examination. Essence remains closed off to us as long as we ourselves do not become essential in our essence" (204–05). If what I am essentially as a being in the world is grounded in freedom, then I am simply not in the position even to frame the right question about what freedom is in its own essence, on its own terms because I am already unable to know what being essentially is, much less what it is that allows being to be.

All we can know, then, is *that* our ability to come to any kind of understanding of a way of being is proof that "freedom *exists*": "The letting-be-encountered of being comportment to beings in each and every mode of manifestness, is only possible where freedom *exists*. *Freedom is the condition of the possibility of the manifestness of the being of beings, of the understanding of being* [Heidegger's emphasis]" (205). The essence of freedom is not something that philosophy can "embrace or possess" in its propositional logic; freedom is not a property of being, much less of philosophy. Freedom "exists," that is, stands outside itself; it is not reducible to the aspect of it that is—to use the term Heidegger turns to in *On the Essence of Truth*— "exposed" as a particular form or, perhaps better said, a trajectory of being, but it is always more than that which it appears to be because it is what lets being appear as it is, in the first place (125–26). It is as if there is a kind of Heisenbergian "Uncertainty Principle" at work in freedom—we know where and when freedom is more than we know what freedom is.

But this means that the problem of freedom must become philosophy's horizon as it asks its "leading questions" about the meaning of being. As he says in OET, freedom puts the "Da" in Da-sein: "Disclosedness itself is conserved in ek-sistent engagement, through which the openness of the open region, i.e., the 'there' ['Da'], is what it is" (Heidegger 1993: 126). Human existence always has a "there"; that is, a situation that dictates what it makes sense to do and that, therefore, conditions how we think about what it means to be in that situation. The challenge for philosophy,

however, is to talk about the meaning of our "there-being" as humans not as the inevitable result of determining causes or physical properties, but as an openness of possibility. By "possibility" Heidegger does not mean one of many options, but rather a way of thinking about and acting with respect to something as it is, "letting beings be" the beings that they are. My earlier example of threading a needle applies here. I am letting the needle and thread be the beings that they are when I let them be sewing implements and use them as such. Of course, philosophy wants to ask a number of questions about this situation that don't just apply to needles and threads. Above all, philosophy is concerned with what it means to be human. But from the very beginning of his career, Heidegger talks about the importance of questioning our received understanding of the meaning of being as the optimal mode of being human: "The ek-sistence of historical man begins at that moment when the first thinker takes a questioning stand with regard to the unconcealment of beings by asking: what are beings?" (1996: 126). But the problem we continually run into is that the "what" of the question "what are beings" can only be answered by the specific "that(s)" in which beings reveal themselves as what they are. It is endemic to the freedom of being—the openness to the disclosedness of beings—that I will forget being in thinking beings: "Precisely because letting be always lets beings be in a particular comportment that relates to them and thus discloses them, it conceals beings as a whole" (129–30). What Heidegger means here is that the very ability beings have to manifest their identity, their distinctiveness from other beings, their "essence"—which is what Heidegger means when he talks here about "the unconcealment of beings"—depends upon the way in which beings require me to comport myself towards them.

This problem is a significant one for history. Returning once more to our needle and thread example, the needle and thread that I may have pulled from a sewing kit "essence" themselves to me as tools that I take up to sew a button on a shirt, not when I talk about them, nor even when I look at them. When I go to use this needle and this piece of white thread I don't really think about the needle, especially in relation to the thread, as a being that could manifest itself differently, say, as a piece of sports equipment. As mentioned earlier, this comportment in which I approach the thing, and in which the thing reveals itself to me as what it is, is not simply a random choice I make about how I want to use it, but is instead a way for me to yield in a non-theoretical way to the being of the needle by, indeed, letting it be what it is. But history might make it possible for us to think of the needle as sports equipment if we, for instance, encounter evidence of a distant culture playing a game similar to our game of darts with something that looks like a needle. Of course, even within our own epoch, we might see or think about the needle somewhat differently if I come upon one that looks like my metal needle, but is made of wood in a folk art museum in a bullet-proof glass display case, or if one just like mine is featured on *Antiques Roadshow*

as an implement worth "at auction" $500–600 because it belonged to Eleanor Roosevelt. But in none of these examples am I required to comport myself differently to the comportment relative to a needle that is inherent to the world-disclosiveness of the needle. In the latter two cases, the needle-as-artwork or as-historical-object-of-significant-monetary-value is still a needle and thus, doesn't really stray too far away from its being as a tool to be thought about in relation to how it first makes itself available to me as a needle in my pre-cognitive understanding of it when I reach for it in my sewing kit. In the first case, the needle is still a tool, just a different kind now. But what would happen if in my study I discover a culture that worships what looks to me to be a needle? If it turns out that an ancient tribe in Indonesia worshipped the needle *as a needle*, then I am still in familiar territory.

The question that dogs history in this, and for that matter, in all of my examples is: Could I ever see or think about a needle in any other way than in the way that I already know? Could the thing that looks like a needle ever not be the-thing-that-functions-like-a-needle, even when it is by no means clear to me that this tribe knew or used, much less worshipped, needles? In thinking about the needle—even if I want to think about its most divergent uses and meanings within my experience and cultural framework—the needle as needle manages, as it were, my experience with it, forcing me to think it only in the mode of being in which it is familiar to me. In so doing, I orient my thinking about being to the being of the needle and "forget" the fundamental openness in being that allows all beings to show up as they do, whose meaning is configured by the background of my culture's way of being. In other words, in my involvement with a thing as the object it is, I will simply be unable to retain an awareness of how my own background has shaped my perception of how essence in "beings as a whole" shows up at all. I will always "cling to what is readily available and controllable even where ultimate matters are concerned," and even when I "set out to extend, change, newly assimilate, or secure the openedness of the beings pertaining to the most various domains of [my] activity and interest" (Heidegger 1993: 131). In this way, freedom "in-sists," as well as "ek-sists" (132). Now, in thinking about another culture's governmental system, what is it that manages my experience? The answer to this question is far too complex to answer here, but perhaps that very complexity is sufficient for our discussion of how intricate and comprehensive the problem of freedom is for phenomenological history.

But Heidegger is careful to point out that while this problem is a very big one, it does not mean that I must "let the concealing of what is concealed hold sway" (1993: 131). True, we seem doomed to live in "errancy"— Heidegger's term for the problem I just described—in this "in-sistent ek-sistence" of ours, and this situation constitutes a "mystery" that we must live with, rather than against. But it is in recognizing that I will "be led

astray" in my attempt to let beings be that the "possibility" for me "to *not* let [my]self be led astray" can emerge. Again, the key term here is "possibility." Along with questioning, Heidegger talks about freedom, the openness of possibility, as absolutely fundamental and central to an "authentic" way of being. In fact, he defines Da-sein already in *Being and Time* as "the possibility of being free *for* its ownmost potentiality of being" (1996: 144). We cannot be anything we want to be. We are, in fact, "thrown" into a world that puts a number of constraints on who we are and can be. But within those constraints there is a "potentiality" of being that is mine, and my existence becomes authentic—mine—when I move towards that potentiality that is mine in "resoluteness" (*Entschlossenheit*). It is for this freedom to be that I live. In EHF Heidegger echoes this statement in his "Conclusion" and emphasizes where we do this, if not how. In the penultimate paragraph of the text he says that the proof of his thesis—that the question of freedom is the "fundamental" problem of philosophy—"is not the concern of a theoretical scientific discussion, but of a grasping which always and necessarily includes the one who does the grasping, claiming him in the root of his existence, and so that he may become essential in the actual willing of his ownmost essence" (2002: 205). Freedom gives me the possibility to will and not to will my ownmost essence; it shows up in this possibility and as this possibility. And one does this willing in the act of "grasping" being, which is Heidegger's word for taking up one's own being-in-the-world as it is lived, a concept which Merleau-Ponty builds on in his philosophy of embodiment.

Now, we need to pause here to note in passing that when Heidegger talks about "possibilities" and "ownmost potentiality," he employs terms here "early" in his career that cause him some unintended problems. These terms suggest that there is already a given "potentiality" that I move towards or that my being already has a set of "possibilities" already given to me. But later he comes to see that the problem of the freedom of being is that while I must will my "ownmost potential," no particular potentiality is given to me. I must will what opens itself to me within the world that I live through as I live through it. The freedom of my being, then, is that I can be my "ownmost potential" when and where I resolutely will my own embodied existence as it is, when and where I let myself and others be what and who we are as embodied beings, and finally when and where I conceptualize the potential of human existence within the constraints—the "*thrown possibility*" (Heidegger 1996: 144)—of that existence as it is lived. It is only on these terms that I can come to any degree of understanding at all of what being, especially my being, is and might mean (I will never know the meaning of being-in-general, nor will I even know what it means to be me). Yet this also means, again, that it is thanks to freedom that I will continually lose sight of the larger question concerning the being of beings as I deal with the beings I encounter in my everyday world of practical

involvements. In the texts we have been talking about, Heidegger responds to this problem by saying that we must live in "resoluteness," or as he says in OET, live in need: "The full essence of truth, including its most proper nonessence, keeps Dasein in need by this perpetual turning to and fro (i.e., errancy). Dasein is a turning into need" (1993: 134). But even as he turns later to terms like *Gelassenheit* (Letting-be) and "thinking," Heidegger will always claim that being human depends on the possibility and the need to think ever more deeply about being and beings, and that in order to do this in the full freedom, openness, of our being, we must take up a way of being in philosophy that is not only willing to question, but also to "radicalize" the way we question our existence.

Freedom and history

To say, then, that history is the study of freedom is to say that history is a way of radicalizing the questions history has been asking about being in such a way that we are moved to engage ourselves in this dialectic of unconcealing/concealing of being. How can history do this? Merleau-Ponty takes up some of these questions in "The Crisis of Understanding," an essay that explores the nascent phenomenological orientation of Max Weber's history of Puritanism and Capitalism. In this work, Merleau-Ponty finds that the "strength and strike-power" of a phenomenological conception of history lies in the experience of "discovery" that history gives us:

> We discover that we possess a power of radical choice by which we give meaning to our lives, and through this power we become sensitive to all the uses that humanity has made of it. ... All that we postulate in our attempt to understand history is that freedom comprehends all the uses of freedom.
>
> (2004a: 337)

In saying that we "possess a power of radical choice," Merleau-Ponty is not making the mistake that Kant did (placing freedom at the disposal of the human will). Instead, he is restating what Heidegger says about freedom and the "radicalization" of the way we frame questions concerning the meaning of being. Merleau-Ponty emphasizes that we radicalize these questions when we discover our ability not to make the meaning of our lives, but rather to choose what "gives" meaning to our lives. We allow the freedom of being to show up in our choosing. In this choice is the implicit recognition that "man is a possibility of freedom"; that is, that freedom gives my being meaning in the first place by allowing me to recognize and open myself to the world's various ways of being.

Because the freedom of being matters, the discerning of historical meaning as an instance of the freedom of being will not be an idle or disinterested

activity for me. The study of a project in history gives me the opportunity to open myself to the openness of possibility that was on display as the project took shape. And when I reconstitute this project in my study, I "discover" again the openness of possibility in my own present that gives me the power to recognize how an understanding of the past can help me address present concerns. I am an interested party in this process because it is my experience letting the world be meaningful for me that is ultimately at stake:

> The dramas which have been lived inevitably remind us of our own, and of ourselves; we must view them from a single perspective, either because our own acts present us with the same problems in a clearer manner or, on the contrary, because our own difficulties have been more accurately defined in the past. We have just as much right to judge the past as the present. The past, moreover, comes forward to meet the judgments that we pass upon it. It has judged itself; having been lived by men, it has introduced values into history. The judgment and these values are part of it, and we cannot describe it without either confirming or annulling them.

> (Merleau-Ponty 2004a: 336)

Does this mean that we are uninterested in historical objectivity? No, because "objectivity asks only that one approach the past with the past's criteria." In practice, what this means is that we "call upon the past to testify concerning itself" (336), which means that we hear people in the past judge themselves and we see how that judgment reflects not just an understanding of being, but also the way in which they configure that understanding. But it is in hearing the past in their own voice, as it were, that I can begin to choose what it is in and about their understanding of being that will give meaning to the world into which I bear myself forward. It is only after the careful, detail-oriented work of studying the past as an instance of freedom that I can attune myself to the freedom that allows me to begin to understand on what basis I would continue or break with that past.

As Merleau-Ponty grants in the above passage, history comes to us already within a constellation of narrative, judgment, and interest. But we're not simply confined by this configuration. Indeed, we look for other kinds of meaning than those that come to us pre-processed. One of these that Merleau-Ponty mentions in his discussion of Bonaparte in *Phenomenology of Perception* is statistical meaning. When he talks about the significance of the "event" that was Napoleon's coming to power, Merleau-Ponty uses the term as it is used in statistics: given that a number of people were involved in different political projects; given that an individual's project represents the freedom exercised by that individual to take up the project the world offers; and given that what we know as Bonaparte's project was a project "envisaged" by others; then even though the project

was and perhaps could only have been taken up by one, the project itself constitutes a significant event statistically because it at least shows up on the radar screen several times at this particular historical moment (1962: 522). But ultimately, history is very interested in the ways that history gives its own significance because being always manifests itself in ways of being that in themselves do not comprehend being itself in its unity and totality. Consequently:

> Historical understanding ... does not introduce a system of categories arbitrarily chosen; it only presupposes the possibility that we have a past which is ours and that we can recapture in our freedom the work of so many other freedoms. It assumes that we can clarify the choices of others through our own and ours through theirs, that we can rectify one by the other and finally arrive at the truth. There is no attitude more respectful, no objectivity more profound, than this claim of going to the very source of history.
>
> (Merleau-Ponty 2004a: 338)

The categories in which history is placed dictate the terms in which history gives itself to us as a study that is about significant acts of human agency, and is itself such an act. For Merleau-Ponty they also become terms which help us clarify what distinctively configured the agency of the past as compared to our agency in the present.

History and freedom in Botticelli's
Cestello Annunciation

But as we return now to Botticelli's *Cestello Annunciation*, I want to consider one last wrinkle: are the problems (first articulated by Heidegger) that Merleau-Ponty addresses in "The Crisis of Understanding," accentuated, if not created, because we tend to think history in writing? In "Eye and Mind" Merleau-Ponty will tell us that "from the writer and the philosopher ... we want opinions and advice," whereas "only the painter is entitled to look at everything without being obliged to appraise what he sees" (2004b: 293). Is there inherently more freedom for the viewer of a work of art taking up the world that is laid before him or her in a painting free from the kind of determining frameworks that are inevitable in writing? But why did Merleau-Ponty never address this issue, even if a text like "The Crisis of Understanding" was not the right place for him to say this? I want to suggest that Merleau-Ponty could, and perhaps should have said that the very "ontological determination" of the freedom of being that Merleau-Ponty embraces here—the choice over what gives meaning—is a kind of work that comes more easily to history in paint than history on paper. In fact, because a painting like Botticelli's opens us to the Annunciation

as a happening happening, I would argue that a painted history of the Annunciation offers us access to the "power of radical choice" that characterizes the freedom of being in the work of history more so than does a written history of this event.

From our first glance, we notice that something very powerful indeed is happening to Mary in this painting, as she twists and contorts herself before the kneeling Gabriel. Of course, the power of freedom is not necessarily what Botticelli means to talk about when he makes Mary comport herself this way. If anything, our initial glance suggests that Mary reacts negatively, or at least fearfully, to the coming of the Angel and/or the message that he delivers. Is that the freedom this work sets in motion—the freedom to see Mary in terms other than those we usually ascribe to her in this scene? Perhaps, but it is much too premature to "jump" to such a conclusion, even if an interpretation is always something of a leap over questions we cannot completely answer. For Merleau-Ponty the study of history concerns the attempt to find "a certain way of patterning the world which the historian should be capable of seizing upon the making of his own" (1962: xx). So how does Botticelli's painting evince a way of "patterning the world?" I want to take Merleau-Ponty at his word in the conclusion of this chapter and talk about how Botticelli's patterns within the painting as a way of patterning the world. If we can discern this pattern, then it will tell us not just about the way Botticelli and his era constituted the world as meaningful, but it will also tell us something about what we find meaningful for our own.

Let us return then to our earlier question about what is happening in this painting. In the terms we have explored earlier in this chapter, we can say that Mary is in the process of exercising her power to choose what will give meaning to her life by letting the Angel's call on behalf of God Himself *be*. We can also say that she reacts to Gabriel very strongly, and that thereby Botticelli introduces into Mary's "letting be" a sense of dramatic tension in the work, which evokes from us, in turn, a commensurate interpretive tension by giving us a Mary who will take up this call, but who now reacts to the message ambiguously. Indeed, none of Mary's actions in this painting can be interpreted as single-minded because Mary's reaction to the event as it unfolds is spread through her body that moves in several directions at once. No matter how many times I've stared at this painting, I am always struck anew, in Karl-Heinz Lüdeking's words, by the painting's "reciprocal play of forward and backward moving, attracting and repulsing, gestures" (1990: 226). If she is kneeling at the foot of the lectern, it is because she appears to twist away from the angel. Yet because she twists away from the angel, her upper body learns forward toward him. Are her hands instinctively reaching out to catch herself as she falls towards the angel, or are they raised in response to the Gabriel's uplifted right-hand greeting? Is he greeting her, or warning her as her hands rise up in resistance? Or are her

hands signaling humble self-denigration to the angel's deep bow (Gabriel can hardly get low enough to convey his respect, or is it his reluctance to deliver such an ominous message to this unsuspecting woman)?

As if it were a deliberate counter to the way that Mary is typically imagined as so thoroughly at the mercy of an irresistible fate, no gesture of Mary's is self-evidently acquiescent or resistant. The power of this fate is figured in the sheer force that the angel generates, who seems to have just landed in Mary's room like a jet on a short carrier runway, and that causes Mary's knee to buckle. Her knees come together to bow (or to counterbalance her fall), but they also close her thighs tightly together, hence her womb, accentuated by the converging lines of the folds in her robe. And yet her outstretched hands open both her womb and her heart to the angel and the viewer. In particular, the bent knee seems to propel our interpretation onward because it puts her in a state of disequilibrium. We have seen this knee at least twice before in Florentine art: in Donatello's sandstone relief sculpture at Santa Croce and in Fra Filippo Lippi's San Lorenzo *Annunciation* (and Fra Filippo was Botticelli's teacher for two years). Yet what we haven't seen before is this knee in the fluidity of motion that Botticelli constructs in a kind of energetic circularity. Circularity becomes the geometric principle of the problem I am posing, and thus, the "way of patterning" the world. Circles start and end everywhere and nowhere, and they travel in both or either direction. Her motion away produces her motion forward, and vice versa. Yet Botticelli has drawn a circle ultimately to violate its circularity; he interrupts the circularity with this very angular knee, inviting us to put a great deal of interpretive weight on it, as Mary does here literally. The way of patterning the world in its fullest measure here is a circle under erasure. Geometrically, two intersecting lines, two converging forces (which is precisely the opposite principle from that of the circle) produce this knee as an image, an image of the story of the Annunciation in general—God intersects with a human and it produces an interruption in her life, a disruption of her life's course, the sword of which Simeon prophesies. Such geometry, patterning is key to the experience of this painting, but both the patterns and the experience are simply unavailable to a reader of this history.

Mary's body makes this a painting about a young woman's experience with the sheer weight, force, and possibly the pain of the burden that is the givenness of being to which she opens herself without comprehending it. And it is this burden of the givenness of being that makes us situate the painting within the structures of being that appertain to the culture in which Botticelli works. Given our understanding of the background of Italian Renaissance culture, the markedly strong, even exaggerated motions she engages in perhaps signal Botticelli's interest in sketching how strong her faith would have to be in order to take up the burden that God places on her shoulders. If we take Fra Roberto's sermon as indicative of this cultural

background, providing us with the criteria according to which we might interpret and judge the painting, then Botticelli has tried to understand how Mary's body registers her act of "enowning" the call to be the Mother of the Son of God *as* an act of reversing her former choice for another way of being—virginity, a way that made a good deal of sense at the time for a young woman who wanted her life above all to please God. Mary chooses to take up the way of being that her world opens to her as now *her* way of being without knowing what that really means. This reading is corroborated by the details of the painting. In the biblical account, we move sequentially through the event, and we know only at the end—when Mary says, "fiat mihi secundum verbum tuum" ["be it (so) for/unto me according to thy word"]—that she accepts the call. In the painting, there is no plot, no self-evident ordering of the story, suggesting the logic of the story in its "chrono-logic." Everything is happening at once—the delivery of the message and the response to the message. But we can nevertheless see Mary giving her "fiat" in the painting; it comes as she begins to kneel. The words that she speaks in the written account are nowhere to be found in the painting, but her response is present in other words that are present, but remain unseen to us. On the right edge of the painting stands a lectern with what appears to be a large, but somewhat slim volume. The legend had existed for some time before Botticelli paints this work that Gabriel, upon entering, finds Mary reading the prophecy about herself in Isaiah 14:7: "Ecce virgo concipiet et pariet filium et vocabitis nomen eius Emmanuhel" ["Behold, a virgin will conceive and will bear a son, and his name will be called Emmanuel"]. And it is to this lectern and book that Mary is in the process of kneeling. We usually translate this passage as "a virgin," rather than "the virgin," for several reasons, but it is a particularly appropriate translation for this painting in the context of my discussion. Mary turns to the prophecy about a virgin and it is plausible to see this moment as her taking up this scriptural passage as now one that is about her. It's not that the scripture was always about only her; it's that it is becoming about her at this moment.

But I am in danger here of traveling too far outside the painting for my reading. In this painting the question of letting the Annunciation be—of Mary's fiat—is one that is formulated almost exclusively by Mary's body. And what this remarkably animated body shows us is that the question itself about Mary's freedom can only be asked as a series of reciprocal, strong bodily motions and actions. In the story, Mary thinks, reflects on the message and the manner of its delivery, but in the painting, Mary's body does the thinking in response to the world as it opens itself to her. And as Botticelli has painted it, it can only think ambivalently. Though the painting seems to call out to us to finish it, Mary isn't kneeling yet, she has not gestured quite yet so that we can confidently say with the resources the work itself gives us what will happen at its end. Mary can only bow to *and* twist away from, open and close herself to, the future and, indeed, the

givenness of that future that opens before her. Botticelli radicalizes the questions we usually ask of this scene—the questions implicit in Fra Roberto's sermon that details what we should and should not see—by grounding them in the embodied experience of Mary responding to the angel with a variety of simultaneous, spontaneous, and counterpoised body processes. Mary cannot think her response in this painting; she bodies it forth into a future that at this moment cannot be certain, no matter how much that future has been defined by an as yet unfulfilled prophecy. Botticelli's *Cestello Annunciation* is a remarkable image of encapsulated freedom as each movement implies both the next movement that we already know will happen in our given sense of this historical moment, and also its opposite—the ones that history records as not having happened. The work of history in this painting is not to realize the end for which she is destined in being and in history, nor is it to fulfill the prophecy that religion has decreed for her. If it is her destiny to be a part of the story that articulates the promise of hope, then it is also fundamental to that destiny that she takes her being from a story that also holds out the promise of despair as an equal possibility. Defiance, too, is an end we can glimpse alongside supreme, self-sacrificing submission and faith. The issue here is not that we could not find meaning in a subversive reading of Botticelli's *Cestello Annunciation*, but rather that the choice the painting places before us is to choose what it is here in this monument of the past that can give meaning to our present.

Of course, we are in the present not confined solely to monuments of the past, to art from a previous era. The pastness of the past is very clear and forceful in Botticelli's painting, but what of paintings of this subject in our own era, when it is harder to come into the clearing of our own culture. One of the most powerful I know of is the *Annunciation* of John Collier (2001) (Plate 27), a contemporary artist who may be better known for his *The Catholic Memorial at Ground Zero*. But at this very different moment in history—at least with respect to my sense of how history is unfolding in my present relative to the past and to my sense of the future—when this work asks me to find the past-which-has-been in my own present world, I find this past to be much stranger than I did when I encountered it in Botticelli's work. There is, of course, not time to explore this phenomenon fully here at this moment of concluding this chapter. But by way of conclusion, I will simply say that when I come to this work after Botticelli's, I sense that the kind of motion that Botticelli envisions for his Mary as a kind of emblem of freedom (what freedom is and what it is not) in her domestic sphere is simply unavailable to Collier in rendering Mary in hers. Collier glimpses the way the past makes the present strange, and I find myself working harder to let this Annunciation scene be in a world I recognize all too easily as being the one outside my door. In fact, a number of interpretive possibilities rush into the gap this painting creates between the scene as it is depicted and my

187

sense of my own world, all of them creating a kind of static interference in my reception of this work. Is it even possible to see Gabriel at first glance as an angel, instead of someone who is performing a prank, someone who is not in full possession of his mental faculties, or someone who is here for more sinister purposes? I did not have too much trouble making Gabriel fit in the world of Botticelli's Mary, but he doesn't fit here. What do we make of the way his strangeness looks like it poses a threat to Mary? How do we think Mary's virginity in this environment? Even if we had a Fra Roberto to assure us that Mary isn't afraid here, does not the world of my everyday concerns give me more easily a manipulative, treacherous figure than a heavenly one? While I do not quarrel with the brief description of the painting that is listed on Collier's agent's website (Hillstream LLC at www.hillstream.com), namely that Mary "is welcoming St. Gabriel," caught up as I am in the daily concerns of my world, I see this Mary—again in the tell-tale first glance—as confronting all too innocently not a life of joy and pain that lies before her, but instead, a very real and present danger of violence and violation. Would this feeling I'm describing not be even stronger if Collier's Mary were as animated and contorted as Botticelli's Mary?

I find, in other words, that I have a harder time letting this painting be about the Annunciation. This does not mean that this painting is not a powerful meditation on faith and the miraculous. In fact, this has everything to do with my being embedded in the dailyness of my own era. For when measured against the task that opens up before his Mary, Collier's uncertain schoolgirl in modern suburbia has perhaps even a greater leap of faith to take than does Botticelli's elegant, mature Madonna who is dressed in the aristocratic robes of Renaissance Florence, and who can stretch herself out in the full freedom of her being. Indeed, Collier asks us to work our imaginations and our faith in our own world much harder to find a Mary who could emerge from middle-America to consort with deity. Yet while these features can make Collier's painting even more powerful and meaningful for many in a contemporary audience, it also makes its relationship to its own era more ambiguous. By making it harder for Mary to be Mary, the painting seems to mourn the loss of our ability to welcome the kind of strangeness that would require such faith to welcome, in the first place. This is not a flaw in this painting. Perhaps it's inevitably hard to take a stand on one's own history, and even more so, to envision in the study of one's present how one might break with that present to move towards something better. I will still turn to Botticelli for an experience with how all possibility must be open to Mary, and how her decision in the full freedom of her being must hang in the balance so that the ultimate choice that she makes to belong to being never allows that choice to become inevitable, and so that being will never lose its power to drive us onward in the search for salvation and transcendence. But because it is harder to do this with Collier, perhaps

that means that I should be spending more time with his work because ulti-
mately his work may force me more than Botticelli's does to do history as a
way of taking a stand on that history and as a way of finding within my
world a way of breaking with that which denigrates and enervates my being.

Notes

1 My thanks to James E. Faulconer and Mark A. Wrathall for helpful comments
 and suggestions on this chapter. Also, my treatment of Botticelli's *Cestello
 Annunciation* here bears a few similarities to an article I wrote several years
 ago for a different audience and purpose: (1995–96) "Narration and Quattrocento
 Annunciation Paintings," *Journal of the Rocky Mountain Medieval and
 Renaissance Society* 1–17: 188–200. In some ways, the present essay provides some
 much needed correction to the conception of my earlier attempt.
2 See Mark Wrathall's entire essay, "Motives, Reasons, and Causes" in Carmen
 and Hansen 2005. The next several sentences are in many ways a paraphrase of
 his discussion there.
3 See Heidegger 1971: 53.
4 Merleau-Ponty's use of Napoleon is, I believe, not an arbitrary choice on his part.
 In choosing a notorious figure from his own cultural past in post-World War II
 France, he enacts another of history's central tasks in an existentialist-phenome-
 nological understanding of history: to take responsibility for and a stand on one's
 own history. For those who know Lev Tolstoy's *War and Peace*, Merleau-Ponty's
 sense of history bears a striking resemblance to Tolstoy's. Even without properly
 wringing our hands over the problems that exist in using nationality as some kind
 of determinative category, we can still say that a history of Bonaparte becomes
 something very different for Merleau-Ponty, a "Frenchman," than it is for
 Tolstoy, a "Russian," precisely because Bonaparte is integral to the Frenchman's
 own sense of the meaning that is unfolding in "his" French history to his present
 day and beyond. Perhaps Merleau-Ponty has in mind what Heidegger says in
 Being and Time concerning authentic historiography as a critique of the present
 done in light of what the past tells us is possible for, in this case, France.
 Heidegger focuses in an affirmative vein on performing this historical critique as a
 way in which a culture may "choose its hero." Perhaps, however, it is not too far-
 fetched to hear in Merleau-Ponty's use of Napoleon a subtle rebuke of Heidegger.
 Merleau-Ponty may be suggesting that history done in good faith—which in his
 case would be French history—must take responsibility for the Napoleons, and
 by implication the Pétains, if not the Hitlers, as well as the Charlemagnes. In other
 words, Merleau-Ponty might be saying here that if Heidegger would talk about
 the necessity for authentic historiography to choose its hero, then he and the
 Germans would do well to take responsibility for their past choice for Hitler as
 they engage in a new generation of historically enabled critiques of their present.
5 As Colin Smith's footnote to his translation of *Phenomenology of Perception* indi-
 cates, by "One" Merleau-Ponty means Heidegger's realm of "das Man"—the
 foreground of everyday actions and uses (1962: 522).
6 For a lucid and compelling account of the range of meanings of this term, see
 Polt's entire essay (2005: 375–91).
7 Sarah Sorial has recently traced the strands that connect Heidegger's treatment
 of freedom in EHF to his earlier "piecemeal" conception of freedom as arti-
 culated in *Being and Time*, *The Basic Problems of Phenomenology*, and
 Metaphysical Foundations of Logic. She argues persuasively that EHF is very

much a culmination of his thinking in those earlier treatises, and dismisses the concerns voiced by Michel Haar, Kathleen Wright, and Immanuel Levinas that Heidegger is abandoning ethics and responsibility, but rather "provides a way of rethinking our conception of freedom, not as a set of specific determinations and rights, but as the very condition for the possibility of both existence and community" (Sorial 2006: 205–06). Both EHF and *Being and Time* offer a "radical decentering of the subject ... which allows Heidegger to think of freedom removed from the ontology of traditional subjectivity [that] opens up a space from which we can think freedom in terms of community and human solidarity" (212). Sorial is, on the one hand, right to show that Heidegger's treatment of freedom in EHF is still "on task" with a philosophy that is profoundly concerned with human ethics and responsibility. On the other hand, there is also a danger in Sorial's attempt to understand Heidegger's sense of freedom—and it is more a sense, rather than an understanding—in the act of trying to rescue it as something we can use to rethink the "leading questions" of being. The danger, I would argue, is that freedom by its very nature is something that disorients, rather than reorients, our understanding of beings, which is why Heidegger thinks that the question of freedom is the perfect "Introduction to Philosophy." In fact, Sorial's apologetics for Heideggerian freedom function as a kind of register of this disorienting effect, though in her treatment's own effect, she also takes Heidegger off the boil.

References

Baxandall, M. (1988) *Painting and Experience in Fifteenth-Century Italy: A Primer in the Social History of Pictorial Style*, 2nd edn, Oxford: Oxford University Press.

Carman, T. and Hansen, M.B.N. (eds.) (2005) *The Cambridge Companion to Merleau-Ponty*, New York: Cambridge University Press.

Dreyfus, H. (1993) "Heidegger on the Connection Between Nihilism, Art, Technology, and Politics," in C. Guignon (ed.) *The Cambridge Companion to Heidegger*, Cambridge: Cambridge University Press.

Dreyfus, H. and Wrathall, M. (eds.) (2007) *A Companion to Heidegger*, Blackwell Companions to Philosophy, Oxford: Blackwell Publishing.

Guignon, C. (1993) *The Cambridge Companion to Heidegger*, New York: Cambridge University Press.

Heidegger, M. (1971) *Poetry, Language, Thought*, trans. Albert Hofstadter, New York: Harper & Row.

——(1993) *On the Essence of Truth*, in D.F. Krell, *Martin Heidegger: Basic Writings*, New York: HarperCollins.

——(1996) *Being and Time*, trans. Joan Stambaugh, Albany: State University of New York Press.

——(2002) *The Essence of Human Freedom: An Introduction to Philosophy*, London: Continuum.

Lüdeking, K.-H. (1990) "Pictures and Gestures," *British Journal of Aesthetics* 30: 218–32.

Merleau-Ponty, M. (1962) *Phenomenology of Perception*, trans. Colin Smith, London: Routledge and Kegan Paul.

——(2004a) "The Crisis of Understanding," in T. Baldwin (ed.) *Maurice Merleau-Ponty: Basic Writings*, London: Routledge.

——(2004b) "Eye and Mind," in T. Baldwin (ed.) *Maurice Merleau-Ponty: Basic Writings*, London: Routledge.

Polt, R. (2005) "*Ereignis*," in H. Dreyfus and M. Wrathall (eds.) *A Companion to Heidegger*, Blackwell Companions to Philosophy, Oxford: Blackwell Publishing.

Sorial, S. (2006) "Heidegger and the Ontology of Freedom," *International Philosophical Quarterly* 46, no. 2: 205–18.

Wrathall M.A. (2005) "Motives, Reasons, and Causes," in T. Carman and M.B.N. Hansen (eds.) *The Cambridge Companion to Merleau-Ponty*, New York: Cambridge University Press.

9

SHOWING AND SEEING

Film as phenomenology

John B. Brough

In a passage from *The Prime of Life* that would make a delightful vignette in a film about the intellectual milieu of Paris in the 1930s, Simone de Beauvoir describes an evening spent with Jean-Paul Sartre and Raymond Aron over apricot cocktails at a café on the Rue Montparnasse. Aron, who had been studying Edmund Husserl's phenomenology in Berlin, pointed to his glass and said to Sartre: "You see, my dear fellow, if you are a phenomenologist, you can talk about this cocktail and make philosophy out of it!" Sartre, de Beauvoir reports, "turned pale with emotion at this. Here was just the thing he had been longing to achieve for years—to describe objects just as he saw and touched them, and extract philosophy from the process" (de Beauvoir 1962: 112).

If Husserlian phenomenology really does open up such a prospect, then the idea of film as phenomenology would not seem farfetched. Husserl himself, however, famously promoted phenomenology as rigorous science, and took great pains to distinguish the philosophical attitude, reflective and rational, from the "natural" attitude, the frame of mind in which we find ourselves in ordinary, non-philosophical life. Film making and film viewing would seem to be firmly rooted in the natural attitude. Movie makers, in common with other artists, make things; specifically, the complex images we call films. Phenomenologists, on the other hand, do not make things; they instead reflect on the experience of things and on things as experienced—on image-consciousness, for example, and on images themselves and the arts in which they are deployed. One might be forgiven, then, for thinking that Husserl would be incensed by the very idea of film as phenomenology. There could indeed be a phenomenology *of* film, but it would be nonsense to claim that films themselves could *do* phenomenology.

But perhaps phenomenology could be more accommodating. Husserl was aware of motion pictures almost from the time of their inception. As early as 1898, in his first analyses of image-consciousness, he refers to the mutoscope, a recently invented photo-flipping machine that represented

192

moving figures.[1] Other texts suggest that he accepted film as a form of art, and that he intended what he says about the essential nature of images to apply just as much to film as to painting, sculpture, drama, and the other arts. None of this shows, of course, that film could function as phenomenology. There are, however, certain general features of the phenomenological enterprise, as Husserl conceived it, which have parallels in film. True, film may not have the shape of philosophy as an academic discipline, but when one considers the powerful arsenal at its disposal—moving images, sound, color, narrative, all shaped by directors, editors, cinematographers, and a host of other technicians and artists—it is surely reasonable to think that it might open up rich phenomenological possibilities. This, of course, is not to claim that the filmmaker whose creation has phenomenological import explicitly intended to make a phenomenological film, or even that philosophically informed viewers responding to it would immediately find explicitly phenomenological elements flickering on the screen. It is to say that the thoughtful viewer would encounter what amounts to phenomenological revelations about important dimensions of our experience. I shall attempt to show this, first, by pointing to certain general affinities between film and phenomenology, and then by considering ways in which a few films develop phenomenological themes or describe and reveal phenomena in ways akin to phenomenology. The chapter will focus particularly on Husserl's understanding of phenomenology rather than on its variations in thinkers such as Heidegger, Sartre, and Merleau-Ponty.

Some general reflections

Film and seeing

The pathbreaking film director D.W. Griffith said that "the task I am trying to achieve is, above all, to make you see" (Kracauer 1965: 41). This could serve as a concise account of the phenomenological project, for phenomenology, Husserl wrote in 1907, is "reflection that simply sees" (Husserl 1958: 44; Hardy 1999: 34). Anticipating by several decades Wittgenstein's famous injunction "Don't think, but look!" (Wittgenstein 1953: 36)— Husserl seeks to let the mind's intuitive eye have its say and not be seduced by discursive arguments cut loose from the things themselves. Husserl's point is that the presence of formal argument is not identical with the presence of philosophy. Authentic philosophical argument must be founded on a seeing, an insight, a showing. Films show and present; they rarely argue in a formal sense. Phenomenological films, one could say, "monstrate" rather than "demonstrate" (D'Arcy 1962: 55). By doing so, one can argue, they open up much richer possibilities for philosophical insight than films that presume that philosophy must trade in arguments or advance theories. To show and to see, as film and phenomenology do, is to take a path every bit

as demanding and rigorous as demonstrative argument. "It is a task to come to see the world as it is" (Grau 2006: 127), Iris Murdoch said. Phenomenology takes on that task, and so do many films.

The cinematic epoché

The way to phenomenological seeing is through what Husserl calls the phenomenological reduction or *epoché*. The *epoché* represents a change from the natural attitude, the condition in which we find ourselves when we are not doing philosophy, to the philosophical attitude. Ordinarily we are absorbed in straightforward living, only exceptionally reflecting philosophically and undertaking the task of uncovering the essential features of our experience. We perceive, for example, but do not inquire into what perception is; we enjoy images flickering on the screen, but do not investigate what images are and what is essential to our experience of them. Now it is precisely the philosopher's business, Husserl thinks, to engage in such inquiries and to strive to see those essential features. In order to do that, we must disengage ourselves from ordinary living, and that is the business of the phenomenological reduction. Husserl characterizes it as the "bracketing" or "suspending" of the natural attitude. This does not entail, as some of Husserl's critics have charged, the abandoning of the world of actual existence. If it did, then film, which displays the cornucopia of existence as no other medium, could hardly function phenomenologically. But phenomenology no more turns away from the world than film does. Indeed, the whole point of bracketing the world is to give us new eyes with which to see what was there all along, but that our quotidian absorption in the natural attitude had hidden from view. Thanks to the reduction, *"every experience whatsoever can be made into an object of pure seeing and apprehension"* (Husserl 1958: 31; Hardy 1999: 24). Phenomenology and film share a deep affinity in this respect. One can say of both that they *"explicate the sense this world has for us all, prior to any philosophizing,* and obviously gets solely from our experience—*a sense which philosophy can uncover but never alter"* (Husserl 1963: 177; Cairns 1960: 151). Films that work phenomenologically refine, concentrate, and manipulate our experience, but do not fundamentally alter it. On the contrary, the refinement and concentration they bring to the phenomena reveal their essential structures.

Film has unique ways of detaching us from the natural attitude and turning us into phenomenological spectators. We will examine some of these in later sections of the chapter, but it is interesting to note here that just going to the movies is a disengagement from everyday life. We take a seat in a darkened theater—already a kind of bracketing—and focus our attention on what unfolds on the screen. What we see there is an image, not reality. Husserl's comment about a painting by Titian applies equally to the image in film: "I do not take what I see to be 'real.' It does not exist"

(Husserl 1980: 149; Brough 2005: 178). Because it is not something real, the film image effectively forces a suspension of the natural attitude; it represents the real to us in a way that does not call for action and participation. To see a film, then, is to enter into a cinematic *epoché*.

The phenomenological seeing that results is not like a security camera's mindless recording of whatever crosses in front of its lens. Films do not simply *reflect* reality, like a mirror; they reflect *on* reality, understood as a phenomenon. The character of factual existence does appear in film, as it does in phenomenology, but in brackets, as a phenomenon created by the filmmaker's reflection and offered to the viewer's reflection. The proper task of cinematic reflection is not to copy something, but, to borrow Husserl's language, "to consider it and explicate what can be found in it" (Husserl 1963: 73; Cairns 1960: 34). Because the film is a product of imagination and creates a world of its own, it is free to explore the world of the natural attitude, not just repeat it. The film as an imaginative reconstruction of the world is a lens through which the world reveals itself. It facilitates phenomenological insight because it distances and distills, enabling us to enter what Husserl calls the attitude of "fictionalizing experience" in which we "live in the 'image' world," which is "a suspended world," not the real world (Husserl 1980: 518; Brough 2005: 619). The "image world" is the world of the natural attitude captured in images and recreated for our contemplation.

With the adoption of the phenomenological attitude, Husserl writes, the ego "splits," with the reflecting ego establishing itself "as '*disinterested onlooker*,' above the naively interested ego" (Husserl 1963: 73; Cairns 1960: 35). This splitting of the ego occurs in film as well. Through the cinematic *epoché*, the film viewer becomes a disinterested spectator. The characters we see in the film, however, remain naively interested egos, presented as living their lives and going about their business in the natural attitude. In *High Noon* (1952), Marshal Will Kane, played by Gary Cooper, learns on his wedding day, which is also the day he is resigning from office, that a vicious outlaw whom he had sent to prison years before is returning, bent on revenge, on the noon train. Three members of his gang are already in town waiting for him at the depot. Kane appears in the film as determined not to run, but also as deeply anxious about losing his new bride, who is a Quaker and says she will leave him if he fights. And when no one from the town is willing to help him, it is clear that he does not think he will survive. We see all of this in viewing the film, but like the reflecting phenomenologist, we are non-participant onlookers. This does not mean that we are indifferent to Kane's fate or that we do not empathize with his desperation in the face of what seem to be insurmountable odds. Indeed, a key source of the film's power is that it draws us in emotionally, but Kane's plight is still not lived by us as it is lived by him. We experience it within the frame of the cinematic *epoché*, and the emotions we feel are, in Husserl's terms,

"*quasi*-feelings," as-if emotions (Husserl 1980: 389; Brough 2005: 461). If it were otherwise, we could not be spectators; we would be back in the natural attitude, forced to make a decision about whether to help Kane or not. The reduction, whether phenomenological or cinematic, takes us out of the natural attitude, turns us into spectators, and lets us contemplate the world as phenomenon.

Transcendental consciousness

Films such as *High Noon* go further than merely presenting fictional characters engaged in the world. They *show* what engagement in the world is. They let us see what it means. In phenomenological terms, I do not merely see the characters as objects or things; I see them as *subjects* presenting their worlds. A world is always a world for a conscious subject. The reduction therefore presents us not only with the world as phenomenon but also with the consciousness that presents the world. Husserl calls this consciousness the "transcendental ego" or "transcendental subject." It has the privilege, as Aron Gurwitsch says, of being "the only and universal medium of access to whatever exists" (1966: xix).

This means that when I view a film, I am a transcendental ego presenting the image world of the film, in which I see, in turn, other transcendental egos, the characters in the film presenting their worlds. We see transcendental egos in action. King Vidor said that he tried to make his pictures "from the viewpoint of the leading character" who "sees it all happen." Vidor described this as "a first-person technique" (Schickel 2001: 158). Phenomenology, too, takes the first-person perspective. It does not view the subject in third-person fashion as one more object in the world, but as that which makes possible the having of a world and objects in the first place. Films that take the first-person perspective encourage the viewer to identify with a character and to see things through that character's eyes. We become one with the character's consciousness, seeing and presenting what he or she sees, revealing what it is to be a transcendental subject presenting a world. Alfred Hitchcock's *Rear Window*, which will be discussed in a later section, is a nice example of this. But even when we are not "inside" a particular character seeing everything from that character's perspective, when we are just looking at characters, we can still get a sense of the conscious experiences they are living through. Facial expressions, tone of voice, the body's posture and movement, reveal not only the particular emotions and desires of the people we see on screen, but more generally the fact *that* they have a transcendental life. There are also techniques unique to film that represent what a character may be thinking. A blurred image on the screen, for example, may signal a movement from present perceiving to remembering, as it does in *Casablanca* (1942), when Rick, confronting Ilsa, recalls their last hours together in Paris as the German army approaches.

This is a cinematic showing of Husserl's observation that when we remember something it is as if we were seeing through a veil or fog (Husserl 1980: 202; Brough 2005: 241).

Since the transcendental subjects and everything else displayed on the screen are presented through the camera, the camera might aptly be described as the film's ultimate transcendental subject.[2] George Linden notes that "in a film the camera is the ground for any objects appearing at all" (Linden 1970: 157, 11n). And King Vidor said that "something about the lens is very akin to the human consciousness which looks out at the universe. 'I am a camera'—we are all cameras" (Schickel 2001: 159). The camera as ego can take many forms. Sometimes it functions as an anonymous ego providing views that anyone present to a landscape, event, and so on, might have, although this neutral subject easily slides into identity with my own ego, so that the views become my views and it is I who am walking down a street or watching a boy play on his sled in the snow. In other cases, the camera becomes the ego of a character with whom I identify, looking out a window or gazing into another character's eyes or watching someone burst into tears. In still other cases, the camera closely follows a perceiver who is examining an object from many sides and aspects. It *shows* us what perceiving is like. It lets us *see* seeing in a way that escapes ordinary perception. All of these ways in which the camera functions as an ego confirm John Belton's observation that "in the cinema, there is always present, in the positioning of the camera and the microphones, a consciousness that sees and (in the sound film) hears and that coexists with what is seen and heard." Thanks to that, Belton argues, "the cinema remains the phenomenological art par excellence, wedding, if indeed not collapsing, consciousness with the world" (Belton 2004: 394). Husserl himself refuses to collapse consciousness and world, insisting on maintaining the integrity of both, but he emphatically affirms the inseparable bond between them, which film confirms again and again.

Film and essence

There is a mistaken understanding of phenomenology that takes it to be an exclusively descriptive enterprise, recounting in minute and unbounded detail the appearances of things. This view reduces phenomenology to a parody of the imitation theory of art. Neither phenomenology nor phenomenological films, however, are merely descriptive. Both articulate what they present, and in both seeing becomes the grasping of the essence of phenomena. They also share affinities in the ways in which they achieve the showing of the essential.

Films are the products of the creative imagination, and it is through imagination that phenomenology reaches the essential structures of experience. Husserl describes this process as "free imaginative variation." Its aim, as

Dermot Moran writes, is to allow "the essence to come into view and anything merely contingent to drop away" (Moran 2000: 154). It varies the phenomena imaginatively until their necessary features disclose themselves. The best films do precisely that: they hone the phenomena and pare away the incidental to let essence shine through. The essence is universal, but not abstract. It reveals itself only in the film's concrete images, which reflect the essential because they have been shaped and distilled by the filmmaker's imagination, always with a view to seeing. The film might therefore be described as a "prepared particular," a richly complex image created precisely to present something. This imaginative distillation disclosing the essential can also serve aesthetic ends, of course, and in the best films always does.

One might argue that films as fictional and as products of the creative imagination are well suited for entertainment, but too far removed from perceptual reality to serve as vehicles for essential insight. Husserl insists, however, that as far as the possibility of intuiting essence is concerned, "perception and imaginative representation are entirely equivalent—the same essence can be seen in both, ... the positing of existence in each case being irrelevant" (Husserl 1958: 69; Hardy 1999: 50). It makes no difference whether Will Kane, the hero of *High Noon*, ever actually existed. What is important is that the film lets us see what courage and integrity are, and that is an insight that comes from the created images we see, not from facts or any belief about real existence.

We have discussed in general terms how film as phenomenology presents the world in a unique and heightened way, transforming us into spectators who see life's essential core glowing within the images the filmmaker has created. The next sections explore some particular ways in which two films function as phenomenology.

The Purple Rose of Cairo and the phenomenology of the film image

Woody Allen's *The Purple Rose of Cairo* (1985) is a poignant and playful reflection on the cinematic image. It effectively carries out a phenomenology of image-consciousness, the sort of awareness we have when we contemplate a painting or sculpture, or see a play or film. Husserl finds three moments in image-consciousness: the image itself, the characters I see on the screen, for example; the image's physical support, such as the projector and film stock; and the subject of the image, what it is about. Image-consciousness is unique in that it has a foot in both the perceptual and imaginative worlds. If I imagine a centaur, I have only an "as-if" perception. When I view a film, on the other hand, I actually perceive something, and what I perceive is an image up on the screen. Husserl therefore refers to image-consciousness as "perceptual phantasy" or even "physical

198

imagination" (Husserl 1980: 21, 476, 504; Brough 2005: 22, 565, 605). When I view a film, I live in perceptual phantasy.

The Purple Rose tells the story of Cecilia (Mia Farrow), a young woman living in a small New Jersey town during the great depression. She works as a waitress, at least until she is fired early in the film, and is married to an unemployed, feckless, and sometimes abusive lout. She finds relief from her unhappy life in going to the movies, and her vehicle of escape in Allen's eponymous film is *The Purple Rose of Cairo*, a 1930s romantic comedy about rich, globe-trotting sophisticates.

We first encounter Cecilia standing in front of the local movie house looking wistfully at a poster advertising *The Purple Rose*, the new feature that will open that night. The manager tells her that she will like it: it's "more romantic than the last one." The film then cuts to the diner where Cecilia works as a distracted waitress, spending more time discussing movies with her sister, who works there too, than in taking care of customers. On her way home from work, she meets her husband pitching pennies with his buddies. She asks him if he wants to see the new feature with her that night, but he tells her he's going to shoot dice. Against that background, Cecilia goes to see *The Purple Rose of Cairo* alone. In a sequence that constitutes a kind of phenomenology of moviegoing, and ultimately of the film image, we see her standing in line for her ticket at the theater, entering the lobby with a smile of anticipation, buying a bag of popcorn, and then settling into a seat just in time for the lights to go down, the curtain to part, and the flickering images of *The Purple Rose* to appear on the screen. In the opening scenes, the suave but silly Manhattanites, bored with night-clubbing, decide to fly off to Egypt for excitement. There they discover Tom Baxter, self-described "explorer, poet, and adventurer, of the Chicago Baxters," rummaging around in a Pharaonic tomb, and looking very much the explorer in his pith helmet. On a whim, he agrees to go back with them for a "mad-cap Manhattan weekend."

These are the initial images Cecilia sees. They bear out what Husserl holds to be essential to image-consciousness: the threefold conflict between the appearing image, on the one hand, and its material support, real surroundings, and subject, on the other. Image-consciousness is "consciousness of inactuality and consciousness of conflict" (Husserl 1980: 151; Brough 2005: 180). To see an image is not to see a real thing, even if the image may enthrall us. The image is a figment, a semblance or show (*Schein*) (Husserl 1980: 580; Brough 2005: 698). We are conscious of it as a semblance thanks to its conflicts, which Allen's film, by showing us Cecilia and the rest of the audience looking raptly at the images on the screen, puts us in a perfect position to observe. In the conflict between the image and its physical support we maintain a "suppressed" awareness of the real screen on which the film is projected and of the real machinery projecting it. Filmmakers have tried over the years to overcome the tension between

image and reality through a variety of technical innovations from sound to 3-D projection to Cinerama, but they have never managed to erase completely our awareness of the physical basis of the image, and hence of the difference between what can be seen on the screen and reality. As John Belton notes, "the cinema never quite succeeds in masking the work that produces it" (2004: 393).[3] Husserl would add that it *must* not succeed if we are to experience an image at all: without conflict, we would take what we see to be reality. The point of seeing a film, however, is not to hallucinate or to have reality all over again, but to experience that peculiar kind of thing, the image, which can do what ordinary things, such as flowers or stones, cannot do, that is, be about something or have a content.

The image also stands in contrast to its real environment (Husserl 1980: 148; Brough 2005: 175). The Egyptian tomb or the elegant nightclub in New York appearing to Cecilia on the screen do not fit harmoniously into the real surroundings of the small movie house in her depressed New Jersey town. The image she sees is in the world, in the sense that it appears *in* the theater, but it is not *of* it, and this conflict lets the audience know that what they are experiencing is an image and not something real.

Finally, there are empirical conflicts emanating from what appears on the screen. Tom Baxter and his new-found friends are larger than life, larger than the members of the audience. Their voices are unnaturally loud and resonant, and the shades of black and white in which they appear are not the colors they would have in reality. Even if they were projected in techni-color, what Husserl says of color in painting would apply equally to them: "*empirical experience* offers resistance. … Painted colors are not exactly like actual colors. The difference *can* be perceived" (Husserl 1980: 149; Brough 2005: 176).

What makes *The Purple Rose of Cairo* phenomenological is that it shows these conflicts, which are essential to the consciousness of the film image, by making the *seeing* of the film part of its content. In viewing Woody Allen's film, the "imaging" *Purple Rose*, we see Cecilia and the other members of the audience in the theater in New Jersey experiencing the "imaged" *Purple Rose*. The imaging film makes patent the conflicts and differences between image and reality. It becomes a phenomenology of what is essential to viewing a film.

The result is that when Cecilia sees Tom Baxter on the screen, she does not take him to be real, like the bag of popcorn in her lap. The world of the film, "the world of celluloid and flickering shadows," is clearly set apart from reality. Cecilia does, however, actually perceive Tom as an image-object on the screen. She *sees* Tom, and we see her seeing him. She is not just having a private phantasy in the "airy realm" of "the 'world of phanta-sies'" (Husserl 1980: 152; Brough 2005: 180). One can entertain a phantasy anywhere and at any time, and with one's eyes open or shut, because it is not in the world and not public. To see a movie, on the other hand, one must

be in a specific place at just that time when the film is being projected for all to see. Cecilia therefore *goes* to the movie theater where *The Purple Rose of Cairo* appears to her, just as she appears to us, with the full force and intensity of perception (Husserl 1980: 57, 60; Brough 2005: 62, 64). But just as image-consciousness is not phantasy, it is not normal and full perception either, since the image-persons and the image-things on the screen are not actual. Image-consciousness, as we have seen, presents us with a perceptual semblance, with a show of reality, not reality itself. The image, though genuinely perceived, "truly does not exist" (Husserl 1980: 22; Brough 2005: 23). It is a *"nothing,"* a *"nullity,"* which nonetheless appears (Husserl 1980: 46, 48; Brough 2005: 50, 51).

This unreality of the image is a theme that runs throughout the film and is at the core of some of its most interesting phenomenological aspects. These emerge after Cecilia drops a customer's lunch on the floor and is fired from her job. She takes refuge at the movies, and, with tears streaming down her cheeks, begins a serial viewing of *The Purple Rose of Cairo*. As she watches the movie for the third time that day, something astonishing happens. Tom Baxter suddenly glances fleetingly out at the audience, as if he were noticing something; then, after a brief hesitation, he looks straight at Cecilia and says, "My God, you must really love this picture. You've been here all day, and I've seen you twice before." And with that he steps out of the picture and into the theater. Images are not supposed to escape the screen and join the real world; they inhabit a different ontological realm. Pandemonium breaks loose in the audience and among the characters left stranded in the film, one of whom protests to Tom, "You're on the wrong side of the screen." But Tom is undeterred. He grabs Cecilia by the hand and dashes out of the theater, shouting "I'm free! After 2000 performances of the same monotonous movie!" The spell of the film's ideal world, insulated from the real, is broken. Tom leaves the black and white world of the film and enters the real world of color. Cecilia no longer sees Tom *in* the film; she sees him face to face.[4] *The Purple Rose of Cairo* shows the distinction between these two different ways of being related. Face to face, Tom and Cecilia can now interact. In short order, Tom falls in love with Cecilia, and Cecilia, though confused about Tom's status with respect to reality, quickly develops a strong affection for him as well.

Freedom, integrity, and the cinematic image

Once Tom is off the screen, the film begins to explore a broad array of themes involving the cinematic image. One of these is the integrity of the narrative film.

The Purple Rose of Cairo, like narrative films generally, has a unity established by the script. Tom's departure from the film leaves it in tatters. As one of the characters stranded on the screen says, "one little minor

character takes some action, and the whole world is turned upside down." The characters left behind are reduced to milling around plotlessly and bickering among themselves about the importance of their roles. The one thing they agree on is that they need Tom back in the picture, since the "story doesn't work" without him.

The collapse of the narrative shows the irreconcilability of Tom's declaration of freedom and the necessity of maintaining a fixed storyline. It may be that "the most human of all attributes is your ability to choose," as Larry, a character in the film, says, but another character reminds us that the inhabitants of the film are not really human at all. They are fictions who have been created by screenwriters. They are not free to go beyond what the screenwriters have given them. They are, as the agitator who suddenly appears on the screen after Tom's departure declares, "slaves to some stupid scenario." If the film is to maintain its integrity and satisfy the audience, the characters must adhere to the scenario, stupid or not. This means, as Tom says, that his universe is limited to what has been "written into my character." It is written into his character, for example, to fight bullies like Monk, Cecilia's husband, and to know what an amusement park is, but it is not written into his character to know the difference between play money and real money. There is something comforting about this, since the fact that the film's story is fixed means that it will be the same each time one sees it. "Where I come from," Tom tells Cecilia, "people don't disappoint; they're consistent, they're always reliable." Cecilia replies that "you don't get that kind in real life." Real life is not the creation of a screenwriter. It is unpredictable and free.

As a fictional being abandoning the plot and inserting himself into the real world, Tom is guilty of egregious ontological trespassing. Of course, this does give him a few advantages. In his fight with Monk, for example, he appears to have been knocked out cold, but he immediately jumps to his feet as if nothing had happened, explaining to Cecilia: "I don't get hurt or bleed. It's one of the advantages of being imaginary." Cecilia tells him, however: "That's why you'll never survive off the screen." Imaginary characters can breathe only the air of the image world. They can survive only in the story, which is why Tom finally decides that the only way he can live happily with Cecilia is to take her with him up onto the screen. So Cecilia steps into the world of the film with Tom, just as Tom had stepped out of it into the world of reality. But since Cecilia is real, not fictional, she turns out to be just as much an ontological alien and disruptive force in the film's fictional world as Tom was in the real world. The other characters object that "she'll tip the balance," and she does. When the group arrives at the Copacabana and asks Arturo, the maitre d', for a table for seven, he replies, "But that's impossible; it's always six." Jenny, the singer at the club, discovering that Cecilia is real, screams and faints, just as a member of the audience fainted when Tom stepped off the screen earlier in the film. The

maitre d' asks whether they are "just chucking out the plot?" Tom replies: "Exactly. It's every man for himself." The maitre d' then starts tap-dancing across the club's stage.

Cecilia's incursion into the film shows that just as there is no place for fictional people in the real world, there is no place for real people in the fictional world. One of the studio executives remarks that "the real ones want their lives fictional, and the fictional ones want their lives real." Neither wish can be fulfilled. The real world is reserved for real people; the fictional world for fictional people. This is an imperative of being. By showing it, *The Purple Rose of Cairo* becomes a phenomenology of the unity of the work of art and of the radical difference between the fictional and the real.

Actors and fictions

Word of Tom's truancy from the film quickly reaches the producers in Hollywood and the actor who plays Tom, Gil Shepherd.[5] The studio lawyers are afraid that Tom will do some mischief as "an extra guy running around" in New Jersey (although it is obviously written into Tom's character that he is a thorough gentleman), while Gil Shepherd, the actor, worries that Tom on the loose will damage his career, which is just starting to take off. Gil and the studio executives rush to New Jersey to get Tom back into the film, a task that falls to Gil. While searching for Tom, Gil inadvertently runs into Cecilia, who at first thinks he is Tom in different attire. They get over that confusion, and before long they are smitten with each other, with Gil urging Cecilia to come see Hollywood with him. With Cecilia's help, Gil finds Tom, who is also in love with Cecilia and wants to marry her. Their encounter opens up a phenomenological reflection on the complex relation between the actor and his or her role. The film both plays with and displays the idea that a character in a film is identical and yet not identical with the actor who plays the part. The identity rests in the fact that a character must be played by an actor to become an appearing image-being on the screen. The actor is the character's physical support, just as the film stock is the material substratum of the cinematic image. But when the actor plays the role, there is distinction between the two.

The film shows this identity and difference in a variety of ways. When Gil meets Tom, for example, he introduces himself ("I'm Gil Shepherd; I play you in the movie"), which would be superfluous if Tom and Gil were straightforwardly identical. In another scene, Gil tells Cecilia that he created Tom, but Cecilia asks whether it wasn't the screenwriter who was responsible. Gil responds: "Yeah, technically. But I made him live, I fleshed him out." The fictional character needs to get off the page and into a body, and the actor supplies it. The embodiment, however, makes the character real "for the screen only." Tom remains a semblance, an image, dependent

on the physical support of the actor and capable of existing only in the fictional world of the movie. In another exchange, Gil tells Tom that "if it wasn't for me, there wouldn't be any you," to which Tom replies: "Don't be so sure. I could have been played by Frederic March or Leslie Howard." Since the character is not literally identical with any particular actor, different actors can support the same character, just as different reels of film can support the same movie. Finally, Cecilia captures perfectly the slippery nature of the relation between actor and role when she says, plaintively and with amazement: "Last week I was unloved. Now two people love me, and it's the same two people." The actor Gil Shepherd is Tom Baxter and yet not Tom Baxter, which is why Cecilia can be loved by both of them, and they can be, in the way in which actors are their characters, the same person.

An ontological chasm

In the chaos that follows Tom's departure from the film, the usher shouts "turn the projector off." That might restore order in the movie house, but it causes panic among the characters in the film. The projector is the film's life-support system. One of the characters screams in panic: "No, no! Don't turn the projector off. It gets black and we disappear. You don't understand what it's like to disappear, to be nothing, to be annihilated. Don't turn the projector off." This may be a Woody Allen riff on death, but from the phenomenological perspective the characters are articulating the fundamental point that the image depends on its physical support. If the projector is turned off, the images cease and become nothing. But even when the projector is running, they are still nothing in the sense that they are semblances or fictions. They are not real—and their unreality is a recurrent motif in the film. "I just met a wonderful new man," Cecilia says at one point. "He's fictional, but you can't have everything." Gil tells Cecilia that she's a sweet girl and deserves "an actual human." Cecilia protests that Tom is perfect, but Gil asks: "What good is perfect if a man's not real?" Tom says he could learn to be real, but Gil tells him that being real is not something you can learn. "Some of us are real, some are not," he says. There is an ontological chasm between image and reality that cannot be bridged, which means that Cecilia could no more marry Tom than she could marry Hamlet. Both are fictional. On the other hand, she could marry the actor who plays Tom.

These declarations of Tom's unreality lead to the climax of the film. Cecilia, in love with both Tom and Gil, must choose whether to join Tom, who is perfect but fictional, in the world of the film or go with Gil, who is real, to Hollywood. She is torn, but chooses Gil. "I'm a real person," she tells Tom. "No matter how tempted I am, I have to choose the real world." Tom says goodbye and dejectedly returns to the film, watching Cecilia leave

the theater with Gil. Cecilia rushes home, packs her suitcase, and hurries back to the theater, where she thinks Gil will be waiting to take her to Hollywood. Her husband shouts after her: "See what it is out there. It ain't the movies; it's real life. It's real life, and you'll be back." Her husband is right. The flesh and blood actor Gil Shepherd effectively turns out to be nothing in the sense in which real people can be nothing. He reneges on his promise and flies back to California without her. The film ends with Cecilia in the theater, her suitcase next to her seat, watching Fred Astaire and Ginger Rogers dancing in *Top Hat*, the new feature that has replaced *The Purple Rose*, her happiness, such as it is, once again coming from the images flickering on the screen.

Rear Window and the phenomenology of perception

Alfred Hitchcock's *Rear Window* (1954) is a masterpiece of suspense. It is also a cinematic primer for a rich array of themes that have traditionally been targets of phenomenological investigation, such as perspectival perceiving, evidence, and the worlds in which we live.

The principal protagonist of the film is L.B. "Jeff" Jeffries (Jimmy Stewart), a photojournalist whose leg was broken when he was struck by a racecar he was photographing. Confined to a wheelchair in his cramped apartment, Jeff entertains himself by observing the activities of his neighbors in the apartments surrounding the courtyard behind his building. Looking through his rear window, he sees them as they appear through *their* rear windows. Rear windows suggest the opportunity of glimpsing what people do when they think no one is looking, which can be anything from setting the table to practicing dancing to getting drunk, even to murdering someone. When the rear window belongs to an apartment that looks across a courtyard into many other rear windows, the opportunity is there to see multiple private worlds. Jeff seizes the opportunity. There is "Miss Torso," a young, energetic dancer who practices in her underwear; "Miss Lonelyhearts," a middle-aged woman who drinks to escape her loneliness; a struggling songwriter; a couple who sleep on their fire escape on hot summer nights and who lower their small dog down to the courtyard in a basket; a sculptor often seen napping in a lounge chair outside her apartment; newlyweds who rarely raise the shades on their windows; and a jewelry salesman who lives with his invalid and nagging wife. On Jeff's side and behind his window, there are two frequent visitors. One is Lisa Fremont (Grace Kelly), a beautiful socialite who works in the world of high fashion and belongs, as Jeff puts it, "to that rarefied atmosphere of Park Avenue—expensive restaurants, literary cocktail parties ..." Lisa is in love with Jeff and wants to marry him, but Jeff thinks his world of globe-trotting photojournalism with its assignments in harsh and hostile places would make a poor fit with Lisa's world of fashion and glamour. The other visitor

is Stella (Thelma Ritter), the sardonic insurance company nurse who drops in to check on Jeff every day. Jeff's detective friend, Tom Doyle (Wendell Corey), appears later in the film. The plot revolves around whether the jewelry salesman, Lars Thorwald (Raymond Burr), has murdered his wife. One evening Jeff sees Thorwald bring his wife dinner in bed, and later sees the two of them arguing. At some point amid the general background noise from the city there is a scream and what sounds like a woman's voice crying "Don't!" Jeff then dozes off in his wheelchair. Much later a thunderstorm wakes him up, and he observes Thorwald leave his apartment three times in the rain with a suitcase and then return, with the suitcase apparently empty each time. The next morning he sees Thorwald wrapping a saw and a butcher knife in newspaper. Thorwald comes to the window and looks around carefully, as if he were trying to determine whether anyone could have seen what he had been doing the night before. There is no sign of Mrs. Thorwald, who can usually be seen lying in bed. Jeff concludes that Thorwald has killed his wife.

Perspectival seeing

Jeff's broken leg, confining him to his apartment and limiting his visual field to what he can see from the perspective of his window, is the means through which the film becomes phenomenological. The broken leg carries with it a kind of forced phenomenological reduction. Jeff is "bracketed," "put out of action," and thus transformed into a spectator who can see what we ordinarily do not see in our active absorption in the world. Stella accuses Jeff of being a peeping Tom and says he is "window shopping," and Jeff admits that what he is doing is like watching "a bug under glass." If these were taken to be descriptions of phenomenology, they would not be very flattering, but they do capture a key aspect of what phenomenology does. Seeing what transpires across the courtyard through the frame of his window is a kind of disengaged seeing, a device for letting the phenomenology of certain key themes come to the fore. To the extent that we become identified with Jeff, we become spectators, too, and the film's reflective "meditations" becomes ours as well.

Perspective is one of these themes. Every shot of what is outside Jeff's apartment is from the perspective of his cramped living room. Even the close-ups occur exclusively through Jeff's binoculars or telephoto lens. The film brings home to the viewer how the perceiver is tied to a fixed spot at any given moment, and how this shapes and limits what can be seen. The camera could, of course, wander about independently of Jeff's situation, taking us inside Thorwald's apartment and showing us the interior spaces that Jeff cannot see, or transporting us into the street and letting us follow Thorwald on his mysterious nocturnal excursions. This never happens because Jeff is incapable of making those movements, and Hitchcock, apart

from a few reverse shots, steadfastly shoots the film from Jeff's point of view. The fact that virtually every scene is filmed from Jeff's perspective sharpens the theme of perspectival viewing, and shows us the limitations it imposes, and what we have to do to overcome them.

The film also discloses how perspectival perceiving conceals as much as it reveals. It shows the face of the object or event turned toward me, but hides the aspects I do not see. I am aware that what I am perceiving does have other sides or properties, but my consciousness of them is, in Husserl's language, "empty" or "open." To fulfill these empty "intentions,"[6] the perceiver must take action and progressively realize new moments of a total perceptual experience. Jeff himself does not have the mobility to open up the empty spatial horizons of much of what he sees. To grasp things from other perspectives, he must rely on Lisa and Stella as surrogates. Unlike Jeff, they are able to go into the courtyard searching for evidence, and, in Lisa's case, into Thorwald's apartment. When they leave Jeff's apartment, however, we still see them exclusively from his perspective. Jeff knows and we know that they are seeing things we do not see, which is precisely why they have ventured outside the apartment. But we always see them doing the searching from his perspective, not theirs.

In all of this, Jeff comes before us as a transcendental ego or subject in action, presenting the world. This follows directly from the focus Hitchcock takes in the film: "I'm inclined to go for the subjective; that is, the point of view of an individual," he said in an interview, adding that "the picture when pure cinema in the subjective sense was used was *Rear Window*" (Schickel 2001: 285). *Rear Window* lets us see seeing; it shows us the essence of what it is for a subject to perceive perspectivally. In that sense it does phenomenological work.

To say that Jeff represents a transcendental consciousness presenting a world is not to suggest that he is trapped in egocentric isolation. The presenting subject forms a union with other perceivers in its presentational life. Precisely this occurs with Jeff and Lisa as the film progresses. The two come to share "a dual point of view, with the reverse shots finding *both* Jeff and Lisa intently staring out the window at the neighbors across the way" (Modleski 2004: 856). Transcendental *intersubjectivity* comes into being before our eyes as we view the film. We see Jeff and Lisa together experiencing the same objects and events. They share an intersubjective or common world through the perspective of Jeff's window.

On the other hand, their dual point of view does not extend to everything they perceive, and this suggests another sense of perspective: perspectival interpretation. Things seen from the same spatial and temporal perspective can be interpreted differently by different people, and the interpretation, like any perspective, will be limited. Thus Jeff describes the people he sees from his window in a one-sided way. He observes aspects of the private world of "Miss Torso," for example, but given his male perspective, can

only see so much, which the name he attaches to her shows. Interpretations and their limitations have their source in what Husserl, borrowing Leibniz's term, calls the "monad," that is, *"the ego taken in its full concreteness"* (Hussserl 1963: 102; Cairns 1960: 67). The interpretive ego is not an empty pole inspecting the world as a neutral observer. What I am and how I present the world are matters of what I have lived through and the people I have known and know now, of my decisions and the habits I have formed, of my gender and my vocation. All combine over time to provide me with "an abiding style …, a 'personal character,'" out of which my presenting and interpreting flows (Husserl 1963: 102; Cairns 1960: 67). Hence, while Jeff and Lisa may share spatial and temporal perspectives when they look out the window, they also interpret what they see through the lens of their personal styles. And since their styles differ, so will their interpretations. We see this happening in the film. Lisa "relates to the 'characters' through empathy and identification," while Jeff's approach is more detached and objective (Modleski 2004: 856). In one scene, for example, Miss Torso entertains three men in her apartment. As Jeff and Lisa look across the courtyard at the group, Jeff comments that "she's like a queen bee with the pick of the drones," while Lisa says in reply, "I'd say she's doing a woman's hardest job—juggling wolves." When Miss Torso goes out on her balcony with one of the men and briefly kisses him, seemingly without conviction, Jeff's reaction is that "she sure picked the most prosperous looking one." Lisa responds that "she's not in love with *him*—or with any of them, for that matter." Lisa's interpretation turns out to be true: at the end of the film, a short, chubby soldier, not at all the image of prosperity, appears at Miss Torso's door. She shrieks "Stanley" and gives him a genuine hug, after which he heads straight for the refrigerator. She is in love with Stanley, not with one of the wolves. Lisa's perspective will also be important to solving the crime, as we shall see.

Seeing and evidence

Perspective, seeing, interpretation, and evidence are all connected in complex ways, and *Rear Window* explores their connections. The quest for evidence has it origins in seeing and interpretation. Jeff sees Thorwald take his mysterious journeys late at night and interprets them, along with Mrs. Thorwald's absence, as evidence that Thorwald has murdered his wife. Jeff did not see Thorwald commit the crime, however, and originally he was alone in thinking that Thorwald had murdered her. Lisa and Stella at first interpreted Thorwald's actions and the absence of his wife as innocent and easily explained. So did Tom Doyle, Jeff's detective friend. They all had cogent *arguments* for their views, but none of them had *seen* what Jeff had seen the night before. Lisa began to share in Jeff's suspicion only when, in a revelation that leaves her transfixed, she sees Thorwald tying rope around a

large trunk in the couple's empty bedroom. "Let's start from the beginning again," she says. "Tell me everything you saw, and what you think it means." These suspicions, though based on seeing, are still largely empty intentions. To fill them, Jeff and Lisa need more evidence, that is, they need to see more. At first they think the trunk will supply it in the form of Mrs. Thorwald's body. But Tom Doyle ascertains that the trunk in fact contained Mrs. Thorwald's clothes, and was picked up from the rail station at a town 80 miles north of New York by someone identifying herself as Anna Thorwald. With that revelation, a phenomenology of how experience can be corrected unfolds on screen. Our conscious lives normally flow along harmoniously, our empty intentions and expectations steadily fulfilled and our certainties confirmed. But the harmony is not always sustained; and when the expected evidence fails to appear, certainties can turn into "mere possibilities, doubts, questions, illusions" (Husserl 1962: 164–65; Carr 1970: 162), which is what happens to Jeff and Lisa when they hear what Tom has to say about the trunk.

As Husserl observes, however, even if one's expectations are dashed in a particular case and one's certainty is rattled, "*a harmony in the total perception* of the world is always sustained" (Husserl 1962: 163; Carr 1970: 161). This means that other possibilities for evidence can arise, and in this case they do. Jeff and Lisa watch as the dog that belongs to the couple who sleep on the fire escape digs in the courtyard flower bed Thorwald tends. Thorwald shoos the dog away. Later it is found dead in the courtyard, its neck broken. Jeff, Lisa, and Stella think Thorwald must have hidden something under the zinnias where the dog was digging. Shortly after the incident with the dog, Jeff, using his telephoto lens, sees Thorwald sort through the contents of his wife's purse, which is filled with jewelry, including what appears to be a wedding ring. Lisa, from her interpretive perspective, observes how odd it is that Mrs. Thorwald did not take her favorite handbag and jewelry, and especially her wedding ring, with her. "The last thing she would leave behind would be a wedding ring," she says.

Jeff and Lisa do not really know what might be buried in the flower bed, or whether it was really Mrs. Thorwald's wedding ring that Jeff saw. They therefore set about trying to get the evidence they need. Jeff sends Thorwald an anonymous note with the message: "What have you done with her?" Then, to get Thorwald out of his apartment so that Stella and Lisa can search in the flower bed without being seen, Jeff calls him with an offer to meet at a nearby hotel bar to discuss his "late wife's estate." The ruse works, and Lisa and Stella leave Jeff's apartment and dig up the suspect zinnia. They find nothing, however, leading to one more disappointed expectation. Then Lisa, on her own initiative and to Jeff's horror, decides to look for the wedding ring in Thorwald's apartment. In a scene of almost unbearable anxiety for Jeff, helpless in his wheelchair, she climbs up the fire escape outside Thorwald's apartment, swings herself through an open

window, finds the purse, and puts the wedding ring on her finger. At that point Thorwald returns. Jeff calls the police. Thorwald and Lisa struggle, but the police arrive just in time to save her.

Lisa's interpretive perspective lets her know what to look for, and when she finds it, she has a strong piece of evidence that Thorwald is indeed a murderer. It would not occur to Jeff, from his perspective, to see the wedding ring as an essential clue. But once Lisa presents that possibility and then fulfills it by finding the ring, he sees that it is.

While the police, who think they are investigating a routine case of breaking and entering, question Lisa, Thorwald notices—we see this through Jeff's telephoto lens—that Lisa has the ring on her finger, which she is wiggling behind her back, apparently so that someone across the courtyard can see it. Jeff does see the ring through his telephoto lens, but he also sees Thorwald look across the courtyard in the direction of his apartment. Before Jeff can retreat from view and turn off the lights, Thorwald sees him. That leads to one more critical bit of evidence and the climax of the film. Lisa has been taken to the precinct house and Stella has gone to bail her out, which leaves Jeff alone. Thorwald figures out that it is Jeff who sent the note and that Lisa was searching the apartment for the ring. He finds Jeff's apartment number, and in another scene of nail-biting suspense, we hear him slowly mount the stairs to Jeff's apartment, see him open the door, and then, after struggling with Jeff, push him out the second-floor window. Doyle and the police arrive just in time to break Jeff's fall. This was not part of Jeff's and Lisa's plan, but it fulfills their empty intentions. Evidence for Husserl occurs when something is there itself, present "in person" or "bodily present." Presence in person in this case would not simply be Thorwald's presence in Jeff's apartment, but his presence as attempting to kill Jeff. The kind of evidence, or presence, must fit the nature of the absence. Thorwald, through his actions, reveals himself as a killer. As Jeff lies in the courtyard, his other leg broken now, we hear a detective shout from his apartment: "Thorwald's ready to take us on a tour of the East River," which would supply the final evidence: seeing the body. In phenomenology, evidence is to have the thing itself, to see it. *Rear Window* lets us see, phenomenologically, the twists and turns of the process of bringing something to evidence. It gives us the evidence for what evidence is.

Worlds

Rear Window shows that perspectival seeing leaves open the possibility of further determination. This leaving open forms what Husserl calls the "horizons" of our experience (Husserl 1963: 83; Cairns 1960: 45). The ultimate horizon is the world, a universal horizon common to all (Husserl 1962: 167; Carr 1970: 164). *Rear Window* thematizes the world horizon and the particular worlds that nest within it. It lets us see them and how they form

the constant background and setting of our experience. There are vocational and cultural worlds, for example, which we glimpse in the songwriter at his piano or in the photographs scattered around Jeff's apartment. And then there are what Husserl calls "home" worlds (Husserl 1973: 196): the space where one lives, one's domestic routine, one's friends, one's pets, and so on. *Rear Window* presents such a diverse array of home worlds that a kind of imaginative variation occurs that discloses what it is to be a home world essentially. Detective Doyle formulates one of the essential elements of the home world—what one might call its "rear window" side—when he reminds Jeff and Lisa: "That's a secret, private world you're looking at out there." Miss Lonelyhearts, for example, sets up elegant dinners for herself and an imaginary guest, whom she graciously greets at the door. "He" gives her an affectionate peck on the cheek before she escorts him to the table where "they" sit down, toast, and engage in animated conversation, until, sobbing, she buries her head in her hands. We also see the songwriter come home drunk one night and violently knock his compositions off the piano stand. Later we see him give a large and noisy party, but it is clear that he is a lonely and unhappy man. We see all of this and much more about the worlds of the characters in the film.

But *Rear Window* does more than present the home worlds of Miss Lonelyhearts and the others. It also makes us aware that these plural worlds appear within the universal horizon of *the* world, which we ordinarily take for granted and which the film lets us see. *Rear Window* might at first appear to offer a severely contracted horizon reduced to what little Jeff can view from his window. Hitchcock, however, employs a variety of devices to make us aware that there is a larger world embracing the confined world of the courtyard, whose image fills virtually all of the screen throughout the film. We hear the sounds of the surrounding city—the resonant blasts of a ship's horn, the cacophony of traffic, sirens—and through the narrow alleyway between buildings we glimpse a minuscule slice of street with its pedestrians and passing vehicles. These bare indications are enough to give the viewer a consciousness of the infinite horizon of the surrounding world. Hitchcock focuses us on this horizon precisely by letting us experience so little of it. Thus through the alleyway we glimpse just enough of the world to see Thorwald disappear down the street with his suitcase. The little we perceive makes his actions seem all the more strange and even ominous because we are aware that the world extends far beyond what we actually see, and that Thorwald has entered it and is up to something. Phenomenologically, we are being *shown* the world as background, not only of Thorwald's actions, but of the many worlds nested in it.

One world that is conspicuously missing throughout most of *Rear Window* is a "neighborly world" in a sense other than the geographical. The film does reveal what the nature of such a world might be, however, by dramatically showing its absence. When the owner of the dog Thorwald has

killed sees its still body in the courtyard, she screams, which brings people to their windows and balconies, spontaneously giving birth to a community of curious onlookers. The dog's owner tearfully addresses them from her fire escape:

> Which one of you did it, which one of you killed my dog? You don't know the meaning of the word "neighbors." Neighbors like each other, speak to each other, care if anybody lives or dies, but none of you do.

A brief silence follows, and then the artificial community dissolves, as the onlookers, the excitement over, retreat to their apartments and their private worlds. Phenomenology makes distinctions, and in this poignant scene the film subtly distinguishes between an environing world and a neighborly world, and tells us that an environing world is not necessarily neighborly.

At the end of the film, when Jeff is convalescing, now with two broken legs and with Lisa keeping him company, suggestions of a neighborhood world appear. We see Miss Lonelyhearts in the songwriter's apartment, sitting close to him, and we can hear her telling him how much she likes the new song he has written. Their mutual loneliness may be coming to an end. It is interesting that before this point and with almost no exceptions we have not been able to hear the various apartment dwellers distinctly enough to understand what they are saying, suggesting the absence of an authentic world of neighborly caring. Now, as the film draws to a close, we can. Finally, Jeff seems to have come to see Lisa in a new light. Her courage has shown that there is more to her than Park Avenue society, and that she can cope extraordinarily well in dangerous situations. There may be a future for Jeff and Lisa after all. In Husserl's language, the "window shopping" in *Rear Window* shows, among many other things, that subjects presenting the world "make up, for me and for one another, an openly endless horizon of human beings who are capable of meeting and then entering into actual contact with me and with one another" (Husserl 1962: 167; Carr 1970: 164) and of doing so in ways that are complex, sometimes disturbing, but often heartening.

Conclusion

I have attempted to show in this chapter that films, in their own fashion, can do something on the order of what phenomenology does. I have not tried to argue that all films do this, but that some, such as the ones we have discussed, go beyond merely furnishing examples that might be used as illustrations for phenomenological investigations. Rather, they carry out the investigations themselves in the rich medium of cinematic imagery. They show, and they let us see. Perhaps in their own way they become, as

Husserl said of philosophers, "functionaries of mankind" (Husserl 1962: 15; Carr 1970: 17).

Notes

1 Edmund Husserl, *Phantasie, Bildbewusstsein, Erinnerung (1895–1925)*, Husserliana XXIII, ed. Eduard Marbach (The Hague: Martinus Nijhoff, 1980), 489, note. English translation: *Phantasy, Image Consciousness, and Memory (1898-1925)*, Edmund Husserl: Collected Works, Volume XI, trans. John B. Brough (Dordrecht: Springer, 2005), 584, note 3. References to Husserl's works, following the initial citation, will be to page numbers in the appropriate volume of the Husserliana series (the critical edition of Husserl's works) followed by the page number of the translation listed alongside the Husserliana volume in "References."
2 Jean-Louis Baudry sees in the camera and its moveability "the most favorable conditions for the manifestation of the 'transcendental subject'" (1985: 537).
3 See also Belton 2004: 388.
4 Richard Wollheim (1987: chs. 2, 3) contrasts the seeing-in that occurs when we see something in an image with the seeing face-to-face that occurs in perception. Husserl also developed a view of seeing-in. See Husserl 1980; Brough 2005.
5 Jeff Daniels plays both Tom Baxter and Gil Shepherd, introducing further phenomenological complications.
6 "Intention" is Husserl's technical term for the act of consciousness. Husserl's doctrine of intentionality holds that every act of consciousness has an object, whether that object is intuitively given or not. "Intention" and "intentionality" in Husserlian phenomenology mean directedness toward an object, not resolve or purpose.

References

Baudry, J.-L. (1985) "Ideological Effects of the Basic Cinematographic Apparatus," in *Movies and Methods*, Vol. II, B. Nichols (ed.), Berkeley: University of California Press.
Belton, J. (2004) "Technology and Aesthetics of Film Sound," in *Film Theory and Criticism*, Sixth Edition, L. Braudy and M. Cohen (eds.), New York: Oxford University Press.
D'Arcy, M. (1962) *No Absent God*, New York: Harper & Row.
De Beauvoir, S. (1962) *The Prime of Life*, Cleveland, OH: The World Publishing Company.
Grau, C. (2006) "*Eternal Sunshine of the Spotless Mind* and the Morality of Memory," *Journal of Aesthetics and Art Criticism* 64: 119–33.
Gurwitsch, A. (1966) *Studies in Phenomenology and Psychology*, Evanston, IL: Northwestern University Press.
Husserl, E. (1958) *Die Idee der Phänomenologie*, Husserliana II, W. Biemel (ed.), The Hague: Martinus Nijhoff; trans. L. Hardy (1999) *The Idea of Phenomenology*, *Edmund Husserl: Collected Works*, Volume VIII, Dordrecht: Kluwer Academic Publishers.
——(1962) *Die Krisis der Europäischen Wissenschaften und die Transzendentale Phänomenologie*, 2 Auflage, Husserliana VI, W. Biemel (ed.), The Hague:

Martinus Nijhoff; trans. D. Carr (1970) *The Crisis of European Phenomenology and Transcendental Phenomenology*, Evanston, IL: Northwestern University Press.

—— (1963) *Cartesianische Meditationen und Pariser Vorträge*, Husserliana I, S. Strasser (ed.), The Hague: Martinus Nijhoff; trans. D. Cairns (1960) *Cartesian Meditations*, The Hague: Martinus Nijhoff.

—— (1973) *Zur Phänomenologie der Intersubjektivität*, Dritter Teil, Husserliana XV, I. Kern (ed.), The Hague: Martinus Nijhoff.

—— (1980) *Phantasie, Bildbewusstsein, Erinnerung (1895–1925)*, Husserliana XXIII, E. Marbach (ed.), The Hague: Martinus Nijhoff; trans. J.B. Brough (2005) *Phantasy, Image Consciousness, and Memory (1898–1925)*, *Edmund Husserl: Collected Works*, Volume XI, Dordrecht: Springer.

Kracauer, S. (1965) *Theory of Film*, New York: Oxford University Press.

Linden, G.W. (1970) *Reflections on the Screen*, Belmont, CA: Wadsworth Publishing Company.

Modleski, T. (2004) "The Master's Dollhouse: *Rear Window*," in *Film Theory and Criticism*, Sixth Edition, L. Braudy and M. Cohen (eds.), New York: Oxford University Press.

Moran, D. (2000) *Introduction to Phenomenology*, London: Routledge.

Schickel, R. (2001) *The Men Who Made the Movies*, Chicago: Ivan and Dee.

Wittgenstein, L. (1953) *Philosophical Investigations*, trans. G.E.M. Anscombe, New York: The MacMillan Company.

Wollheim, R. (1987) *Painting as an Art*, Princeton, NJ: Princeton University Press.

INDEX

215

154, 174, 176, 177, 180; transcendental
80–1
Being and Time (Heidegger) 42, 44–5,
140, 142–3, 148–9, 156, 169, 176, 180,
189nn4, 7
Belton, John 197, 200
Benjamin, Andrew 56, 58, 63, 66–7, 72
Betrachten see observation
binocularity 100–1
Blanchot, Maurice 153
Blattner, Bill 142–3
Blue Vase and Other Objects (Morandi)
47, 48, Pl. 7
body 4, 5–6, 17–20, 28, 85, 170, 171;
"lived" 36, 41 (*see also* embodiment);
as medium 21–7; representation 91,
131, 156n3
Boehm, Gottfried 47
Bonaparte, Napoleon 145, 173–4, 182–3
Botticelli, Sandro 7, 162–3, 164–7, 168,
183–9
boundaries 77, 78, 80–1, 83, 85
"bracketing" 51n3, 194–5, 206
Brough, John 7–8
Brunelleschi, Filippo 13–14, 97
Bryson, Norman 45–6, 47

camera as ego 197
camera obscura 97, 100, 138, 141
Caracciolo da Lecce, Roberto 168,
185–6, 187
Caravaggio 91, 92, 98, 100, 102
Carroll, Noël 34, 35
Cartesian dualism 6, 106, 123, 139, 170
cartography 7, 138, 141, 157n6
Casablanca (Curtiz) 196–7
Catholic Memorial at Ground Zero, The
(Collier) 187
Cats, Jacob 138
causality 23, 74n19, 79–80, 165, 170,
171–2, 176–7
Cestello Annunciation (Botticelli)
162–91, Pl. 26
Cézanne, Paul 2, 6, 11–12, 15, 59, 74n22,
98–101, 154–5, 156
"Cézanne's Doubt" (Merleau-Ponty) 11
Chardin, Jean Baptiste Siméon 48, 95–7,
102

choice *see* freedom
Christian: imagery 117–20; narrative
105–6, 109–10, 120, 164–7 (see also
Genesis narrative); tradition 109–10,
120, 132, 163–4
Chrysostom, St. John 110
Cimabue 13, 16
circularity 185
circumspection 19–20, 24, 149
classificatory definition 36–7, 42
"clearing" 172, 187
Collier, John 187–8
color 3, 12, 27, 39, 59, 98–9, 157n7, 166,
200; Cézanne 59, 98, 155; -field
paintings (*see* Rothko); in film 193,
200; Morandi 49; Rothko 5, 77, 78–9,
82–6, 87–8; Vermeer 144, 150
commendatory definition 36–7, 41–2
connotation 47–8, 49, 141
conscious experience 5–6, 39, 105, 196,
209; *see also* consciousness
consciousness 5–6, 18, 35, 79–81, 85,
213n6; of the ideal 32; of identity 39;
image- 47–8, 192–3, 198–201, 211;
self- 105–37; transcendental 196–7,
207
contextualization 138, 139–42, 144,
149–51, 153, 167–8, 169–70, 175
corporeity *see* body
Courbet, Gustave 74n16
Cozens, J.M. 64, 73n13
Cranach the Elder, Lucas 6, 105–37
creation 22–3
"Crisis of Understanding, The"
(Merleau-Ponty) 162, 181–2, 183
Critique of Judgment (Kant) 33
Crowell, Steven 1–2
Cubism 26–7, 94
cultural context(s) 7, 69, 138, 141–2,
167–8, 169, 172, 178–9, 185–6, 189n4,
211

Da Vinci, Leonardo 12–13, 14–15, 16,
91, 93, 103n1
Danto, Arthur 33, 38, 43, 51n4, 73n9
Dasein 142–3, 147, 148, 149, 150–3, 181
Davidson, Donald 54, 61–4, 67, 70,
73n10, 74n19